What is Enlightenment?

WHAT IS ENLIGHTENMENT?

Questions for the Eighteenth Century

Edited by Raphael Gross and Liliane Weissberg
for the Deutsches Historisches Museum

Content

7 Raphael Gross: Preface
11 Kulturstiftung des Bundes: Foreword
13 Liliane Weissberg: Asking Questions

27 **1 Clarification of the Term**
29 Daniel Fulda: Clarifying a Term that Both Configures and Prefigures
39 Horst Bredekamp: Light and Dark as Spheres of Enlightenment
46 Antoine Lilti: Rethinking the Enlightenment from a Pluralistic, Global Perspective

55 **2 The Question of Reason**
57 Gunnar Hindrichs: The Long March to Maturity
68 *Exhibited Object*
69 Hartmut Böhme: Enlightenment as Critique – Critique of the Enlightenment
74 *Exhibited Object*

75 **3 The Search for Knowledge and the New Science**
77 Michael Hagner: The Science of Man and Its Discontents
87 *Exhibited Object*
88 Jonathan Israel: Spinoza and the Enlightenment
93 *Exhibited Objects*

97 **4 The Order of the World**
99 Ulrich Johannes Schneider: Producing and Ordering Knowledge
110 Kirill Ospovat: Enlightenment in Russia between Absolutism and Revolution
119 *Exhibited Objects*

123	**5 The Question of Religion**
125	Margaret Jacob: Religion in Europe's Age of Enlightenment
133	Paul Franks: What is *Haskala*?
138	Paweł Maciejko: The Controversies of Rabbi Jonathan Eibeschütz
142	*Exhibited Objects*
145	**6 Gender Roles**
147	Pamela Cheek: The Position of Women
156	*Exhibited Objects*
159	**7 The Importance of Pedagogy and the Emergence of the Modern Individual**
161	Emma Rothschild: The Importance of Pedagogy
171	*Exhibited Objects*
175	Paul Guyer: Kant's Enlightened Individualism
183	*Exhibited Objects*
185	**8 The Equality of All Humankind**
187	Anne Norton: The Affirmation of Equality
195	*Exhibited Objects*
199	Adam Sutcliffe: The Demand for Jewish Civil Rights
207	*Exhibited Objects*
209	**9 The Lessons of Antiquity**
211	Elisabeth Décultot: On Winckelmann's Concept of Freedom and Its Interpretations in the Era of Enlightenment
221	*Exhibited Objects*

225	**10 Statesmanship and Political Liberty**
227	Martin Mulsow: Illuminatism, Kantianism and Early Constitutionalism
236	*Exhibited Objects*
239	**11 Mercantilism and Cosmopolitanism**
241	Urvashi Chakravarty: What is the Racial Enlightenment?
248	Michael F. Suarez, S. J.: Slavery, Sugar, and the Abolitionist Movement
254	*Exhibited Objects*
257	**12 Publication Media and Public Spheres**
259	Roger Chartier: The Influence of Publication Media
271	Robert Darnton: Kant, Piracy, and Enlightenment
277	Volker Gerhardt: Enlightenment, the Public Sphere, and Morality
286	*Exhibited Objects*
289	**13 What Remains?**
291	Peter E. Gordon: The Enlightenment and Its Legacy
300	Jürgen Habermas: What Does Enlightenment Mean?
303	**Appendix**
305	Bibliography
321	Notes on the Authors
324	Index of Persons
329	Picture Credits
331	Lenders and Acknowledgements
333	Credits

Preface

What is Enlightenment? Questions for the Eighteenth Century from the Twenty-First Century

It is popular to criticise modernization and the 'enlightenment' associated with it. Anti-modern and anti-Enlightenment attitudes were not only widespread in the twentieth century; they are also especially virulent today. They come in many different forms, be they expressed as criticism of 'Western enlightenment' values, or reflected in esoteric thinking and anti-universalist or anti-modern views. This in turn has put pressure on many of the institutions that arose from the Enlightenment, ranging from scientific research establishments to museums and journals. The spread of ever-stronger anti-modern movements, moods and resentments in recent decades may perhaps also be interpreted as a reaction to the challenges posed to society by multiple, complex crises. We see this situation as an opportunity to take a historical look at the development of the Enlightenment, which began in Europe towards the end of the seventeenth century and focused on human reason as the most important basis of every action. Yet ambivalence and contradiction were also inherent to the Enlightenment and accompanied it from the very beginning – something that Adorno and Horkheimer later termed the "dialectic of enlightenment". Rather than glossing over this aspect in our historical review, we aim to make it recognizable and comprehensible for visitors today.

The Age of Enlightenment is associated with numerous concepts that are essential to the way we think today, especially in the area of ethics. Yet some of the Enlightenment thinkers most closely linked to these notions also initiated or reinforced traditions of thought that have proven, throughout history, to be highly destructive, discriminatory and inhumane, such as racism. Moreover, a

number of movements that ostensibly oppose the Enlightenment actually put forward arguments based on many of the standpoints and notions associated with it.

We are presenting the exhibition *What is Enlightenment? Questions for the Eighteenth Century* at the Deutsches Historisches Museum in 2024 – three hundred years after the birth of Immanuel Kant (1724–1804). Notwithstanding this, he is not the main focus of our exhibition. We go beyond Kant's person, work and time to survey the period known as the "long eighteenth century" from an international perspective.

Criticism of the Enlightenment is as old as the Enlightenment itself. The debates between figures such as Ernst Cassirer in Germany, the criticism of the Enlightenment through the critical theory of Max Horkheimer and Theodor Adorno, and postmodern criticism of the Enlightenment are just a few, more recent, examples. Nowadays, the voices of anti-colonial movements and various forms of identarianism are strong. Enlightenment concepts of progress can also be linked to environmental damage and the climate crisis, which raises fundamental questions about their validity. Against this background, we have decided to go back to the eighteenth century and reconsider the very question that posed problems from the start: "What is enlightenment?"

The exhibition *What is Enlightenment? Questions for the Eighteenth Century* is not structured around personal biographies or a historical timeline; it rather reflects the contemporary discussions that shaped the interpretation of this term and the various concepts and demands associated with it. Its thesis is that the questions and problems formulated by Enlightenment thinkers during this period form the legacy that we have today, but do not lead us to easy answers. Interestingly, the Enlightenment as a movement (if not an era) did not receive its name from the historians of a later time, but was named as such by its own protagonists. Their decision to call it "enlightenment", like *Aufklärung*, *lumières* and *illuminismo*, was inseparable from the discussion about its essence and its purpose.

The DHM hopes that the exhibition on the Enlightenment will open up a space for self-reflection. It is also intended to shed light on the genesis of the concept of "historical judgement", which has guided the museum's programme in recent years. In a similar fashion to our exhibitions on the Humboldt brothers, Karl Marx, Richard Wagner and Hannah Arendt, we felt it important to take a figure or subject from the past that is especially controversial in the present and place it back into the context of its time, so that the restored historical dimension can reveal as many new perspectives as possible. That approach is reflected in this publication, which accompanies the exhibition.

Acknowledgements

The essays that appear in this volume are illustrated with photographs of selected objects from the exhibition. These come from the collection of the DHM and from many leading museums, art collections, archives, libraries and universities in Austria, Belgium, France, Germany, Great Britain, the Netherlands and Switzerland. We would like to express our gratitude to all those who have loaned items for the exhibition.

We would also like to thank all the staff and colleagues who have put such energy and commitment into making a success of the exhibition and the publication *What is Enlightenment? Questions for the Eighteenth Century*. The project was managed by Dorlis Blume under the departmental leadership of Ulrike Kretzschmar, with Saro Gorgis as research assistant, Dr Wolfgang Cortjaens on behalf of the Collections Department, Harriet Merrow as project assistant, Nina Markert as student assistant and Nicole Schmidt, our registrar. Special thanks are due to the highly dedicated advisory board: Professor Elisabeth Décultot, Professor Astrid Deuber-Mankowsky, Professor Moritz Epple, Professor Elísio Macamo, Professor Steffen Martus, Professor Annette Meyer and Professor Damien Tricoire.

In order to assess the relevance to today of the problems and questions of the Enlightenment, we conducted interviews with internationally respected figures from science, culture and the media. Excerpts of these are shown in the exhibition and are available in full on the DHM website. Felice Fornabaio, assisted by Sina Aghazadehsaeini, had overall responsibility for the media processing. Selected interviews were featured in the spring 2024 issue of the DHM's magazine *Historical Judgement* and we would like to thank Oliver Schweinoch for editing them.

The exhibition is designed to be inclusive, with multimedia and interactive elements as well as a children's trail. During the preparatory phase of the exhibition, an outreach programme sponsored by the Federal Cultural Foundation engaged public groups in Berlin with the critical examination of the historical themes of the Enlightenment. The team worked with young people to devise participatory activities for the exhibition. For developing the didactic accompanying programme, the children's trail and the outreach programmes, we would like to thank Claudia Braun Carrasco, Miriam Finkeldey, Verena Günther, Attila Magyar, Dr Crawford Matthews, Norman Salusa, Lilja-Ruben Vowe and Brigitte Vogel-Janotta from the Department of Education and Communication.

The design of the exhibition lay in the capable hands of the DHM's designers, Hans Hagemeister and Marie-Luise Uhle, with student assistants

Johannes Karger and Jelle Spieker. Stephanie von Steinsdorff and Dr Nike Thurn are responsible for the accompanying scientific programme. Thanks are also due to Ilka Linz for producing this publication and to Dorit Aurich for her thorough editing.

For the generous financial support of our exhibition and especially our outreach programme, the DHM would like to express its gratitude to the Federal Cultural Foundation, and in particular to the Artistic Director, Katarzyna Wielga-Skolimowska, and the Administrative Director, Kirsten Haß, for their confidence in our project. The curator of the exhibition and the co-editor of the volume that accompanies it is Professor Liliane Weissberg, of the University of Pennsylvania. This is not the first time that I have had the pleasure of producing an exhibition with her – but once again it was overwhelming to see how much intellectual brilliance and clarity she brings to such a project and how much energy she pursues it with. For this and much more, I would like to express my special thanks.

Raphael Gross
President, Stiftung Deutsches Historisches Museum

Foreword by the Federal Cultural Foundation

Immanuel Kant calls on us to be brave and use our reason. In his answer to the question "What is enlightenment?" he describes how difficult it can be for the individual to cast off immaturity. As an effective means of help, he mentions the combined efforts of the public: "But that a public should enlighten itself is more likely; indeed, it is nearly inevitable, if only it is granted freedom."

He wrote this at a time when the first museums were putting this notion of mutual enlightenment into practice. But who were their visitors? Probably only a select few of the people who Kant is thinking of in his essay. And even the philosopher of universalism makes it clear, in his examples, that he is primarily addressing the members of the professional classes.

Museums nowadays appeal to a wider audience; they aim to be attractive to a variety of first-time visitors and to build long-term relationships. This involves embracing change. They scrutinize their collections, try out new and inclusive forms of presentation, and work participatively with local communities.

The questions of the Enlightenment era remain pertinent today. They need to be posed in new ways so as to reach a diverse range of people. This is why the Federal Cultural Foundation is supporting the Deutsches Historisches Museum in the process of accompanying its exhibition on the Age of Enlightenment with measures for outreach and inclusion. For many years, participatory educational work has been a special focus of the projects that we support. For this exhibition, the DHM is developing parts of the exhibition and the accompanying programme in cooperation with educational institutions and artists' collectives such as Young Arts Neukölln and the Lohana Berkins Education Centre. They are planning joint events and developing digital learning material. Together with three schools specializing in hearing, vision and cognitive development, the museum's education specialists are implementing inclusive measures for young people with disabilities.

Culture and enlightenment were considered together long ago by the philosopher Moses Mendelssohn in Berlin. He addressed the question "What

is enlightenment?" two months before Kant and his answer still offers guidance for burning issues today: "Enlightenment relates to culture as theory generally does to practice, as knowledge to morality, as criticism to virtuosity. Considered in and of themselves (objectively), they stand in the most exact relationship; although subjectively they can very often appear to be separate."

The Federal Cultural Foundation would like to thank the Deutsches Historisches Museum and its President, Prof. Dr. Raphael Gross, the exhibition director Ulrike Kretzschmar, the project manager Dorlis Blume and the curator Prof. Dr. Dr. h.c. Liliane Weissberg for planning and producing this exhibition. We would particularly like to thank the partners cooperating on the outreach and inclusion projects for their hard work and dedication, as well as the project manager Brigitte Vogel-Janotta, the research assistant Dr. Crawford Matthews, together with Claudia Braun Carrasco, Miriam Finkeldey, Verena Günther, Attila Magyar, Norman Salusa and Lilja-Ruben Vowe, for their tireless work on developing and implementing the physical and digital inclusion and outreach projects.

We hope that the exhibition will be well received and that its visitors will discover and share inspiring perspectives on the Enlightenment.

Katarzyna Wielga-Skolimowska Kirsten Haß
Executive Board / Artistic Director Executive Board / Administrative Director

Liliane Weissberg

Asking Questions

What is Enlightenment? This is not only a question, but also a quotation.
In December 1783, the *Berlinische Monatsschrift*, a monthly magazine edited by Johann Erich Biester and Friedrich Gedike in connection with the *Mittwochsgesellschaft* (Wednesday Society) in Berlin, carried an article by the theologian Johann Friedrich Zöllner, in which he spoke out strongly against the introduction of civil marriage. This, he argued, would allow unions to take place independently of the churches and thus also between partners of different denominations. Moreover, such an institution, which an anonymous author – possibly Biester himself – had put forward in the September issue of the *Monatsschrift*,[1] would be contrary to the interests of the state. To Zöllner, this proposal was nothing more than a result of the bewilderment that was spreading everywhere in the name of enlightenment. Thus, he posed a question in a footnote to his article, "What is enlightenment?" and continued " This question, which is almost as important as 'What is truth?' should surely be answered before one begins to enlighten! And yet I have not found it answered anywhere!"[2]

The editors of the *Monatsschrift* held up Zöllner's remark as a challenge to their readers – a step that spread awareness of their paper, which had only been founded earlier that year. Among the many responses that they received was an article by Moses Mendelssohn, which was printed in the issue of September 1784. Mendelssohn dealt with the term as a verb: "On the question: What does 'to enlighten' mean?" he wrote, treating it rather as a process, as his British contemporaries did. "Civilization may be divided into cultivation and enlightening the public mind",[3] he observed, having described these three terms as newcomers to the German language, like people to a country. The author thus saw enlightenment as a problem of immigration as well; however, refinement as the highest level of both cultivation and enlightenment should be open to every citizen.[4] A different approach is evident in Immanuel Kant's essay "Answering the Question: What is Enlightenment?" This appeared in December 1784 and has since become one of the philosopher's most quoted texts. His

thoughts focused on the individual; it was up to people to emancipate themselves, given that their immaturity was self-incurred. "*Sapere aude*! Have courage to make use of your *own* understanding! is thus the motto of enlightenment!" he wrote.[5] But how was this to happen? Despite all his exhortations to gain maturity, the author also thanked the ruler whose subject he was. One might not yet be living in an enlightened age, he wrote, but in an Age of Enlightenment, the "century of Frederick".[6]

That century was almost over. Many of the philosophical writings that are counted among the main works of the Enlightenment today had already been published, many of its great scientific discoveries had already been made, and the British colonies in North America had already gained their independence, not least in the name of this new idea. Yet no clear answer to Zöllner's question could be agreed upon, and Kant's essay, which could be seen as a manifesto, left much open: Were slaves allowed to emancipate themselves? Did women also have a way out of immaturity? And what form of government would make this possible?

I. „Enlightenment" Under Discussion

The search for a definition of enlightenment was linked to questions that each had a different focus and yet related to one another like the coloured shapes in a kaleidoscope. The German term for enlightenment, *Aufklärung*, did not come from philosophy, as might be assumed, but from meteorology, in the sense of the sky clearing. Daniel Chodowiecki alluded to this in a well-known etching of that title for the *Göttinger Taschen Calender* (Göttingen Pocket Calendar) of the year 1792. Although the picture was composed after the French Revolution, it does not show political events, but rather a horse-drawn carriage passing through an idyllic landscape. The clouds are parting to reveal the rising sun. French and Italian neologisms, among others, also refer to light, although not necessarily to the weather. The French *philosophes*, for example, spoke of *lumières*. This term was meant to preserve a distance both from traditional Christian imagery of the radiant divine manifestation and from the political metaphor of a planetary system centred on the Sun King, the ruler of France. The sovereign, divine light was now the light of reason. In their essays for this book, Daniel Fulda explores the history of the term, while Horst Bredekamp shows how the contrast of light and darkness characterizes the art of this period.

While the term was still being discussed in Berlin, the Enlightenment, as a European movement, had long since spread to regions far beyond Europe, as Antoine Lilti shows. Explorers set out on expeditions to distant lands; raw materials were brought to Europe and processed there. There had been serfs

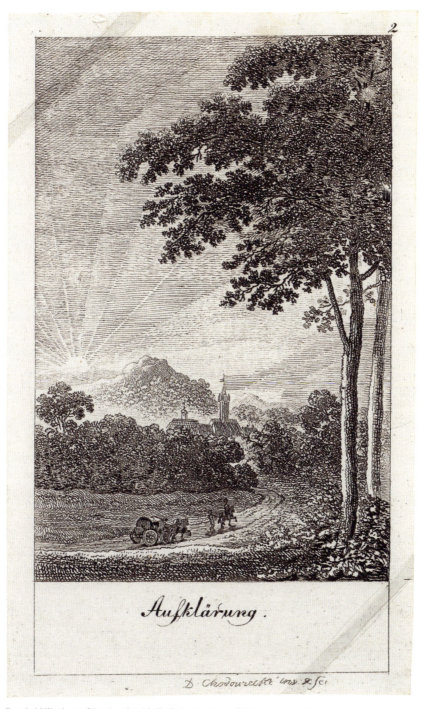

Daniel Nikolaus Chodowiecki, *Enlightenment*, Göttingen, 1791

and slaves before this, but now they mainly came from elsewhere; the 'importation' of people from Africa led to new wealth in Europe and the Americas. This was neither voluntary nor non-violent. The light of the new sun did not shine on everyone.

For those who could perceive the sun, it was the symbol of reason. People should now learn to think and act for themselves. Like enlightenment, however, defining reason was not a straightforward matter. Was reason, or *Vernunft*, or *raison* independent of emotions? The Scottish Enlightenment thinkers Adam Smith and David Hume addressed this question, as did the French *philosophes* Voltaire and Denis Diderot. Kant sought to give his thoughts an overall structure and composed three critiques: the *Critique of Pure Reason*, the *Critique of Practical Reason* and the *Critique of Judgement* (in this book, Gunnar Hindrichs outlines Kant's argumentation). However, the deeper people delved into the notion of reason, the more its limits became clear: dreams, visions and the unconscious mind itself remained inaccessible by this route. This was expressed in art instead, by works such as Giovanni Battista Piranesi's architectural etchings, Francisco de Goya's depictions of violence and Johann Heinrich Füssli's supernatural subjects; as Hartmut Böhme describes, they paved the way for perhaps the most paradoxical Enlightenment thinker of the twentieth century: Sigmund Freud.

II. Science, Order, Religion

In a world ruled by reason, superstition was to be banished and the way cleared for science in a new form, guided by reason. Here, too, the focus lay on light; the eye, which could see and examine things, became the privileged sensory organ. Isaac Newton's ground-breaking research into optics showed the way forward. Experiments and research generated facts. But what precisely could be observed and verified – and how? Firstly, there was the problem of blindness, which Diderot, for example, addressed in his *Lettre sur les aveugles à l'usage de ceux qui voient* (1749, Letter on the Blind), and of phenomena such as magnetism and electricity, which could only be perceived through their effects. Experiments were performed not only by scientists, but also by many different members of the public. At the same time, the question arose whether God had vanished in the course of empirical investigation or had simply relocated. Conclusions reached many years earlier by Baruch de Spinoza, a lens grinder by profession, now seemed less shocking: the divine could be found in the material world. Jonathan Israel discusses Spinoza's influence as a 'radical enlightenment thinker' and contends that after Spinoza, the Enlightenment was essentially over.

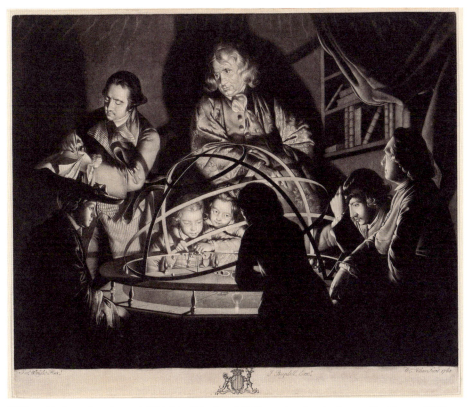

William Pether after Joseph Wright of Derby, *A Philosopher Lecturing on the Orrery*, 1768

 Science had largely broken away from the church already, but the challenge of translating reason into results came with its own share of dead ends. Newton was interested in alchemy, and his sketch of the Temple of Jerusalem remained in the realm of speculation. Phrenologists claimed to deduce personal traits from the shape of the skull; Johann Caspar Lavater sought to tell them from the profile of the face alone. Emanuel Swedenborg believed that he could communicate with individuals over long distances. This fascinated many people, not least Kant, who actually rejected the idea of seeing spirits. Above all, there were now not only new ways of experiencing the world, but also of defining human beings as objects. Michael Hagner's essay describes the course taken by this new anthropological research, which led to the racial studies of the twentieth century.

 All this led to a dual conclusion: firstly, the world was perceived to embody order and secondly, that order should be determined by scientists and bureaucrats. The Swedish naturalist Carl Linnaeus organized expeditions and

had plant specimens collected on his behalf; these he classified systematically, along with the animal kingdom and minerals. The value of knowledge, however, also lies in the uses to which it is put. That was the view of Benjamin Franklin, who published *A Proposal for Promoting Useful Knowledge among the British Plantations in America* in 1743, as part of his efforts to found a society in the colony akin to the Royal Society in London. The search for ways of applying knowledge was also accompanied elsewhere by the desire not just to demonstrate the order of nature, but to manage and control it. This was evident not only in the planning of public institutions such as prisons or mental institutions; towns and districts were also designed as a whole and then populated.

While cabinets of curiosities still displayed the extraordinary nature of individual objects, the ordered system of relationships between them, despite seeming equally astonishing, was now explicable. In 1753, the British Museum was founded on the basis of Hans Sloane's private collection; universal knowledge could now be presented in a structured manner to the general public. This was not apolitical. Among the objects on display was the Magna Carta – visitors could assure themselves of ancient rights with regard to the state. Subsequent museums also owed their existence to political agendas, albeit different ones. The Hermitage, founded five years later in Saint Petersburg, signified Russia's opening to the West (in his essay here, Kirill Ospovat puts this into a broader context); in 1793, Napoleon converted the royal palace in Paris into a public museum, the Louvre, where the treasures taken during his military campaigns were put on show.

The desire to present knowledge in an orderly manner was also evident in publications. Between 1751 and 1772, a masterpiece of printing technology appeared: the richly illustrated *Encyclopédie, ou Dictionnaire raisonné des sciences, des arts et des métiers*. Diderot, Jean le Rond d'Alembert and a host of collaborators produced the contributions alphabetically and eventually filled 28 volumes. Ulrich Johannes Schneider's essay describes the history of encyclopaedias and the context of this special undertaking. A hundred years later, in his novel *Bouvard et Pécuchet* (1881), Gustave Flaubert would satirize the ambition to describe everything and catalogue it alphabetically.

How did religion fit into this order? Spinoza's works were received eagerly, and some of his followers, including Gotthold Ephraim Lessing at one time, were suspected of atheism. No literary event shook mid-eighteenth-century Europe as much as a quite literal one: the Lisbon earthquake of 1755. Voltaire's satirical novella *Candide* (1759), the tale of a naive young man, is

one of many texts that appeared in response. The earthquake shook people's faith in God's presence and ultimately their confidence in the mastery of nature by mankind with the guidance of reason. What god could one still believe in? Might there be more than one true religion?

The motto now was tolerance. Many Enlightenment thinkers insisted that there should no longer be any scope for conflict between Catholics and Protestants, and that Christianity should not be seen as a successor to Judaism, but simply exist alongside it. Lessing, for example, took a tale from Boccaccio and featured it in his play *Nathan the Wise* (1779) as the "ring parable". At its heart is the fact that Judaism, Christianity and Islam, which was less well known in Europe at the time, are equal members of a monotheistic family, all sharing in the central text of European culture, the Bible. Nevertheless, neither atheism nor religious diversity were acceptable to many Enlightenment thinkers. Catholics were suspected of being loyal not only to the secular ruler, but also to the Pope. Jews were evangelised; Lavater simply declared Mendelssohn to be a Christian according to physiognomy, a science he devised. Various new Protestant movements emerged. The relationships between the religions are examined in this book by Margaret Jacob. Paul Franks describes the emergence of the Jewish Enlightenment, the *Haskalah*, and its efforts to reform Judaism, while Paweł Maciejko highlights a simultaneous controversy about amulets, which ran counter to this movement. The eighteenth century also saw the founding, in England, of an organization associated with the Enlightenment and independent of religion, though taking the construction of the Temple of Solomon as its origin. Its members were dedicated to virtue and righteous action. Instead of a religious hierarchy, these Freemasons, as they were called, were ranked according to the three degrees of medieval craft guilds. The secret organization even counted some rulers as members and it was prominently alluded to in Mozart's opera *The Magic Flute* (1791).

III. Gender Roles, Pedagogy and the Emergence of the Modern Individual

It was the argument over civil marriage that prompted Zöllner to ask about the definition of enlightenment. The proposal for civil marriage not only called into question the role of the church, but also touched on the roles of the sexes. In *A Vindication of the Rights of Woman: with Strictures on Political and Moral Subjects* (1792), Mary Wollstonecraft championed the rights of women inside and outside marriage – an institution for which she did not actually want to advocate.

The fact that many women could now read gave them access to the writings of the Enlightenment; some saw the opportunity for themselves to become independent businesswomen, to devote themselves to science, or to reach an audience as writers. Pamela Cheek describes these new authors and the new, female readership. Publishers adapted to cater to women readers. Yet academies and universities still generally closed their doors to women. Although women such as Olympe de Gouges supported the French Revolution, the Parisian revolutionaries did not campaign for equal rights for women, but rather for the emancipation of slaves in the overseas colonies and for the emancipation of the Jews, who largely lived in the south of France, Alsace and Lorraine. Philosophers, however, conceived a special role for women: they should neither have a political voice nor take part in science, but rather take advantage of their "special proximity to nature". Their literary work should also reflect feelings close to nature; the private medium of the letter was thought to be particularly suitable for this, which led to the development of the modern epistolary novel. Ultimately, the newly conceived private sphere of the house was to be reserved for the woman; here she was meant to find fulfilment as a wife and mother.

However, this meant that women bore a special responsibility, because the early education of children was particularly important and, as Emma Rothschild points out, pedagogy became a core component of philosophy. Children, too, as Jean-Jacques Rousseau sought to show in *Emile ou De l'éducation* (1762), were seen as being close to nature, and their best qualities were to be fostered so that they could become responsible citizens (if boys) and capable housewives (if girls). Whereas previously, educators had largely been private tutors employed by aristocratic families, now public schools were founded for the expanding middle class. A veritable flood of educational works and children's books dealt with the relationship between nature and civilization, and with the progression from the innocence of childhood to the moral awareness of an adult as a being who acts freely and independently. Literacy spread rapidly. Many schools, which were run not by philosophers but by civil servants, however, followed a rather military model and were committed to the principle of discipline and power. Poorer families probably found it difficult to endorse the idea of childhood innocence; it was common for children to work in the fields or in manufactories.

Educational content came from outside. But the study of biology and in particular botany also popularised the concept of education. The aim here was to foster and develop the potential that was already present in people. Educa-

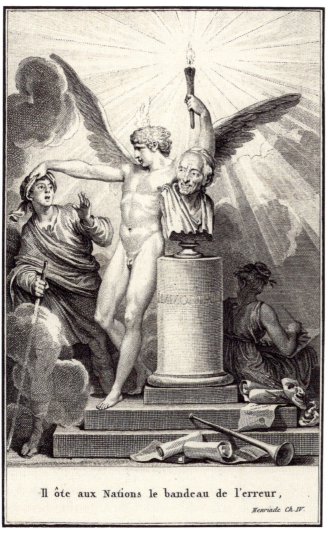

Louis Croutelle after Jean Michel Moreau le Jeune, *He frees the nations from the blindfold of error*, France, after 1790

tion not only defined the new citizen, but defined him or her as an individual. In his essay, Paul Guyer describes the individual as defined by Kant in his writings. The story of each and every person could now be considered significant. Rousseau led the way when he pointed out, in the introduction to his autobiographical writings, *Confessions* (1782/1789), that although he was no more important than anyone else, he was unique.

IV. The Demand for Equality, the Relation to Antiquity and Reflections on Constitutional Form

While the individual may have been considered unique, there were also written and pictorial publications that sought to describe entire peoples in all their diversity. Bernard Picart published illustrated works on the ceremonies and rites of various peoples. Even the theologian Johann Gottfried Herder no longer saw the differences between peoples as being due to God's will, but rather to climatic zones and geography. Here, too, a pedagogical concept was applied because the development of mankind and societies was ordered in stages from the primitive to the civilized. Thus, paradoxically, comparisons were used on the one hand to justify the demand for equality, but on the other hand to justify dominion over others who were considered more primitive.

The postulate that all men are created equal was formulated in 1776 in the Declaration of Independence of the United States, which thus proclaimed the end of their status as colonies. Yet Thomas Jefferson, who drafted the document and was among its signatories, also owned slaves. In 1789, the French revolutionaries codified a number of human and civil rights, which have since been continually revised and supplemented in various declarations, not least by the United Nations. Anne Norton traces the complicated history of demands for equal rights in America and Europe.

What the revolutionaries proclaimed in France, the Jews of Prussia strove to achieve through petitions. Adam Sutcliffe describes their struggle to acquire civil rights by political means and places it within a European context. Jews such as the philosopher Salomon Maimon and the ichthyologist Marcus Elieser Bloch had already made a name for themselves in Berlin, and so-called court Jews had helped to shape Prussia as an economic powerhouse. Court Jews also made a decisive contribution to Prussia's successes in the Seven Years' War by organizing uniforms and provisions for the army and minting the coins needed. Yet even Mendelssohn, who managed and inherited a silk factory, had no permanent right of residence in the city. The work of civil servant Christian Wilhelm Dohm *On the Civil Improvement of the Jews* (1781) illustrated an approach peculiar to Prussia, in which education was a path to acculturation; Jews should show that they deserved emancipation.

Yet the new notions of freedom and equality didn't look only to the future, they often harked back to antiquity. In the late seventeenth century, the "quarrel of the Ancients and the Moderns" (*Querelle des Anciens et des Modernes*) had shaken the French academy, but now the classical age was itself considered modern. In this book, Elisabeth Décultot examines Johann Joachim

Winckelmann's particular reception of a Greek notion, the *polis*. The reception of ancient art gave rise to a new, European classicism, whose artistic symmetry corresponded to contemporary ideas of order. The Enlightenment thinkers also looked to Rome. The first archaeological finds from Pompeii and Herculaneum helped to promote this reception.

The Grand Tour became popular: young, wealthy Englishmen travelled to Italy, followed not long after by Germans. They marvelled at the ruins and then recreated them in landscape gardens at home. The architects of the French revolutionary period emulated Roman temples. Later, when Georg Wilhelm Friedrich Hegel was writing about the crucial significance of Greek art, he could simply look out of his window in Berlin at buildings designed by Karl Friedrich Schinkel in the classical manner.

What was the political freedom that the revolutionaries demanded with *liberté, égalité, fraternité* supposed to look like? Rousseau envisaged a society in which a social contract regulated coexistence. In his contribution to this volume, Martin Mulsow introduces us to a secret pioneer of German thinking on constitutional law and statehood. Few models for political freedom existed in the real world. Wars caused the political structure of Europe to change constantly and sometimes radically during this period. One country, Poland, disappeared entirely after a third partition; its population became subject to one of three different monarchies (Prussia, Austria, Russia), each with a different language and culture. In practice, the so-called enlightened monarchs, such as Frederick II of Prussia, did not behave much differently from absolutist rulers. Some of the continent's Enlightenment thinkers saw the parliamentary monarchy of Great Britain as a better model. Many of them, however, could only imagine a monarchy, and even the French revolutionaries were initially quite willing to keep the king on the throne, as long as his power were limited.

Revolutions managed to put new ideas into practice, at least for a while. The American Revolutionary War did not cause the king to be deposed in Great Britain. The surviving minutes of the discussions between the signatories of the Declaration of Independence about their new nation document the philosophical exploration of a broad range of Enlightenment concepts. The French revolutionaries of 1789 were aware of their relationship to events in America. Thus, the Marquis de La Fayette, through Thomas Paine, presented a key of the Bastille to the first president of the United States, George Washington, in whose house, Mount Vernon, it is still kept today.

V. Cosmopolitanism and Mercantilism, Publishing Media and Public Spaces

The philosophers and scientists of the eighteenth century saw themselves as citizens of the world. They maintained international networks, travelled to broaden their knowledge, studied languages and translated literature. As cosmopolitans, they were the European participants in an exchange of ideas that extended far beyond Europe, while the leaders of the French Revolution even extended membership of their new state to those who sympathized with their political ideals. In 1792, Georges Danton granted honorary French citizenship to Friedrich Schiller for his services to freedom and humanity. However, the cosmopolitans also affirmed a hierarchy of countries. This was, not least, to serve business interests.

The import of raw materials for processing was a mainstay of the national economies of the period. English and Dutch companies grew into important trading entities and competing political organizations. Mahogany wood was imported from the New World to England and made into furniture that eventually became typical of English home interiors; cotton was brought to the textile mills of Manchester, which would become the birthplace of the Industrial Revolution. Tea, from China and then India, became the English national drink. The Prussians were not content with merely importing silk; Frederick II had mulberry tree plantations laid out around Berlin and Potsdam with the plan of becoming economically independent of imports. The ships that brought goods from America, Asia and Africa to Europe transported a human 'cargo' on the voyage out to the new colonies. Their economies, dominated by sugar, cotton and rice cultivation, depended on the slave trade, which itself made huge profits for American plantation owners as well as for traders and shipping investors in France, the Netherlands and England. In her contribution, Urvashi Chakravarty shows how much this economy and its associated ideology influenced the writing of Enlightenment thinkers.

Soon, enlightener would clash with enlightener: those who insisted on the advantages of this economic system versus those who insisted on human equality and called for slavery to be abolished. Josiah Wedgwood, whose ceramics company reinterpreted Classical pottery forms with great success, became a leading English abolitionist and created the movement's symbol: an image of a Black man kneeling in chains. As Michael Suarez shows, British campaigners against slavery focused mainly on the call to boycott sugar from the Caribbean. The drop in demand was meant to weaken the profitability of the triangular trade and thus make slavery unviable.

The abolitionists published articles and pamphlets. All this was made

possible by a publishing industry that changed dramatically during the eighteenth century. The spread of printing presses made it possible to respond quickly to the new appetite for reading. It also helped Enlightenment thinking to spread rapidly beyond the major cities and publishing centres. Lending libraries and reading circles were set up. In their chapters, Roger Chartier surveys the changing book market of the time, and Robert Darnton points out the special importance of pirated books with regard to Kant. With brochures and pamphlets growing in popularity alongside printed books, government censors found it difficult to control the flood of political (and pornographic, sometimes both combined) printed matter. Anonymous authorship, false publishing information, or a foreign publishing base made many things possible. Magazines and newspapers became especially popular: they were cheap to produce and buy and they could be distributed quickly, all of which multiplied the potential readership. People were eager for news in times that were marked by major political upheavals. At the time of the French Revolution, around five hundred newspapers were in circulation in Paris alone.

Printed matter added a new dimension to the public sphere, as did the learned societies, clubs and reading circles where enlightened citizens gathered to exchange information and discuss topical subjects. The *Mittwochsgesellschaft* in Berlin, whose initiators would decide to publish the *Monatsschrift*, was one such group. As well as meeting privately in homes, people now went to coffee houses, which represented a new kind of public space. Those who could not join the conversation in person might be present symbolically: Johann Wilhelm Ludwig Gleim, for example, created a temple of friendship in Halberstadt with portraits of contemporaries whom he admired. The salons of the nobility gave way to the tea parties of the bourgeoisie, some of which were even hosted by people such as Henriette Herz or Sara Levy, who, being Jewish, were not citizens. In his contribution to this book, Volker Gerhardt discusses these new forms and perceptions of the public sphere.

The state academies, which still restricted their membership, stood in contrast to the universities, which were already beginning to change if perhaps not quite in membership, then in the mode of instruction, and to cease using Latin. In Halle, Christian Wolff was renowned for his philosophical lectures, held in German. Göttingen saw itself as a reform university; the salon hostess Dorothea Schlözer received her doctorate in philosophy there. Philosopher Anton Wilhelm Amo, who came from the Dutch Gold Coast, became an academic in Halle before returning to West Africa (where in all likelihood he was involved in the Dutch West India Company's trade in goods and slaves).[7]

VI. What Remains?

"Let us imagine that the *Berlinische Monatsschrift* still exists and that it is asking its readers the question: 'What is modern philosophy?'" writes Michel Foucault in his essay "What is Enlightenment?" He continues: "Perhaps we could respond with an echo: modern philosophy is the philosophy that is attempting to answer the question raised so imprudently two centuries ago: *Was ist Aufklärung*?"[8] Perhaps, then, it is not the question that characterizes our philosophy today and ultimately our understanding of modern times, but the lack of agreement on the answers, the discussions, the problems.

It was not only Foucault who, in his *Archaeology of Knowledge*, seemed to put the Enlightenment at the centre, but also other philosophers of the twentieth and twenty-first centuries, who sought to grasp the Enlightenment in all its complexity. A few such works can be mentioned here: in 1932, Ernst Cassirer wrote *Philosophy of Enlightenment*; Isaiah Berlin defined a counter-enlightenment in *Political Ideas in the Romantic Age* (1952); Hannah Arendt began her principal work, *The Origins of Totalitarianism* (1951), with an examination of the Enlightenment. Max Horkheimer and Theodor W. Adorno, with the assistance of Gretel Adorno, published *Dialectic of Enlightenment* (1944/1947/1969), which is probably the best-known work of the Frankfurt School today. It is referred to by several of our contributors. Peter E. Gordon, who has written much on Adorno's work, puts it into context at the end of this book, and Jürgen Habermas, a leading figure of the second generation at the Institute for Social Research, takes up the question "What is enlightenment?" again. It has lost none of its relevance, however open the answer may remain.

1 E. v. R. 1783.
2 Zöllner 1783, 516 note.
3 Mendelssohn 2014.
4 See ibid.
5 Kant 1912 (AA 8), 35.
6 Ibid.
7 See Tricoire 2023, 96.
8 Foucault 1984, 32.

CLARIFICATION OF THE TERM

1

Daniel Fulda

Clarifying a Term that Both Configures and Prefigures

We often ask the question "What is . . ." when something seems new and in need of explanation, but we might also ask it when something has already been discussed at length many times and we want to be certain about the meaning of a familiar or significant term. The question "What is enlightenment?" and the ensuing debate, to which Moses Mendelssohn and Immanuel Kant contributed in their essays of 1784, belongs to the second category. By then, the word "enlightenment" – in the sense of improving the use of the mind – had already been in use for more than a hundred years.[1]

It is therefore misleading when the historian Reinhart Koselleck dates the establishment of enlightenment as a term to around 1780 and compares it to Hegel's "owl of Minerva", which only comes out at dusk – that is to say, near the end of the era.[2] By no means was the Enlightenment spoken of only in retrospect after a century of constant struggle against prejudice, received knowledge (from authorities or tradition) and the privileges conferred by birth. Rather, the notion of enlightenment inherently looks forward, prefiguring the future, and it was already being used in this way by the early Enlightenment thinkers in formulating and communicating their message. Kant's canonical essay "Answering the Question: What is Enlightenment?" also works with this programmatic concept. In his definition of enlightenment as "man's emergence from his self-incurred immaturity", Kant assumes that, for the most part, the effort required for it has yet to be made.[3] To this day, the concept of enlightenment has been characterized by a call to make progress.

A closer examination of the Enlightenment's historical vocabulary reveals that it can be divided into roughly three aspects. Firstly, the use of language by the Enlightenment philosophers reveals to us what objectives they were striving toward, how they imagined that these could be achieved, and what problem diagnoses they started from:[4] in short, their self-conception. Secondly, from the spread of this vocabulary we can deduce how the Enlightenment

formed as a social movement, since the use of language was a way in which pioneers and the mainstream alike could identify themselves and recognize each other. This in turn helped to bring together diverse groups seeking reform in a variety of academic, journalistic and literary fields and thus form a movement that was perceived as coherent. Thirdly, the way in which the Enlightenment programme was presented tells us something about what made it so attractive. The 'publicity' for enlightenment did not just consist of rational argumentation; rather it derived the core of its persuasive power from impressive imagery. Consider how the question "What is enlightenment?" was answered by Christoph Martin Wieland: "This is known to everyone who, by means of a pair of eyes that see, has learned to recognize the difference between brightness and obscurity, between light and darkness."[5]

Figurative ideas are associated with the aforementioned vocabulary in every European language: *lumière(s)* and *éclairer* in French, *to enlighten* in English, *ilustrar* in Spanish, *i lumi* in Italian, *Verlichting* in Dutch, Просвещение [*prosveščenie*: illumination] in Russian.[6] In each case, the term signifies a heightening of awareness and thus a possible improvement in social conditions. In terms of their original meaning, moreover, all of these expressions evoke ideas of bringing light, being illuminated, creating clarity, or (rather negatively) being dazzled in the specifically optical sense. This also applies to the German word family of *aufklären/aufgeklärt/Aufklärung*, because the original meaning in this case, which remained the primary one until the end of the eighteenth century, applies to the sky becoming clear of clouds, or clearing things up.

What distinguishes this German word family from the Enlightenment vocabulary of other European languages is that its meaning was originally meteorological. In the course of the seventeenth century, it was increasingly used in a metaphorical way for states of mind and facial expressions, just as we speak today of someone's expression brightening or their brow clearing. The next step in the evolution of the meaning – which initially remained entirely in the realm of metaphorical use – was its transfer to the rational mind. Here it converged with the traditional weather and light metaphors of scholarly language, from the clouded mind (today's brain fog) and the mists of error to the light of truth,[7] the sunlight of reason and illuminating knowledge. In the literature, we can see how "enlightenment" gradually came to augment these metaphors as a generic term and how it evolved from a metaphor to a philosophical term – a sense in which it was first used in 1708, as far as is known at the moment.[8]

In any language, the Enlightenment vocabulary was (and still is) attrac-

tive because the ideas of light associated with it all have distinctly positive connotations. When the talk is of light instead of darkness, clarity instead of an obscured or blocked view, sunshine instead of storm clouds, then the question of who was right, the Enlightenment thinkers or their opponents, has apparently been answered from the outset. In its implicit judgement, the imagery with which the Enlightenment thinkers promoted themselves and their causes is so asymmetrical as to make it almost impossible for opponents to position themselves against it. Instead, they tried to redirect the suggestive power of Enlightenment imagery in support of their own anti-Enlightenment positions. Only this can explain why, in the first third of the eighteenth century, we find that the then-new vocabulary was most frequently used in German by a Pietist theologian, Joachim Lange. He polemicized against Christian Wolff, a fellow scholar teaching at the university of Halle, attempting to counter his rationalist philosophy with a theological argument that describes man as completely dependent on divine grace and in no way destined for self-determination.[9] Lange uses "enlightenment" as another word for "divine revelation" and thereby attempts to give it a pious connotation. Not until the age of German Romanticism were darkness and the night explicitly praised once more.

The Elaboration of the Enlightenment Concept in Images

What the Enlightenment vocabulary conjures up initially are images in the mind, generated through metaphorical language. In the eighteenth century, however, manifest images with light, sun, or weather motifs also reinforced the idea of an enlightenment to be brought about, the hope of achieving it, or the determination to do so. When the word "enlightenment" in a cognitive sense was first becoming established, the main medium for this new idea was actually the graphic print. Not only do prints seem to have been more widespread, but they were also more conspicuous, for example as frontispieces – that is, book illustrations on or opposite the title page whose purpose was to convey key messages in an eye-catching way. In the German-speaking world until the 1720s, it was exclusively in images that a fully-fledged programme of enlightenment was worked out.

A multi-volume publication by Jacob Friedrich Reimmann, in which the word "enlightenment" is used terminologically for the first time,[10] contains, in the 1710 volume, one of the most complex pictorial compositions of how enlightenment should take place and what it should achieve. It imagines the "history of knowledge" – as we might refer to the concept of *Historia Literaria* in modern parlance – as a flaming torch carried ahead of a carriage, in which personifications of the four university faculties ride towards the left of the picture,

Frontispiece of *Versuch einer Einleitung In die Historiam Literariam Insgemein und derer Teutschen insonderheit*, Vol. 3,2, by Jacob Friedrich Reimmann, Halle, 1710

where the sky is clearing and magnificent buildings stand in front of neat rows of trees. Philology and philosophy, in the form of two powerful, prancing horses, pull the carriage forward. In contrast, two donkeys are harnessed to the back of the cart. The matter of where the carriage with the sciences is heading is simultaneously one of historical orientation: back into the past of unproductive, received knowledge, or forward into an enlightened future of well-ordered living conditions based on sounder knowledge and greater mastery of nature? The sight of the sky clearing on the left should be understood as prefiguring a better future.

And precisely this was the source of the programmatic and propaganda potential of the term and images of the Enlightenment. The meteorological origin of the German word *Aufklärung* provided visual motifs that were strongly suggestive and easily understood. It may well have become one of the most appealing social notions of the modern era simply because, semantically, the weather phenomenon that underlies it suggests a results-oriented process in which dark and light are in clear opposition and a positive ending supposedly comes about through the forces of nature. This applied to the word family *aufklären/aufgeklärt/Aufklärung* as a whole, provided both interlocutors remained aware of the concrete meteorological meaning. The latent appeal of Enlightenment images was even greater than that of the words, however, which explains why the new concept was elaborated first in images and only subsequently in texts.

Christian Wolff, a pioneering early Enlightenment thinker in Germany, never used the words *aufklären/aufgeklärt/Aufklärung* and the like in his works, but he did repeatedly include frontispiece illustrations with meteorological motifs.[11] Firstly, these feature the sun at the centre or at the very top, dispelling clouds or rising above them; in a commentary on himself, Wolff explicitly identifies it with his methodically proceeding intellect. Secondly, these frontispieces show a segment of the world that extends ostentatiously far into the depth of the picture and is being infused with light, warmth and life. This underlines the general benefit of the enlightenment propagated by Wolff: knowledge of the world as a prerequisite for shaping the world.

Religion, Power, Knowledge and the Arts as Arenas of Recoding

The vocabulary that brought forth the keywords of the Enlightenment was not new in any language in the eighteenth century. Rather, an existing vocabulary was utilized and endowed with new meanings. This involved, on the one hand, adapting general metaphors of light and illumination that were common in scholarly language and, on the other hand, making secular use of traditional

Frontispiece of *Vernünfftige Gedancken von Gott, der Welt und der Seele des Menschen, Auch allen Dingen überhaupt. Den Liebhabern der Wahrheit mitgetheilet* (Second version) by Christian Wolff, Halle, 1751

terms for spiritual enlightenment or being enlightened. In French, the secularization of the Enlightenment vocabulary took place earlier and more markedly than in other Romance languages. In the intermediate phase, during the early eighteenth century, an Enlightenment vocabulary became established in English and German without a clear-cut distinction from religious usage. The English noun "enlightenment" remained entirely in the spiritual realm for a long time; not until the middle of the nineteenth century did its meaning shift to a secular context, under the influence of translations from German.

Because the key terms of the Enlightenment were not neologisms, in some cases it is difficult to decide whether a word is being used in an Enlightenment sense or not.[12] The phrase *siècle éclairé*, which spread during the second half of the seventeenth century, had little to do with being enlightened in the modern sense; as a rule, it referred to the expansion of power and the flourishing of culture in France under the rule of Louis XIV.[13] Nevertheless, the pre-Enlightenment usage of such terms favoured the spread of new, enlightened thought, because its proponents could latch on to established tropes. Adopting customary modes of speech or figurative representation did not hinder them from significantly shifting the meaning, for example by using light in metaphors for the human mind rather than Christ ("I am the light of the world", John 8:12).

After all, in the religious and political spheres, and in connection with the arts and sciences, metaphors of light – in particular, the sun – and corresponding pictorial motifs had been widespread long before the Enlightenment.[14] They had served to illustrate the glory of God and the saints, or the power of a ruler. The authority of science, philosophy and the arts had likewise been asserted through metaphors of light and the sun, be they formulated by Cicero as the "light of truth" or embodied by Apollo, who as "the bright one" (*phoibos*) was conflated with the sun god. At the threshold of the Enlightenment era, Louis XIV's sun iconography forged a connection between artistic splendour and the political assertion of power.

The protagonists of the Enlightenment were able to build on all of these uses. Admittedly, it was a risky move to draw analogies between the rays of the sun, symbolizing the beneficence of a country's ruler, and the sun as it is meant in Wolff's frontispiece, symbolizing the author's "penetrating" and "fruitful" cognitive power. Overlaps with religious light metaphors and imagery likewise contained potential for tension – both dangerous and productive – because they reflected the very real competition between Enlightenment thinkers and the clergy in claiming competence to interpret the world and to provide intellectual and moral leadership.[15]

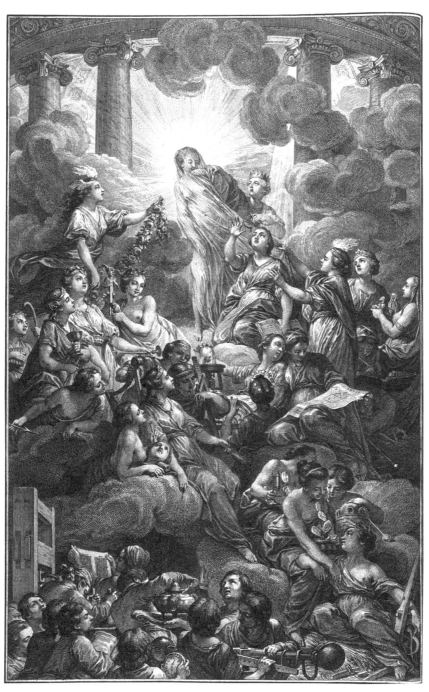

Bonaventure-Louis Prévost after Charles-Nicolas Cochin le Jeune, Frontispiece of the *Encyclopédie* (Second version) by Denis Diderot and Jean le Rond d'Alembert, Paris, 1772

An example of the inclusion and simultaneous recoding of Christian light motifs is provided by the frontispiece to the *Encyclopédie* published by d'Alembert and Diderot (17 volumes of text and 11 volumes of plates, 1751–72). This work contributed to the breakthrough of the French Enlightenment, which was critical both of the state and the church. The illustration features light radiating from the background, receding clouds, an array of allegorical figures in front of architectural elements, and a glorified central figure (Truth, in this case) in the highest position. The composition is modelled on Baroque high altars, which adorned many churches at the time and can still be found today. Slightly to the right, a separate shaft of light falls almost vertically on the kneeling figure of Theology. The arrangement of columns with an entablature, a shaft of light and a religious figure with a transfixed gaze is reminiscent of Giovanni Lorenzo Bernini's *Ecstasy of Saint Teresa* (1645–52) in the church of Santa Maria della Vittoria in Rome. The allusion to this provocatively erotic sculpture, in which the saint is about to be pierced with an arrow held by an angel looking rather like a Cupid (in the frontispiece of the *Encyclopédie*, the corresponding figure is on the left) deliberately sets the figure of Theology in a dubious context. Moreover, she has turned away from Truth, who stands next to her. The fact that she is lit by a separate shaft of light should therefore not be understood as reverence, but rather as signifying the exclusion of theology from the illumination or enlightenment taking place in the rest of the scene.

No End

Just as the Enlightenment was constituted by the rewriting of traditions, it was subsequently subjected to constant rewriting that ranged from critiques or exploration of it to attempts at continuing it. Nowadays, critical assessments generally focus on masculine dominance in the era. And fiction such as Angela Steidele's 2022 novel *Aufklärung* takes a feminist angle on the Enlightenment that adds fresh interest for today's readers. It is set in Leipzig between 1720 and 1760, when Johann Christoph Gottsched was making a nationwide impact as a reformer of the German language, literature and theatre. The plot centres less on him than on his wife, Luise. The narrator is also a woman, a daughter of Johann Sebastian Bach.

One of the novel's many tongue-in-cheek plays on historical facts concerns the 'invention' of the term "enlightenment". It is the narrator herself, in 1735, who first utters the word. It occurs to her spontaneously when the publisher Johann Heinrich Zedler is explaining the alphabetical order of his projected book, the *Universal-Lexicon*:

"E for enlightenment."
It just slipped out. The gentlemen looked at me.
"What do you mean by that?"[16]

The fictional nature of the genre legitimizes the counterfactual rewriting of the term's history to create the desired gender-political shift. By making the male characters need an explanation, the author shows that it is not they who are the avant-garde. Nonetheless, the question that they ask makes sense and it demands an answer, now as then.

1 See Fulda 2022a. I find "enlightenment" used in respect of "reason and judgment" for the first time in Stieler 1673, 335.
2 Koselleck 2001, 5.
3 Kant [1784] 1970, 54.
4 It should be noted that the German word *Aufklärung* (enlightenment) is used in many different ways, many of which do not refer to the eighteenth century (e. g. sophistic enlightenment), not even by analogy (military reconnaissance, intelligence gathering, criminal investigation, sex education), see Grimm 2002, 559–563. The differences and similarities between the term *Aufklärung* in its universal usage and in its eighteenth-century usage are examined in Zelle 1999.
5 Wieland 1789, 97, trans. in Schmidt 1996, 79.
6 See Delon 2001.
7 See Blumenberg 1993.
8 Fulda 2022a, 36.
9 See ibid., 47–51.
10 See Reimmann 1708–1713, vol. 1, 146 (note g).
11 See Schneiders 1990, 87–93.
12 See Mortier 1969.
13 See Gembicki 1996, 245.
14 See exhib. cat. Potsdam 2023.
15 See Fulda 2022b.
16 Steidele 2022, 96.

Horst Bredekamp

Light and Dark as Spheres of Enlightenment

The Loss of Darkness

Ever since his time teaching at the University of Hamburg in the early 1920s, the quantum physicist Wolfgang Pauli maintained a close friendship with the art historian Erwin Panofsky. One of their conversation topics was the early modern controversy between the Prague astronomer Johannes Kepler and the English physician and natural philosopher Robert Fludd. Panofsky, an enlightened scholar of the humanities, tended to agree with Kepler; Pauli, who was in close contact with the psychoanalyst C. G. Jung, did not dismiss Fludd's occult imagery. In a notable letter of February 1952, Pauli wrote to Panofsky that the seventeenth century lost "darkness" and thus everything that eludes the standardization of the world. The evil result was that "the power of the bright [*lichte*] order expanded into nature as well," he continued, stressing the need to reclaim darkness and thus a sense of the unique and non-standard.[1]

It is possible that Pauli was familiar with *Dialectic of Enlightenment*, published five years earlier by Max Horkheimer and Theodor W. Adorno. What Pauli associated with the light of order, Adorno and Horkheimer described as the "discipline", or even drill, of the Enlightenment, which reversed its own mission to lead human beings out of immaturity.[2]

The eighteenth century, as the century of the Enlightenment, did in fact see itself as an epoch of light. In his treatise *Light as a Metaphor of Truth*, which appeared in the influential journal *Studium generale* five years after Pauli's letter to Panofsky, the philosopher Hans Blumenberg described light and the light metaphor as an incomparably important source in the formation of philosophical concepts. Like Pauli, however, he underlined the bipolarity of light and darkness, which as metaphysical counterforces rule each other out "and yet bring the world-constellation into existence".[3] Darkness is therefore the counterworld, representing that which is not visible and thus not existent, but nevertheless remains present as the counterpole to light. In this sense,

enlightenment is not torn from darkness, as Plato so distinctively described in his allegory of the cave.[4] Rather, it is participation in the abundance that constitutes darkness.[5] According to Blumenberg, true enlightenment lies in conceiving the light as part of the cave.[6]

Robert Fludd's *prima materia*

Diagnosing the loss of darkness since the seventeenth century, Pauli referred to Robert Fludd who was associated with the Rosicrucian movement. In Fludd's multivolume work on the history of the macrocosm and the microcosm,[7] the Swiss engraver Matthäus Merian the Elder contributed the images that are generally printed as jet black,[8] in anticipation of Kazimir Malevich's *Black Square* of 1915.[9] This, however, obscures the fact that the image is by no means a square, but instead a tipped quadrilateral pointing up and towards the right. An inscription appears on each of the four sides: "Et sic in infinitum" (And thus to infinity). Hence, this is not a regular shape, but a detail of something extending onwards without end. Also, a magnifying glass is needed to recognize that in the original version of the images, this darkness is actually a black-and-white woven texture with peculiar flecks. When some versions are enlarged, another phenomenon appears: these dark "clouds" consist in part of painted surfaces into which spiralling lines were incised with a stylus before the paint dried.[10] These etchings evidently visualize the idea that in the beginning of all Being, the spiral – as a line of becoming, of the formation of cosmos from chaos – emerges from the dark clumps of black matter, or *hyle*. In the first book of *Physics*, chapter 9, Aristotle says of this prime matter: "For what I mean by matter is this: the primary substratum of each thing, from which it comes to be and which is in there not accidentally."[11] In this sense, the spirals evoke a formation that has not yet taken place, but that indicates the possibility of becoming.

This prime matter as defined by Merian's spiral rotation is by no means passive. It is the medium of a longing, an activity, a searching for form and certainly not its negation, as Aristotle explained in *De anima* (*On the Soul*), with colour and the light that makes it visible as the principle of movement: "Now light is the activity of this transparency *qua* transparent. Potentially, wherever it is present, darkness is also present."[12] The two are mutually conditional; they exclude each other but each is inconceivable without its counterpart.

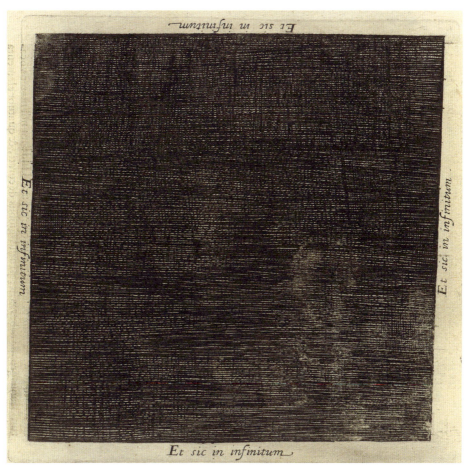

Matthäus Merian the Elder, *Black Square*, from: *Utriusque Cosmi Maioris scilicet et Minoris Metaphysica. Physica Atque Technica Historia*, Vol. 1,1, by Robert Fludd, Oppenheim, 1618

Tiepolo and Piranesi: The Tension of Opposites

Alongside Fludd's powerful seventeenth-century presentation of primary matter suggesting formation by light, the mid-eighteenth-century frescoes of the Würzburg Residence created from 1750 to 1753 by the Venetian painter Giovanni Battista Tiepolo stand as equally strong epochal images. The huge fresco in the entrance staircase is dominated by Apollo, the god of sunlight, who rises above the four continents known at the time – America, Asia, Africa, and Europe. The fresco's main axis extends into the sky from the personification of America in the form of a powerful female chief at one of the narrow sides. Hovering above her is the dark cloud of Mars, the god of war, who

could be subdued only by Venus, resting at his side on the cloud. Apollo the sun god appears above them all, surrounded by the rays of time, the seasons and hours. But above Apollo, one's gaze is drawn to a central, bluish zone of light that has become detached from all figurative ties and thus takes on the character of colour and light per se. Above all earthly conditions and even above the world of the Greek gods, the sky breaks opens into a zone of "light ether", which opens up to light itself.[13] The light is unfettered, as it were, and removed from all ties, drawing the viewer into a sovereign sphere that can no longer be subjected to authority. The massive fresco is without a doubt a celebration of enlightened absolutism, but goes beyond that in painterly terms: the light of the sky itself becomes the intention of the work as a whole.[14]

This goes to the heart of the twentieth-century criticism of what was seen, and inimitably formulated by Adorno and Horkheimer as an image of "discipline" that, from the triumphalism of light, created a cold order culminating in the despotism of norms. Yet this view of the eighteenth century is itself part of the very delusion diagnosed. Tiepolo's frescoes cannot be understood without the context of the counterimages that another Venetian painter of the period, Giovanni Battista Piranesi, gave to the world from Rome. The dystopic visions of Piranesi's *Carceri* show dark prisons, illuminated only by a narrow indirect light source, in which instruments of torture appear amidst the stone blocks while prisoners bound in heavy chains cry out, bewailing their imprisonment. It is not captivity per se that constitutes the egregiousness of the dungeon, however, but the bending and breaking of the rooms themselves. These prisons possess various perspectives, so that spatial curvatures arise within the seeming three-dimensionality, driving the space into a fourth dimension. In the era of the ostensible dominance of the enlightening light, Piranesi's prisons attest also to the darkness whose loss was bemoaned by Wolfgang Pauli.

The mid-eighteenth century as the axis of the era of Enlightenment, then, reveals the alluring opening towards light, sky, insight, harmony, but also towards darkness, irrationality, captivity, and departure from three-dimensional space. If there is one duality capable of giving the century that appearance, it is that of Tiepolo and Piranesi. Their doubling leads to the judgement that these two definitions of space and light do not oppose each other antithetically, but must become interlinked – which, philosophically, can be called Enlightenment. What Robert Fludd envisioned in Merian's presentation of the *prima materia* is only apparently broken apart in Tiepolo and Piranesi. In the sense of an enlightenment truly worthy of the name, the two share a tense connection that avoids the coldness that the norm of pure light tends toward.

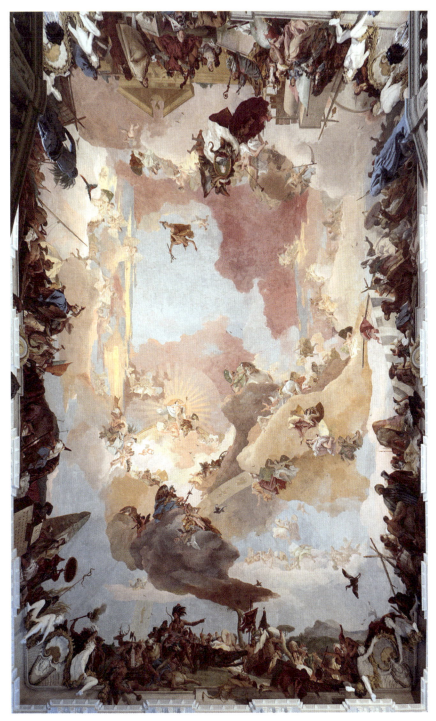

Giovanni Battista Tiepolo, Ceiling fresco in the stairwell of the Würzburg Residence, Würzburg, 1750/53

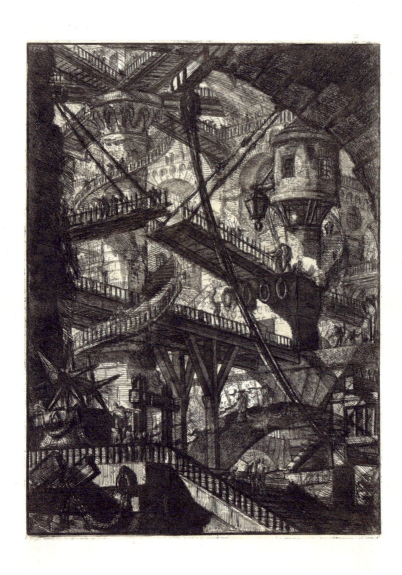

Giovanni Battista Piranesi, *Carceri d'invenzione (Imaginary Prisons)*, Plate 7, *Die Zugbrücke (The Drawbridge)*, Italy, 1761

1. Wolfgang Pauli to Erwin Panofsky, 10 February 1952, in Panofsky 2006, 275; see also Pauli 1996, [1364], 540.
2. See Horkheimer/Adorno 2002, 28 and 33.
3. Blumenberg 1993, 31.
4. See Plato, *Republic* 7, 514a–517a (–521b), in Plato 2013.
5. See Blumenberg 1993, 41.
6. See ibid., 54.
7. Fludd 2018.
8. See Wüthrich 2007.
9. Fludd 2018, vol. 1, 26. See also Godwin 1979, 14.
10. See Bredekamp 2016, esp. 111–113.
11. Aristotle, *Physics* 1.9, 192a32–33, in Aristotle 1996.
12. Aristotle, *De anima (On the Soul)* 2.7, 418b, in Aristotle 1935, 105.
13. See Schöne 1954, 166.
14. See Linke 2022.

Antoine Lilti

Rethinking the Enlightenment from a Pluralistic, Global Perspective

The Enlightenment was long seen as a European phenomenon, as an event in the intellectual history of eighteenth-century Europe, as a process that – if we acknowledge the importance of Spinoza, Locke and Newton, as I believe we should – had its roots in the late seventeenth century. The Enlightenment emerged as a body of writings, ideas and concepts that revolved around natural law, religious tolerance, the autonomy of the individual and the struggle of reason against superstition and prejudice. Most importantly, it took shape as a reflexive stance that enabled modern Europeans to define Europe as a continent of reason and civilization. It was the central narrative of European modernity and its origins.

The view of the Enlightenment as a European phenomenon was not substantially affected by the shift in the discipline of social history in the 1970s with its new emphasis on the institutions of the Enlightenment (academies, salons, lodges), the materiality of cultural exchange and transportation (the history of books and mobility), and cultural practices (reading, conversation). If there was any change at all, it was that debates now centred on geographic questions within Europe: Should Paris be regarded as the capital of the Enlightenment or should attention be turned to national characteristics? What role was played by the Dutch Enlightenment, which began a bit earlier, the German Enlightenment, which was a bit more religious, the English Enlightenment, which had a conservative bent, or the Southern European Enlightenment, which proceeded more cautiously? Should the Enlightenment be viewed as extending to Europe's eastern and northern periphery or should studies focus on works written in Paris and Berlin?

The global turn in historical scholarship has radically changed all of this. There is a growing awareness that the historical context in which eigh-

Johann Georg Klinger, Globe triplet with earth globe, celestial globe and armillary sphere, Nuremberg, after 1791

teenth-century philosophers thought and wrote was not limited to the European continent, but encompassed Europe's colonial offshoots in America and Asia as well as encounters and confrontations with other cultures and civilizations. The eighteenth century was characterized by an increase in interactions between Europe and the rest of the world, as evidenced by the growth of colonial and international trade and by the numerous scientific and imperial expeditions, including the major voyages of Louis-Antoine de Bougainville and James Cook. This led to an expansion of European influence in the world, starting in India, which from the seventeenth century onwards increasingly came under British control. European philosophers not only grappled with the great tragedy of the Atlantic slave trade, but also discussed the achievements of Chinese culture, the perceived misdeeds and contributions of European colonization, abolitionism, the advantages and disadvantages of civilization versus nature, and the merits of the various world religions.

Today, in an age when people are calling into question the ideological and political hegemony of the West and critically examining colonial history,

it is no longer possible to take at face value the proclaimed universalism of the European Enlightenment. The Enlightenment must be subjected to a critical review. Did it serve as a pretext or even a justification for a "civilizing mission" on the part of the West? It is unlikely that Europe ever had a monopoly on critical reasoning. Is it possible to write a cosmopolitan history of the Enlightenment that does not revolve around eighteenth-century Europe yet still acknowledges European achievements?

The European Enlightenment and the Rest of the World

Postcolonial criticism has challenged the grand European narrative of the Enlightenment as the source of modern emancipation, liberty and democracy.[1] Instead, from the postcolonial perspective, the Enlightenment movement masked European hegemony and led to the violent implementation of European ideas throughout the world – particularly the European concept of modernity, rooted in material progress, individualism and economic freedom. The Enlightenment provided a universal model for humanity that in reality was closely aligned with white Europeans and their values, lifestyles and ideals.

Some scholars have criticized the Enlightenment for promoting a universalism that was anything but universal, as it ignored the rights of women, the enslaved, and colonized peoples. They have denounced the silence, indeed the indifference, of leading Enlightenment thinkers in the face of slavery and colonialism. In the writings of David Hume, Immanuel Kant and Voltaire, for example, it is easy to find statements whose Eurocentrism or even blatant racism is deeply shocking. Even more problematic is Thomas Jefferson's relationship with slavery. All of this criticism is directed at a lack of universalism in the Enlightenment. The critics do not, however, question the ideal of universalism itself, based on the natural equality of human beings and their common humanity. They merely emphasize that the philosophers of the eighteenth century did not always live up to their own ideal of equality and freedom.

Another, more radical point of postcolonial criticism addresses the very concept of universal values.[2] It regards the universalism of the European Enlightenment not simply as insufficient and incomplete, but as an inherently flawed principle. According to this criticism, the concept of universal moral and political truths is an instrument of political control, since it suppresses the fact that every universal explanation is historically, geographically and politically situated. Universalism is an act of hubris, a pretext for imposing one's own values on others. From this perspective, the flaw of the Enlightenment was that it was *too* universal, that it abusively declared the values of an emerging liberal Europe – based on the autonomy of the individual, science, and a

secularized worldview – to be universal. This led Europeans to disparage and ultimately destroy the belief systems and ways of life of other societies.

Some of these criticisms are justified and useful. They have led to new interpretations of classic Enlightenment works and a new focus on the ambivalences of European modernity. They have also shifted attention to important anti-colonial works from the Enlightenment period, such as Abbé Raynal's *Histoire des deux Indes*, a bestseller in the 1780s.[3] But the radical attempts to paint the Enlightenment as a colonialist, even racist, ideology are a distortion that ignores the movement's plurality and diversity. The Enlightenment also produced currents of thought that rejected colonization and slavery, criticized European ambitions and expressed concerns about preserving cultural diversity. One of the harshest critiques of colonization can be found in Denis Diderot's *Supplément au Voyage de Bougainville* (1772), in which two Tahitians question hegemonic European discourse. In "The Old Man's Farewell", a Tahitian elder inveighs against the European intruders, warning his people of the moral and political consequences of their arrival. He accuses Bougainville of wanting to impose his "useless knowledge" by force.[4] Another chapter takes the form of a Socratic dialogue between the second main character, Orou, and a European chaplain. Orou confronts the man with his contradictions, which are inextricable from his Christian religion and European culture. Orou makes rational arguments based on the rule of nature.

Admittedly, during Diderot's lifetime, his bold criticism was probably known only to the few people who read *Correspondance littéraire, philosophique et critique*, a hand-copied periodical edited by Diderot's friend Friedrich Melchior Grimm. The topic of "civilization" was more widely discussed, encompassing not only advances in knowledge and the decline in superstition and prejudice, but also the improvement of material living conditions. In the late eighteenth century, the idea that Europe would lead the world to freedom was further strengthened by the French and American Revolutions. In a fragment titled "Propagating the Enlightenment across the Globe", the French philosopher Condorcet explained that people still living in barbarism, if they wanted to become civilized, had to emulate the "most enlightened nations". No group of people could close themselves off to the universal progress of human liberty: "Soon liberty will soar skyward on the secure wings it has received from France and America. It will enthral all people, who will open their eyes and finally understand it."[5] Here, the ambiguity of the verb "enthral" (*subjuguer*) is noteworthy. It refers to the irresistible attraction of the European model while also evoking a form of domination and an imperialist threat.

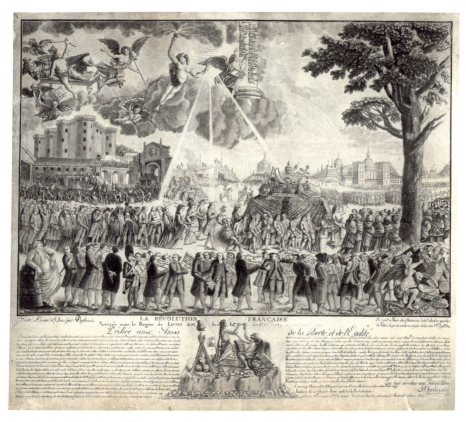

Jean Duplessi-Bertaux, *Allegory on the French Revolution*, Paris, 1792

The Diversity of the Enlightenment

Another way to approach the Enlightenment from a global perspective is to consider that Europe never had a monopoly on ideas about emancipation, reason and freedom. This is not to deny the important contributions of European thought in the eighteenth century. However, the European Enlightenment was not a turning point, despite all its claims. It drew on the humanism of the Renaissance, the rationalism of the Middle Ages and the philosophy of antiquity. All these traditions were transmitted to other cultures, which often continued them in fundamental ways. One need only think of al-Fārābī, who commented on Aristotle's philosophy in tenth-century Baghdad, Avicenna in Persia one century later or Averroës in twelfth-century Cordoba. Another example is the Jewish rationalism embodied by Maimonides in the twelfth century, which Moses Mendelssohn, the great Jewish thinker of the German Enlightenment, rediscovered in the eighteenth century. Generally speaking, the philosophers

of the European Enlightenment did not hesitate to borrow from other intellectual traditions those elements they needed for their critique of Christianity, affirmation of freedom and appeal for tolerance. To criticize Europe, writers also used the exotic figure of the "savage critic", such as the Huron tribesman Adario in Lahontan's *Dialogues de M. le baron de Lahontan et d'un sauvage dans l'Amérique* (1704). The "savage critic" was not a simple literary creation, but the result of the anthropological shock that convulsed European thinkers from Montaigne to Diderot.[6]

Conversely, the writings and ideas of European philosophers were translated into different languages and appropriated, adapted and incorporated into other intellectual traditions, which sometimes changed as a result and sometimes contained elements familiar to Europeans. In the United States and Latin America, the Enlightenment was accompanied by revolutions and wars of independence – or it began in their aftermath. In the Middle East and the Ottoman Empire, it fuelled the reforming efforts of elites, from the Arab Awakening to the Young Turk movement.[7] The Meiji period in late nineteenth-century Japan saw a great openness towards European ideas, and the reformer Fukuzawa Yukichi used them to modernize the country while also drawing on Japanese thought, which had begun its own process of renewal in the seventeenth century.[8]

It would be mistaken to view such historical developments simply as the spread of European ideas throughout the world. These ideas were translated, modified, hybridized and reconfigured, and they often made their way back to Europe. The Enlightenment was multifaceted, had roots in specific intellectual traditions, and raised particular questions about modernity and emancipation. This is illustrated by the Black Atlantic movement, which emerged from the experience of slavery in the late eighteenth century, particularly in Haiti and the United States, and drew on the successes of the Haitian Revolution to affirm the universality of human rights based on true equality among people. The writers who claimed these rights for themselves addressed the topics of the European Enlightenment but lent them a new dimension by radically condemning a system based on exploitation and slavery – the "colonial system", as the Haitian writer Pompée Valentin Vastey called it.[9] The African American poet Phillis Wheatley and the Haitian historian Nau identified a distinct religious element in the will for emancipation. In the nineteenth century, their works were read on both sides of the Atlantic; in the twentieth century, these works were commented on and discussed in connection with African decolonization movements and the African American struggle for civil rights.[10]

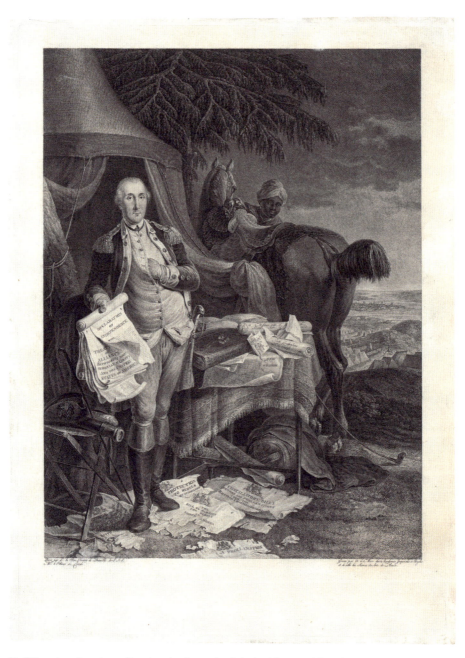

Noël Lemire after Jean-Baptiste Le Paon, *Le Général George Washington*, Paris, 1780

A comparative approach such as this offers the opportunity to reassess the eighteenth-century European Enlightenment. As is well known, the German term *Aufklärung* was not used to describe an era or an intellectual movement until the nineteenth century, and it was only in the early twentieth century that the terms *Lumières*, *Enlightenment*, *Illuminismo* and *Ilustracion* (all capitalized) emerged as designations, translating the German word and establishing the idea of a pan-European intellectual movement.[11] The term *keimō* in Japanese and its Chinese equivalent *qimeng* became popular at the same time. Debates on interpretations of the European Enlightenment have always been characterized by political stakes, ideological biases and conflicts over authorship. Whether radical or moderate, national or cosmopolitan, religious or anticlerical, all these forms of the Enlightenment stand in opposition to each other and are crucial to identifying the fault lines within a seemingly homogeneous concept.

Viewing the Enlightenment from a pluralistic perspective also allows us to examine the fuzziness of the term. "Enlightenment" describes a number of phenomena that are frequently lumped together: emancipation as an ideal achieved through the spread of knowledge and education; secularization and the affirmation of the individual's autonomy; a greater appreciation for scholarship and technological and material progress; human rights and political liberalism. In the grand narrative of European modernity, these different elements once formed a coherent system, but that is no longer the case today. In the current age, modern science and technology seem at times to be eminently reconcilable with restrictions placed on individual freedom and new forms of religious fundamentalism.

Although we can no longer view the desired universalism of the Enlightenment uncritically today, the emancipatory power of knowledge and the critical use of reason are ideals still worth defending in the twenty-first century. Two things are necessary for a successful defence of the movement. First, we must adopt an analytical, self-critical approach that stresses the ambiguities and limits of the Enlightenment without ignoring its genuinely cosmopolitan dimension. Second, we must encourage more openness and acknowledge the diverse forms that the ideal of emancipation has taken in non-European contexts.

1 See Carey/Festa 2009; Lilti 2019.
2 See Mignolo 2011.
3 Raynal 1780; see also Courtney/Mander 2015.
4 Diderot 1979, 220.
5 Condorcet 2004, 943.
6 Lahontan 2023; see also Pagden 1982; Van Damme 2023.
7 See Conrad 2012.
8 Fukuzawa 2018.
9 See Daut 2017.
10 See Rossignol/Roy 2023.
11 See Cronk/Décultot 2023.

THE QUESTION OF REASON

2

Gunnar Hindrichs

The Long March to Maturity

Does the Enlightenment belong to the past, the present, or the future? There was a time when books appeared with titles like *Philosophy after the Enlightenment* or *Religion after the Enlightenment*.[1] That sounded impressive, but the quest of the Enlightenment could not be declared finished so easily. Perhaps this is because the Enlightenment is essentially a work in progress and therefore cannot be thought of as completed. If that is the case, then the question "What was enlightenment?", although phrased in the past tense, could also prompt us to consider the history of the Enlightenment in its very incompleteness. I shall endeavour to do just that here, with regard to certain crucial positions. Their past may then become the present – and perhaps even the future, for enlightenment is not a state, but a path. That idea is expressed in Kant's definition of enlightenment: "*Enlightenment* is man's emergence from his self-incurred immaturity."[2] Rather than establishing a state of affairs, the focus here lies on starting out, setting off on a path.

This path is not just any path. It is the way *out* of a specific situation, from which it derives its purpose. Kant describes this situation in blunt words: "self-incurred immaturity" (*selbst verschuldete Unmündigkeit*). The formulation has two implications. The first is that, in their present state, people are not yet mature – in legal terms, they are 'minors'. The German word *unmündig* describes someone without the capacity to act in law. Children and some adults, for example, can be made wards of court, with guardians appointed to manage their affairs, care for them, make decisions for them and control their behaviour. By analogy, Kant is saying that people in general are under guardianship, both politically and spiritually or intellectually. The second is that the inability to act for themselves is their own fault. People are not – at least, not primarily – in this situation as a result of adverse external circumstances. Rather, it is they themselves who fail to take their affairs into their own hands, submitting instead to the care and decision-making power of their

Immanuel Kant, First edition of *Critik der reinen Vernunft (Critique of Pure Reason)*, Riga, 1781

guardians. This evokes the problem of "voluntary servitude" (*servitude volontaire*) as the main obstacle to people leading a free existence.[3] Taken together, the two parts of Kant's formula amount to saying that if people are to make their way out of their initial state of tutelage, they have to stop behaving like minors and assume responsibility for their own affairs. It is a matter of taking steps towards maturity.

Kant also defines the state of immaturity in greater detail. Immediately following his definition of enlightenment, he writes: "*Immaturity* is the inability to use one's own understanding without the guidance of another." That sounds not only blunt, but even callous. It seems to be more than just a matter of weak will that could be overcome if people were to pull themselves together; instead, the problem lies in an insufficient ability to think. And the ability to think seems not to be a matter of will – you either have it or you don't. Then the following would apply: people who are unable to use their intellect without the guidance of others remain dependent on those others. They need guardians, and the path out of immaturity would require a capacity for thought that most people do not possess. However, Kant continues: "This immaturity is *self-incurred* if its cause is not lack of understanding, but lack of resolution and courage to use it without the guidance of another." Here it becomes clear that people's inability to use their intellect is not a state of affairs that is given and has to be accepted: it is one that people bring on themselves by not resolving or daring to think independently.

We can therefore summarize the initial situation as follows. The external condition consists of people's incapacity to manage their affairs; this corresponds to the rule of guardians over those people. The internal condition consists of people's weak will and lack of courage to manage their affairs themselves; this corresponds to the atrophy of their ability to think. The path to enlightenment lies in transcending these inner and outer conditions. Enlightenment therefore involves, firstly, casting off the legal relationship between wards and guardians. This does not mean that the ward wants to become the guardian – in enlightened society, nobody wants to be either a ward or guardian anymore. Secondly, enlightenment involves overcoming one's own lack of courage and weakness of will. Kant therefore formulates an imperative: "*Sapere aude!* Have courage to make use of your *own* understanding! is thus the motto of enlightenment." *Sapere aude!* (Dare to know!) is the call to overturn all the internal and external conditions of disenfranchisement.

The knowing that we are exhorted to "dare" is both theoretical and practical; it is achieved through interpreting the world and changing the world. The motto of the Enlightenment calls for *all* forms of guardianship, both in

thought and in deed, to be annulled. In this way, the path of enlightenment leads out of theoretical and practical guardianship towards its goal of human maturity.

The Enlightenment as an Ape
The question answered by Kant, "What is enlightenment?", was originally posed in an essay by a pastor in Berlin, Johann Friedrich Zöllner – as a mere footnote. It read: "What is enlightenment? This question, which is almost as important as 'What is truth?' should surely be answered before one begins to enlighten! And yet I have not found it answered anywhere!"[4] Zöllner's article appeared in 1783 in the *Berlinische Monatsschrift*, the most important forum of the German Enlightenment. In 1784, Moses Mendelssohn responded to it in the same journal,[5] as did Immanuel Kant. In the same year, a poem by a certain "Z." also appeared there; today, this is believed to refer to the same Zöllner. Its title is *The Ape. A Little Fable* and it goes like this:

> Once an ape set fire
> To a cedar grove at night,
> And felt truly inspired
> When he found it so bright.
> "Come, brothers, see how well I play;
> I – I turn night into day!"
>
> Big and small, the brothers came,
> Admired the glowing flames
> And then they all began to scream:
> "Long live our Brother Hans!
> Hans Ape deserves eternal fame,
> For he has enlightened the land!"[6]

There is no mention here of maturity or the courage to think for oneself. Instead, the verses poke fun at a destructive aspect of the Enlightenment. Illuminating the world could also mean setting light to it. Thus the light of reason would become a source of fire. It would leave behind only the charred remains of a once-vibrant landscape. In short, the path of enlightenment could lead to a *tabula rasa*.

It is not surprising that the author of this little fable was a clergyman. As the provost of St Nicholas in Berlin, Zöllner saw people as sheep in search of a shepherd. Did they not need a guardian? Leaving that aside, there does

Jean-Antoine Houdon, *Voltaire*, Sèvres, after 1778 (original), copy

seem to be something destructive about having the courage to think for yourself without the guidance of others. Religion, in particular, knows all too well what can happen as a result. Enlightenment, then, also entails casting doubt on the symbols of faith that have been set above any form of reason – even to the point of abolishing them. Not letting the spiritual authorities tell us how to behave, it was feared, would lead to a rampage of independent but hubristic thinking.

That is precisely what the course of the Enlightenment in France seemed to have shown. "Ecrasez l'infâme!" was Voltaire's repeated appeal: "crush the infamous" – by which he meant the superstition fostered by revealed religions. Yet even for those with less education, the light of mature thinking was more persuasive than the flames of Hell. Scepticism and the uninhibited use of the intellect winnowed the riches of religion to such an extent that in the end, all that remained was the rational concept of an abstract supreme being, which

withered away as a figment of thought far removed from human life. As heir to the Enlightenment, the French Revolution even sought to establish a state cult of the Supreme Being. A secular construct of this kind was no substitute, however, for the Mystery of the Blessed Eucharist.

The French Revolution seemed to demonstrate a second side-effect of enlightenment. Did the emergence from self-incurred immaturity not change beyond recognition as it proceeded, taking the form of a reign of terror? During the *terreur*, the wards had found the courage to think for themselves and as a result, they beheaded their guardians with the guillotine. Setting out along the path to maturity could therefore also mean donning the Phrygian cap of the Jacobins and destroying traditional institutions and ways of life. All the accustomed hierarchical relationships now seemed to belong to a reign of servitude – and the day had finally come to emerge from that reign by smashing its apparatuses, its symbols and its representatives.

The good provost of St Nicholas had no inkling of these events, of course, but in retrospect, they seem to confirm the general thrust of his argument. The grove set on fire by the ape of enlightenment can therefore be interpreted from two perspectives. Firstly, it is the spiritual world of the old religion; secondly, it is the political world of the old government. The Enlightenment demystified both. And this demystification involved violence. So in fact, the land *was* enlightened by burning down the grove. "The bright glare of sunlight has conquered the night, / As truth shatters falsehood and wrong flies from right!" sings Sarastro, the high priest in Mozart's Masonic opera *The Magic Flute*. But the brothers in the little fable chime in: "Hans Ape deserves eternal fame, / He has enlightened the land!"

Terror and Mourning

The complex addressed in Zöllner's fable may be termed the negativity of the Enlightenment. Hegel, too, struggled with it. In *Phenomenology of Spirit* (1807), he deals not least with the destructive consequences of the Enlightenment.[7] In doing so, Hegel distinguishes between two forms: the French Enlightenment and the German Enlightenment. The respective chapters are headed "The Spirit Alienated from Itself" and "The Spirit Conscious of Itself" – in France it is a matter of alienation and in Germany a matter of consciousness.

Let us consider the French Enlightenment first. Alienation means that people cannot relate to their circumstances. It becomes a problem in situations when people don't want to feel like strangers in the world that they live in – a feeling that is particularly strong when their circumstances have been arranged

Voltaires anti-clerical outcry "Ecrasez l'infâme!" ("Crush the infamous!") as his letter signature, from : *Correspondance de Voltaire et documents le concernant. I–VIII Lettres de Voltaire*, 1763

to enable them to lead a successful life. We call such arrangements 'institutions'. They do not come about naturally, but are deliberately established and put into effect. In other words, they are human-made. If people cannot relate to them, then they cannot identify with something created by human agency. Accordingly, not only do the circumstances become alien to them here; so, too, does the humanity that created those circumstances. That is why Hegel speaks of the human "spirit alienated from itself".

What does this structure have to do with the Enlightenment? That's easy: the Enlightenment questions the given facts by demanding that we think for ourselves. This calls the institutions into question, which in turn leads to people's alienation from their institutions – and from their own coexistence, which is supposed to be structured by those institutions. Voltaire's battle cry of "Ecrasez l'infâme!" therefore ultimately means that people become strangers to themselves and to their society.

For Hegel, this all culminates in "absolute freedom and terror" – in the executions of the French Revolution. Here, the absolute negation of the guardians is carried out by the blade of the guillotine: "the coldest, shallowest of deaths, with no more significance than cleaving a cabbage head or swallowing a gulp of water."[8] This is the consummation of the French version of the Enlightenment.

Things are different with its German counterpart. Instead of an alienated external relationship, it established an internal relationship based on the conscience – at least that is how Hegel saw it. His view is based on a particular interpretation of the Reformation, according to which religion purified itself by its own efforts in the sixteenth century and thereby attained a rational substance. It did so by shedding the dogmas and rites of the institution and concentrating on the freedom of a Christian. These two processes culminated in the individual conscience. This is where human maturity found its place – without external guardians, in internally guided thought and deed. Consequently, it was able to act less violently against tradition and against institutions. Instead, mature people reflected upon both before the inner law court of their own conscience, in which the voice of God spoke to the individual. Hegel calls this the "spirit conscious of itself".

However, a different malaise resulted, because now the internal and external relationships between people parted ways. By withdrawing into their inner selves, members of the Protestant churches did indeed break free from their spiritual guardians. They also found the courage to use their own conscientious minds. However, they no longer realized themselves in the world. Instead, they moralized about life, ossified in bigoted pretence, or be-

came refined spirits clashing with others who were likewise acting only from within.

That is Hegel's view of the two lineages of the Enlightenment. If we consider them from the outside, it becomes clear that both were struggling with the same problem, namely, revolution. In one case (France) it did take place, and people's alienation led to "the coldest, shallowest of deaths" because it amounted to the unconditional rejection of the institutions. In the other case (Germany) it did not take place, and people's inner selves could no longer be realized in the world because the world had not been changed accordingly. It therefore makes sense that the Canadian philosopher Rebecca Comay interprets Hegel's remarks as "mourning work" for the revolution.[9] In Sigmund Freud's distinction between melancholy and mourning, melancholy cannot get over the loss of a loved object whereas mourning processes it.[10] Comay sees this at work in Hegel's analysis of the Enlightenment. The love object of the Enlightenment is the revolution, which was lost in two ways: through the Jacobin Reign of Terror on the one hand, and through the inwardness of the Reformation on the other.

This leaves us with a striking diagnosis: the negativity of the Enlightenment had to do with the inability to emerge from self-incurred immaturity by means of a revolution that would nonetheless be humane. The question "What was enlightenment?" would then be a question about which steps on the path to maturity need to be processed through mourning.

Blocked Path

At this point, a fourth text comes into play: *Dialectic of Enlightenment*, written by Max Horkheimer and Theodor W. Adorno in 1944.[11] This dialectic, too, processes grief for a revolution that has not yet been completed. In this case, however, it is not a revolution of the middle class, but the proletarian revolution. The October Revolution of 1917 ultimately succeeded in Russia, but elsewhere it failed and variants of fascism took hold instead. These brought new guardians to power, who were even welcomed by their wards. In *Minima Moralia*, which he wrote at the same time, Adorno poses the "grimly comic riddle: where is the proletariat?"[12] Apparently, there was no longer any answer to be found – except in a dialectic of enlightenment itself. The question raised by that dialectic was: does the emergence from self-incurred immaturity ultimately lead to a new guardianship, distorted beyond recognition by European fascism?

Horkheimer and Adorno argue that the one has at least something to do with the other. The emergence from self-incurred immaturity takes place

through the use of the intellect, and this use of the intellect is peculiarly determinative. It subjects the world to its categories, laws and ordering structures. In doing so, it disenchants the world, but it also makes the world equivalent to itself. Whatever does not conform to the categories, laws and ordering structures must be sheared off. The Enlightenment's disenchantment of the world thus encloses it in a rational cage. Accordingly, anything that transcends the enclosure is taboo.

A taboo is a prohibition on touching. It is known to us from pre-enlightened ways of life in which certain animals, people, or places may not be touched: they are taboo. The Enlightenment actually seemed to have abolished such irrational prohibitions on contact; its comprehensive rationality dispelled the mythical taboos. In four culturally speculative essays published under the title *Totem and Taboo* in 1913, Freud links the taboos of pre-enlightened ways of life with the prohibitions of contact that neurotics imposed on themselves in his own day.[13] Adorno and Horkheimer approach the matter more radically. They argue that the Enlightenment itself places taboos on whatever cannot be registered in terms of its categories, and thereby cuts off entire realms of experience. The result is that our courage to use our own intellect simultaneously stunts our capacity to think and act – and subjects it to a kind of universal neurosis.

What does this have to do with the new immaturity? And what about the unfinished revolution? Both are related to the rational cage. If the modern world is the enlightened world, then it seems to represent the world of responsible people. But their use of the intellect has produced the rational systems of the capitalist economy, the bureaucratic state, and standardized law. And these form a new "casing of bondage",[14] to quote Max Weber, a "shell hard as steel" founded on the very same use of the intellect that has made it possible to emerge from self-incurred immaturity. As a result, the emergence from immaturity translates into a new immaturity. Furthermore, because it subordinates everything not covered by these rational systems to a new taboo, it no longer allows any recourse to a form of life that could take shape beyond the enclosure. Yet that is exactly what the goal of a revolution would be. Consequently, the emergence of human beings from immaturity creates a new immaturity, which in turn blocks the path of emergence from immaturity itself. That is the dialectic of enlightenment.

Here we see the object of Horkheimer and Adorno's mourning work. In reflecting on the dialectic of enlightenment, they also mourn for the revolution that was made impossible – and thus for the blocked path out of wardship.

In Inconclusion

Looking at four positions, we have asked the question: "What was enlightenment?" The answers are: enlightenment was the emergence of people from their self-incurred immaturity; enlightenment was the destruction of the mental landscape; enlightenment was the inability to carry out a humane revolution; enlightenment was the tipping over of maturity into a new immaturity. If we now ask the question: "What is enlightenment?", then given these parameters, enlightenment appears to be a path that threatens to destroy itself and which can only be continued along by processing its self-destruction. Anyone who undertakes to do that is, in essence, setting out on the long march of enlightenment.

1 Lübbe 1980 and 1986, followed after some years by Lübbe 2001.
2 Kant 1970, 54 [emphasis in original].
3 La Boétie 2019.
4 Zöllner 1783, 516 note.
5 Mendelssohn 1784.
6 [Zöllner] 1784.
7 Hegel 1977.
8 Ibid., 360.
9 Comay 2011.
10 See Freud 1957.
11 Horkheimer/Adorno 2002.
12 Adorno 1974.
13 Freud 1940.
14 Weber 2002, xxiv.

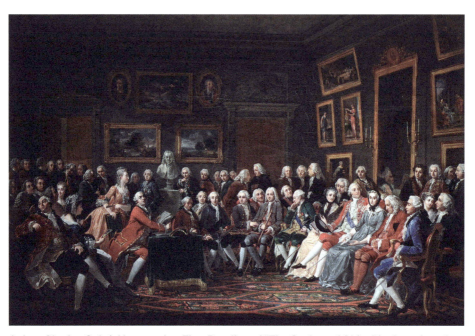

Anicet Charles Gabriel Lemonnier, *First Reading of "The Orphan of China" in the salon of Madame Geoffrin*, France 1814/1824 / Musée des Beaux-Arts, Rouen

The painting shows an imaginary scene in the Parisian salon of Marie Thérèse Rodet Geoffrin (1699–1777). An actor reads from Voltaire's play *L'Orphelin de la Chine*, the adaptation of a Chinese play, first performed in 1755. Since the middle of the 18th century, the salon of Madame Geoffrin acted as a meeting place of the intellectual elite of France, including the philosophers Fontenelle, Helvétius, Rousseau and Montesquieu; Diderot and d'Alembert, publishers of the *Encyclopédie*, which was financially supported by Geoffrin; but also social celebrities like the Prince of Conti, a cousin of Louis XV, the natural scientist Buffon, and the composer Rameau. Geoffrin is prominently portrayed in the front row (fifth from the right). Voltaire was in exile at the time and is represented by a bust in the background. In reality, the people portrayed here never came together in this constellation – due both to their differing opinions and to the fact that women were seldom invited.

DORLIS BLUME

Hartmut Böhme

Enlightenment as Critique – Critique of the Enlightenment

As an era of the eighteenth century, the Enlightenment began as critique. Paradigmatic are the criticism of injustice and repression under absolutism and of censorship used against a new, liberal public sphere; criticism of the privileges of the nobility and of the unjustified influence of the churches on politics, morality and education; and criticism of patriarchalism and a gender order that was detrimental to children and women. In terms of Kant, it may be said that his three critiques make up a comprehensive study of the subject and its capabilities, rejecting any religious or metaphysical basis for the ultimate justification of human existence. That is a huge step on the path to human liberation. But in the Enlightenment, critique also means a critique of religion. That began by historicizing the biblical narratives and the questionable authorship and authority of the texts, and subsequently went beyond the deconstruction of metaphysical imagery as mere fiction.

In enlightened absolutism, meanwhile, political repression went hand in hand with the formal rationality of law, with administration and organization, and with military technology. While a critically reflective public sphere began to flourish (for example with the voices of Lessing and Wieland, later Heine and Marx), the censorship of politically undesirable literature became systemic. The political structures and the traditional elites were anti-democratic; republican journalists were persecuted. At the level of its pedagogical and emancipatory impulses, state regulation turned the welcome expansion of school education both in towns and in the countryside into a factory for obedient subjects. Poisonous pedagogy and enlightenment were linked through pain: reason was instilled into pupils with rote learning and the cane. Criticism of patriarchalism was rendered ineffective by endowing men with legal privileges and declaring women and children legally incompetent – at the same

time as recognizing human rights, which were, however, constrained or eroded in practice.

The separation of church and state was implemented in a wavering and fragmented manner. The powerful influence of religion on politics and social morality remained largely intact. The political opposition that emerged under the banner of Enlightenment was persecuted by the police and the courts. The authority of the national interest was used to justify oppression. Enlightenment thinkers such as Johann Peter Frank invented "police science", which provided the knowledge required for the biopolitical penetration of the population and the systemic expansion of controlling power.

The sciences, being intrinsically republican, were promoted primarily in the field of technology. But technology was tied to the imperatives of economics and power. The industrialization of labour was propagated as a way of rationalizing the traditionally conservative relations of production and the disorganized productive forces. However, the industrial organization of labour turned out to be a system for maximizing profit and subduing the masses of workers recruited for it. Their alleged enlightenment and political representation consistently failed to keep pace with the industrial and technological development of capitalism. The increase in knowledge resources was contained by an ideology of technological progress, which was passed off as social improvement. In reality, this progress served to distribute the profits that it generated unequally among the classes: wealth and luxury for some, poverty and hardship for the rest. The pre-Enlightenment social hierarchy of the estates gave way to the post-Enlightenment class society.

The connection of scientific progress with social progress remained ineffectual, as did the critique of colonialism, a phenomenon that was indispensable to the development of European countries. In terms of its economics, ideology and racism, globalized colonialism was a systemic imperative of European politics that was rooted in the Enlightenment. The competition between nations in overseas trade, in territorial acquisition through the violent seizure of land, and in the exploitation of colonized peoples is precisely what led to the emergence of an early form of geopolitics that implemented the globalized strategies of the Enlightenment. The world became a playground for the technologically, economically, militarily and ideologically advanced countries of Europe and North America. They pronounced themselves to be superior world powers by right, having stolen the instruments of knowledge and technology from the Enlightenment and made them serve their own purposes. This is the opposite of the self-reflexivity that Kant had deemed to be a duty of intellectual existence.

Warning sign / Declared as outlaws, Coburg, 1731

The natural and technical sciences, which drove cognitive development more effectively than the humanities did, never succeeded in developing a 'social' natural science with political impact. Their dependence on state and commercial funding weakened the enormous potential of the sciences to promote a liberated society. Science and technology became providers of solutions that were all too often commissioned by business interests, if not by the masters of war.

The great eighteenth century, which came to be synonymous with the Enlightenment, was far from consisting solely of achievements and effects

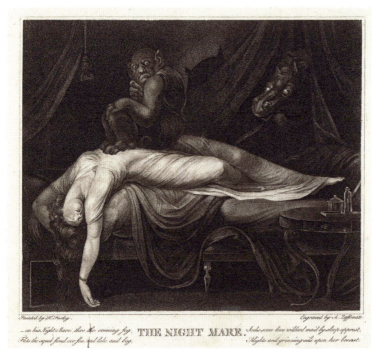

Angelo Zaffonato after Johann Heinrich Füssli, *The Nightmare,* 1795

that changed the state of the world for the better. To be sure, the elites in science, culture and politics held that conviction and still do, but people did not participate to an equal extent in the growth of freedom, education and prosperity. Lack of freedom, lack of education, and poverty remained the norm for the majority. In Enlightenment Europe, public spirit, tolerance and mutual respect formed the core of a 'humanity' that was actually the preserve of an exclusive minority. The same applied to medicine and healthcare: the era of enlightenment was still overshadowed by epidemics, incurable diseases and nutritional deficiencies. The lower classes of the population, in particular, lived in constant danger of starvation and poverty. After the collapse triggered by the Thirty Years' War (1618–48), life expectancy did not return to sixteenth-century levels until around 1720. At the end of the eighteenth century, it was barely longer than it had been several hundred years earlier. High infant and child mortality, poor medical care, lack of hygiene, unhealthy nutrition, squalid dwellings, and harsh working conditions that even the industrial age barely improved, as well as the ruthless exploitation of colonized peoples: together these formed what must be called the persistence of the negative in the glamorous *Époque des Lumières*. It must be acknowl-

edged that even the Enlightenment era belongs to the dark zone of European barbarism.

It is part of Horkheimer and Adorno's "dialectic of Enlightenment"[1] that not only did the era's brilliant intellectual achievements not prevent the systemic expansion of repression but, on the contrary, they supplied the epistemic and technical resources for an apparatus of power. Ever since, that apparatus has used the latest technical developments to perfect its capabilities.

Paradoxical forms of subjects' relationships to themselves reduced the effort required to exercise power over them by re-casting control as self-control. This is both an achievement of the Enlightenment and a structural flaw that paved the way for the bureaucratization of the mind. Promoting the internalization of everything politically and socially expedient became the primary mission of society's agencies of socialization. The 'inner nature' of human beings was declared to be unbridled animality, and had to be kept in check by the subject him- or herself. This had pathological consequences for individuals' mental well-being. The inner space of the psyche became overburdened, if not neurotic, as a result of struggling with the energies of drives and desires. Things became even worse when people projected what was frowned upon and shunned in their own nature onto the outside world and persecuted it there. The enemies that emerged from such projective identifications were soon oppressed or persecuted in reality: children, women, Jews, Roma and non-European peoples. What is dialectical about this is that in the process of imposing reason, unreason was also produced. The same dialectic informs one of the Caprices by Francisco de Goya: *El sueño de la razón produce monstruos* (1799; *The Sleep of Reason Produces Monsters*), a print that would become emblematic of the era. Reason excludes the Other of its Self, the non-identical, and confines it to the unconscious mind, to the realm of dream. Or else it gains the freedom to transform inner resistance to cultural constraints and deprivations into aggression, which is then directed against minorities or 'races' – in the name of self-preservation, morality and reason, which are, of course, always on one's own side. These pathogenic transformations were analysed most clearly by another great enlightener, Sigmund Freud.[2] Without him, there would be no "dialectic of enlightenment".

1 Horkheimer/Adorno 2002.
2 See Freud 1961.

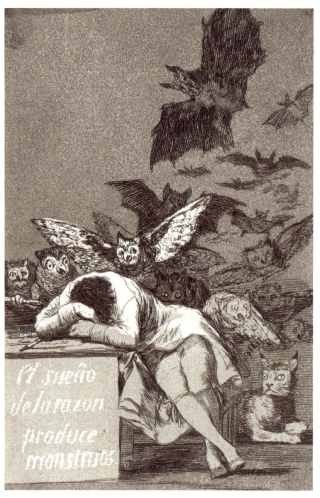

Francisco de Goya, *The Sleep of Reason Produces Monsters* (*Caprichos* 43), Spain, 1799 / Staatliche Museen zu Berlin, Kupferstichkabinett

Francisco de Goya's ambiguous graphic *The Sleep of Reason Produces Monsters (El sueño de la razón produce monstruos)* is part of the cycle known as *Los Caprichos*. Here, Goya criticises the political corruption of elite circles and the power of the Inquisition, which initially denounced the work. Print No. 43 is a reflection on the contemporary discussion over reason versus irrationality. It shows a sleeping man. Owls and bats emerge from a dark background, a cat lurks and a lynx stares, reinforcing the impression of a threatening, dream-like atmosphere. The identity of the *monstruos* (monster) is uncertain, just as the translation of the word *sueño* is ambiguous: if interpreted as "sleep", the artist seems to be warning about the absence of reason, but if it is understood as "dream", he might be stressing the very ambivalence of reason. The influence of the enlightened metaphor of light is mirrored in Goya's masterful use of light and dark contrast. LILJA-RUBEN VOWE

THE SEARCH FOR KNOWLEDGE AND THE NEW SCIENCE

Michael Hagner

The Science of Man and Its Discontents

In *Das Unbehagen in der Kultur* (*Civilization and Its Discontents*), Sigmund Freud characterizes culture as a never-ending process in which individuals and human communities seek an accommodation between their instinctual nature and its domestication. Culture is the strongest bulwark against the terrible struggle of all against all, but it brings with it problems on a different level. If the scales come down on the side of culture, unease arises because the instincts cannot be followed; if the scales tip towards the realm of nature, unease arises because we are either sanctioned by an external authority or troubled by an internalized authority, our guilty conscience. Human beings are condemned to culture – and to preoccupation with themselves, it must be added – but this does not set them on the path to happiness, as Freud emphasizes in several places.[1]

Published in 1930, Freud's short book expressed his all-too-justified concern about the impending breakdown of civilization, but given its generalizing perspective, it can also be read as criticism of Enlightenment progressivism, which had posited the perfectibility of every person as reason, knowledge and morality continued to develop. Freud himself had grown up in this intellectual tradition and was therefore far from casting fundamental doubt on rational thinking. Yet even though he acknowledged all cultural achievements, especially those in science and technology, and in 1932 stated, almost imploringly (but in vain), that "our best hope for the future is that intellect – the scientific spirit, reason – may in process of time establish a dictatorship in the mental life of man",[2] he did not believe that this would lead humanity to a state in which nature and culture unite happily. It was more a matter of avoiding the worst.

The Predicament of Anthropology between Nature and Culture

The noble idea of human perfectibility essentially took the form of a scientific project in which the Enlightenment chose Man as the noblest object of study. In the late eighteenth century, an ensemble of human sciences emerged, ranging from pedagogy and economics to psychology and psychiatry, that sought to explore the various facets of human life. At the heart of these human sciences was anthropology. Now that the creation story with Adam as progenitor had been relegated to the metaphysical realm and René Descartes' proposition of an ontological division of labour between body and mind as two fundamentally different substances had faded in the face of the increasing knowledge of anatomy, physiology and natural history, the relationship between nature and culture became the starting point for anthropology. That faced anthropology with a hopeless task from the very beginning. If anthropology focuses on the mind, culture and customs, then the physical dimension is always the elephant in the room – the result is unease. If it focuses on nature and the body, then the mental and cultural aspects nevertheless work their way into its logic – again, unease.

The predicament of anthropology as *the* new science of the Enlightenment manifested itself not only at the level of the epistemic object, but also in the epistemic process itself. In order to create its typologies, classifications, preferences and hierarchies, anthropology repeatedly engaged with the demons of pure speculation, prejudice and arrogance, which did not act in a vacuum, but in eye contact with exploitation, stigmatization and colonialism. The ambivalence of the Enlightenment project is reflected in the fact that the problems of anthropology in detail and as a whole were recognized and critically reflected upon at an early stage.

In Kant's view, for example, it was futile to seek the natural causes of the cognitive faculty in the brain, because the brain's structure and function were simply unknown: "therefore all theoretical speculation about this is a pure waste of time".[3] But the same Kant tried, in several essays, to define the idea of the "human race" in terms of natural history – and that meant finding heritable characteristics that were not subject to the contingencies of the social and physical environment. The problem here is that in this natural history frame, he attributed a lack of perfection and an inability to develop culture to people of colour. If "human races" are constant units, their characteristics cannot be solely arbitrary; they would need to have a natural cause, which Kant, however, does not name.[4] Is it nature or culture? The interpretation is left to the reader. In short: in one case, Kant rejects speculative reasoning with admirable clarity; in the other case, he indulges in speculation himself. Such

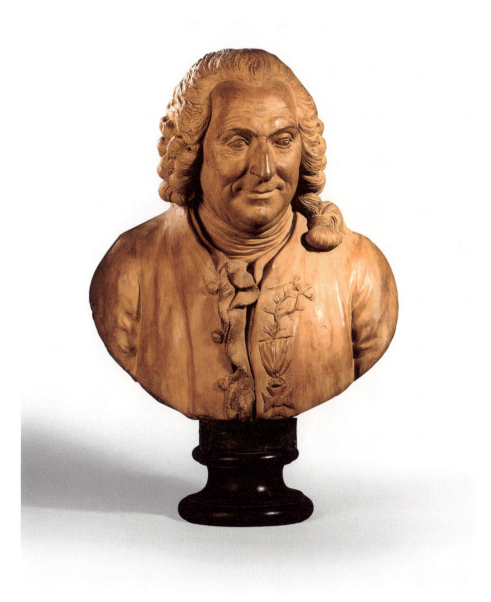

François Martin, *Carl von Linné* (Carl Linnaeus), ca. 1785

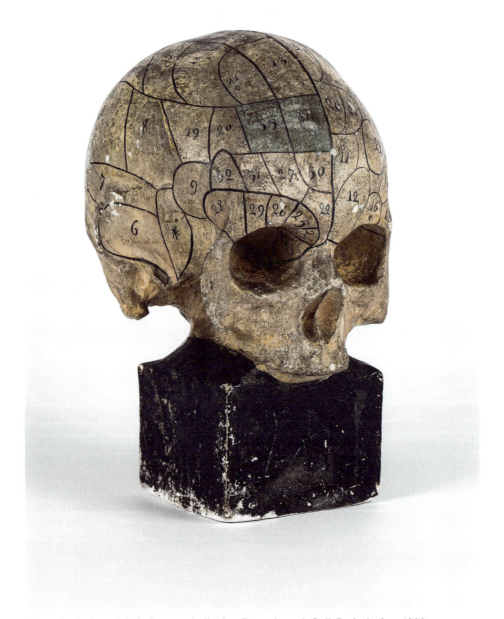

Phrenological model of a human skull, after Franz Joseph Gall, Paris, before 1833

ambivalence suggests that we should indeed look at the history of anthropology with an unease similar to the "discontent" with which Freud regarded culture.

From Self-knowledge to Race
The history of the emergence and consolidation of these ambivalences in the century of the Enlightenment can be traced back to a course set before anthropology was even thought of. In 1735, a 28-year-old botanist by the name of Carl Linnaeus published a booklet of just a few pages in which he made an initial attempt to classify the three kingdoms of nature (minerals, plants, animals). Humans were also included in *Systema naturae*, divided into four groups according to skin colour: whitish, reddish, dark, black (*Homo Europaeus albescens*, *Homo Americanus rubescens*, *Homo Asiaticus fuscus*, *Homo Africanus nigriculus*). Linnaeus did not stop there, however. The tenth edition of *Systema naturae* (1758) contains two extraordinarily momentous additions. Firstly, human beings are included in the binomial classification for the first time. Whereas in the earlier editions, Linnaeus had confined himself to the famous Delphic formula *Nosce te ipsum* (Know thyself), he now appended the term *Homo sapiens*, thus reframing a morally loaded appeal to the individual as an attributive characteristic. Human beings were thereby also endowed with reason in the sense of a characteristic to be recorded in natural history.

Secondly, Linnaeus augmented the division by skin colour to include a series of physical and mental characteristics that supposedly distinguished four human groups. Drawing partly on ancient humoral physiology and the theory of temperaments, partly on stereotypes that had spread quickly among readers of travel literature in the eighteenth century's Republic of Letters, Linnaeus created the blueprint for an interweaving of nature and culture that focused on the *whole human being*. According to this typology, the American is choleric, unyielding, cheerful and free; the European is sanguine, lighthearted, witty and inventive; the Asian is melancholic, strict, arrogant and greedy; the African is phlegmatic, cunning, lazy and careless.[5]

The problem with this enlarged classification is not whether Linnaeus presupposes a clear idea of a 'race' defined through natural history or not. In fact, he doesn't – he never used the term 'race'. Nor is it the question of where human characteristics lie on the spectrum between constant characteristics, on the one hand, and variants caused by climate, living conditions and other combinations of factors on the other. In fact, Linnaeus changed his views on this matter several times. The crucial and fateful point for anthropology is that

with his four groups, Linnaeus created a "collective body",[6] consisting of physical and psychological characteristics, which could serve as the basis for the evaluation of entire peoples, ethnic groups and even 'races'. Furthermore, his classification established a clear hierarchy of positive and negative characteristics, with Americans at the top and Africans at the bottom. Even if Linnaeus does not talk of 'race', this is certainly scientifically rationalized racism.[7] Since then, countless attempts have been made to postulate classification systems that place people in typological, racial, sexual, cognitive, pathological or moral categories. To this end, in addition to skin colour, the cranial bones, the brain, the hair, blood groups and ultimately the genome have been cited, both separately and in combination.

Linnaeus' framework was soon extended in various directions. It was left to Kant to provide clarity regarding the concept of 'race'. In doing so, he rejected the environmental conditions still assumed by Linnaeus, such as climate, nutrition, or social conditions, and in 1785 determined that a 'race' was characterized firstly by a common origin and secondly by the constant inheritance of characteristics.[8] Kant's definitional demarcation is an example of Enlightenment rationality, to be sure, yet these criteria also made it possible to view 'race' as a natural and constant entity, which was tantamount to an essentialization of racial identity into which other characteristics than skin colour could also be incorporated.

What Linnaeus proposed was merely a correlation of physical and psychological characteristics; the relationship between them was not clarified. That void remained unsatisfactory for the Enlightenment ideal of reason with its penchant for epistemic certainty and causal-analytical observation. If the hair, the physique and the humoral characteristics of the body could be invoked as distinguishing features alongside skin colour, it was still not clear what they might be able to explain. In this confused situation, the increasingly important role of the brain in defining the human being came at just the right time, making it possible to transform the correlation between culture and nature into a causal relationship. The brain became a symbolically charged organ, through which the order of the mental hierarchies could be rearranged.

Cerebral Anthropology

With regard to anthropology, this transformation can be illustrated by a small thought experiment that goes back to a radical Enlightenment thinker and physician, Julien Offray de La Mettrie. At the very end of his materialist treatise of 1748 *L'Homme machine* (*Man a Machine*), in which the brain is

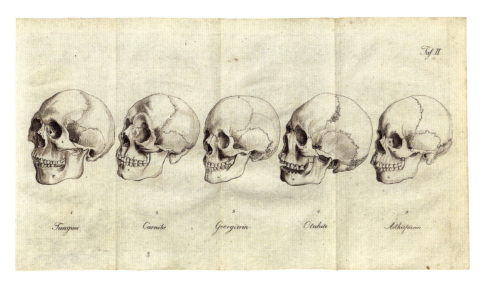

Hierarchization of skulls according to origin in Johann Friedrich Blumenbach's *Über die natürlichen Verschiedenheiten im Menschengeschlechte* (On the Natural Variety of Mankind), Leipzig, 1798

given a prominent place, La Mettrie posits that the brain of even the greatest genius, such as Descartes or Newton, is fundamentally no different from that of an uneducated peasant.[9] This rather inconspicuous passage, like Linnaeus' taxonomy of the human being, forms a meridian of anthropology precisely marking the difference between 'before' and 'after'. Before it, there had been comparative studies between the brains of monkeys and human beings; the differences were reduced to quantitative parameters. After it came comparative studies of the human brain; the postulated differences were embedded from the outset in a system of moral, intellectual and cultural hierarchies.[10]

One generation after La Mettrie, his observation was taken up in an anthropological context by the physiognomist Johann Caspar Lavater, who gave a clear response. He was appalled by the idea that Newton "would have weighed the planets and split the ray of light in the head of a Labradorian who cannot count beyond six, and who calls anything beyond that uncountable".[11] Some paradox: while the materialist La Mettrie doubted whether Newton's brain was noticeably different from that of a farmer, it was unthinkable for the anti-materialist Zurich pastor Lavater that a brilliant mind could be housed in a Newfoundland skull. This reflects a European sense of superiority that was by no means limited to Lavater and was more pronounced and aggressive around 1775 than it had been in La Mettrie's time.

Yet it characterizes only one side of Enlightenment debate. On the other side, Lavater's most uncompromising opponent, Georg Christoph Lichtenberg, discarded Eurocentrism in his pamphlet attacking physiognomists and in 1778 reacted to the idea rejected by Lavater with the laconic question: "And why not?"[12] Lichtenberg did not claim to be able to give a clear answer to his own question, but he averred that all of humanity had an equally distributed potential, which could be realized once slavery, exploitation and oppression had come to an end. However, few protagonists of the late Enlightenment took this step towards universalism. Although the condemnation of slavery and violence can be found more frequently at that time, it was rarely accompanied by a decidedly anti-racist stance.

Once the question of whether mental differences within humanity can be ascertained by considering the brain had been answered in the affirmative, it was not too difficult to examine brains using that measure and to find something there. As if wanting to decide empirically the dispute between Lavater and Lichtenberg over whether the brain of a Newton could be located in the head of an African, the anatomist Samuel Thomas Soemmerring examined three brains of Black people in search of differences between them and the brains of white people. He deployed the entire arsenal of quantitative and qualitative parameters that were available to cerebral anthropology in the late eighteenth century: the brain's size and weight, its texture, and the shape and proportion of its ventricles. He took the results to indicate that Black people had smaller brain ventricles and smaller brains in general than white people. In 1785, Soemmerring deduced from these supposed findings their "wildness, unruliness and somewhat inferior capability for finer culture" and defined their place in the chain of being as closer to the apes than to the Europeans.[13]

Soemmerring's brain anatomy was the scientifically upgraded version of Lavater's physiognomy, for while the latter, with intuitive steadfastness, portrayed the facial skeleton as an expression of the immaterial soul, the anatomist Soemmerring postulated constant characteristics of the brain that would explain intellectual and moral differences. He did so with an air of scientific authority, claiming impartiality and declaring that he would have been just as satisfied if he had found that the brains of Europeans were positioned closer to those of apes.[14]

With Soemmerring's work, the physical "missing link" that was meant to bridge the gap between nature and culture took its place in the anthropological world. The brain was fetishized as the organ that made it possible to identify differences between moral or cultural superiority and inferiority, intel-

ligence and sensuality, masculinity and femininity, white and black. Yet opposition to this emerged from perhaps unexpected quarters. The Göttingen-based natural historian Johann Friedrich Blumenbach had already published two editions of his 1775 book *De generis humani varietate nativa* (*On the Natural Variety of Mankind*), which is generally considered one of the founding texts of physical anthropology. And not without reason, because Blumenbach shifted the focus of anthropology from skin colour to the skull, thus initiating a new direction in practice and discourse that can safely be described as a European skull mania. During the nineteenth century, countless skulls were measured and catastrophic conclusions drawn from the measurements. Natural history museums filled up with piles of bones – ghosts that are now returning to haunt these institutions as critical questions are asked about the provenance of body fragments and the circumstances of their acquisition.

Can Blumenbach be held responsible for this development? In contrast to Kant, he did not regard 'races', which he preferred to call "varieties", as sharply separated entities, but assumed that there were fluid transitions from one to the other and thus gave more importance to the similarities and common origin of various peoples than to their differences. Even more significant is Blumenbach's categorical restriction of anthropology to physical characteristics. In one of the few unequivocally anti-racist publications of the Enlightenment, he rebukes Lavater, Soemmerring and Kant – all of whom doubted the intellectual abilities of people of colour – in no uncertain terms. Among other things, he states that there is not a single physical characteristic distinguishing Black people that cannot also be found in other ethnic groups, and that anyone who questions the intellectual and moral qualities of enslaved Black people should rather focus on the "bestial brutality of their white executioners".[15]

For once, it seems, the light that was meant to be cast for the enlightenment of humanity was not extinguished immediately. On the other side of the equation are the perilous distinctions between culture and nature that enshrined unease in anthropology from the very beginning. Blumenbach's fascination with skulls, evident in his insatiable passion for collecting, also stands in a strange relation to the limited importance that he attributed to the skull for understanding the human being. Yet perhaps this confirms a sense of unease with the totalizing anthropological gaze that ultimately leads via the *physis* to the slaughterhouse. The Enlightenment was not entirely free of blame for this, but if unease can be incorporated as an epistemic virtue into the open-ended project of the Enlightenment, perhaps the worst can be avoided in the future.

1. See Freud 1961.
2. Freud 1932–1936, 4769.
3. Kant 2006, 3.
4. See Willaschek 2023, 209–219.
5. See Linnaeus 1758, 20–22.
6. As discussed by Geulen 2007, 48.
7. See Linnean Society of London.
8. See Kant 1912 (AA 8), 99.
9. La Mettrie 1990, 133–135.
10. For details, see Hagner 2004.
11. Lavater 1775, 46.
12. Lichtenberg 1972, 272–273.
13. Soemmerring 1785, 67 and 77.
14. See ibid., xix.
15. Blumenbach 1790, 91.

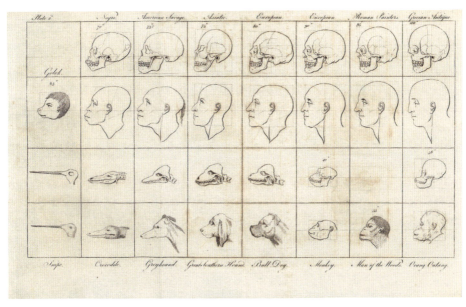

Hierarchical depiction of non-European peoples in Charles White's *An Account of the Regular Gradation in Man,* London, 1799 / University of Heidelberg, University Library

In contradiction to the enlightened principle of the equality of all humankind, the Enlightenment also provided the prerequisites for scientific racism. The belief in a biblical history of salvation gave way to the desire to provide a rational definition of the position of humankind within natural history. Against the backdrop of European expansion and a new understanding of science, hierarchical systems of classification were developed that divided people into different "races". In a graduated *scala naturae*, Europeans were situated right behind the Greek "ideal type" due to their supposed superior physical and aesthetic characteristics, while Africans were often disparaged as the "missing link" between humans and apes. In 1799, Charles White put together a chart of the then current theories of race, which popularised them for the British public. SARO GORGIS

Jonathan Israel

Spinoza and the Enlightenment

Baruch Spinoza (1632–77), as he is usually called – though there is no evidence that he ever used that Hebrew form of his name after his expulsion from the synagogue in 1656 – was the Enlightenment era's most universally reviled and denounced thinker in the decades after his death right down to the late eighteenth century. There were also more attacks on, and refutations of, the ideas and books of Benedictus de Spinoza – as he normally called himself after 1656 – than is the case with any other Enlightenment thinker. A very large number of denunciations of his philosophy appeared from 1670 onwards, at first mainly in Latin, but from the 1690s onwards increasingly in French, English, German, Dutch, Spanish, Portuguese, Italian, Danish, Hebrew and Greek.[1]

It took historians a long time to realize the enormous breadth and uninterrupted longevity of Spinoza's impact on the Western mind. This is because the many dozens of scholars opposing Spinoza's ideas in his own time and in the following decades throughout Europe were under pressure to do so in such abstruse and masked fashion as to avoid drawing the attention of ordinary folk, the common people, to what were considered the most ruinously dangerous set of ideas of the age. Some of the most important early attacks on Spinoza, such as the *Demonstratio Evangelica* (1679), devote many pages to attacking Spinoza without mentioning his name at all. This general admonition not to draw attention to Spinoza and his books was first openly defied by Pierre Bayle (1647–1706), writing in French in the 1680s and 1690s, who insisted on highlighting Spinoza the person and thinker at great length.

Besides assailing the person and ideas of Spinoza himself, there was also an acute awareness that a powerful underground movement of support for his ideas existed surreptitiously, first in Holland and then more widely; consequently there were also numerous denunciations in many languages of what was referred to as Spinozism, *spinosisme*, or *Spinozisterij*. The main reason for

the unparalleled scale of the rejection of Spinoza's philosophy and influence between 1670 and 1800 is that he was the first and most thorough Enlightenment thinker to insist that Nature is the only reality and measure of truth, and that experimental science and the laws of physics as demonstrated by science are the sole criterion for what is true. For Spinoza, God and Nature are identical, which means that the whole of reality is governed by one single unified set of interlinked and unalterable laws of Nature. Consequently, according to Spinoza, nothing supernatural exists or could exist, all theology and church teaching is by definition nonsense, there is no heaven, there is no such thing as divine providence or reward and punishment in the hereafter, and no miracle has ever happened, ever will happen, or ever could happen. It is for this reason that the attacks on Spinoza, though written by a mixture of university professors, scientists, churchmen, jurists and journalists were instigated especially by church leaders: Calvinist, Catholic, Remonstrant, Anglican, Lutheran, Mennonite, Collegiant and Greek Orthodox, as well as rabbinic.

Spinoza's name was reviled more than that of any other Enlightenment thinker; in France at the time it was advisable and discreet not to attack the leading "atheistic" *philosophes* directly by name, so down to the 1770s Voltaire and other critics regularly used the term "nouveaux spinosistes" (new Spinozists) when referring to those later Enlightenment contemporaries, such as Diderot and d'Holbach, whom Voltaire thought had overstepped the bounds so far as attacking revealed religion and the existing political order was concerned. Rather provocatively, Diderot included a short teasing article on *nouveaux spinosistes* in the famous *Encyclopédie*.

Although Spinoza himself always angrily denied being an atheist, it is clear that he could do so only by fundamentally redefining what atheism is: in his philosophy, to be an "atheist" is to lack all ethical sense and to lead an immoral life. For although Spinoza took the view, like Einstein and Gödel in the twentieth century, that religions – meaning organized religions based on divine revelation – are bad, he saw "true religion" – in the sense of devoting oneself to leading an ethical life, helping others to do so, and cultivating a society genuinely based on the common good – as the most precious of human treasures. He was also acutely aware that only someone systematically adhering to reason as the sole guide to truth and sufficiently educated to understand the implications of this, could embrace "true religion" out of conviction, so that even though organized religion relied on what he regarded as myths or untruths, it would nevertheless remain the chief prop for the capacity of the ignorant, uninformed person – that is, the vast majority of people – to eschew evil conduct, hatred, and vengeance and to cultivate within themselves the

highest and noblest human ideals. This contradiction – that revealed religion is untrue, but necessary for the time being – creates a trap for all human society: the problem of religion, from which mankind can only extricate itself with the greatest difficulty, slowly and laboriously, by gradually enlightening society as a whole.

Spinoza's two most important books, his *Tractatus Theologico-Politicus* (1670) and his *Ethics* (1677) are very different in tone and apparent subject matter, but are nevertheless very closely linked in their basic arguments, conclusions, and purposes. Both are designed to promote what he called "true religion" and the noblest ethical sense in humans, to demolish all religious authority in

Baruch de Spinoza, *Ethica, ordine geometrico demonstrata,* in: *Opera Posthuma*, Amsterdam, 1677

the traditional sense, to make science the only criterion of truth, to abolish belief in miracles, and to revolutionize the principles of philosophy itself by making mathematical reason the sole basis for adequate arguments and rejecting all past metaphysics and philosophy. The two books are further closely conjoined in demonstrating that the pursuit of the highest good in individual human life is inseparable from politics and pursuing the highest good in society. But in addition to these common goals, the *Tractatus Theologico-Politicus* set out to revolutionize Bible criticism by demonstrating that the Old and New Testaments are purely human and highly imperfect books, and carry essentially the same message. According to Spinoza, every Muslim, Jew, or Christian is equally near to or distant from the "spirit of Christ", in the sense of the highest human understanding and ideals, and the only measure that determines the distance of a particular individual from "Christ" is how moral or immoral that person's conduct and behaviour is.

In the *Tractatus Theologico-Politicus* and in his last tract, the *Tractatus Politicus,* which he worked on in 1674–76 but did not finish, Spinoza also develops what was in fact the first philosophical, democratic, republican theory

Isaac Newton, Manuscript with sketches of optical experiments, from: *Hydrostatics, Optics, Sound and Heat*, 1670–1710

of modern times. In these texts, he explains why democracy is intrinsically superior to all monarchy and aristocracy, and inseparably connects his general philosophy and the pursuit of the common good – in an individual and collective ethical sense – to the pursuit of the common good politically, via the democratic republic. Within his own premises, there can be no question that Spinoza was quite correct in insisting on and emphasizing the intimate, inseparable connection between "true religion" in his sense, his system of ethics, and a republican politics based on the genuine pursuit of the highest good for society. In subsequent decades this particular linkage – rejection of religious authority closely tied to democratic republicanism – assumed a fundamental significance in all Enlightenment thought, either attracting or repelling all Enlightenment thinkers and writers. The structural causes of this basic dichotomy in Enlightenment thought stemmed from the repressive dominance of religious authority, combined with monarchy and aristocratic ascendancy over society, something that applied to every part of Europe and the European colonial empires as well as other regions of the world.

Spinoza was the first and also the most thoroughgoing of the Enlightenment thinkers to reject religious authority while tying this rejection closely to overthrowing monarchy and aristocracy in favour of the democratic republic – of which he was a passionate supporter. It is for this reason that Spinoza's philosophy became a basic template for a Europe-wide tradition of thought and was widely recognized as the seedbed of an underground tradition of radical thought that eventually culminated in works such as Abbé Raynal's *Histoire des Deux Indes* (1770), Diderot's and d'Holbach's (not Rousseau's) concept of *volonté générale*, the political writings of d'Holbach, and subsequently the writings of Condorcet, Thomas Paine, and other democratic revolutionaries of the French Revolution era. It is also therefore the reason why "radical Enlightenment" came to be labelled and dismissed by Voltaire as the ill-judged philosophy of the "nouveaux spinosistes".

1 On this aspect, see Israel 2023, 3–20, 804–834, 1164–1194.

Model of a human eye in a cup, Nuremberg, ca. 1700 / Deutsches Historisches Museum, Berlin

Probably in reaction to the latest findings in optics – in 1690 Christiaan Huygens published *Traité de la lumière*, the first wave theory of light – the Nuremberg woodturner Stephan Zick began specialising in the manufacture of artificial eyes made of fine woods, ivory or horn. It is recorded that Zick's models were also used in medical practices "for the benefit and teaching of anatomy". He also published, together with the natural scientist Johann Georg Volckamer the Younger and the Nuremberg city physician Daniel Bscherer, the work *Kurtze und mechanische Beschreibung Dieses Kunst-Auges* (Short and mechanical description of this artificial eye, 1700), in which he attempted to validate his discovery scientifically. The turner Zick fashioned the cup that holds the eyeball on his lathe; it consists of eight dismountable parts that are screwed to its base. Unlike other comparable models in which the eyeball can be moved by means of a stick attached to the rear side, the DHM's model is static. WOLFGANG CORTJAENS

Robe à la française with balloon motifs, probably France, ca. 1783 / Deutsches Historisches Museum, Berlin

"Fashion has ascended to a higher element," according to the English writer and politician Horace Walpole, who wrote in a 1783 letter to Sir Horace Mann: "All our views are directed to the air. Balloons occupy *senators*, philosophers, ladies, everybody." The two-piece silk dress with its ornate embroidery illustrates that the first hot-air balloon flight in 1783 prompted joy, emotion, and a veritable balloon fashion. The appliqués illustrate this enthusiasm for the "aerostatic machines", set against a sky-blue background. The aircrafts displayed on the *Robe à la française* depict the heavenward flight that was now possible, and this technological development's promise of modernity. The fashionable materialisation of the balloon fever also shows that – at the threshold to the Modern Age – fashion had already become established as a cultural practice. JULIA FRANKE

Electrophorus of Georg Christoph Lichtenberg, Göttingen, late 18th century / University of Göttingen, Physicalisches Cabinet

The 18th century was fascinated with electricity. Showmen and scholars carried out sensational experiments at marketplaces and in bourgeois salons without, however, being able to explain the observed phenomena scientifically. Georg Christoph Lichtenberg also used physical demonstrations to illustrate his lectures. As a philosopher and experimental physicist he saw it as his duty to observe and describe his experiments with extreme precision. One day, by pure accident, he discovered that the dust on his electrophorus had formed patterns caused by an electrical discharge: Lichtenberg had made electricity visible. By means of the dust patterns created on a round platter ("cake") made of resin, he was also able to prove the existence of two different kinds of charges, which he called positive (+E) and negative (-E) electricity. SARO GORGIS

THE ORDER OF
THE WORLD

4

Ulrich Johannes Schneider

Producing and Ordering Knowledge

In the eighteenth century, books, magazines and newspapers reproduced and disseminated knowledge about the world. They reported on major and minor events, described distant lands and told exciting stories to ever-growing audiences. Encyclopaedias summarized and contextualized this new knowledge. What all of these publications had in common was the problem of organizing knowledge. How, precisely, could the world be made comprehensible? How could news about human civilization and nature be structured and how could very different objects best be explained? People experienced the world as a multifaceted, miraculous place, as in the previous century, but how could they achieve greater clarity in their understanding of it? In the preface to his *Cyclopaedia*, first published in 1728, the English encyclopaedist Ephraim Chambers included a diagram of knowledge, illustrating the need for order.

Heroes of Knowledge
Knowledge is produced by people. In Chambers' encyclopaedia, a copperplate frontispiece offers a counterpoint to his diagram of knowledge. It depicts a large number of people in ancient dress engaged in knowledge production on a public square. They work alone or in groups, supported by measuring instruments and charts, and together form a kind of ideal academy of sciences in the open air.

Many people devoted themselves to the pursuit of knowledge in the early modern period, among them Georg Eberhard Rumpf. His work on the natural history of Ambon – an island in the Maluku archipelago (now Indonesia) – was published posthumously in 1741; it subsequently went through several editions and was translated into several languages. Rumpf carefully studied plants, minerals, shellfish and other marine animals, laying the groundwork for a comprehensive survey of the island's flora and fauna.

The writing of Rumpf's *Herbarium Amboinense* (six volumes, 1741–55)

and *Amboinsche Rariteitkamer* (1705 and 1766) illustrates the dramatic nature of knowledge production in a single lifetime. Initially, Rumpf had favourable conditions for his work. He was employed by the Dutch East India Company to oversee its spice vessels. He lived with his wife on Ambon and received funding to document the island's natural environment. But then fate struck. Rumpf lost his vision and had to dictate his texts to assistants. His wife and daughter were killed in an earthquake and a major fire destroyed his library and the records within it. His son helped him to complete a new manuscript, but the ship carrying it to Holland sank. After each setback Rumpf found the strength to resume his work, but he did not receive the recognition he deserved until after his death. His texts and drawings were published well into the 1770s.

Rumpf embodied modern Europe's passion for collecting, the boundless curiosity that drove Europeans to observe and analyse everything under the sun, their determination to organize the collected objects and present them in book form. His career shows the extent to which knowledge production in the early modern period – a result of collaboration and support from patrons – depended on favourable conditions to succeed. Knowledge certainly came at a high price.

Despite all these difficulties, heroes of knowledge like Rumpf emerged throughout the centuries and contributed to disciplines as diverse as archaeology and astronomy. The French Benedictine monk Bernard de Montfaucon, for example, published more than 1,100 illustrations of Egyptian, Greek and Roman antiquities in his work *L'Antiquité expliquée et représentée en figure* (fifteen volumes, 1719–24). In 1721, parts of his book were published in English and in 1757, a Latin version appeared in Germany. A milestone in astronomy was the detailed map of the moon drawn by Tobias Mayer in 1750 and published by Georg Christoph Lichtenberg in 1774. And when the English astronomer Edmond Halley boldly predicted that a comet would return to Earth in 1758, he astonished contemporaries, but his forecast was merely the result of careful observations of the heavens.

The Adventure of Curiosity

Rumpf was a European who lived on the distant island that he reported on. Others stayed only temporarily in foreign lands. The eighteenth century saw a large number of expeditions, including those to the north-eastern reaches of the Asian continent, the Kamchatka Peninsula and beyond. It was in this direction that the Dane Vitus Bering first travelled in search of a land route to the North American continent. His expedition lasted from 1725 to 1730 and

convinced the Russian government to make a second attempt not only to survey coastal areas and study flora and fauna, but also to document the indigenous population, its languages and its everyday life. This second undertaking, known as the Great Northern Expedition, began in 1733, involved more than 3,000 individuals and lasted ten years. One of its highlights was the European discovery of Alaska, but Bering died in 1741 on the return journey and only a few of its members – including the German naturalists Georg Wilhelm Steller and Johann Georg Gmelin from the "academic contingent" – had the opportunity to expand knowledge of the world with their discoveries. Gmelin's research continued to be published after his death, with volumes three and four of his *Flora Sibirica* (1768, 1769) appearing under the editorship of his nephew Samuel Gottlieb Gmelin.

The work of the German zoologist Peter Simon Pallas is worth mentioning in this context. Pallas was a member of the Russian Imperial Academy of Sciences in St Petersburg, which put him in charge of its own expeditions in 1768. In the journals *Stralsundisches Magazin* and *Neue Nordische Beyträge*, Pallas also published materials and findings from the Great Northern Expedition, including the manuscripts, drawings, and travelogues of Georg Wilhelm Steller. Later, in 1793, Steller's travelogues were also published in book form. Pallas wrote about his own experiences in Russia in *Reise durch verschiedene Provinzen des Russischen Reichs* (1771, 1776) and he also edited the first two volumes of *Flora Rossica* (1784, 1788), which drew on the findings of several expeditions.

The expeditions undertaken by Europeans to uncharted regions in the East show an insatiable hunger for knowledge as well as an intense curiosity that was restrained only by the budgets of their backers, in most cases states. In his description of Kamchatka, published in 1774, Steller refers to the minerals collected, but notes: "The Kamchadals are not in the least knowledgeable or curious about them."[1] These expeditions, which always served practical trade purposes as well, demonstrate that the eighteenth century regarded every new bit of knowledge as just the start of a long process: curiosity was needed to broaden and deepen it. And it was of course an accepted fact among the learned gentlemen from Europe that the indigenous population could not provide any information reliable enough for this scientifically schooled curiosity.

Other journeys were less concerned with natural history than with historical facts. One was the 1761 expedition to the Arab countries of the Middle East, organized by the Göttingen orientalist Johann David Michaelis and financed by the Danish royal family. This undertaking was ultimately a failure,

as almost all its members died within a few years of setting out, but Carsten Niebuhr, the surviving cartographer, continued to use the catalogue of questions drawn up by Michaelis and eventually published his own account of the journey called *Beschreibung von Arabien* (1772). Among the many things Michaelis had wanted to know was whether the Red Sea could actually "part", as described in the Old Testament. Niebuhr considered this likely because of its shallows and the prevailing strong winds.

Collections Everywhere

In the eighteenth century, knowledge about the world came not only from the print media that ensured its wide dissemination, but also from the collections of objects, artefacts and *naturalia* upon which many of these publications were based. Telling in this regard are the instructions given to the painters accompanying the Great Northern Expedition in 1733. These guidelines stipulated that the artists must work with the utmost care, spraying water on dead fish, for example, to accurately reproduce the colour and shine of their scales.[2] As was evident to all, illustrations such as these were mere reproductions of reality, so every effort was made to collect the original objects as well. Some of them were preserved in alcohol and can still be admired in St Petersburg's Zoological Museum today.

Another group of objects documenting the expeditions to Siberia and beyond comprised dried botanical specimens. However, original items such as these accounted for only a part of the new knowledge. In addition to his descriptions of plants, Gmelin recorded the temperature and air pressure of their natural habitats, thus documenting the contexts of their discovery. Nomenclature was another important element, yet it could be tricky in the case of flora because of the often competing and overlapping classification systems. In Gmelin's detailed notes on the 1,178 species he presents in his work – many previously unknown in Europe – he refers to contemporaries such as Linnaeus from Sweden, Albrecht von Haller from Switzerland, Adriaan van Royen from Holland and occasionally earlier botanists as well.

But even if nomenclature was controversial in botany, at least systems existed and brought order to objects. This was absent in most eighteenth-century collections, which – like the curiosity cabinets of earlier days – provided little information on their objects. Explanations were given orally by curators in the exhibition spaces.

Aside from the information found in the rare collection publications, object-related knowledge was shared in letters between interested parties and many collections were also described in travelogues, a genre that reflected a dual

James Simon, *The north front of Montagu House and Gardens,* seat of the British Museum since 1759, London, 1714

interest in both the objects themselves and their overall arrangement. Exhibited in rows, specimens such as birds, fish and stones created a sense of wonder and prompted viewers to consider connections. This effect could be seen in the collections of the Francke Foundations in Halle and the Wasserkirche ("Church by the Water") in Zurich; by contrast, the princely collections at the courts of Gotha, Kassel and Munich presented a broad selection of interesting facts. The largest collection complexes of the eighteenth century were found at the Russian court in St Petersburg, where the cabinet of curiosities was entrusted to the Academy of Sciences in 1719 and opened to the public in 1727, and at the British Museum in London, whose collection was based on the bequest of 71,000 objects from the estate of Hans Sloane, a physician born in northern Ireland in 1660. Other collections were privately held, including the one owned by the Lincks, a family of pharmacists in Leipzig (Heinrich Linck, 1638–1717; Johann Heinrich Linck the Elder, 1674–1734; Johann Heinrich Linck the Younger, 1734–1807). Opened to the public in 1767, this collection consisted of eight hundred zoological specimens preserved in alcohol as well as stuffed songbirds and two hundred boxes of minerals as well as fossils.

In their descriptions of such highly heterogeneous collections, most travelogues provide only a list of objects without any more detailed information.

Denis Diderot and Jean le Rond d'Alembert, *Illustrated System of Human Knowledge*, from: *Encyclopédie*, Vol. 1, First version, Paris, 1751

The opposite is true of the *Bibliotheksreisen* of the eighteenth century – trips taken to libraries by educated travellers who were able to distinguish between rare and commonplace objects. We are fortunate today that a keen observer such as the French Benedictine monk and scholar Augustin Calmet visited St Gallen monastery in Switzerland to view its library. Calmet also inspected the monastery's collections, where in July 1748 he discovered and marvelled at a large stone removed from a horse's stomach.

Collection reports in list form could also be found in lighter publications intended for entertainment purposes. One example is the *Großes vollständiges Universal-Lexicon* (68 folio volumes, 1732–54), the most comprehensive encyclopaedia of the century, edited by the Leipzig publisher Johann Heinrich Zedler. Its article on the imperial capital Vienna, which runs to almost three hundred columns (vol. 56, 1748), contains a detailed description of a visit to the Hofburg palace and its collections.

Only a few images have survived from the eighteenth century that show the collections in their exhibition spaces. These include the specially commissioned engravings produced by Salomon Kleiner around 1744. They show Göttweig Abbey near Krems and two specially set-up display rooms, one for antiquities and coins and the other for weapons and preserved animals, including birds and snakes.

Multiple Orders

As Immanuel Kant once observed, knowledge of things and knowledge of "what is" are two related but entirely different concepts. Kant made a distinction between knowledge from experience, on the one hand, and knowledge from reason on the other; in his seminal *Critique of Pure Reason* (1781/1787), he argued that "all knowledge, subjectively regarded, is either historical or rational. Historical knowledge is *cognitio ex datis*; rational knowledge is *cognitio ex principiis*."[3] Here, "historical knowledge" refers to empirical knowledge from observation, which Kant distinguished from *cognitio rationalis*. In so doing, he differentiated knowledge of what is given from rational knowledge based on "Gründe" ("grounds"). Kant did not consider experience less valuable than knowledge, but called for a combination of the two in the sense of processed experience – that is, distilled knowledge.

One of the most remarkable publication projects of the eighteenth century, *Physica sacra* (four volumes, 1731–35) by the Swiss scholar Johann Jakob Scheuchzer, fails to meet Kant's criteria. The work is a compilation of biblical passages, interpretations, and prayers in honour of God. A special role is played by its natural history illustrations – almost eight hundred large-

format copperplate engravings – which combine biblical events and natural history in a picture-by-picture series.

The attempts to organize knowledge in the eighteenth century are reflected in the wide variety and large number of encyclopaedias, which generally sold well. These publications served various purposes and often focused on specialized fields of knowledge. In addition to language dictionaries like the one compiled by the French Academy, they included encyclopaedias of fashion, mathematics, philosophy and even mountains. Compilations of historical facts were also popular, such as the *Dictionnaire historique* by the French cleric Louis Moréri, which was initially published in a single volume in 1674 and contained numerous geographical and biographical articles. The ten-volume edition of 1759 – like the twenty or so editions before it – was a joint effort by Catholic publishers in Paris and Calvinist publishers in Rotterdam and Basel. A truly European endeavour, it transcended religious boundaries and was translated into German, English and Italian. It organized historical knowledge alphabetically.

Many botanical and medical encyclopaedias of the period contained keyword indexes of diseases and treatment methods in addition to the intellectual classification systems created by experts. Therapeutic interests influenced the way in which users sought information. An emphasis on the practical application of knowledge is also evident in the eleven volumes of plates in the French *Encyclopédie* (1762–77), which were meant to complement and expand the text volumes and were commissioned at a later date, probably for financial reasons. The illustrations show crafts and machines that were normally relegated to "economic" encyclopaedias, and present them as the latest advances in knowledge.

Knowledge and Healing

In the eighteenth century, knowledge was often practical in nature: the ordering of the world helped people to navigate their everyday lives. Scheuchzer's use of natural history for pastoral work is one example; the practical application of medical research is another altogether. Illness was commonly treated in the period by the practice of bloodletting; the incision sites were traditionally stipulated by magical knowledge. After the English physician William Harvey introduced the idea that blood circulated through the body, in 1616, physicians abandoned the anatomical charts found in traditional bloodletting works.

There were two Enlightenment approaches to applying the new order of the blood – as something that circulates – to medical treatment. In the

Encyclopédie article on bloodletting ("Saignée", vol. 14, 1765), the surgeon Antoine Louis emphasizes the freedom of physicians to choose the best incision site and the best time for the procedure: physicians could override the wishes of patients who wanted to use the old puncture points. But the view that research findings should directly influence medical practice was rejected by other sources. In the article on the same topic in the German *Universal-Lexicon* ("Aderlass", vol. 1, 1732), the author – probably the Leipzig physician Heinrich Winkler – argues that despite Harvey's discovery, physicians should defer to their patients' opinions on the matter.

Orders of Inscription

When knowledge was acquired from expeditions, journeys, books and magazines, it inevitably found its way into encyclopaedias, which were first invented as compendia of knowledge from various disciplines and subject areas in the eighteenth century. Following the example of other English, French and German encyclopaedias, the *Encyclopaedia Britannica* conceptually combined empirical and subject-specific knowledge in a work that lives on in digital form today (first edition, three volumes, 1768–71; second edition, ten volumes, 1777–84; third edition, twenty volumes, 1788–97).

In the first edition of the *Encyclopaedia Britannica*, the ordering of knowledge is reflected in the topics of the longer articles (e.g. "Agriculture", "Metaphysics", "Surgery"). Each of these entries is around twenty-five pages long, with "Medicine" running to 111, and together they make up around one-third of the entire reference work. The publishers later abandoned this approach, adding more articles, increasing the number of keywords and accepting minor repetitions so that their readers would not have to jump between individual and survey articles. A system of cross-referencing was needed to make the links between the various topics legible and to signal at the end of the articles their connection throughout the work. The French *Encyclopédie* also contains a reference system, but one that was subject to weaker editorial oversight. Whereas the *Encyclopaedia Britannica* presents all the articles anonymously, the *Encyclopédie* uses abbreviated author names.

One of the most prolific contributors to the *Encyclopédie* was Louis de Jaucourt. As an encyclopaedist he was a typical scholar of the eighteenth century – that is to say, he was a copyist. This probably explains how he managed to write almost 9,000 articles for the work, including 60 per cent of the geographical articles and 35 percent of all articles published in the last ten volumes. Jaucourt also surreptitiously inserted biographical information, despite the editors' decision to exclude it. The entry on Stratford, for example (vol. 15,

Chrétien Frédéric Guillaume Roth, *Genealogical distribution of the arts and sciences*, from: *Encyclopédie*, Register Vol. 1, Paris, 1780

541–44), deals primarily with William Shakespeare, and "Wolstrope" (vol. 17, 630–35) focuses exclusively on Isaac Newton. In this way, curiosity about the heroes of knowledge who were admired in the era was satisfied in an indirect way. Incidentally, Jaucourt did not become a contributor to the *Encyclopédie* until his own reference work went missing. The medical encyclopaedia that had taken him ten years to complete sank with the ship carrying it to an Amsterdam printing shop.

1 Quoted in Posselt 1990, 200.
2 Quoted in exhib. cat. Gotha 1997, 66.
3 Kant 2003, 655–56.

Kirill Ospovat

Enlightenment in Russia between Absolutism and Revolution

Russia occupies a paradoxical place on the map of Enlightenment. When Gottfried Wilhelm Leibniz designed the St Petersburg Academy of Sciences for the Russian reforming autocrat Peter I in 1724, he viewed Russia as a *tabula rasa*, an ideal site for rational top-down transformation to be carried out by an absolute monarch.[1] Decades later Voltaire, enlisted by Empress Elizabeth to assert the accomplished work of Russia's Enlightenment, approached Russia as a peripheral case of catching up-development, a country where the progress of Enlightenment was hindered by local conditions. Blamed on the backward mores of the empire's population, these hindrances were still brought up to justify Peter I's violent sovereignty. Grasping for explanations, Voltaire coined the famous paradox: Peter was a sovereign barbarian who civilized his lands.[2]

Capturing the dialectic of Enlightenment, this formula points towards the amalgamation of emancipated reason and coercive governance which the serf-owning eighteenth-century Russian absolutists eagerly adopted from the West. Russian imperial elites viewed the "new science" and philosophical reason as reasons of state, as tools of sovereignty, governance, and violent colonization.[3] Many major protagonists of European Enlightenment agreed, and even moved to Russia to drive this effort; for example, British philosopher and social reformer Jeremy Bentham designed his Panopticon, an architectural concept allowing extensive observation within penitentiaries, for a Russian naval school.[4] Kant's definition of Enlightenment and its major elements – reason and (im)maturity, freedom of speech, privacy and publicity – through the lens of sovereignty ("Argue as much as you please, but obey!"[5]) encapsulates the stakes of Russia's Enlightenment.

Jeremy Bentham, *Panopticon*, from: *Management of the Poor*, Dublin, 1796

Johann Baptist Homann, *Topographical presentation of the new main Russian residence and seaside city St Petersberg,* from: *Atlas Novus Terrarum Orbis Imperia, Regna et Status exactis Tabulis Geographice demonstrans*, Nuremberg, 1707–1763

The Empire of Reason: Peter the Great

Russia's Enlightenment starts with Peter I, "The Great", who aimed to 'westernize' his lands by reforming the military, ordering his subjects to wear western clothes, and introducing a new, Protestant-type arrangement of faith, knowledge and power that was centred on monarchy and the secular institutions of government. This new order was embodied by Peter's new capital with a German name, St Petersburg, complete with a harbour, the governing colleges (ministries), and an Academy of Sciences, designed by Leibniz. The latter included a school, a library, and a *Kunstkammer*.[6]

In describing the founding of St Petersburg, Peter's chief ideologist, the Ukrainian bishop and scholar Feofan Prokopovych, wrote that its inhabitants were not allowed to settle wherever they wanted because "those

cities are not properly populated which are not built according to royal design".[7]

'Royal design' or 'governing reason' (*pravitel'ski promysl*) is a formula of the Petrine Enlightenment, an equivalent of Giovanni Botero's 'reason of state'. In Machiavelli's *Discourses on Livy* (1531), the building of a city that, through hardship, will shape the republican virtue of its inhabitants is a primary achievement of a legislator. In Descartes' *Discourse on Method* (1637), the powers of the legislator who designs a nation's laws from scratch and the architect who gets to plan "orderly towns... without constraints on an empty plain", both model and delimit the thought of a philosopher as an individual and a subject of a state.[8] Peter's new city, the site of sovereignty, administration, and learning, represented an epistemological paradigm which inscribed philosophical reason and "new science" into developing visions of statehood, governance, and obedience.

In 1698, Peter I visited London and its Royal Society, which epitomized a Baconian – and "Newtonian" – alignment of the new science and the secularized church with the monarchic order.[9] Combining a theory of knowledge with a theory of government, Francis Bacon had understood learning as a source of civic zeal.[10] Peter's church law, the Ecclesiastical Regulation (1721), modelled on Restoration England, was drafted by Feofan Prokopovych. As a primary example of a policy built on learning, the law names Peter's military reform: "the Degeneracy and Feebleness of the Russian Soldiery, whilst it was under no regular discipline" has been remedied by "our Potent Monarch" who "instructed it in the Principles and Art of War by his excellent Rules and Regulations."[11] Amalgamating *instruction* and *discipline*, Peter's law posits that the disciplined soldier could function as the model for the reformed and educated Christian subject.[12] The emperor's undated note states: "Those who do not know for themselves should very much be instructed... in the words of Saint Paul: Wilt thou then not be afraid of the power? do that which is good. But this innocence should be steeped in reason, not in foolishness."[13]

Scriptural authority, political coercion, and secular knowledge are aligned as parallel modes of regulating the subjects' inner selves through a politically steered public education, seen as a central element of governmental reason.[14] Indeed, throughout the Russian eighteenth century, royally sponsored educational institutions such as the Noble Cadet Corps (1732), Moscow University (1755) and the Smolny Institute for Noble Maidens (1764) remained central sites of social discipline.[15]

The Royal Public Sphere: Catherine II

Discipline remained the central issue of Russia's royal Enlightenment under Catherine II, an interlocutor of Voltaire and Diderot and an author and intellectual in her own right. In her *Instruction to the Legislative Commission* (1763), she famously built on Montesquieu's analysis of Peter I's reformation. Peter was wrong to use tyrannical means to change the mores and customs of his subjects because Russians already were an inherently European nation, and because manners should not be changed by law, but by the example of different manners. Adopting this vision, Catherine II retained its association of Enlightenment with the figure of the royal legislator transforming her realm in ways reaching far beyond direct decrees and formal obedience.

In this spirit, Catherine went about instituting a public sphere which encouraged her subjects to voice their opinions on general wellbeing. After assembling and then disbanding the Legislative Commission, she founded the Free Economic Society to promote the discussion of Russia's serf-owning economy, allowed private printing presses, and initiated a series of satirical weeklies in which Enlightenment writers such as Nikolai Novikov could engage in polemics with the empress' humorous alter ego, thus modelling novel modes of public deliberation.[16]

Just as Kant associated Enlightenment with "the freedom to use reason publicly in all matters" but described this freedom as "the least harmful of all"[17] to monarchy and obedience, Catherine emphasized the importance of personal reasoning – "A Man ought to form in his own Mind an exact and clear Idea of what Liberty is" – but associated liberty very closely with obligation: "Liberty can only consist in doing that which everyone ought to do."[18] Negating any connection between reasoning and political emancipation, Catherine – once again, not unlike Kant – makes it a matter of a royally steered re-education of the realm: "In order to introduce better Laws, it is essentially necessary to prepare the Minds of the People for their Reception."[19]

Polemical journalism of 1769, initiated by Catherine with Novikov in the role of her majesty's loyal opposition, introduced a juxtaposition of enlightened satire and sovereign punishment as competing, yet compatible, methods of reshaping customs and mores. Playfully suspending royal terror, often employed by her predecessors, as the foundational scenario of sovereign power, Catherine introduced enlightened discourse as an alternative, more lenient, but – to her mind – more penetrating mode of private and public (self-)discipline.

A version of the Kantian protagonist of the Enlightenment, the minor on the verge of adulthood, appears in Denis Fonvizin's 1782 comedy *The*

Empress Catherine the Great of Russia, Southern Germany, ca. 1770

Minor, which is set in a country estate run by ignorant and violent landowners who abuse their serfs and fail to educate their son properly. The state, embodied by a group of enlightened servitors, intervenes, suspending the owners' legal rights over the estate and sending the minor, Mitrofan, to fulfil his duties in state service. Enlightenment or not, sovereignty remained absolute and "the Source of all imperial and civil Power".[20]

Russia's Radical Enlightenment

If we do not accept Fonvizin's cranky and ignorant, yet obedient, minor as the genuine protagonist of Russia's Enlightenment, we may turn to a state criminal and a runaway serf: Aleksandr Radishchev and Nikolai Smirnov. Radishchev's *Journey from Petersburg to Moscow* (1790) is the most radical book of Russia's eighteenth century. In a chapter on censorship, Radishchev evokes Fonvizin's Mitrofan in clearly Kantian terms to examine the freedom of speech and thought promised by the absolutist governments and expose it as a disguise of despotism:

> We all have permission to possess printing establishments, and the time when it was feared to grant this to private individuals has already passed ...Now everyone is free to maintain printing tools, but what can be printed remains under regulation. Censorship has become a nanny to reason, wit, imagination, all that is grand and exquisite. But where there are nannies it follows that there will be children; they go about in a harness, as a result often their legs are crooked; where there are guardians, it follows that there are young, immature minds unable to control themselves. If nannies and guardians carry on forever, then the child will long go about in a harness and at maturity be a complete cripple.[21]

The book earned the author a commuted death sentence and Siberian exile after Catherine II personally read it and rightly concluded that Radishchev's critique of the serf-owning monarchy echoed the radicalism of the French Revolution. Radishchev's travelogue addresses many different abuses – from court corruption to false pedagogy – but foregrounds the social evil that Catherine's Enlightenment failed to remedy: serfdom, a version of global slavery which Radishchev sees as the core contradiction of the enlightened age. Drawing a direct parallel between Russian and American slave markets, the narrator meets an abolitionist American who cannot believe "that in a place where everyone is permitted to think and worship as they wish such a shameful custom exists".[22]

In attacking the right of property – recognized as a natural right even in the *Declaration of the Rights of Man and of the Citizen* (1789) – as a form of oppression, Radishchev assumed a radical position which granted political and intellectual agency to the peasants. Catherine concluded that he was "a rebel worse than Pugachev", a Cossack who had led a massive rebellion of peasants and colonized nomadic groups in 1773–75. In fact, in Radishchev's reading the Pugachev rebellion emerges as an intriguing parallel to the Haitian revolution – a later subaltern revolt which combined 'savage' violence with a utopian potential unmistakably resonating with the Enlightenment's promises of equality and human rights. In the Atlantic context, issues of slavery and emancipation were debated through the prism of racial difference. In Russia, peasants and masters were not separated by a racial divide, and a different theory of slave emancipation was required. Anticipating a Marxian logic, Radishchev expects future liberation from a peasant revolution dialectically driven by the economic conditions of oppression: "one should expect freedom... from the burden of enslavement itself".[23]

Once the trajectory leading from immaturity to education is projected onto the path from slavery to emancipation, the question of the enlightened subject merges with that of the revolutionary agent. In another countryside scene, Radishchev's narrator meets a serf who is not just "sensible" but educated – possibly an allusion to the real-life educated serf Nikolai Smirnov, who was exiled to Siberia in 1785 after trying to escape from Russia in order to receive an education in Europe. This wish would have been in line with Catherinian Enlightenment had Smirnov not belonged to the enslaved peasantry.

In an autobiography written for his trial, the historical Nikolai Smirnov recounts how the impossibility to achieve "that which seemed more precious than anything: freedom" produced "misery and grief" which "brought me to the very portal of the grave".[24] In his Siberian exile Nikolai Smirnov would go on to publish a version of the archetypical abolitionist story of an indigenous woman sold into slavery by her white lover, paraphrased from Raynal's *Histoire des deux Indes* (1770).[25] Smirnov, now an officer in Russian colonial administration in Siberia, signed his published work with an intriguing pseudonym signalling his identification with colonized indigenous groups. Just as the peasant rebellion emerges in Radishchev as a counterintuitive act of political Enlightenment comparable to Western revolutions, the enslaved and the colonized appear in this radical perspective as the proper subjects of an unfulfilled Enlightenment.

1. See Guerrier 1873, 176.
2. See Voltaire 1999.
3. See Raeff 1991, 99–115; Vulpius 2017, 113–132; Ospovat 2022, 259–280.
4. See Bartlett 2022; Schneiders 1975, 58–80.
5. Kant, in Schmidt 1996, 59.
6. See Keenan 2013.
7. Prokopovych 2010, 473.
8. Descartes 2006, 12–13.
9. See Cracraft 1971; Shapin/Schaffer, 2011; Jacob, 1990.
10. See Bacon 2008, 130.
11. Consett 1962, 61–63.
12. See Foucault 1995, 167–169.
13. *Zakonodatel'nye akty Petra I.* 1945, 151–152 [author's translation].
14. See Fedyukin 2018, 200–218.
15. See Fediukin/Lavrinovich 2015.
16. See Jones 1985; Leckey 2011.
17. Kant, in Schmidt 1996, 59.
18. Butler/Tomsinov 2010, 367.
19. Ibid., 369.
20. Ibid., 365.
21. Radishchev 2020, 157–158.
22. Ibid., 187.
23. Ibid.
24. Smirnov 2009, 27.
25. See Smirnov 1979.

Engraved ostrich egg with motifs from Jan van Linschoten's *Itinerario* (1594–1596), Netherlands, ca. 1600/1620 / Deutsches Historisches Museum, Berlin (acquired with the generous support of the Museum Association of the Deutsches Historisches Museum)

In the course of the overseas expeditions in the 15th and 16th centuries, more and more exotic objects found their way into European art and natural history collections. The engraved surface of the ostrich egg from the art chamber of the Oettingen princes shows a date palm, an islander harvesting coconuts, and a woman planting tobacco crops. The designs are based on copper plates from the travelogue *Itinerario* from 1596 by the Dutch voyager Jan van Linschoten, formerly secretary of the Archbishop of Goa. The maps of the shipping and trade routes in the Indian Ocean that accompanied the book strongly influenced its success. Van Linschoten's voyages provided the impetus for the founding of the Dutch East India Company in 1602. This aimed to break the Portuguese monopoly on maritime trade with the East Indies and Brazil and launched the beginning of the "Golden Age" of the Netherlands. WOLFGANG CORTJAENS

Map and veduta of the residence city of Berlin with the extensions of the early 18th century, Augsburg, 1737 / Deutsches Historisches Museum, Berlin

The extension of Berlin between 1721 and 1740 reveals that the Prussian "Soldier King" Friedrich Wilhelm I was influenced by rationalistic principles of the early Enlightenment. He had plans made for the "Friedrichstadt" as a complete urban metropolis, to be located to the west of the modern fortified belt around the medieval double-city of Berlin-Cölln. The map printed in 1737 by the Augsburg publishers Homanns Erben shows a new spatial understanding: a straight-lined grid of streets interspersed by three radial axes, the fixed point of which was the "Rondell", now Mehringplatz. Together with Pariser and Leipziger Platz, it can be seen as a symbol of the high aspirations of the creators of this urban complex. A circle and square surround an octagon: this was considered a step towards solving the most difficult mathematical problem of the time: squaring the circle. THOMAS JANDER

Tongan basket made of coconut fibres (*kato mosi kaka*), Tonga, Oceania, 18th century / University of Göttingen, Ethnographic Collection

The Cook expeditions to the Pacific were among the most acclaimed research journeys of the 18th century. Although they served above all the imperial and commercial interests of Great Britain, they also had scientific objectives. "Unknown" territories were to be mapped, the riches of nature explored, and foreign cultures described. Aboard the ship was the German scholar Georg Forster, who collected artefacts of ethnographic interest and documented them in *A Voyage Round the World* (1777). He did not always recognise the objects' particular significance. Described in the book as merely "made with great taste", the basket was in fact a status symbol that defined its owner as a member of the highest nobility. In the course of the expeditions, such objects found their way into the museums and university collections of Europe, including the British Museum and the University of Göttingen. SARO GORGIS

American pepper vine from the Schildbach Xylotheque, Kassel, 1780–1800 / Natural History Museum in the Ottoneum, Kassel

In the mid-18th century, Carl Linnaeus introduced binominal nomenclature, a system for naming plants that is still accepted worldwide. To this end the naturalist had specimens and descriptions of flora sent to him by a network of travelling researchers from around the globe. The fascination with the "Linnaean" classification system was reflected in contemporary wood libraries, the so-called xylotheques: every "book" consists of wood from a specific kind of tree. The parts of the plants needed to classify the wood, such as seeds, fruit or leaves, are skilfully arranged inside the book. The libraries of wooden objects were presented as botanical showpieces in natural history cabinets. Carl Schildbach, an autodidact, was particularly interested in plants from the vicinity of Kassel. In his 530-part xylotheque, foreign tree and plant species are the exception. On the label of the American pepper vine, Schildbach writes that he is "uncertain whether it would be suited to Germany."
HARRIET MERROW

THE QUESTION OF RELIGION

Margaret Jacob

Religion in Europe's Age of Enlightenment

The Enlightenment sanctioned the secular. Nothing, however, succeeded in making religion irrelevant. For the first time in European history, religious beliefs were openly contested; the irreligious, the blasphemous, the anti-clerical became public, and, in some select quarters, even fashionable. The greatest ally of impiety lay in anonymity: irreligious authors concealed their identity; publishers left their names off title pages or credited their works to a certain Pierre Marteau. Not a person, but an imprint, Marteau claimed to publish from Cologne. 'He' specialized in tracts against monarchs, clergy (priests and nuns), courts and aristocrats, best illustrating their behaviour by pornography new to the age, which Marteau excelled in publishing. Some of these clandestine books, found in French, Dutch, German, and even English, were outrageous and intended to offend; others simply offered a willingness to accept viewpoints at odds with Judeo-Christian beliefs, or were just sceptical toward the authority of priests, even rabbis. Two examples of the outrageous ones should suffice: *Le Traité des trois imposteurs,* published anonymously in the Dutch Republic in 1721, and *Thérèse Philosophe,* a 1748 French novel ascribed to Jean-Baptiste de Boyer, Marquis d'Argens. The three impostors were identified as Jesus, Moses and Mohammed, while Thérèse postured as an enlightened philosopher who never took money for her very explicitly described sexual favours.

Advocates of religion might be said to have had their attention singularly focused by the need to combat the outrageous. And indeed, there was a vast repertoire of combative texts in support of the clergy. They were fighting an uphill battle. Late in the reign of Louis XV (1715–74) the French Church blamed him for the surge in materialism and irreligion, and the Jesuits led the attack on the *philosophes*; Paul-Henri Thiry d'Holbach, the most extreme materialist of his time, was at the top of their list. Yet Louis XV expelled the Jesuits in 1764 and much of Catholic Europe followed suit. Their schools

were deficient in the teachings of science while, as clergy, they felt a greater loyalty to Rome (the Vatican) than they did to their local bishops or even to their monarchs. Whether Catholic or Protestant, kings wanted a piety that validated only them.

The Situation in the Netherlands

In the two places where Protestantism dominated, the Dutch Republic and the unified kingdom of England and Scotland, diversity as well as complexity could be found in both pulpit and worship in the seventeenth century. The Dutch lacked a legally enforced version of Christianity such as was the Anglican Church in the British Isles. Unlike its Anglican counterpart, the Dutch Reformed Church postured as tolerant toward Christian heresies such as Socinianism[1] and toward the many Jews who had come to the Republic, like the Ashkenazi from central Europe or the Sephardic (Spanish and Portuguese) Jews from the Iberian Peninsula. There were other religious refugees. After the brutal revocation of the Edict of Nantes in 1685, which ended toleration for French Protestants, they went everywhere rather than convert, including the eastern colonies of British America, while whole districts of Amsterdam came to speak French and attend French Protestant churches.

Many Sephardim (called *conversos*) had converted to Catholicism when living in Catholic Spain or Portugal while secretly practicing Judaism. Once in the Republic, they returned to their true faith. Saul Levi Morteira (d. 1660), an important rabbi, helped many *conversos* to rediscover their lost Judaism. Morteira also taught the great philosopher, Baruch Spinoza (1632–77). Spinozism was equated with atheism by its many, largely Christian, detractors. Spinoza placed man as a part of Nature, and self-governing, thus also a part of God. Spinoza's work[2] was widely received: among students of the new science, and particularly among the followers of René Descartes (d. 1650) who himself had lived for many years in the Republic. In his last work, the *Ethics,* published after his death, Spinoza organized the text geometrically around propositions, followed by demonstrations, sometimes explained in *scholia*. For centuries, no original manuscript copy of the 1677 text in the hand of Spinoza or his scribe was found. It finally appeared in the first decade of this century, buried in the archives of the Vatican at the Office of the Congregation for the Doctrine of the Faith. It was accompanied by a description of the "poisoning" that Spinoza's text delivers by its assertion that God is "extended", both materially and rationally, "every body is part of Him".[3] It had been placed on the Index of Forbidden Books, which the Catholic Church

only abolished in 1966. Nothing stopped the fame of Spinoza's challenge to theism, both Christian and Judaic. His pantheism became important to free-thinking and materialism, the most radical forms of enlightened thought. Many forms of devout belief, often endorsing toleration, could be found within Dutch Protestantism. The Mennonites traced their origin to the 16th century Reformation, and they laid emphasis upon simplicity in worship and life. In the cities of the Dutch Republic, they were receptive to enlightened ideas, although they did not practice gender equality. By contrast, another very liberal sect, the Collegiants, became a part of Spinoza's circle and practiced the priesthood of all believers, both men and women. By 1800 they had largely disappeared, and in the eyes of strict Dutch Calvinists they were heretical. In many respects, especially in their open meetings, the Collegiants resembled the Quakers, an import from seventeenth-century English Protestantism, who have flourished in the Anglo-American world well into the present.

Religions in England

Of the many forms of European Protestantism, only the Church of England struggled with the challenge to distinguish itself from Roman Catholicism. James II (1633–1701) had been converted to Catholicism during his youth, having fled to France during the English Civil War. His older brother Charles II (1630–85) returned from exile to ascend to the throne in 1660 as a Protestant, but his religious affiliation was always suspect to devout English and Scottish Protestants. The removal of James in the Glorious Revolution of 1688/89 did little to dampen the tendency toward Catholicism found among the non-juring Anglican clergy (those who would not pledge allegiance to the Protestant king and queen installed in the revolution).

The Anglicans' situation after 1689 required innovation. They wished to secure the church's hegemony against Catholics, but largely against the Dissenters; that is, non-Anglican Protestants, such as Presbyterians, Quakers and Congregationalists. They fervently supported the Revolutionary Settlement of 1688/89 and non-juring was unknown among them. It granted toleration to all Protestants who believed in the Trinity, although for many decades, as a bulwark against Dissenters, anyone seeking public office was expected to "occasionally conform"; that is, to take Anglican Communion at least once a year.

The Church of England divided informally into 'low church', or latitudinarians, and 'high church', who wanted to retain as much as they could of Catholic ceremonies, elaborate decorations and ritual. In politics, they were Tories while the latitudinarians were Whigs, thus devoted supporters of the

Glorious Revolution. Low and high churchmen became, and remained, deeply suspicious of each other, in matters political but also doctrinal. Distinctively, the latitudinarians embraced Isaac Newton's science – with his assistance – and sought to make it into the central proof for the argument that all of Nature conformed to God's design. Newtonian science, they argued, proved the order and design that was manifest in the heavens, and this law-like design provided a universal model. The argument for design expressed the order so desired in society and the state. The first generation of Newtonians, led by Samuel Clarke, dominated the pulpits at home and spread their arguments abroad in translation. Only when Charles Darwin, in the *Origin of the Species* (1859), documented the randomness at work in evolutionary development did the argument for design fall by the wayside, undone by the scientific impulse that had, in the 1690s and beyond, made Anglicanism so avant-garde.

Isaac Newton, Attempt to reconstruct Solomon's Temple in Jerusalem, sketch from the manuscript of *The Chronology of Ancient Kingdoms Amended*, 1727

The alliance of Anglicanism with a form of the conservative Enlightenment made religious toleration and science acceptable. Low churchmen embraced the revolution of 1688/89 and the Protestant succession to the throne, but throughout the century they remained hostile to radical politics with its anti-monarchical stance and certainly, after the French Revolution of 1789 and beyond, unable to accept most liberal forms of reform. The leader of British opposition to the French Revolution, Edmund Burke, loudly proclaimed his Anglicanism although, like the Tory clergy, he was often suspected of being a secret Catholic. Many Dissenters, such as Joseph Priestley, supported the early stages of the French Revolution and, before it, the American Revolution of 1776. Protestantism did not fare as well in southern and eastern Europe. Spain, like France, retained the Catholic clergy as a signifi-

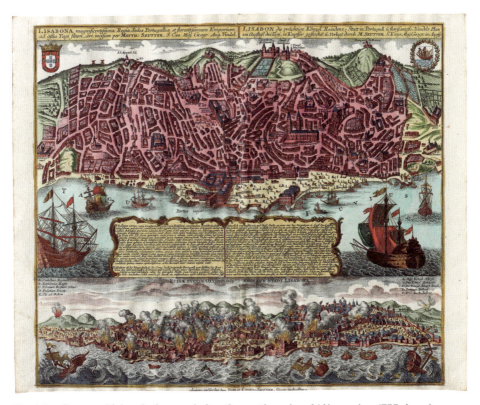

Matthäus Seutter, *Lisbon before and after the earthquake of 1 November 1755,* Augsburg, 1755–1777

cant percentage (1.37%) of the population into the 1780s. Combined with the confraternities, the relatively high proportion of clergy to laity in Spain, as well as Italy, meant that parishes were well serviced and sacramental life flourished. This does not explain: why did no movement toward Protestant reform seize the attention of French, Spanish or Italian clergy as it did in Germany, the Dutch Republic and Britain?

This is too complex a question to be answered in this short introduction. What we can best know about religious devotion in Catholic Europe comes from what the pious laity said in their last wills and testaments. The French testaments are particularly instructive in that, as the decades passed, pious language invoking the passion of the Christ, or the Virgin Mary, receded markedly. A similar recession can be seen in Spanish last wills, although there as in Francem the absence of pious language is more pronounced among the nobility and the prosperous. Literacy rates declined as levels of prosperity and education faltered. Predictably, where the reading of the Bible became central

to Protestant piety, literacy was more pronounced: in Scotland and the Dutch Republic, for example, in contrast to large, particularly rural, sections of Catholic Europe.

Despite the absolute authority of both the French Church and monarchy, and their power to censor, independent sources of public opinion spread widely and deeply in urban France. Nearly three thousand writers are known to have been active by the 1780s. Managing to censor all of them must have been a herculean task. Among the most outrageous, such as Voltaire and Diderot, a prosperous livelihood became possible. In this bohemian universe many writers could be tempted to dip into the clandestine or the impious even though the number of Catholic censors grew along with the expansion of print. Opposition to orthodoxy did not, however, necessarily mean being irreligious.

Dissension within the Catholic Church flared in the seventeenth century around the issue of who merited grace and salvation. Of Dutch origin, Jansenism, despite the various papal encyclicals condemning it, had a large lay and clerical following that extended into the leadership of the French Church. In part a quarrel about who deserved salvation, the practical thrust of Jansenist thinking condemned luxury and loose living. By the 1720s, Catholic enthusiasm focused on new examples of miraculous cures, particularly around the Paris grave of a Jansenist deacon. There the fervent sometimes shook in convulsions. The Church, led by Cardinal Fleury, closed the cemetery of Saint Médard and even denied the last rites to the most frenzied and doctrinaire individuals. Not every Jansenist supported the *convulsionnaires*, as the partisans at the deacon's grave were called, but many had turned to Jansenism to express their outrage. The judicial tribunal, the parlement of Paris, also gave its approval. Some historians have seen Jansenism as one of the many causes at the root of the French Revolution.

The Establishment of Masonic Lodges

Cardinal Fleury had other enemies. The freemasons were a British import with involvement in the politics arising from the Glorious Revolution of 1688/89. By the 1720s, they had followers among Whigs, Tories, and freethinkers, both in Britain and in various Continental cities. Despite the papal condemnation of freemasonry in 1738, lodges existed in France, largely in Paris – even meeting in the home of the British ambassador. Freemasonry was new to the age of Enlightenment, and the various lodges, at their private meetings and in anonymously published texts, expressed a set of secular values distinctive to the age: merit, not birth, as the sign of individual worth; religious toleration; all

Tin with motifs and symbols of the Freemasons, ca. 1750

men meeting "upon the level"; voting and elections for all brothers, and charity for those who had fallen on hard times. The masonic *Constitutions* (London, 1723) excluded all women and men of defective morality.[4] By the middle of the century, there were Continental lodges that 'adopted' women and even talked about their equality, but these were controversial, and certainly not typical.

Reports about the freemasons by the watchful French police emphasized their exclusive garments and ceremonies, and the condemnation in the papal encyclical noted their use of frequent elections. However imperfectly in practice, the lodges expressed enlightened values, without gender equality, and in 1789 the enemies of the French Revolution blamed it on the freemasons as well as the *philosophes*, the leading voices of the Enlightenment. That myth remained part of right-wing ideology well into the twentieth century. Such idealism did not dissuade aristocrats and kings from becoming brothers in a lodge, as did the king of Protestant Prussia, as well as leading German *philosophes*, such as Lessing and Herder, who wrote masonic texts advocating reform.

Freemasonry was not a new religion, but it took on psychological aspects of a secular religiosity. It was able (like the Enlightenment itself) to

outline basic values. And like the Enlightenment, the lodges suffered turbulence from the reaction against democratic revolutions late in the century, even to the point of having to withdraw from public life. Both Catholicism and Protestantism fared far better, and in many places the ideals of the French Revolution brought greater civic equality for Jews. Yet by the 1820s, religious life had secured a distinctly modern identity, one less dominant or assertive in social and political events, less commanding of attention by the secularly preoccupied. The Enlightenment had opened new social and mental spaces, which had once been filled with pious devotion to the saintly or the divine.

1. Socinianism was a theological movement that rejected the Trinity, favoured rational argument and emphasized the morality of Christianity.
2. For the most recent edition of Spinoza's writings, see Spinoza 2022.
3. Spruit and Totaro 2011, 10–11, discussing Vatican Library, Latin MS 12838.
4. For a longer discussion, see Jacob 1991.

Paul Franks

What is *Haskalah*?

Is *Haskalah* a Jewish version of *Aufklärung* or Enlightenment? Was Moses Mendelssohn (1729–86) the father of *Haskalah*?[1]

These commonplaces are questionable. It is widely recognized that there were many 'Enlightenments' and that local context matters. Moreover, the Hebrew term *haskalah* – from the root *skhl*, signifying intellectual activity – was used to signify a movement only after Mendelssohn's death. Nevertheless, Mendelssohn was an important figure in developments within Jewish society that were connected to contemporaneous developments in England, France, the Netherlands, and Scotland – and of course in German-speaking lands.

By the 1740s, in Mendelssohn's youth, there was already a sense of incipient change among some members of the rabbinically educated Jewish intellectual elite. After the expulsion of Jews from Western Europe, which began in 1290 and culminated in the expulsion from Iberia, there was less intellectual exchange between Jews and non-Jews than there had been in the 'Golden Age' of Andalusia, and the Jewish syllabus narrowed, especially in Europe. This was partly because non-Jewish intellectuals were hostile to Jewish participation, and partly because Jews, taking their Germanic and Hispanic languages to the Polish-Lithuanian and Turkish empires, were more interested in survival and consolidation than in exchange. Although Jewish philosophy – interacting with Christian and Islamic thinkers – never entirely died out, by the seventeenth century it had been either eclipsed by or included in *kabbalah*: ways of thinking presented as based, not on reason, but on the reception of revelation.

However, in 1742, the greatest work of medieval Jewish philosophy, Maimonides' twelfth-century *Guide of the Perplexed*, translated from Arabic into Hebrew, was published for the first time in two centuries. It was published in Jessnitz, near Mendelssohn's hometown of Dessau, with the assistance of relatives of Mendelssohn's teacher, Rabbi David Fränkel (1707–62), whom Mendelssohn followed to Berlin. The printing of the *Guide* was part of a return to pre-expulsion Jewish thought, reopening rabbinic scholarship to interaction

Model of the synagogue (Temple of Jacob) in Seesen that was destroyed in the pogroms of 9/10 November 1938, Berlin, 2004

with non-Jewish thought, and ultimately – and most controversially – broadening the Jewish syllabus.

Mendelssohn became part of this elite project. In Berlin, he encountered one of its main protagonists, Israel of Zamosc (ca. 1700–72), who published new editions of medieval philosophical works with commentaries of his own. Mendelssohn contributed a new edition with his own commentary of the treatise on logical terminology ascribed to Maimonides. It was first published in 1761, without acknowledgment of Mendelssohn's authorship, by the person who commissioned him, Samson Kalir, and was republished under Mendelssohn's – by then famous – name in 1784.

But Mendelssohn's ambitions transcended the republication of 'Golden Age' Jewish philosophical texts. He wanted to engage with *contemporary* non-Jewish culture, and he wanted to revive the *aesthetic* dimension of earlier Jewish thought and writing. In 1758, he had published *Qohelet Musar (The*

Pentateuch translation with commentary by Moses Mendelssohn, Berlin, 1780

Preacher of Morals). Although it failed in immediate terms, this publication pointed towards the future even as it invoked the past. On one hand, the intended periodical was linked to the *musar* or ethical literature that had sprung from *kabbalah*, beginning with *Tomer Devorah* (*Palm-tree of Deborah*, 1588) by Moses Cordovero (1522–70). On the other, it was supposed to inaugurate a Hebrew version of the genre of the moral weekly, which had begun in England, such as *The Tatler* (1709–11) and *The Spectator* (1711–12, revived in 1714). Moreover, the moral instruction was of a novel kind: in a tour-de-force of erudition and mastery of the art of weaving phrases and sentences out of biblical allusions, Mendelssohn advocated the renewal of the Hebrew language. To prove Hebrew fit for eighteenth-century literary life, Mendelssohn translated the first sixty-six lines of *Night Thoughts* by Edward Young (1683–1765). Revival of Hebrew as a literary language would later become a feature of the *Haskalah* movement. In 1782, Isaac Euchel (1756–1804) and others founded

Portrait of Moses Mendelssohn, after Anton Graff, later than 1771

the Society for the Friends of the Hebrew Language, and they published the Hebrew periodical *Ha-Me'assef* (*The Collector*, 1784–1811), first in Königsberg, then in Berlin, where there was both patronage and a printing press.

Mendelssohn went in a different direction. Though a native Yiddish speaker, he became a famous philosopher and critic writing in Standard German (*Hochdeutsch*). He helped revive a self-consciously German rationalist tradition, accommodating within Leibnizian philosophy the insights of English and Scottish philosophers, while helping to found the new philosophical discipline of aesthetics. His translation of the Pentateuch into *Hochdeutsch* written in Hebrew letters, intended to be both aesthetically pleasing and sensitive to Jewish tradition, was received by Yiddish speaking communities elsewhere as a controversial attempt to acculturate Jews and overcome the boundaries separating them from non-Jews.

In 1781/82, the Habsburg Emperor Joseph II (1741–90) published the Edicts of Tolerance, declaring his "purpose to make the Jews more useful and

serviceable to the state, principally through according their children better instruction and enlightenment [*Aufklärung*]".[2] This is one meaning of *Aufklärung* in Central and Eastern Europe: an alliance between the absolutist state and an intellectual elite to destroy the corporate status of both Church and Jewish community. Mendelssohn was sympathetic to the end. In *Jerusalem* (1783), he argued that neither Church nor Jewish community should be corporations enforcing doctrinal or legal rulings. But he was wary of the means: state coercion was not a good way to uproot prejudices that should be overcome by reason. Nevertheless, one of his collaborators, Naftali Herz Weisel (1725–1805) wrote an open letter to Jews in Habsburg lands, advocating German-speaking Jewish schools with a new syllabus featuring Mendelssohn's Pentateuch translation. The Emperor's mandate was an opportunity for Jews to enter a new 'Golden Age'.

After Mendelssohn's death, this state-mandated linguistic and educational innovation, accompanied by his translation, came to represent, in Central and Eastern Europe, a new movement, called *Haskalah*, and Mendelssohn came to be seen as its father. To be sure, Mendelssohn had been one of those who planted the seeds. But, as an observant Jew, he would have been concerned about *Haskalah*'s impact on Jewish life, especially when some of his collaborators – notably Herz Homberg (1749–1841) – allied themselves with the absolutist state in an attempt to impose on Jewish communities not only a broadening of intellectual and aesthetic horizons, but also a far-reaching and highly controversial acculturation.

1 For more on Mendelssohn, see Altmann 1973; Arkush 1994; Freudenthal 2012; Sorkin 1996.

2 German History in Documents and Images: https://ghdi.ghi-dc.org/sub_document_s.cfm?document_id=3648&language=english

Paweł Maciejko

The Controversies of Rabbi Jonathan Eibeschütz

Jonathan Eibeschütz (1690–1764) served as a preacher, chief rabbi, head of the rabbinic court, and head of yeshivah in three major Jewish communities: Prague in the Habsburg Empire (1723–40), Metz in France (1741–50), and the Three Communities of Altona, Hamburg, and Wandsbeck (Hamburg was a free city in the Holy Roman Empire while Altona and Wandsbeck belonged to the Kingdom of Denmark). He was arguably the most prominent Torah scholar during a period that many consider the acme of rabbinic learning in Europe. *Urim ve-Tummim* (1774) and *Kereti u-Feleti* (1765), his two seminal commentaries on the *Shulhan Arukh,* the most important code of Jewish law, are still standard fare for yeshivah students, and a firm command of these works remains a basic requirement for becoming a rabbinic judge. Some of his homilies (preached in Yiddish) were also attended by Christian observers who left enthusiastic testimonies of the electrifying atmosphere and the irresistible intellectual and spiritual delight. Eibeschütz was also a famous master of Kabbalah, the esoteric lore of Judaism. He also engaged in practical Kabbalah, writing and distributing amulets, performing exorcisms, and communicating with spirits.

His fame and achievements notwithstanding, throughout most of his life Rabbi Jonathan Eibeschütz was suspected of heresy. From the 1720s onwards, he was accused of being a believer in the discredited messiah-claimant, Sabbatai Tsevi. Tsevi converted to Islam in 1666, but some of his followers interpreted this as a necessary part of his messianic mission; a hundred years later Sabbatianism was still very much alive among the Jews of Europe and the Ottoman Empire.

Three large controversies surrounded Rabbi Jonathan Eibeschütz during his lifetime. The first erupted in 1725 and focused on the treatise *Va-Avo ha-Yom el ha-Ayyin,* a highly contentious Kabbalistic manuscript that circulated anonymously, but was widely – and correctly – attributed to Eibeschütz.[1]

The second followed five years later, in the wake of the publication in Prague of heavily censored editions of the tractate *Berakhot* from the Babylonian Talmud, the Pentateuch, and the prayer book. Eibeschütz was the *spiritus movens* behind these publications and collaborated with Jesuits in censoring the texts and bringing them to press. The editions provoked strong reactions within Jewish communities, where most copies of the three books were burned.[2] The third controversy, the so-called "Emden-Eibeschütz controversy" or "great controversy", broke out in 1750 and focused on the amulets that Rabbi Jonathan had handed out over the past decades. Eibeschütz's amulets were written in cipher; the controversy erupted when they were opened by the rabbi's detractors, who broke the cipher and proclaimed that their texts contained coded references to Sabbatai Tsevi and tenets of Sabbatian belief.[3]

Historians have characterized the amulet controversy as "the pivotal moment in Jewish history".[4] One scholar has even called it the "Jewish French Revolution".[5] The affair engulfed all major Jewish communities in Europe and the Ottoman Empire. Bans of excommunication on either Eibeschütz and his supporters – or, conversely, on his opponents – were pronounced there. All major Ashkenazic and many Sephardic rabbinic authorities of the period took a stance. The kings of Denmark, France, and Poland, as well as a number of prominent Christian notables and scholars, also became involved. Numerically, there are more pamphlets, broadsides and newspapers on the amulet controversy than on the *Haskalah*.

The Eibeschütz controversies open vistas onto four main areas:
1. "Jewish geography". The pan-European character of the controversy begs the question of the historical geography of early modern Jews. The study of the Eibeschütz controversy demands a redrawing of the Jewish map of Europe in a manner that reflects the formal and informal ties between remote communities. The Sephardic diaspora had its own map of the world: Poland stretched from Salonika to the gates of the city of Hamburg, Lithuania was largely independent from Poland, Hungary was located in a different universe, Rome and Livorno certainly could not be subsumed under a common rubric of 'Italian Jewry'; Ashkenaz (often translated simply as "Germany") also encompassed Amsterdam and the Low Countries, Metz in Lorraine, and Tedesco communities on the Italian peninsula, but did not include the German-speaking areas of Bohemia and Moravia.
2. The public sphere. Literate men and women, through their participation in discursive institutions of print and sociability, transformed the social and political landscape of Europe. At the time of the amulet controversy,

more than 120 newspapers were being published within the Holy Roman Empire and their readership numbered around one million – more than in the rest of Europe combined. When news of the unrest among the Jews in Hamburg and Altona started to make its way into the newspapers, the consequences were far-reaching. The amulet controversy was the first event in Jewish history to receive 'live' coverage in the press. Between 1751 and 1759, no fewer than thirty-seven German-language newspapers reported on it. A few mentions appeared also in Polish, French, Dutch, Danish, and Italian newspapers. Once Jews became a subject of public debate, they felt obliged to respond. Eagerly in some cases, reluctantly in others, they began to explain themselves to the reading public and started to utilize the public sphere for their own debates. The Eibeschütz debate was the first instance of an internal Jewish polemics being fought *in* the public sphere through the means developed *by* the public sphere. This not only shaped the unique dynamics of the controversy at the time, but has also influenced later Jewish religious and political controversies to this day.

3. Christian Hebraists and Christian Kabbalah. Shortly after the eruption of the controversy, clashes among the Jews came to the attention of both the Hamburg Senate and the Danish governor of Altona, who then turned to the royal court in Copenhagen for direction. At some point, courts in both Hamburg and Denmark adjudicated legal cases involving parties to the quarrel. As the controversy escalated, the courts requested expert testimonies on Jewish amulets, Jewish law, validations of bans of excommunication, and the scope of rabbinic authority. Five such testimonies were prepared by Christian scholars. Additional book-length accounts were written in German and in Dutch by former students of Eibeschütz who had converted to Christianity. A large number of the aforementioned newspaper accounts were also written by Christian experts, who offered detailed discussions of *Kabbalah* and amulet lore, the place of magic in Judaism, and various fine points of rabbinic tradition. A number of Christian Hebraists also collected manuscripts pertaining to the controversy.

The Hebraists' responses did not merely multiply the number of sources; they served to create a feedback loop between the accounts penned by the Christians and the writings of the Jewish participants in the controversy. Christian Hebraists were familiar with Eibeschütz's Kabbalistic writings. He, in turn, was familiar with their interpretations and reacted to them. His main opponent, Ya'acov Emden (1697–1776), responded with revelations in his own right.

4. Heresy in Judaism. Traditionally, definitions of heresy in Judaism have been notoriously imprecise. Firstly, the unsystematic character of the rabbinic tradition, combined with the tendency to preserve the minority opinions within the common universe of discourse, have resulted in a lack of precision in delineating the boundaries between the 'orthodox' and the 'heterodox'. Secondly, Judaism never developed either a centralized religious authority or an institutionalized hierarchy of religious functionaries. As a result, theological controversies went unresolved for generations. Instead of formulating clear dogmatic positions, Jewish thinkers preferred to provide analogies exemplifying heretical articles of faith or patterns of behaviour. The most useful analogy of this kind was offered by Christianity. It is not only that Christianity was considered a heresy; for many Jews it was a paradigm for all heresy: every tenet of belief that resembled Christian tenets, every ritual that seemed to betray Christian inspirations was identified as 'heretical'. Similarly, virtually every sectarian group within Judaism was accused of resembling Christians, of surrendering to Christian influences, or of blurring or coming dangerously close to the supposedly clear boundary between the Jewish and Christian religions.

Eibeschütz was probably the most controversial figure of early modern Judaism. These controversies allow us to grasp with clarity the moment of transition from the early modernity to modernity.

1 Eibeschütz 2016.
2 See Maciejko 2014, 147–183.
3 See Graezt 1882, 10, 385–418. See also Perlmuter 1947.
4 Schacter 1988, 392.
5 Shmuely 1940, 144.

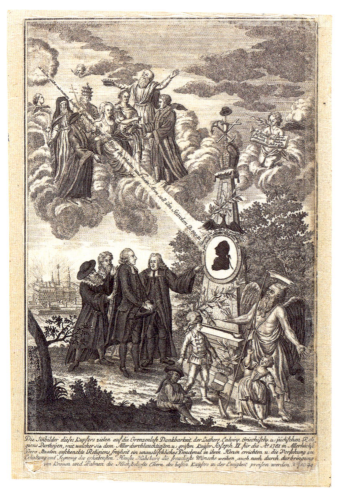

Johann Friedrich Beer, *Allegory of the Patent of Toleration Issued by Emperor Joseph II in 1781*, Frankfurt a. M., 1782 / Deutsches Historisches Museum, Berlin

On 13 October 1781, the Patent of Toleration issued by Emperor Joseph II granted religious freedom to Lutherans, Calvinists, and Greek Orthodox believers; in 1782 another patent extended this freedom to include Jews. The harmony suggested in Beer's allegory, which shows representatives of the various religious denominations gathered before a monument to the Emperor to pay him tribute, was in fact hindered by bureaucratic obstacles and the lack of willingness to implement the newly granted rights. With regard to the legislation on the Jews, the application of the imperial directives in various provinces of the Holy Roman Empire was either delayed or else carried out to a lesser extent or with a reduced period of validity. In certain parts of the country, such as Tirol and the Austrian Netherlands, the patents did not come into effect at all.
WOLFGANG CORTJAENS

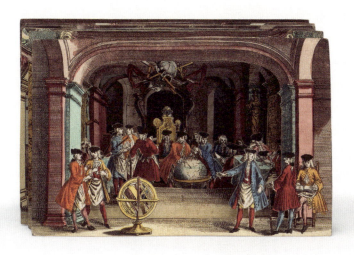

Martin Engelbrecht, Paper theatre scene "Freemason Gathering" (6-part), Augsburg, ca. 1730 / Deutsches Historisches Museum, Berlin

The five rows of scenes and background stage set form a perspective view of a baroque hall in which a group of Freemasons are occupied with scientific instruments and engaged in discussions. Alongside a prominently placed *Sphaira* (celestial sphere) in the foreground and a large globe in the middle, two other types of instruments – the square and compasses, the Masonic symbols – are present throughout the scene. The tools also adorn the throne in the back of the set where the Master Mason of the lodge is seated. From the 18th century on, paper theatres were a popular mode of entertainment and education. The impression of depth is similar to the proscenium stage of the baroque theatre. In this small format it served more as a showpiece than as a stage set where plays could be re-enacted. SABINE WITT

Chasuble from a priestly vestment, ca. 1760 / Franziska von Aachen Catholic parish (formerly St Peter's Parish Church)

The baroque chasuble in the form of a bass violin from St Peter's Parish Church in Aachen is an example of a combination of different traditions. At the intersection of the traverses of the dark-red velvet cross on the back of the garment is a triangle floating on clouds and surrounded by an aureole – the symbol of the Holy Trinity, which was also used in a modified form by the Freemasons. In the centre, standing in place of the name of God, is the Hebrew Tetragram "JHJW" (YHWH, Yahweh, the Only One, He who exists). The use of Hebrew letters in the Christian liturgy and sacred furnishings was quite common in Protestant and Pietistic contexts as well as in enlightened Catholic circles. This can be explained in part by early studies of the origin of the Hebrew language (Hamann, Herder), which directed the focus of linguistic research to the importance of Hebrew as the "ur-language" and authentic language spoken by Jesus.
WOLFGANG CORTJAENS

GENDER ROLES

Pamela Cheek

The Position of Women

In the preface to one of the most popular books of the Enlightenment, Jeanne-Marie Leprince de Beaumont (1711–80) addressed the "Sir Tyrants": "My design is to save" my female readers from "the crass ignorance to which you have condemned them" and "to make them into Logici*ennes*, Geometers, and even Philosophers"[1] For the next century, Leprince de Beaumont's *Le Magasin des enfans; or the Young Misses' Magazine* (1756) showed up in literate homes across Europe; the writer Charlotte von Einem (1756-1833) received a German copy along with a bible when she was six years old.[2] The book featured a governess who taught her young pupils – and readers – how to participate in the Enlightenment: girls should ask questions and reason out answers relying on evidence perceived through use of their senses. A girl should not be an automaton who simply believed her parents or other authorities. She should refine her faith and moral principles through observation of the laws of nature and "submission to the empire of reason".[3]

Le Magasin des enfans and Sarah Fielding's *The Governess* (1749) were the first modern European books to address children and adolescents through a cohesive story. Echoed in form and content a decade later by Jean-Jacques Rousseau, they argued that through the exercise of reason, even women could free themselves from the chains of social prejudice and improve themselves and their societies. Educating girls to face the harshness of a woman's position with grace and virtue became the constant theme of women's participation in the exchange of ideas – a theme sometimes willingly embraced by women and sometimes addressed as the only available conduit for entering Enlightenment debate.

Women's Education

The education of boys followed a regular model, based on learning Latin and Greek and studying Classical texts, whether in schools or with tutors. In contrast, girls' education remained an arbitrary assemblage of religious teachings and maxims for proper conduct. Marriageable young ladies from privileged

families received religious instruction, and perhaps some training in music, drawing, or French at home, in a religious institution, or occasionally at school. Some women reported that as young girls they had resorted to listening in when their brothers received or their fathers taught lessons. Among them, the Humanist Anna Maria van Schurman went on to maintain active correspondence with male and female scholars across Europe, sometimes composing her letters in Greek or Hebrew. In the next generation, the Homeric translator Anne Le Fèvre Dacier mobilized the debate about the comparative merits of the Ancients versus the Moderns (she preferred the Ancients) that set the stage for the Enlightenment. In the following generation, Giuseppa Eleonora Barbapiccola translated René Descartes *Principles of Philosophy* into Italian. Gabrielle Émilie Le Tonnelier de Breteuil, Marquise du Châtelet translated and provided commentary on Newton's *Philosophiae Naturalist Principia Mathematica* and contributed her own influential *Foundations of Physics* (1740). With the exception of Émilie du Châtelet, these women modestly claimed that they were merely translators, although each wrote lengthy prefaces and commentaries. To participate in early Enlightenment debates, women had to know Latin, since Classical knowledge was the portal to participation in the Republic of Letters.

A long-standing cultural anxiety was that too much reading was dangerous for women. Erudite women such as Anna Maria van Schurman were broadly viewed as freaks of nature. Anxieties about reading only accelerated as an expanding print market targeted women consumers with accessible writing in modern European languages. Already in 1712, the British periodical the *Spectator* admonished its "fair readers to be in particular manner careful how they meddle with romances, chocolate, novels, and like inflamers".[4] If leisured women passed time reading novels, commentators feared, their excited passions might yield illicit behaviour.

At the same time, Enlightenment political theorists from Montesquieu to John Millar often explained the advancement of the arts and sciences as a function of the role of literate women in society. France became a case in point. It benefited from lively salons led predominately by a few, highly cultivated women in a practice dating back to the chambre bleue established by Catherine de Vivonne, marquise de Rambouillet (1588–1665) around 1610. Travelers opined that French women's exceptional conversation, taste, and politeness facilitated cultural production. Writing at the end of the century, two prominent feminists summarized the critical Enlightenment argument on French women. In *A Vindication of the Rights of Woman* (1792), Mary Wollstonecraft (1759–97) wrote: "In France, there is undoubtedly a more general

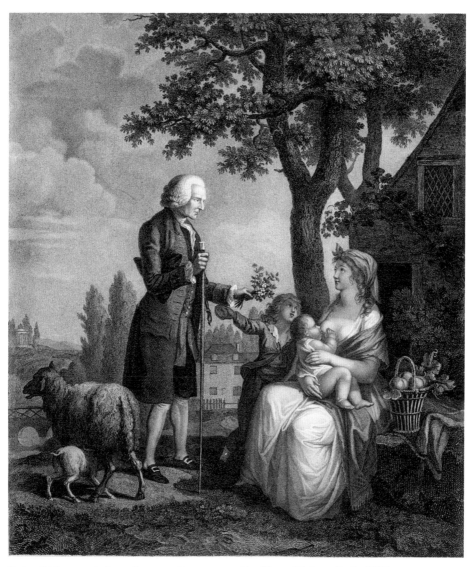

Augustin Legrand, *Jean-Jacques Rousseau or the Man of Nature*, Paris, 1795

diffusion of knowledge than in any part of the European world, and I attribute it, in a great measure, to the social intercourse which has long subsisted between the sexes."[5] Yet the mixing of sexes also explained French decadence, as Olympe de Gouges (1748–93) affirmed in the *Declaration of the Rights of Woman and of the Citizen* (1791). She pointed to a "nocturnal administration of women" in which women illicitly used their "charms" to influence politics.[6]

Adding to the Enlightenment debate on women, pseudo-scientific findings about their distinctive physiology – the fineness of their nerves and accompanying greater capacity for feeling and sensing – underwrote the idea that "sensible" women played a different role from men, but a necessary role, in the creation of a virtuous society. If a sane private life that was regulated by women enabled men's civic engagement in the public sphere, if the production of healthy children by pure mothers constituted the wealth of nations, if sympathetic engagement bound individuals into virtuous societies, then women had a critical role to play in building Enlightenment.

Women, Writing, and Enlightenment Thought

Periodicals and novels, written by women, translated by women, and read by women in modern languages – not Latin – promoted a soft Enlightenment vision of the distinctive role educated and "sensible" women could play in building a virtuous social order. These ostensibly ephemeral forms opened to women writers as a field for expressing their philosophic ideas, even as Classically-inspired tragedy and verse remained elevated literary forms reserved for men.[7] In *On Literature* (1800), the international writer Germaine de Staël (1766–1817) – herself the product of her mother's salon – wrote that "in reading books composed since the renaissance of letters, one can note on every page the ideas that we didn't have before women were accorded a sort of civil equality"[8] Equally, women visual artists, such as Adélaïde Labille-Guiard, Angelica Kauffman, and Élisabeth Vigée-Lebrun communicated arguments about the value of human sympathy, family, virtue, and self-fashioning through portraits of women and children – the subjects they were allowed to paint, even as the privileged genre of history painting remained a male domain.

"Women wrote oceans of letters in the eighteenth century"[9] – to lovers, yes, as epistolary novels suggested, but also to family members, intellectual correspondents, agents, and political affiliates. Less-skilled writers, including women of the lower ranks, as well as the host of privileged women who never learned to spell, could rely on popular letter-writing manuals. As they increased in skill, letter writers found themselves engaged in reflection about the self, a critical Enlightenment practice, even as they addressed their correspondents to communicate their situation, needs, emotions, and queries.[10] Letters containing requests to facilitate a sale, testify, or manage an estate reflected proscriptions against women's appearance in court and ownership of property (including their own intellectual property) and their vulnerability to the interests of male family members.

Literacy provided women with access to the staple practices of the En-

Jean-Antoine Houdon, *Dorothea von Rodde-Schlözer*, Paris, ca. 1806

lightenment: reading, reflection, correspondence, and informed conversation. Basic female literacy, hovering at 27% for adult French women and 35–40% for adult British women, trailed twenty or more percentage points behind male literacy. Exceptional non-Catholic communities, such as those of urban Dutch merchants, German Pietists, and English Quakers showed significantly higher female literacy than in Catholic and rural areas. Literacy rates in general improved over the course of the eighteenth century, fuelled by an expanding print industry in the vernacular.[11]

In what Robert Darnton has called the "business of Enlightenment", women were as active as men.[12] In late seventeenth-century England, a period of lax regulation of the print trade, women worked as "printers, publishers, hawkers" and writers. The period saw "unprecedented female political involvement through print".[13] A century later, excitement about French Revolutionary ideas and events fostered a flood of female political involvement through print and lasting entry into journalism.[14] Although the trade of printer and the role of publisher were dominated by men for most of the Enlightenment, women worked as book sellers and earned income as translators and contributors – often unidentified – to periodicals and anthologies. German women translators, in particular, played a critical role in transferring ideas across national borders.[15] Magazines and periodicals edited by women such as Charlotte Lennox (1730–1804) and Sophie von La Roche (1730–1807), provided opportunities for women to participate in an emerging transnational female literary culture. La Roche's *Pomona für Teutschlands Töchter* (1783–84) was "a polyvocal place for exchanging ideas not just for women but also by women". It gave "all its readers incentive, latitude, and a place to improve their learning and to practice writing."[16]

Periodicals for women encouraged the leisure study of geography and botany as safe areas of science and they introduced female readers to the general European rage for collecting and cataloguing natural specimens.[17] The active women scientists who were recognized in their own time came from varied social conditions: Astronomer Nicole Reine Lepaute (1723–88), daughter of a royal valet, "computed the accurate prediction of the return of Halley's comet". As a servant collecting specimens, Jeanne Baret (1740-1807) became "the first woman to sail around the world." Anatomist Marie-Marguerite Bihéron (1719–95), daughter of an apothecary, was "the first person to teach general anatomy and sex education using models of her own invention".[18] Dorothea Christiane Erxleben (1715–62), daughter of a physician, was the first German woman to qualify as a doctor. Italian physicist Laura Bassi (1711–78), the daughter of a lawyer, was the first woman in the world to receive a

doctoral degree in science, in 1732. Lists of exceptional women scientists nonetheless obscure quotidian engagement in scientific thinking by women like the members of the *Natuurkundig Gennotschap*, a women's scientific society in the Dutch Republic town of Middelburg.[19]

Illiterate and semi-literate women experienced the impact of changing Enlightenment ideas about parenting, childbirth, and sexuality. Debates about whether breastfeeding by a birth mother was crucial to a newborn's health affected wet nurses and new mothers. Male professionalization of childbirth gradually displaced midwives.[20] Concerns about the social ills and degradation of prostitution led to philanthropic projects for institutionalizing sex workers in Magdalen Houses.[21] The availability of second-hand clothing and the invention of fashion enabled women to re-imagine their social positions in acts of self-determination that were consistent with an Enlightenment privileging of personal improvement and transformation. The presence of print in cities, on walls, in shop windows, or inexpensive pamphlets, encouraged servants and workers to attempt reading. Enlightenment slogans appeared in street ballads or in engraved images and found their ways into the mouths of market women and shopkeepers. Illiterate women agitated for political change and political rights and generated new slogans that found their way into print.

Women and Liberty

Enlightenment-inspired projects for exploration or for governing indigenous and enslaved peoples changed women's lives around the globe – an area outside the scope of this essay, but the subject of a growing body of research. Many White British and European writers expressed their enlightened sentiment through depictions of truthful 'noble savage' women, tragic female slaves, or torn biracial daughters of colonists. They highlighted the virtue, self-sacrificial love, and educability of women of colour. Sentimental ideas about female Native Americans and enslaved Africans served to communicate White women's claims about women's position and to consolidate an undifferentiated picture of men's tyranny.

In France, De Gouges rang out the century by urging, "Woman, wake up. The tocsin of reason is being heard throughout the whole universe; discover your rights"[22] and by writing a play titled *The Slavery of Blacks*. In England, Wollstonecraft declared that woman had "always been either a slave or a despot" and that each position "equally retards the progress of reason".[23] In New England, the poet and African slave Phillis Wheatley (c. 1753–84) read the Bible, works of astronomy, geography, history, the Ancients in Greek and Latin, and the Moderns. In a poem seeking liberty for the American colonies, she wrote: "

Mary Wollstonecraft, *A Vindication of the Rights of Women: with Strictures on Political and Moral Subjects,* London, 1792

> I, young in life, by seeming cruel fate
> Was snatch'd from Afric's fancy'd happy seat:
> What pangs excruciating must molest,
> What sorrows labour in my parent's breast?
> Steel'd was that soul and by no misery mov'd
> That from a father seiz'd his babe belov'd:
> Such, such my case. And can I then but pray
> Others may never feel tyrannic sway?"[24]

Wheatley argued that it was her specific vantage point as an educated slave that explained her superior understanding of virtue, sympathy, and liberty. Her poetry, which helped her earn her liberty, confronts readers with a sense of how, for many, participating in the Enlightenment involved a continual tactical negotiation of their place in the world.

1. Beaumont 1768, xvii.
2. See Cheek 2019, 144–49; Dawson 2002, 49.
3. Beaumont 1768, xiii.
4. Quoted in Warner 1998, 136.
5. Wollstonecraft 2010, 85–86.
6. De Gouges [1791] in Levy, Applewhite, and Johnson 1979, 89–96.
7. See Hesse 2003, 216.
8. De Staël 1800, 254.
9. Goodman 2009, 5, 25.
10. See ibid., 3.
11. See Melton 2001, 82–84.
12. Darnton 1987.
13. McDowell 1998.
14. See Hesse 2005; Craciun 2005.
15. See Piper 2006, 119–44; Johns 2014.
16. Dawson 2002, 134–35.
17. See Schiebinger 2004.
18. Gelbart 2021, 5–6.
19. See Jacob/Sturkenboom 2003, 217–52.
20. See Loudon 1992.
21. See Rosenthal 2006.
22. De Gouges [1791] in Levy, Applewhite, and Johnson 1979, 89–96.
23. Wollstonecraft 2010, 98.
24. Wheatley 1988, 73.

Karl Gottlieb Lück after Jean-Baptiste Greuze, figural group *The Good Mother*, Frankenthal, ca. 1770 / Deutsches Historisches Museum, Berlin

Rousseau's novel *Emile* (1762) set off a discussion on whether women should breastfeed their children themselves or leave it to wet-nurses, as was usually the case in upper-class circles in the 18th century. This discourse is taken up in the Frankenthal porcelain group, which is based on the moralistic painting *Le Repos* (1759, London, The Royal Collection Trust) by Jean-Baptiste Greuze, or on his engraving based on the painting. In the pictorial tradition of Caritas, a young woman lays a sleeping infant to her exposed breast. A small child sleeps in a chair next to her while an older boy leans against his mother's chair and plays the flute. A cradle, a basket with a pan, plates, knives and a partly sliced loaf of bread as well as a pot of porridge over a heating vessel on the floor complete the family idyll in which the woman is portrayed as a caring housekeeper and nurturing mother. WOLFGANG CORTJAENS

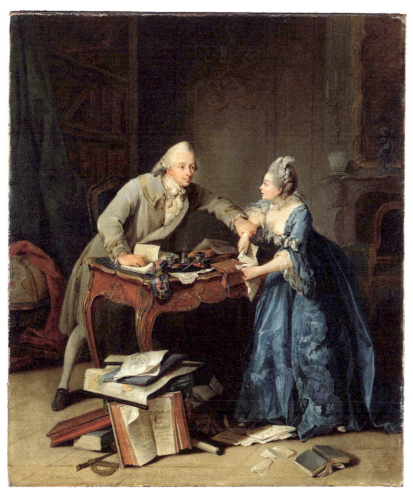

Georg Melchior Kraus, *Torn Between Science and Marriage*, Mainz, ca. 1770/1776 / Germanisches Nationalmuseum, Nuremberg

In his painting *Torn Between Science and Marriage*, Georg Melchior Kraus, a student of Tischbein, takes up the topic of the new emotional bond that couples entered into in the time of the Enlightenment. It shows a quarrelling couple, probably representing Friedrich Carl Freiherr von Groschlag zu Dieburg, who was in the service of the Archbishop of Mainz, and his wife Sophie, Countess of Stadion. Books, maps, graphic prints, a globe, protractors, compasses, and mathematical sketches lie scattered on the desk and floor. The wife demonstratively rips apart a trigonometric sketch. Thus, the painting focuses on the conflict between the pursuit of knowledge and the ideal of mutual care and conjugal love, both achievements of the Enlightenment. DORLIS BLUME

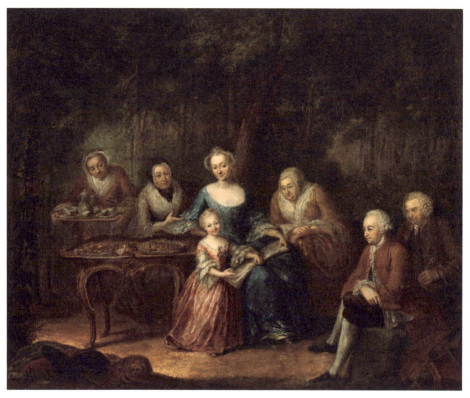

Anna Dorothea Therbusch, *Family Portrait in the Outdoors*, Berlin, ca. 1770 / Stiftung Stadtmuseum Berlin

The family members have gathered in the stage-like glade of a park. Anna Dorothea Therbusch self-assuredly places a young lady in a blue dress in the centre of the painting – possibly a self-portrait with family. Though pictured in nature, the artist creates the intimate atmosphere of an interior with her interplay of light and shadow. Therbusch, Prussian court artist from 1771 on, was the first female Berlin artist to carry out commissions for the European nobility. She succeeded in establishing a notable career at a time when it was hardly even possible for women to be accepted to art academies. Taught by her father, Georg Lisiewski, she was also influenced by the French artists Antoine Watteau and Antoine Pesne. In 1767, she was admitted to the Parisian Académie Royale and from that time on signed her paintings "Peintre du Roi de France".

JULIA NAGEL

THE IMPORTANCE OF PEDAGOGY AND THE EMERGENCE OF THE MODERN INDIVIDUAL

Emma Rothschild

The Importance of Pedagogy

Education has always been the opposite as well as the foundation of enlightenment. It was the wrong kind of pedagogy – the repetition of catechisms and the crushing of doubt, the leading strings of early childhood – that for Kant made enlightenment no more than a distant prospect. It was pedagogy, in the view of Kant's late critics, that could prevent the poison of (revolutionary) enlightenment.

The right kind of pedagogy, or the education that was to be the foundation of enlightenment, was elusive. Education was a requirement of enlightenment in all its multiple senses: as a period in time (an 'age'), as an intellectual movement or sect, and as a disposition or way of thinking, which was Kant's own sense in *What is Enlightenment*?[1]

In the first sense, enlightenment was simply a synonym for education or knowledge. This was the principal meaning of the word *lumières* in French until the 1760s, and of the odd English expression "lights". The age of enlightenment was in this flat sense little more than a multiplication of schools and courses of instruction, literacy, numeracy and other indicators of education. It was a brisk, practical project of new institutions, as in Herder's evocation of the reciprocal influence of government and science in Prussia in 1779: "should we not provide a better link between these universities and our schools, academies, seminars, business activities and public administration?"[2] The "lights of science", in Adam Ferguson's expression, were to be communicated "for one common end of information, invention, science and art".[3]

The Enlightenment as a Project of Education

The Enlightenment in the second sense, of a sect of men of letters, a movement or campaign, was itself a project of education. "It is necessary to change the taste and the customs of an entire nation", says Mentor to Telemachus in Fénelon's *Adventures of Telemachus* of 1699.[4] The philosophers of enlighten-

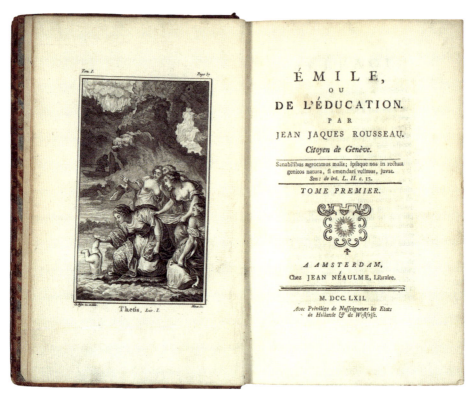

Jean-Jacques Rousseau, *Emile, ou De l'éducation (Emile, or On Education)*, Parts 1–2, Amsterdam, 1762

ment were the tutors of princes; they instructed them to "establish public schools",[5] and to ensure that young men were trained to be "industrious, patient, hard-working, clean, sober, and cautious".[6] The plans of reform had multiplied by the middle decades of the eighteenth century, and the objective of psychological modernization was part of the new rhetoric of economic improvement. It was necessary to make "great Alterations amongst the people for their greater Benefit",[7] in the words of the *Nakaz* or *Instruction* (1769) of the Empress Catherine, and to "exterminate Laziness in the Inhabitants".[8] The "business of a statesman", for the economist Sir James Steuart, was "to model the minds of his subjects".[9]

 These were projects of a Europe-wide revolution from above, imposed by sovereigns and the philosophers who advised them. Just one generation later, they were seen as the portents of catastrophe. This was the charge of the Enlightenment's enemies, voiced most assertively in the decade after the French Revolution and evident in the educational reforms that followed. The deep-

est and most secret origins of the revolution, for Félicité de Lamennais, were to be found in the influence of the philosophical and educational doctrines of the 1760s.[10]

In this retrospect, the Enlightenment had, in its neglect of religious education, overturned the basis of social order. The natural relations between the child, the father and the mother had been inverted and authority had passed into the hands of children. Kant himself became the unlikely anti-hero of the lamentations of the post-revolutionary period. He had built his system of pure reason on the destruction of established "schools, academies and philosophical instruction", according to the conservative thinker Bonald.[11] The "disciples of the God-Kant" were for Barruel, a Jesuit, "another sort of Jacobins", who beguiled schoolchildren with the prospect of eternal equality.[12] Over the entire course of universal history, had there ever been "an example of such blindness", asked Joseph de Maistre, a staunch defender of the Ancien Régime, in 1810, criticising a proposed institute of pedagogy in Russia, "in which metaphysics will be taught according to the method of Kant".[13]

The educational projects of the Enlightenment had been associated with the suppression of guilds, in particular that of the apprenticeship corporations in France through reforms introduced by the Controller-General of Finances, A. R. J. Turgot. These had been followed eagerly by Johann Wolfgang Goethe in Frankfurt and Adam Smith in Edinburgh. "Whether or not it contributes to the comfort and happiness of the working man, to read and write, is a question not necessary to decide, and probably not very easy", Adam Smith's editor William Playfair complained in 1805.[14]

Enlightenment as a Way of Thinking

The third sense of enlightenment, as a disposition or way of thinking, which was Kant's own sense, was founded on education in a more profound and disturbing respect. For if enlightenment is a way of thinking, then the individual, to be enlightened, must be able to think. But can one think without having been educated? Is understanding a condition of everyone, or only of those who have been educated? And can women be enlightened if they have been instructed to depend on others? Can children be enlightened? If to be enlightened is to not be immature, then children can never be enlightened. But what of the child who is no longer an infant, or *in-fans*; that is, incapable of speech under Roman law?

Enlightenment was a far-off prospect for Kant in *What is Enlightenment?* ("There is still a long way to go.")[15] But was it a prospect for everyone, without exception? Or only for the individuals who have learnt to think and

been instructed in understanding? To be resolute is a necessary condition for enlightenment (*Sapere Aude!*). But it is not a sufficient condition, and in order to be wise, does one not have to have been instructed in wisdom? These questions are disturbing because they lead back to the 'flat' sense of enlightenment, as little more than a synonym for pedagogy. Enlightenment was, in the end, a parade of schools and academies, lessons and exercises, failed experiments and new institutions, old and new methods of instruction. They are also disturbing, more profoundly, because they obscure the promise of universality, or Kant's own prospect, in the post-revolutionary *Contest of Faculties* (1798), that all of humanity has a moral character in common.[16] Is enlightenment to be only for "men like us! good, strong, happy men!"[17] as in Herder's sarcastic description of the European colonies?

John Stuart Mill rejected the possibility of equality in "any state of things anterior to the time when mankind have [sic] become capable of being improved by free and equal discussion".[18] This, too, was an assertion about childishness, and about colonies. The idea of the sovereignty of the individual, in particular, was to be limited to individuals "in the maturity of their faculties"; and "for the same reason we may leave out of consideration those backward states of society in which the race itself may be considered as in its nonage".[19]

The question of education is disconcerting for the understanding of enlightenment in its multiple senses. But it has been oddly absent in the historiography and the political philosophy of the Enlightenment, just as the history of education has been absent from general or ordinary history. It has been written, for the most part, as a history of progress, within and for the profession of pedagogy; a history written by men "not otherwise historians", in the description of the historian of the American Enlightenment Bernard Bailyn, or the "patristic literature of a powerful academic ecclesia".[20] This is a missed opportunity. "Looked at more generally", for the British historian of education Brian Simon, "the history of education is full of incident and interest, touching on all sides of life, on the outlook and interests of all classes of society."[21]

Immanuel Kant's Views on Pedagogy

Kant's own writings on pedagogy can even be a source of hope, in our times. Children are friendly and sociable in Kant's description, contained in the lecture notes on pedagogy, of which he authorized the publication in 1803; it would be wrong to impose a severe discipline upon them and to seek to break their will. The pedagogy of restraint was to be avoided – the protective bon-

Protective bonnet for small children (falling cap or "Butzmütze"), ca. 1770

nets or *Butzmützen* that constituted a sort of "negative instruction"[22] – and so were the tools or instruments of learning. The *Orbis pictus* (the illustrated children's book first associated with the Moravian educator Comenius) was a partial exception; the "mechanical-catechistic method" was useful, for the most part, in "what had to be learnt historically".[23] Education was not a matter for the state; that is, for sovereigns who were concerned with the welfare of their own state, with their subjects as the instruments of their own ends. Nor was it a matter for the established church. Education in morality had been neglected, in Kant's account, because for the most part, "moral training was left to priests".[24]

The sequence of pedagogy, in Kant's scheme, began with discipline, of a fairly benign sort; children were sent to school, in the first instance, in order to learn to sit still, and to pay attention to what they were being told to do. It then proceeded to culture, or instruction. The third stage consisted of education in discretion or *Klugheit*. Only in the fourth and final stage did education turn to morality, or *Moralisirung*. Even within moral education, instruction should start with the "law that is within the child"; "morality must come first, theology then follows, and that is called religion".[25] The law within was "called conscience" and religion without moral conscientiousness was mere superstition. The heaping of praise upon God, without thought, was no more than an "opiate for the conscience".[26] Education, or having learnt to think, is a necessary condition for being moral, in Kant's scheme, in the same sense that it is a condition for enlightenment. It is to be able to act in accordance with maxims – the categorical imperative is a maxim – and the possibility of living by maxims is itself the outcome of understanding. Children must be able to see for themselves the equity or *Richtigkeit* of the maxims. His pedagogy, in this sense, was universal, for all individuals, without exception.

Kant's prospect of an enlightened education – and his sense of the friendliness of childhood, so far from his renown as the legislator of pure reason – is close, here, to the more permissive and more liberal ideals of his almost-contemporaries across Europe. Adam Smith, like Kant, was "charmed with the gaiety of youth, and even with the playfulness of childhood".[27] His own account of education was a domestic idyll of equal and reciprocal respect: "Respect for you must always impose a very useful restraint upon [your children's] conduct; and respect for them may frequently impose no useless restraint upon your own."[28] Kant's insistence, in his pedagogy, on the law that is within the child was itself expressed in Smith's language, in an early German translation of the *Theory of Moral Sentiments*: the judgement that is inside us all, or the "*Richterstuhl in unserm Busen*".[29]

Copperplate engravings from Johann Bernhard Basedow's *Elementarwerke für die Jugend und ihre Freunde (Elementary Books for Young People and their Friends)*, 1774

The *Wealth of Nations* (1776) began with an evocation of natural equality; the difference between the philosopher and the common street porter "seems to arise not so much from nature, as from habit, custom and education. When they came into the world, and for the first six or eight years of their existence, they were, perhaps, very much alike."[30] Their very different destinies, as adults, were the consequence of the division of labour, more than its cause. The public, in Smith's account, "can facilitate, can encourage, and can even impose" a system of education on "almost the whole body of the people".[31] The object, for Smith as for Kant, was not the welfare of the state or the society. It was the expansion, rather, of the possibilities of children themselves. The lack of education was, for the children of the poor, "one of their greatest misfortunes", wrote Smith in his *Lectures on Jurisprudence* of 1763. A boy who starts work when he is very young finds that "when he is grown up he has no ideas with which he can amuse himself".[32]

For Turgot, as summarised in Condorcet's *Life of M. Turgot,* instruction in morality would be based on reason, and would begin "with the analysis and development of moral ideas". It would "be easily accessible to everyone".[33] With universal basic instruction, "justness of mind" would be sufficient to ensure that there would be little unfair advantage in the ordinary course of life.[34]

Education and Political Enlightenment

A particularly striking difference between Turgot's, Smith's and Kant's pedagogy, interestingly enough, was in relation to the genre of novels. For Kant, reading novels was particularly damaging to children, because they tended to lose themselves in thought, imagining new romances of their own.[35] For Turgot, by contrast, novels were "books of morality," for Smith, Richardson, Marivaux and Riccoboni they were much better instructors than Stoic philosophers;[36] and for Condorcet, to imagine one's own inner romances was the best way to understand how our actions influence "the people who surround us", which was in turn "the most important and the most neglected part of morality".[37] All the projects of the late Enlightenment were concerned, in the end, with education in enlightenment, in the specific sense of freedom to think for oneself and thus to be able to resist the prejudice that was itself the foundation of despotism and oppression. Smith, in 1776, wrote that people who were educated were less liable to "the delusions of enthusiasm and superstition".[38]

The idyll of political enlightenment was most moving in Condorcet's own project of public instruction of 1792. It was founded on Turgot's and Smith's ideas. Education should be common to girls and boys; if it were not, then it would lead to a marked inequality, "not only between husband and wife, but between brother and sister and even between son and mother".[39] It should be available for adults as well as for children.

Condorcet, like Kant, was opposed to public education in morality. In the revolutionary period, he was opposed to education in political virtue. Little children should not be made "to admire a constitution, and to recite by heart the political rights of man"; there should be "no sort of catechism". The new French constitution was itself something which should be taught in public schools only as a matter of information, or "if one speaks about it as of a fact".[40] Independence of opinions, and the disposition to see through popular delusions, were for Condorcet the only reliable protection against the subversion of political freedom. By what means, Condorcet asked the "friends of equality and liberty" could "your laws, which respect the rights of men, prevent the progress of such a conspiracy?"[41] He found his own answer in the permissive, discursive public instruction that makes it possible for all individuals,

Johann Wolfgang von Goethe, *Germination of the Nasturtium*, from: *Metamorphosis of Plants*, 1798

without exception, to see through the delusions of political oppression; by spreading enlightenment, or *"en répandant les lumières"*.[42] This was in 1792, as the French revolution descended into terror and into European war.

But it is also our question, in Kant's tricentenary year. Condorcet's confidence in an unbounded future – which was also Kant's and Smith's – was founded on an idyll of universal instruction, and on the belief in a universal disposition to discussion and sociability. This is not only a beautiful dream; it is also, or should be, a programme of change.

1 See Kant 1912 (AA8).
2 Herder 1889–1894, vol. 9, 355.
3 Ferguson 1792, vol. 1, 281.
4 Fénelon 2009, 166.
5 Ibid., 348.
6 Ibid., 524.
7 Reddaway 1931, 222.
8 Ibid., 263.
9 Steuart 1966, vol. 1, 3.
10 See Lamennais 1819, 42.
11 Bonald 1838, vol. 1, 42.
12 Barruel 1803, vol. 5, 245 and 250.
13 De Maistre 1861, vol. 2, 311.
14 Playfair 1805, vol. 3, 243 and 251.
15 Kant 1912 (AA 8), 40.
16 See Kant 1917 (AA 7).
17 Herder 1889–1894, vol. 5, 545.
18 Mill 2001, 14.
19 Ibid.
20 Bailyn 1960, 8.
21 Simon 1960, 13.
22 Kant 1923 (AA 9), 450.
23 Ibid., 461–462.
24 Ibid., 477.
25 Ibid., 494–495.
26 Ibid.
27 Smith 1976a, 222.
28 Ibid., 246.
29 Smith 1791, 213.
30 Smith 1976b, 29.
31 Ibid., 785.
32 Smith 1978, 540.
33 Condorcet 1847–1849, vol. 5, 205–207.
34 Mill 1981, vol. 1, 115.
35 See Kant 1923 (AA 9), 473.
36 Smith 1791, 64.
37 Condorcet 1847–1849, vol. 5, 175.
38 Smith 1976b, 787–788.
39 Condorcet 1847–1849, vol. 7, 218–219.
40 Ibid., 211.
41 Ibid., 226–227.
42 Ibid., 228.

Christian Leberecht Vogel, *The Sons of the Master*, 1792/93 / Gemäldegalerie Alte Meister, Staatliche Kunstsammlungen Dresden

Two young boys sit on the stone floor of a terrace with an open picture book in their lap. Gripping a self-made fishing rod in his hand, one of the boys looks attentively at the colourful pictures of animals, while the other boy appears to be briefly distracted by something beyond the picture's edge. This portrait of children by the Dresden artist Christian Leberecht Vogel focuses on a key educational medium of the Enlightenment. At the time, philanthropic scholars were publishing elaborately illustrated non-fiction books aimed at young children in order to teach them about worldly topics such as natural history and ethics in an entertaining way. Learning by observing was a guiding principle of children's education: the forming of concepts, structured thinking and insight should begin with sensual perception.

SARO GORGIS

Dress with leading strings for small children, Silesia, ca. 1780 / Staatliche Museen zu Berlin, Museum Europäischer Kulturen

There is nothing "more ridiculous than the gait of people who as small children were kept too long in leading strings," objected Jean-Jacques Rousseau in his educational treatise *Emile, or On Education*. In the 18th century, small children of bourgeois and aristocratic families were kept on leading strings so that they would quickly learn to walk upright and also to control their radius of movement. Kant carried over the new pedagogical criticism of physical paternalism to that of intellectual paternalism. In his essay "What is Enlightenment?" the leading string became a metaphor for a lack of independent thinking that stands in the way of "man's emergence from his self-imposed immaturity." SARO GORGIS

Chest of drawers with geographic puzzle pieces from *New Atlas for the Youth with 21 cards and a short instruction on how to use it ...*, 1782 / Pfinzgau Museum, Karlsruhe-Durlach

In the second half of the 18th century, pedagogical works and devices flooded the market. Pietists and philanthropists advocated for close-to-life education and extended the catechistic canon to include new topics such as natural science and geography. The didactic materials followed the encyclopaedic principle of describing the world as a cosmos and making it comprehensible through an ordering structure. The *New Atlas for the Youth* by the theologian Jakob Friedrich Klemm intended for children "to not only make the knowledge of our earth pleasant, but also to facilitate it." The miniature cardboard secretaire contains 21 maps for children in the form of puzzles: in keeping with didactic reduction, the child "first sees the parts before the overview of the whole becomes apparent." SARO GORGIS

Vaccination case with glass tubes to store vaccination threads, Berlin, 1802 / Germanisches Nationalmuseum, Nuremberg

For people in the 18th century, smallpox was ubiquitous. According to contemporary calculations, more than 400,000 people died annually of the endemic disease. What the cause of the infection was and how it could best be combatted were the subjects of medical and theological debates among doctors, teachers, philosophers and priests in the Age of Enlightenment. Campaigns to educate the general population aimed to inform them about new methods of inoculation. To this end, vaccination threads were soaked in a pustule of the milder cowpox and administered to people through a small cut in the flesh. This artificial pox vaccination protected a person from the life-threatening smallpox. It was the first step towards an active prevention of the epidemic disease. In 1807 the Kingdom of Bavaria issued a vaccination decree. The German Reichstag passed a law requiring compulsory vaccination against smallpox in 1874.
SARO GORGIS

Paul Guyer

Kant's Enlightened Individualism

The Theory of Enlightened Individualism

"Act only in accordance with that maxim through which you can at the same time will that it become a universal law."[1] In other words, act only on principles that could be principles for everyone. This is the first and most famous of several formulations of the "categorical imperative", the fundamental principle of morality in the form in which it presents itself to us human beings, in Immanuel Kant's *Groundwork for the Metaphysics of Morals* (1785) – one of the most widely read works in the entire history of moral philosophy from ancient Greece to the present. Yet in an essay written in September 1784, thus just a few months before the *Groundwork* appeared and perhaps while he was still working on it, Kant's answer to the question "What is enlightenment?" had been "*Sapere aude!* Have courage to make use of your *own* understanding! is thus the motto of enlightenment."[2] Think for yourself – but act only in accordance with maxims that could be universal laws. Are these two thoughts consistent?

They are, but it takes a few steps to see how. In both the *Groundwork* and the *Critique of Practical Reason* of 1788, Kant reaches this formulation of the categorical imperative by an argument from elimination: a genuine moral law has to be necessarily true, thus known *a priori*, (that is, independently from the particulars of anyone's situation and experience, thus independent from any one person's desires, wishes, hopes and fears) and the only kind of principle that can satisfy this demand is a purely "formal" rather than "material" principle (that is, one that does not depend on any particular person's desires, summed up as their conception of happiness, but is rather true by virtue of its form alone). Thus, a morally permissible maxim must have the form of a law, or be universalizable; that is, universally adoptable. As Kant puts it, "Since I have deprived the will of every impulse that could arise for it from obeying some law," (in other words, any particular desire that might be served

by conforming one's behaviour to the law) "nothing is left but the conformity of actions as such with universal law, which alone is to serve the will as its principle."[3] However, Kant does not think that arguments by elimination can be the last word in philosophy. In the *Critique of Pure Reason*, first published in 1781, which formed the foundation of everything that followed, Kant had written that in rigorous philosophy "its proofs must never be *apagogic*, but always *ostensive*" – outmoded terminology, to be sure, but Kant explained what he meant: "The direct or ostensive proof is . . . that which is combined with the conviction of truth and simultaneously with insight into its sources," while "apagogic proof, on the contrary, can produce certainty, to be sure, but never comprehensibility of the truth" through connection with its "grounds."[4] Accordingly, in the *Groundwork*, where the first proof and formulation of the categorical imperative has been "apagogic" or indirect, Kant follows up with a further step into "metaphysics of morals" that is intended precisely to furnish "the ground of a possible categorical imperative", namely the presentation of "something the *existence of which in itself* has an absolute worth, something which as *an end in itself* could be a ground of determinate laws"[5] – and this is nothing other than our own humanity. Thus the underlying ground of the moral law is captured by this reformulation of the categorical imperative: "So act that you use humanity, whether in your own person or that of any other, always at the same time as an end, never merely as a means."[6] This is because, Kant contends, our "nature already marks [us] out as an end in itself".[7] Acting in accordance with universalizable maxims, it will turn out, is simply the method for making sure that we are treating humanity, whether in our own person or that of any other, as an end and never merely as a means.

Humanity (in Kant's German typically *Menschheit*) can mean a number of different things. We can glean something of what Kant means by one of his illustrations of the application of this second formulation of the categorical imperative: We should not make promises that we do not intend to keep in order to get something that we want from another person because "he whom I want to use for my purposes," (in other words, treat merely as a means to my own ends) "cannot possibly agree to my way of behaving toward him, and so himself contain the end of this action."[8] If we do use other people as means to our own ends, they must be able to agree to our action, they must be able to make it one of their own ends, they must be able to choose the action just as freely as we do.

Kant makes this explicit in a later book, the *Metaphysics of Morals* of 1797, for which the *Groundwork for the Metaphysics of Morals* was indeed intended as the groundwork, when he characterizes humanity, in distinction

Friedrich Wilhelm Springer, Miniature portrait of Immanuel Kant, Königsberg, 1795

from "animality".[9] Humanity is not just anything or everything about us; it is our capacity to set our own ends, to choose our own goals in life freely. Thus, to make humanity always our end and never merely a means is to make the preservation and promotion of freedom of choice, including the choice of how to live, our overriding end. However, to make this our overriding end with regard to *everyone* means that everyone has to make their own use of freedom consistent with the freedom of everyone else. As Kant put it in his *Lectures on Ethics*, "The conditions under which alone the greatest use of freedom is possible, and under which it can be self-consistent, are the essential ends of mankind. With these, freedom must agree."[10]

This might be called Kant's "universalistic individualism": everyone gets to set their own goals and to choose their own ends in life, but only consistently with the freedom of everyone else to do the same. This is the general principle to which every person's use of their own reason, as Kant demands in "What is Enlightenment?", should lead them – but on the basis of that principle, or within the general constraint that we impose upon ourselves by our own reason, everyone gets to decide for themselves how best to live their own life. That is the meaning of enlightenment according to Kant.

The Practice of Enlightened Individualism

What does this mean in practice? Kant answers this question in his last major work, the *Metaphysics of Morals* already mentioned. This book is divided into two parts, the *Metaphysical Foundations of Right* [*Recht*], or the Doctrine of Right, and the *Metaphysical Foundations of Virtue* [*Tugend*], the Doctrine of Virtue. For Kant, as for all others of his time, right is the coercively enforceable part of morality, that which morally can and must be enforced by the public means of a juridical and penal system. He calls the part of morality that should *not* be coercively enforced "ethics"; ethical duties can be enforced only by each person's own respect for morality itself, or her virtue – thus, the Doctrine of Virtue. But both parts of morality are grounded on the fundamental principle that humanity, the freedom of each person to set his or her own ends, must always be regarded as an end and never merely as a means.

Both parts proceed by applying the fundamental principle of morality to certain basic facts about the human condition: The Doctrine of Right derives our juridical and political duties from the fundamental principle combined with the facts that we human beings inhabit the finite surface of a globe on which we cannot avoid contact with each other and that we need its materials and products to survive. The Doctrine of Virtue applies the fundamental principle in the light of the fact that we need to develop our bodily and mental ca-

pacities over our lifetimes and need the assistance of each other to reach our goals, beginning with nurture and education, but continuing through life in all sorts of ways. We can set and pursue our individual ends only within a cooperative social framework consisting of family, schools, agriculture, manufacturing, commerce, and much more.

Kant begins the Doctrine of Right with a "Universal Principle of Right" that is similar to the formula that requires us to act only on maxims that could also be universal laws: "Any action is right if it can coexist with everyone's freedom in accordance with a universal law, or if on its maxim the freedom of choice of each can coexist with everyone's freedom in accordance with a universal law."[11] This is the legal principle of Kant's individualism: Everyone must be free to choose how they please, as long as their choices leave everyone else an equal freedom of choice. Or, each person must be allowed the *greatest* possible freedom of choice compatible with *equally great freedom* for everyone else: "*Freedom* (independence from being constrained by another's choice), insofar as it can coexist with the freedom of every other in accordance with a universal law, is the only original right belonging to every human being [*Mensch*] by virtue of his humanity [*Menschheit*]."[12] Rights are the correlative of obligations: since each of us has the obligation to treat the humanity of others; that is, their freedom to set their own ends, as an end in itself, thus each has the right to have one's own freedom so treated. That is the sole "original" or as Kant also says "innate"[13] right of every human being. Kant analyses this right into three components: the right of each human being to be one's own master, thus not to be a slave or subordinate; the right of each to be beyond reproach unless one has in some way broken the law, thus not to be inherently disadvantaged by law; and the "right to do to others anything that does not diminish what is theirs";[14] that is, interfere with *their* rights or *their* freedom. One example of this is freedom of speech, the right to say anything to others, true or false, *as long as it remains* "entirely up to them whether they want to believe him or not".[15] Freedom of speech, yes; manipulation or fraud, no.

The innate right to freedom also includes the right to acquire further rights that need the possible or actual agreement of others. These include the right to acquire property for one's own use, but only subject to the possibility of an "omnilateral will"[16] (that is, as part of a system of property rights to which all could freely agree), the right to enter into contracts with others, as long as they agree, and the right to enter into certain kinds of relationship such as marriage and employment, but only as long as the relationship is voluntary and preserves various rights of each party. Kant's views about gender differences, for example, were not always progressive, even for his time, but his

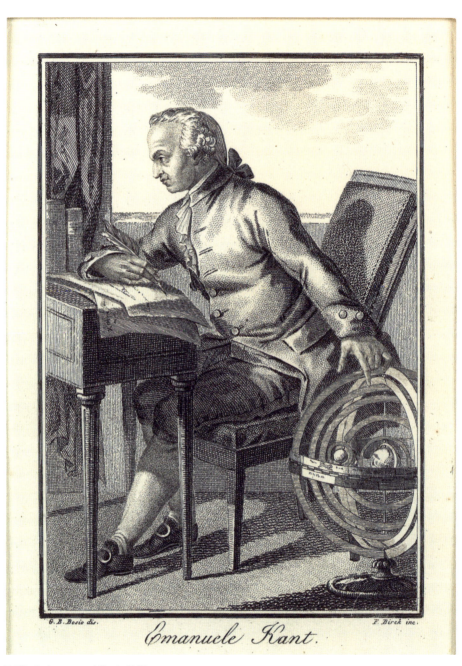

F. Birck, *Immanuel Kant*, 1815

conception of marriage, as a relation that preserves freedom because sexual activity must be consensual on both sides, certainly was. Kant then describes the system of obligations and rights within the public framework of a state that is necessary to make innate and acquired rights determinate and secure. On Kant's conception of the state, the legitimacy of its authority – its ultimate sovereignty – must come from the people as such, although exercised through a legislature, with an executive to enforce the laws so legislated, but an executive who is supposed to function only as an "agent" of the legislature.[17] The executive has to have the possibility of using coercion – the threat of punishment, and actual punishment when the threat is not heeded – to enforce the law, because, alas, although they should, not everyone will always do what is right out of respect for morality itself. Kant abhorred the possibility of anarchy, an abhorrence well-grounded in the recent past and present, in the religious conflicts of the Thirty Years' War, the English Civil War, the French wars between Catholics and Protestant Huguenots (many of whom fled to Prussia), and in the contemporaneous descent of the French Revolution into the "Terror", so he insisted that the executive must have a monopoly on the use of coercion. Nevertheless, the executive must only execute the laws passed by the legislature as, in turn, an expression of the sovereignty of the people: This is the framework within which the maximal equal freedom of all can be *preserved*.

The freedom of each human being to set and pursue his or her own ends is further *promoted* by the more open-ended duties of virtue. These fall under two rubrics: self-perfection, and the promotion of the happiness of others. Human beings are not born with all their potential capacities fully developed; they must work to develop the physical and mental capacities that will allow them the fullest possible range of ends. The same applies to their moral capacities, which will allow them to set their own ends – subject to the overriding condition of consistency with the freedom of others. The idea is that the more means we have, the more developed are our abilities and the wider is the range of ends that we can set for ourselves – in other words, the greater is our freedom. However, we also need the help of others to do this – not only as infants and children, but throughout our lives. The need for assistance from others is built into the goal of self-perfection. But morally, we can only seek assistance from others if we are willing to extend it when others need our assistance and we can provide it – this is Kant's universalism at work. Both the duty of self-perfection and the duty to promote the happiness of others are, in fact, duties to expand the freedom of each of us to set our own ends, not just to preserve that freedom, as the duties of right do. But, Kant emphasizes, particularly

when one person tries to assist others in the realisation of their ends, it must always be the happiness of the others in terms of *their own conception of it* that is being assisted: "It is for them to decide what they count as belonging to their happiness."[18]

In conclusion, let us note that one of Kant's greatest examples of the necessity of individual freedom, from the essay on enlightenment to the final *Metaphysics of Morals*, was *freedom of religion*. This follows directly from "the spirit of a rational valuing of one's own worth and of the calling of the individual to think for himself".[19] The only restriction that Kant is willing to countenance upon this freedom is that in their "private use"[20] of reason (that is, in their conduct of some official position), people must act in accordance with the rules for that position; for example, clergy working within a particular church must follow the rules of that church. But no one can be denied freedom in their "public use"[21] of reason; that is, their freedom of speech and other forms of publication to address the public in their own voice, expressing their own views, as long as others remain free to decide whether to accept their views or not. For Kant, this is the most important exercise of our right to individual freedom within the framework of universal law.

1 Kant 1911 (AA 4), trans. by Gregor 1996 and Heath in Heath/Schneewind 1997.
2 Kant 1912 (AA 8), 35.
3 Kant 1911 (AA 4), 402.
4 Guyer/Wood 1998, A 789/B 817. [author's emphasis]
5 Kant 1911 (AA 4), 428. [author's emphasis]
6 Ibid., 429.
7 Ibid., 427–429.
8 Ibid., 430.
9 Kant 1907 (AA 6), 392.
10 Kant 1974 (AA 27.1), 346.
11 Kant 1907 (AA 6), 230.
12 Ibid., 237. [author's emphasis]
13 Ibid.
14 Ibid., 238.
15 Ibid.
16 See ibid., 263.
17 Ibid., 316.
18 Ibid., 388.
19 Kant 1912 (AA 8), 36.
20 Ibid.
21 Ibid.

Franz Xaver Messerschmidt, Character head *A Grim Finster Man*, 1770/1783 / Belvedere, Vienna

The bust is part of a series originally consisting of 69 sculptures that all show facial expressions. The *traiteur* (restaurateur) Franz Strunz acquired 49 heads from the estate of the sculptor and gave them names, which were then presented to the public in Vienna in 1793 as "caricature heads". *A Grim Finster Man* (also known as the *Grumpy Man*) is among the characters that portray physical or psychological reactions. An expression of denial shows both mouth and eyes scrunched up, the resulting wrinkles echoing each other. With the heads, Messerschmidt wanted to depict the most profound truth of a person, their character and passions. After visiting the sculptor, the Enlightenment philosopher Friedrich Nicolai from Berlin described the reasons Messerschmidt spent so many years with his "character heads", saying that spirits beleaguered him because he had penetrated too deeply into the secrets of the proportions.
BRIGITTE VOGEL-JANOTTA

Johann Wolfgang von Goethe, *Wilhelm Meister's Apprenticeship*, Leipzig / Frankfurt a. M., 1800–1801 / Deutsches Historisches Museum, Berlin

The novel tells the story of Wilhelm Meister, a young man who is searching for his individual destiny. On this journey of self-realisation he passes through various social and emotional stages that help him to reach maturity. The numerous characters that Wilhelm encounters, especially the mysterious Tower Society, have different values and outlooks on life that serve to form Wilhelm's own identity. The novel is the very definition of a *Bildungsroman* and also relates Wilhelm's relationships with various women, giving it a second, interpersonal level. The novel's complex structure underpins the multifaceted nature of its message. From the search for the meaning of life and the diversity of human experience to a reflection on art and creativity, it mirrors the aspiration for personal growth and the individual's quest for self-discovery. MATTHIAS MILLER

THE EQUALITY OF
ALL HUMANKIND

Anne Norton

The Affirmation of Equality

Revolution
The affirmation of human equality is one of the glories of the Enlightenment. Yet there was no novelty in the idea that all men are created equal. Centuries earlier, those who had fought under Thomas Müntzer's rainbow flag, or those who had argued, with Thomas Rainsborough, that "the poorest he that is in England has a life to live as the greatest he" had already affirmed, with many forgotten peasant rebels, that all are created equal.[1] No one can date the first claim to superiority, or the first refusal of that claim. In large rebellions and small, people have affirmed their equality. Yet it was during the Enlightenment that this idea began to burn away hierarchies of wealth and standing in Europe. The revolutions that followed continue to fire our thought, our practices, and our hopes.

Rebellion and revolution had often carried with them a passion for equality, but it was in the Enlightenment that equality was, for better and for worse, given legal and institutional form, when it won a place in law. The constitutions that followed offered form, limits, and license to equality. In the shadow of the guillotine, proven by the deaths of kings, equality moved from an idea to a conviction. Where monarchs remained as constitutional ornaments, the claims of royalty to reverence faded, until they were no more than symbols, unable to command. So compelling did the idea of equality become that a prince would change his dukedom for a surname and become Philippe Egalité. Enlightenment made the idea of equality not only enviable, but ordinary. Equality gave courage to common people. They were made strong enough to question, given dignity enough to reach for power. That is glorious.

Reaction
Enlightenment philosophers and poets had resoundingly rejected hierarchies of birth. Rebellious people and established states affirmed that all men are created equal. And yet, as the Enlightenment took hold, equality became ever more distant, ceasing to be an objective even for the most enlightened of

Enlightenment Europe. Philosophers and statesmen increasingly sought not to free people, but to manage them. The people, once seen as a source of redemption and transcendence, now appeared as danger incarnate. The laws, constitutions, and political institutions that offered to secure equality were mobilized to fight it.

Those who affirmed political equality, too, often feared the passions, appetites, and above all, the memory of the people. People were now thought to be equal in some ineffable fashion, and all the more dangerous for it. People were no longer individuals embedded in time-honoured orders of deference and obligation. They were The People. The old rulers and the new feared the sleeping power of this mass of equals. They had brought down kings. The enlightened began to seek not equality, but means of restraining it. The declarations and constitutions that so resoundingly proclaimed the rights of man were disciplined and displaced by restraints on the people, now only nominally equal. The fearful discovered that laws meant to secure rights could also strip them away.

Long before the Enlightenment, the wealthy and powerful had seen and feared the poor. The poor were many and their desires were just. They might therefore seek to eat the rich, or at least institute progressive taxation. This fear was partially allayed by making a distinction between political and economic equality. That dishonest distinction troubles us to this day.

Enlightenment spread quickly through populations that had nothing to lose but their chains. Yet these classes, too, were suborned: by the comforts of the family for some, and the allure of patriarchal power for their masters. The home remained the first site of natural hierarchies and distinctions. Rousseau had argued that women had traded freedom and independence for protection and provision. Deference to the family contributed to the maintenance of monarchs. Even philosophic individualism might be enlisted in the defence of hierarchical institutions.

Reason and Religion

The Enlightenment brought an end to the absolute ascendancy of the religious in matters of ethics. Religions that had anointed kings and sanctified the hierarchies that held "the rich man in his castle, the poor man at his gate" had already found themselves vulnerable to accusations of corruption.[2] The reformers were often no more committed to equality than the church officials they confronted. Luther's ninety-five theses called the church to account, yet Luther ranged himself with the princes. He was called to account for himself by Thomas Müntzer and an army of peasants. Defeat, torture and death silenced

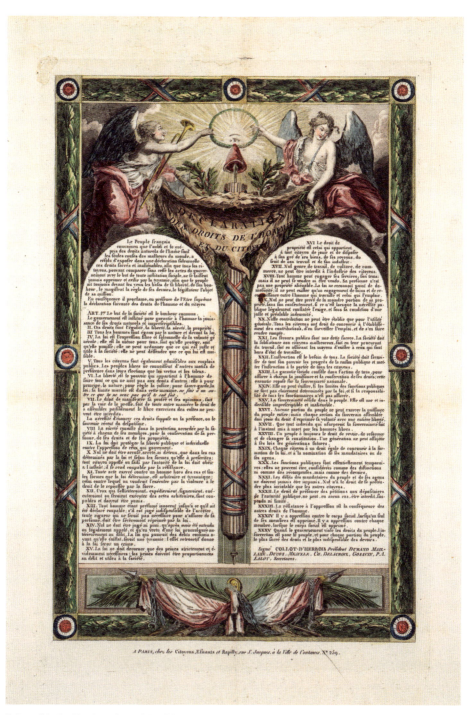

Print with the Declaration of the Rights of Man and of the Citizen of 1793, France, 1793

these rebellious monks and peasants, but did not end critique. People convinced of their equality seized the scriptures for their own. In the place of priests, the Enlightenment offered reason, available to all.

The contest, still unresolved, issued in a settlement structured along the lines of order preferred by the major combatants. Priests and ministers would cease to burn books and bodies, conduct their philosophic inquiries with discretion, and tolerate increasing degrees of toleration. The secular learned would withdraw from debates over religion and inquiries into the divine. This Enlightenment settlement did much to advance equality, for it kept more of the movement's defenders alive.

Science

The revolutions and constitutions that the Enlightenment drove remade the world, yet they were not equal to the task of overcoming the changing power of hierarchy. Philosophic, literary, and political commitments to human equality bowed before an all-too-scientific racism. An unenlightened Europe had enshrined the principle that right was held in the blood. In feudal orders, power, authority, and status passed on through the blood: in descent, in marriage, in conquest.

Science transformed the power of blood lineage into the systematic hierarchies of race. Through race, be it scientific or popular, human beings were ranked in an inalterable hierarchy. Enlightenment science proved a maker of stronger and more readily identifiable distinctions. Signs of subordination could be read in the texture of hair, the shape of a nose, the swell of a breast, a bent back, a small hand.

Enlightenment science inspired projects of exploration and invention. That science also inspired projects of measurement and definition, of classification and calculation. These too were turned against equality. The statistics that enabled statesmen and policy makers to grasp the worlds that they sought to shape and rule also stripped people, landscapes, and ways of life of their beauty and particularity. In their abstract form, people and places were less themselves, less valued, and more easily governed.

This is the dark world of the Enlightenment: the world of the factory and the prison. Both institutions sought the advancement of human welfare. Both presented themselves as scientific advances that would secure the greater good. Both had unintended consequences: The factory promised prosperity and produced poverty; the prison promised safety and produced suffering. The Enlightenment made possible not only greater freedom, but more thorough confinement.

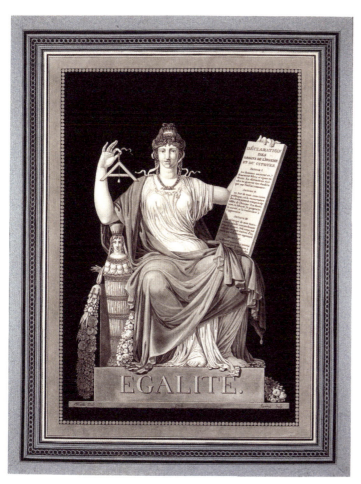

Jean-François Janinet after Jean-Guillaume Moitte, Allegorical print *Egalité*, 1793

The contrast of light and shadow that the Enlightenment cast on equality is yet more stark when seen on a global scale. The Enlightenment had inspired generations of explorers. Scientists and adventurers went off to the South Seas, to the peaks of Chile and Peru, to the Amazon and the Orinoco, the Galapagos, and the Valley of Mexico. They came back with wonders the people of Europe had never seen: flowers and seeds, parrots and monkeys – a chaos of natural beauty. They learned not only wonder, but fear. From his expeditions, Alexander von Humboldt conceived the fearful possibility of human-induced damage to climate.

These scientific expeditions brought the exotic to Europe, in the form of plants and foods that would later become commonplace. The fruits of these

explorations are among the glories of the Enlightenment. They delighted the eyes of all, they instructed all, they fed the hungry. They made a new kind of hero: no longer martial, but every bit as brave, a hero driven by wonder.

Colonization and Capital
These explorers were followed, however, by others. Empires are made when soldiers follow the paths made by merchants, and states seize the places that traders have opened to them. The age of Enlightenment was also the age of empires. The writings of philosophers, poets and revolutionaries fired the imagination of people across the world, even as more and more of them fell under imperial rule. The bodies of the colonized came under the rule of these enlightened conquerors, despots and bureaucrats, to be sure. They were always subjected, sometimes enslaved, sometimes traded and transported. Exploration and discovery were the glory of the Enlightenment. Colonization remains its enduring shame.

The principle that all human beings are to be treated as ends in themselves fell to the dreadful calculus of industrial labour. Capitalism as a systemic whole took human beings as part of the machinery of manufacture, as articles of trade, as security for loans. There was a rough equality here, as one worker, one consumer, one rational actor might be assumed to be of equal value with another. They might be distinguished, in terms of value, only if cast into another form. The idea that each person is equal to another fell before the categories, taxonomies, and racial classifications of science, and fell again to the quantifications and calculations of human value in monetary terms.

A few of the enlightened held fast to the idea of human equality. More found themselves seeking a justification for that trade in bodies upon which so much of Europe and the Americas depended. Perhaps the problem was not philosophy or politics or science, but capitalism. Perhaps political equality cannot be separated from economic equality. Perhaps we still have work to do.

Our Work
Equality, reason, science, and revolution gave rise, in their turn, to mass movements, to scientific racism, to statistics, and a continuing inquiry into the human condition. Amidst all the perversities of the Enlightenment, there is the always present desire to learn, to question, to critique. There is always daring enough to debate. Between wonder and horror, questions came in bursts: is equality sameness? Can there be equality in difference? These questions drove not only inquiry, but policy. We are still learning that equality requires us both

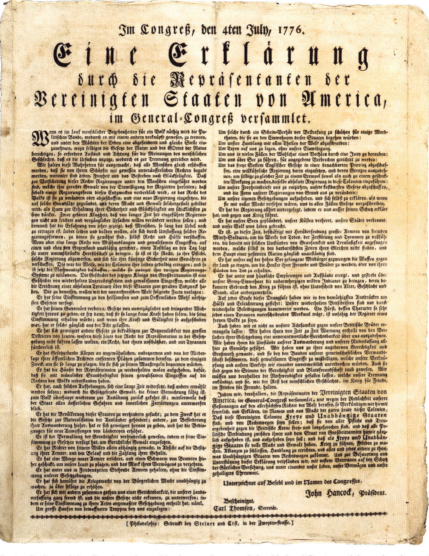

First printing of the Declaration of Independence of the United States of America from 4 July 1776, printed by Steiner & Cist in German, Philadelphia, 6–8 July 1776

to act and to hold back. We are still learning that equality is at once an achievement and a discipline.

Equality, like all the great achievements of the Enlightenment, has not been accomplished once and for all. Reason never ceases. Freedom is won not in one revolution, but in continuing work for revolutionary aspirations. Secur-

ing equality requires constant questioning, constant change. The idea of equality poses questions for us, not in one moment, but in every age. These questions drive reason and revolutions. It is in the question that overcoming begins.

1 Thomas Rainsborough, quoted in *The Putney Debates*, ed. Baker 2007, 69.

2 "All Things Bright and Beautiful" traditional Anglican hymn, authored by Cecil Frances Alexander, 1848.

Johann Gottfried Haid after Johann Nepomuk Steiner, *Angelo Soliman*, Vienna, ca. 1760/65 / Wien Museum, Vienna

The portrait shows Angelo Soliman (ca. 1721–1796), then valet of Prince Joseph Wenzel von Liechtenstein in Vienna, wearing an oriental-style livery. Enslaved as a child and brought to Europe, Soliman succeeded in building a notable career in aristocratic circles of the court and with the enlightened Habsburg elite. Dismissed by the prince upon his secret marriage, he was rehired two years later by the former's successor. As head of the servantry, companion, and instructor of the hereditary princes, Soliman held a prestigious position. He became deputy master of ceremonies in the Freemason lodge "Zur wahren Eintracht" (True Concord), which Mozart and Haydn frequented. All this did not protect him from the exoticism of European courtly culture. After his death his corpse – in a decision from on-high – was taxidermised and publicly displayed in the imperial natural history cabinet, set in the midst of an exotic swamp landscape. In the course of the Viennese Uprising of October 1848, his mortal remains were consumed by fire. SARO GORGIS

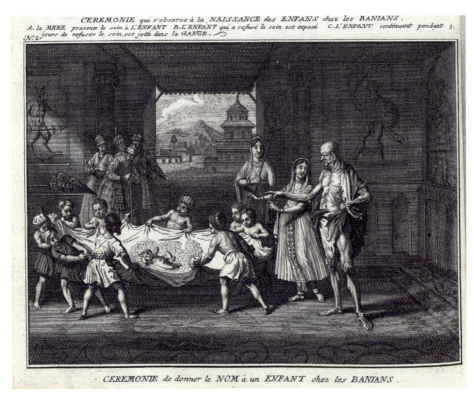

The Ceremony of Naming an Infant among the Banians, after Bernard Picart (1728), in: *Religious Ceremonies, or religious customs of the idolatrous peoples of the world* by David Herrliberger, Zurich, 1748 / Deutsches Historisches Museum, Berlin

The multi-volume work *Cérémonies et Coutumes Religieuses de tous les Peuples du Monde* (Amsterdam, 1723–1743) by Jean Frédéric Bernard, a Huguenot living in exile in the Netherlands, was the first to give insight into religious rituals worldwide – with an unprejudiced view uncommon for the 18th century. The folios became a bestseller, not least of all owing to the detailed copperplate engravings by Bernard Picart. His early anthropological illustrations contributed to a better understanding of non-European cultures. In the case of the South Asian *Banians*, the engraving portrays a name-giving ceremony whereby a newborn is placed on a sheet strewn with rice grains, which is repeatedly lifted into the air by young children. The *Cérémonies* were published in numerous translated editions, including one by the Swiss copperplate engraver David Herrliberger. HARRIET MERROW

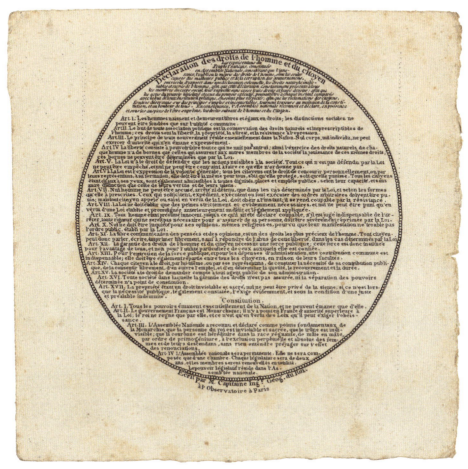

The human rights in pocket size from the possessions of the Mayor of Lyon, Louis Vitet, Paris, probably September 1791 / Archives Municipales, Lyon

The Declaration of Human and Civil Rights proclaimed by the French National Assembly on 26 August 1789 was based, like its American model, on natural law. When the National Assembly passed the first French Constitution on 3 September 1791, it placed the Declaration of Human Rights at its top. In the case of this pocket-size edition, the Preamble and all 17 Articles of the Declaration as well as the first five Articles of the Constitution are printed on hand-made paper. The size and form are not reminiscent of the tablets of the Ten Commandments, a popular depiction at that time, but rather of a Communion wafer. The print was made in the workshop of the royal cartographer, Louis Capitaine. It was probably printed in September 1791 to celebrate the adoption of the Constitution and the founding of the French state as a constitutional monarchy. It is not known how this precious item came into the possession of the Mayor of Lyon or whether other copies of it exist. DORLIS BLUME

Simon Troger, Figural group *Beggars*, Haidhausen near Munich, probably 1732/1760 / Deutsches Historisches Museum, Berlin

Small sculptural curiosity cabinet objects made of mounted ebony and ivory parts were a specialty of Simon Troger. Starting in 1732, the artistic carver worked primarily for the Bavarian Elector Maximilian III Joseph. The emaciated bodies, torn clothing and sometimes vulgar gestures of these bizarre beggar figures were based on detailed observations of reality. The pieces conjure up the challenges confronting enlightened absolutism in the face of the growing numbers of vagrants in German territories, especially in the cities. In the Electorate of Bavaria, which was hit particularly hard during the Austrian War of Succession (1740–1748), panhandling and "professional" begging were very strictly punished. A number of social disciplinary measures were instituted, including beggar passes and statutes, restricted areas, and committing those capable of working to workhouses and prisons. WOLFGANG CORTJAENS

Adam Sutcliffe

The Demand for Jewish Civil Rights

The extension of civic rights to religious minorities in late Enlightenment Europe only applied directly to a small minority of propertied males. The intellectual resonance of these measures, as an expression of fundamental Enlightenment values, was nonetheless immense. The reforms and eventual removal of discriminatory 'Jew Laws' drew particularly intense attention and controversy, because of the special resonance for Christians of the theological and historical significance of Jews. In the Germanic world, this process of normalising the political status of Jews was extremely tortuous and complicated.

From 'Court Jews' to the 'Civic Improvement' of Jews
The forcrunners of Jewish social and cultural integration in early modern Germanic Europe were the 'Court Jews'. During the Thirty Years' War (1618–48), Jews acquired an important role as victuallers, provisioners and financiers to all of the warring parties. In many German courts in the late seventeenth century, the leading Jewish provisioner acquired this semi-official status. These individuals and their families were accorded special – though revocable – privileges and at times they lobbied politically on behalf of local Jewish communities.

In commercial centres such as Amsterdam and London, a broader segment of prosperous Jewish financiers and merchants had, by the middle of the eighteenth century, assimilated into the upper echelons of Dutch and English society to a significant extent. Jewish integration remained, however, a potentially sensitive political issue. In 1753, there was a public furore over a British parliamentary measure designed to facilitate the naturalisation of a small number of wealthy, foreign-born Jews. This led to the almost immediate repeal of the so-called 'Jew Bill'.

In France, meanwhile, the most prominent Enlightenment advocate for toleration – Voltaire – was also intensely Judeophobic throughout his writing

career. Like many other eighteenth-century thinkers, Voltaire conflated the Jews of the Old Testament with those of his own day, citing biblical passages as evidence for their supposedly eternal 'barbarism'.[1] He thought of the Jews as standing outside history, stuck in a non-rational mindset of superstition and uncritical obedience to arbitrary laws.

In Prussia, Frederick II's annexation of Silesia in 1742 brought large numbers of Jews under his rule. Frederick was eager to productivise his new territories, in typical 'enlightened absolutist' fashion. This suddenly placed the Jews and their economic activities on the political agenda in the Prussian capital, in contrast with the outlook in Voltaire's Paris, or in Amsterdam and London, where there was no similar moment of expansion in Jewish numbers. It was in this environment, the Berlin of the late 1740s, that the young Gotthold Ephraim Lessing embarked on his writing career. Lessing's dramatic presentation of counter-stereotypical, virtuous Jews, first in his early play *Die Juden* (written 1749, published 1754 and first performed 1775) and then in his famous *Nathan der Weise* [Nathan the Wise] (1779, first performed 1783), has traditionally been seen as the product of his precocious personal humanity and liberalism, reflected in his close friendship with the leading Jewish intellectual in Berlin, Moses Mendelssohn.

Whereas in Paris, Amsterdam and London, those Jews who penetrated non-Jewish intellectual circles were highly assimilated, in Mendelssohn, Lessing encountered a Jew who was actively engaged in the intellectual uplift of his own cultural tradition.

The Prussian government repeatedly revised the legal apparatus regulating the lives of the Jews in its realm. The first Jewry law issued by Frederick II – the *Revidiertes Generalprivilegium und Reglement* of 1750 – was more detailed than previous ones, having been framed in response to increasing Jewish migration to Berlin from the east and the resulting economic tensions in the Prussian capital. It carefully classified the Jews of Prussia into six classes, only the first two of which were 'privileged' with limitedly inheritable residence rights. The remaining four groups were more precariously 'tolerated'. As was already customary, these rights were secured by a fee, paid regularly by the Jewish community of each Prussian province.[2]

The first self-consciously reformist Jewry policy in Europe did not emerge for another generation. It too was promulgated by a newly enthroned, 'enlightened absolutist' monarch: Joseph II of Austria, who had become sole ruler of the Habsburg lands after the death of his mother, Maria Theresa, in 1780. Since the first partition of Poland in 1772, these lands had included the southern Polish province of Galicia, which was populated, like Silesia, by

many poor Jews. Joseph's *Toleranzpatent* [Patent of Toleration] of October 1781 extended the right of discreet public worship to all non-Catholic Christians in the Habsburg realms. Later edicts soon extended this right to Jews and also permitted them to pursue any trade and to enter any educational institution under imperial authority. In exchange, however, they were expected to take steps towards social and economic integration by using German rather than Yiddish in their business records and reforming the education of their children.[3]

At around the same time, tensions between Jews and non-Jews in Alsace, on the opposite side of the Germanic world, led indirectly to a broad philosophical debate about Jewish rights. In the late 1770s, thousands of debtors in Alsace refused to continue their repayments to Jewish moneylenders, producing forged payment receipts in justification of this. In response to the increasingly anti-Jewish mood in the region, community leaders asked Moses Mendelssohn to intervene on their behalf. Mendelssohn, believing that in this case a prominent Christian advocate for the Jews was needed, passed on their request to Christian Wilhelm von Dohm, a Prussian diplomat and scholar. This led to the publication of Dohm's *Über die bürgerliche Verbesserung der Juden* [On the Civic Improvement of the Jews] (1781): the first extended Enlightenment argument in favour of Jewish civil rights. Dohm shared the consensus view among educated Germans that the Jews of his own day were, apart from a few honourable exceptions such as Mendelssohn, a physically, culturally and morally impoverished people.[4] He argued, however, that this was not their natural state: they had, rather, degenerated as a result of the discriminatory and hostile treatment they had suffered for centuries at the hands of Christians. Once embraced by the broader political society, the Jews would rapidly regenerate themselves. Before too long, their interests would align with those of the states in which they lived.[5] Legal equality, Dohm clearly argued, stood at the top of the list of measures necessary to transform the Jews into useful citizens.[6]

Controversies over Jewish Integration and Regeneration

Dohm's treatise stimulated much debate. Johann David Michaelis, a Hebraist professor at the University of Göttingen, believed the ancient Hebrew texts he studied reflected the true and unchanging essence of the Jewish character. Dohm's vision of Jewish integration into German society was unattainable, he argued, because the very purpose of the Mosaic law was to preserve the Jews as a separate people. They could never serve the state as military fighters, because their religion forbade them from eating with other soldiers and from

Johann Christian Reich, Medallion on the freedom of religion for Protestants and Jews, Fürth, 1782

fighting on the Sabbath, and because they were in any case too short.[7] The prospect of political transformation also posed challenges from a Jewish perspective. A particularly awkward issue for Mendelssohn was restriction of the rabbis' authority to expel individuals from the community (the *herem*). He now called this authority into question. His own collaborative project to translate the Torah into German had been met with rabbinical threats of his own expulsion.

Mendelssohn's most famous work, *Jerusalem* (1783), was written in response to pressure from a Christian deist admirer, August Cranz, to take his reformist arguments further. If the traditional power of rabbis could be reduced, Cranz had asked in an anonymous open letter to Mendelssohn, what reason was there not to reject their authority altogether; and would not such a further modernising step open the way to reforming Judaism so profoundly as to bring it to the brink of unification with deistic Christianity?[8] Rejecting Cranz's vision of a universally shared religion, Mendelssohn argued for religious pluralism. The universal truths of reason, he emphasised, were fully compatible with Judaism, and equally accessible to all. Judaism was simply a supplement to these truths, consisting not of beliefs, but legally prescribed actions for Jews alone. Enlightenment universalism, religious diversity and Jewish practice, according to Mendelssohn's argument, were fully compatible with each other.[9]

In France, the 1780s was a decade of intensifying discussion of the social and political status of Jews. The French Revolution of 1789 thrust this issue to the fore. Both François Hell, the leading agitator against the Jews of Alsace, and the abbé Henri Grégoire, the leading French advocate for Jewish 'regeneration', were members of the post-revolutionary National Assembly,

where they vigorously put forward their contrasting views. Jews accounted for approximately 0.2% of the French population at this time, but the Assembly discussed the status of the Jews at no fewer than twenty-five sessions during its first year. The issue of Jewish citizenship was clearly of great symbolic importance in determining the boundaries of citizenship itself. After much heated debate, in September 1791 all male Jews in France who met the standard property qualification were deemed eligible for 'active citizenship'.

Jewish civil equality was extended across much of western Europe by the invading armies of the Directory and Napoleonic periods. Napoleon's approach to the Jews became increasingly pragmatic over time, however, as his interest in their regeneration focused more narrowly on securing their political loyalty and promoting their economic productivisation. In 1806, as he passed through Alsace, continuing local tensions over Jewish moneylending were brought to Napoleon's attention. In response, he convoked an 'Assembly of Jewish Notables', charged with providing definitive answers on whether or not the Jews were willing and able to integrate into the French nation as patriotic and loyal citizens. The members of the Assembly did their best to supply the emperor with the reassurances he clearly wanted. This did not stop Napoleon from introducing, in 1808, a decree imposing many discriminatory regulations on Ashkenazi Jewish moneylending and on Jewish life in Alsace. The civil equality extended to French Jews after the Revolution, as this edict highlighted, was fragile.

The Unsteady Advance of Jewish Civil Rights in Germany

The Rhineland and other German territories annexed to Napoleonic France were among those areas where Jewish civil rights were exported from France. In German states established or reshaped by Napoleon, such as Westphalia and Baden, similar legislation was also passed. After Napoleon's military triumphs in 1806, the trend everywhere in Germany was toward reform. In some places, Jewish rights came with significant strings attached: in Bavaria, a new registration system aimed to restrict Jewish numbers, while in Frankfurt a large payment was demanded from the Jewish community.[10]

Developments in Berlin followed a distinctive path. The rise to great wealth of the city's Jewish leading financiers during the Seven Years' War (1756–63) enabled the emergence, by the 1780s, of a particularly fluid and religiously lax social environment among the elite. In 1799 David Friedländer, the most prominent figure in the Berlin Jewish community, wrote an open letter to leading Lutheran cleric in the city, Wilhelm Teller, in which he provocatively proposed that the Jews be offered a 'dry baptism'. They were to

Henriette Herz, Embroidered portrait of Napoleon Bonaparte, Berlin, 1807

abandon the rituals of Judaism and formally convert to Lutheranism. Friedländer's deistic proposal may not have been meant entirely seriously. It was firmly rejected, but nonetheless stimulated significant debate.[11]

The occupation of Berlin by French troops from 1806 to 1808 changed the mood in the city. The rise of German nationalism fuelled anti-Jewish sentiments. A reformist agenda nonetheless moved forward in Prussia in the years immediately following the Napoleonic occupation. Karl August von Hardenberg, state chancellor from 1810, was the main architect of the sweeping edict of March 1812 that finally reformed the legal status of Jews. This law conferred civil equality (with some provisional restrictions on holding government office) on the established male Jewish residents of Prussia and their families, while also obliging them to adopt fixed surnames and to use German in their commercial and official transactions.[12]

After the fall of Napoleon, the diplomats assembled at the Congress of Vienna in 1815 decided, after much discussion, not to protect these reforms, and in much of Europe the civic rights of Jews were rolled back. In the 1830s, the battle to restore these rights became widely known by the phrase still used by historians today: 'Jewish emancipation'. This term was adopted from the campaign in Britain at the time for 'Catholic emancipation'. Those campaigners for Catholic political rights had in turn borrowed the term from the abolitionist struggle, which was extremely active at the time, in order to imbue their cause with the same righteousness as the literal emancipation of slaves.

It was finally agreed, in the constitution of the German Federation adopted in June 1815, that only the rights of Jews granted by the German states – and not those bestowed by Napoleonic administrations – would be safeguarded. There were further setbacks in the following decade. In 1819, a wave of anti-Jewish violence, known as the Hep-Hep riots, spread from Bavaria to many other parts of Germany. Across Europe, from Paris to Saint Petersburg, the dominant political mood of 'throne and altar' conservatism was not hospitable to cultural pluralism or to the protection of minority rights. Despite this, the new thinking on these issues from the late phase of the Enlightenment could not be undone. Debates over the civil rights of Jews – and of other religious minorities – continued to rage over the next few decades: a period that was marked by further advances followed by disappointments, above all in 1848. The ideal of civil equality for Jews was not realized across most of Europe until the second half of the nineteenth century. It then faced new challenges almost immediately, as a newly defined antisemitism gathered strength in Germany, France and elsewhere during the century's final two decades.

1. See Sutcliffe 2003, 231–246; Voltaire 1878, 73.
2. See King Frederick II of Prussia, *Rividiertes Generalprivilegium und Reglement* [1750], in Freund 1912, Vol. 2, 22–55.
3. See Emperor Joseph II, *Toleranzedikt* [January 2, 1782], in Pribram 1918, Vol. 2, 494–500, trans. in Mendes-Flohr/Reinharz 1995, 36–40.
4. See Dohm 1781, 18–24, 105–109 and 143.
5. See ibid., 144.
6. See ibid., 110 and 144.
7. See Michaelis 1783, 41–51.
8. See Cranz 1782.
9. See Mendelssohn 1983, 99–204, trans. in Arkush 1994.
10. See Rürup 1986, 10–15; Jersch-Wenzel 1997, 7–49.
11. See Friedländer 1799, trans. in Crouter/Klassen 2004, 77.
12. The text of the *Edikt betreffend die bürgerlichen Verhältnisse der Juden in dem Preußischen Staate* is reprinted in Freund 1912, 455–59. See also Rürup 1986, 14–15; Jersch-Wenzel 1997, 24–27.

Friedrich August Darbes (d'Arbes), *Portrait of Daniel Itzig*, Berlin, 1787 / Stiftung Stadtmuseum, Berlin

Daniel Itzig (1723–1799), Prussian court banker and one of the most important coin entrepreneurs in Frederick II's employ, supplied the Prussian army with cloth, trimmings and provisions as a so-called Court Jew. In 1791, due to a patent of naturalisation, he was the first Jew to receive the rights of Prussian subjects, alongside his 15 children and his sons-in-law, which declared the family equal citizens of the state. As such, the men were no longer required to wear a beard. Itzig's portrait reflects his effort to present himself without outward signs of his religious background, for example adjusting his clothing to the bourgeois society of 18th-century Prussia. Here, he is shown wearing a fashionable wig and a luminous blue *justaucorps*. For his portrait, Daniel Itzig commissioned an internationally recognised painter whose fame was based on pastel portraits known for their similarity and psychologization of the subjects depicted. Darbes was court artist of the Prussian royal house. URSULA COSMANN

Ephraimite from the Seven Years' War, probably Leipzig, 1754 (backdated) / Deutsches Historisches Museum, Berlin

The Prussian "General Jewish Privilege" of 1730 banned Jews from all guild-related professions. They therefore traded in precious metals and provided the mints with the metal needed for coins. After Frederick II reorganised the Prussian mintage system with the Graumann Reform of 1750, some of the state-owned mints were leased to Jewish "coin entrepreneurs". After occupying Saxony in the Seven Years' War (1756–1763), Frederick II also came to control the mints in Dresden and Leipzig. In Leipzig, the Jewish merchant Veitel Ephraim developed the "Ephraimites", backdated to before the war. The coins contained a smaller amount of silver and were coined under the stamp of Saxony. In this way, Frederick financed his war. The deteriorated value of the coins led to a veritable coin crisis – and to a dangerous situation for coin entrepreneurs like Veitel Ephraim. As a concession they were granted a General Privilege that placed them on an equal footing with Christian merchants.
LILI REYELS

THE LESSONS OF ANTIQUITY

Elisabeth Décultot

On Winckelmann's Concept of Freedom and Its Interpretations in the Era of Enlightenment

In his *History of the Art of Antiquity* from 1764, Johann Joachim Winckelmann uses the word "enlightenment" only once.[1] His historical work – which, according to the preface, aims to "inform us about the origin, growth, change, and fall of art, together with the various styles of peoples, periods, and artists"[2] – has nonetheless definitely also been read as a prominent work of political thought of the Enlightenment era. This is due to the key significance it assigns to the ideal of freedom. As early as 1765, Denis Diderot listed the arguments with which Winckelmann, this "charming enthusiast", declared the perfection of Greek art, naming first and foremost "the sentiment of liberty".[3] At the time of the French Revolution, Winckelmann's art historical study was widely acclaimed in France, especially since – as interpreted by important proponents of revolutionary art policy – it established a link between the Athenian democracy of the Periclean age and the unsurpassed pinnacle of Greek art at the time of Phidias, thereby offering historical evidence that political freedom and cultural blossoming are mutually conditional.[4] To what extent does such a reading do justice to Winckelmann's statements in his *History of the Art of Antiquity*? How do political freedom and the flourishing of culture in a country relate to each other in the body of thought on art and history? Does his history of ancient art also leave room for alternative readings? This essay aims to answer these questions and shed light on Winckelmann's position in a central discourse of the European Enlightenment.

Anton von Maron, *Portrait of Johann Joachim Winckelmann*, 1768

Freedom in Antiquity?

Winckelmann did not treat the subject of freedom all too extensively in the writings he published during the German phase of his life. During his time in the library of the Imperial Count of Bünau in Nöthnitz near Dresden between 1748 and 1754, he collected numerous materials on the political history of ancient and modern times, such as on the Periclean democracy in the fifth century BCE, on the Glorious Revolution in the late seventeenth century, and on the critique of absolutism in the eighteenth century, as is clearly evident from his excerpt notebooks.[5] However, his first work, the *Reflections on the Painting and Sculpture of the Greeks*, which appeared in Dresden shortly before he moved to Rome in late 1755, shows virtually no trace of this political material.[6] It was not until his major historical work, *History of the Art of Antiquity*, completed in Italy almost ten years later, that he assigned the concept of freedom a key role as a pillar of art history. Therein the category of freedom functions as the root cause and essential condition for artistic creativity: in the chapter on the "Art of the Greeks," he writes: "With regard to the constitution and government of Greece, freedom was the chief reason for their art's superiority."[7] The Greeks were inspired by an ardent love of freedom, according to Winckelmann, and this love explains the unsurpassed development of the arts among them. Nothing, he continues, reveals this basic principle more precisely than the heyday of the Athenian democracy in the fifth century BCE, during which "through freedom, the way of thinking of an entire people sprang up like a fine branch from a healthy trunk." Winckelmann asserts that his authority, Herodotus, has shown "that freedom alone was the reason for the power and majesty that Athens attained, since previously, when this city had to recognize a ruling lord, it could not keep pace with its neighbors."[8]

While the Athenian democracy is cited as positive proof of the advantages of freedom, Winckelmann also enumerates a series of negative examples that reinforce his argumentation *a contrario*. Thus for the Egyptians, Persians, and Phoenicians, the fine arts were not able to flourish "as is the case in free states, ancient as well as modern," because under despotic governments only the "absolute ruler" had statues "bestowed" on him for his "service to his native land".[9] Likewise, after the rule of Alexander the Great, "[a]rt, which received its life, as it were, from freedom," had to "necessarily decline and fall with the loss of freedom in the place where it had particularly flourished."[10] The Romans attempted to revive the arts, but even Emperor Hadrian was not able to prevent their collapse: "The spirit of freedom had retreated from the world" and with it the beauty of art.[11]

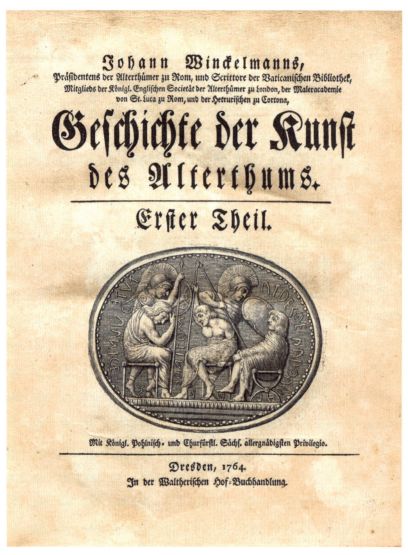

Johann Joachim Winckelmann, *Geschichte der Kunst des Alterthums (The History of Art of Antiquity)*, Dresden, 1764

With that Winckelmann became part of a key historiographic discourse of the eighteenth century, which developed notably in France between François Fénelon, Jean-François Melon, Voltaire, and Gabriel Bonnot de Mably, and which gave birth to the myth of a civic – or even bourgeois – Greece and above all Athens.[12] In this discussion, Winckelmann stood for the image of a free, patriotic Greece deeply informed by bourgeois virtues.

In contrast to Egypt, Phoenicia, and Persia, it knew how to liberate itself from both tyranny and religion and could therefore give rise to beautiful works of art.

Freedom in Nature and Culture

Winckelmann's concept of freedom, however, is connected with qualities that make it seem fundamentally ambivalent. In *History of the Art of Antiquity*, freedom is presented on the one hand as the product of a highly developed political form of government, namely, of Periclean democracy, and thus as the product of a historical development that had a positive impact on the arts: "[R]hetoric first began to flourish in the enjoyment of full freedom among the Greeks... Greeks in their prime were contemplative beings: they were already thinking twenty years or more before we generally begin to think for ourselves."[13] Very much in the spirit of Enlightenment-era education, Winckelmann turned the Greeks into subjects who thought for themselves, who in their early years had already learned to use their own intellect. On the other hand, he presented freedom as an *inborn* quality of Greeks and thus ascribed to it an invariable dimension independent of history. According to this interpretation, the Greeks were always free: they did not *achieve* their freedom by being educated to think for themselves or by progressively eliminating political systems based on servitude and tyranny, but rather they *possessed* this freedom *from birth*, independent of the political regime. In other words, Greeks do not *become* free, they *are* – as Greeks – born free. This is suggested by the following passage:

> Freedom always had its seat in Greece, even beside the thrones of the kings, who ruled paternally before the enlightenment of reason allowed the people to taste the sweetness of full freedom; and Homer called Agamemnon a "shepherd of the people" to indicate the latter's love for them and concern for their welfare. Though tyrants installed themselves soon after, they succeeded only in their native lands, and the entire nation never recognized a sole ruler.[14]

In this context, the fifth-century BCE Greek democracy, which led to the culmination of the "enlightenment of reason", was merely the realization of an inborn, natural kinship between Greeks and freedom. Even "beside the thrones of the kings", that is, in the pre-Periclean, non-democratic period, according to Winckelmann, the winds of freedom blew. Winckelmann's concept of freedom therefore offers a revealing insight into a fundamental pattern

Friedrich Wilhelm Eugen Döll, *Johann Joachim Winckelmann*, 1773/1782 (original), copy, Berlin, 1994

of thought in his work. He tends to trace phenomena that could be attributed to political development back to a natural – in the sense of being given by nature – cause. The love of freedom is thus naturalized.

Reception of Winckelmann's Work in France and Germany in Times of Revolution

How was this ambiguous concept of freedom received? This question must be raised because Winckelmann's art history – precisely with reference to the highly charged concept of freedom – had become a significant source of (art-) political thought in late-Enlightenment Europe. In this context, the French reception of Winckelmann's work deserves particular attention.

Soon after his first publication, Winckelmann was already being widely read in France. The *Reflections on the Painting and Sculpture of the Greeks*, of which around fifty copies were printed in 1755, was translated the same year into French. Three other French translations of it followed by the mid-1780s.[15] The same went for *History of the Art of Antiquity*, published in German (*Geschichte der Kunst des Alterthums*) in 1764, which was translated into French three times by the end of the eighteenth century.[16] Interest in Winckelmann's work grew significantly with the French Revolution. Poets such as André Chénier, people involved with art policy, such as Armand-Guy Kersaint and Pierre Chaussard, and artists such as Jacques-Louis David praised the model of Greek antiquity in hardly disguised variations of *History of the Art of Antiquity*.[17] With the support of the revolutionary government, the work was re-translated by the Hendrik Jansen publishing house in Paris, and this new, high-quality, three-volume edition with numerous additional appendices made its way into the main cultural institutions of the new regime. Alexandre Lenoir, founder of the Musée des Monuments Français, commissioned a bust of Winckelmann from Louis-Pierre Deseine in 1797 and had it displayed in the museum's entrance hall along with six busts of "famous Frenchmen". Against the background of the art policy of the French Revolution, it is not surprising that Winckelmann was included in this illustrious series. The main reason for this attention was his thesis of the essential coherence of art and freedom – a connection that leaders of revolutionary art policy took as an opportunity to create a prestigious continuity between the new republican regime and ancient Athens.[18] *History of the Art of Antiquity* was to provide the scholarly basis for this ideological construction.

The new regime had a concrete interest in spreading the idea of a fundamental connection between freedom and flourishing arts: it would legitimize the assertion that artworks confiscated by the revolutionary troops in conquered countries were being 'returned' to Paris, the new seat of freedom. In 1798, the government of the Directorate decided to celebrate the 'return' of the artworks confiscated in Italy with a triumphal procession in Paris. For this festive event – the *Fête des arts* – Pierre Chaussard suggested displaying not

only the artworks themselves, including the *Laocoön* and the *Apollo Belvedere*, but also pictures of scholars and authors whose works had made an impact on art. This included Winckelmann alongside Joshua Reynolds, Denis Diderot and Anton Raphael Mengs.[19]

These interpretations from the late eighteenth century offer an illuminating example of the selection processes that generally accompany the phenomena of reception. The revolutionary readers disregarded Winckelmann's "naturalizing" notion of freedom, instead viewing his statements on the model of Athenian democracy as the basis for an understanding of freedom that could be detached from the singular character of the Greeks – as imagined by the author of *History of the Art of Antiquity* – and also assigned to the French citizenry.

Another French voice from the time serves as evidence that Winckelmann's texts can also call forth very different political interpretations. Antoine Quatremère de Quincy's *Lettres à Miranda* (*Letters to Miranda*) in 1796 were a protest – once again based on Winckelmann – *against* the 'return' of Italian artworks to France.[20] In his view, the "museum" constituted by the Roman collections as a whole forms a uniform body that would be mutilated if individual members were torn from it and transported to Paris.

The French reception of Winckelmann in the late eighteenth century thus reflects the conflicting relationships between the approaches underlying Winckelmann's work. Whereas individual proponents of revolutionary art policy justified their looting with reference to the freedom-loving interpretation of the heyday of Athenian art, opponents of the very same art policy also referred to Winckelmann in defending the integrity of the Roman art corpus. And while these interpretations are virtually opposites, their premises are identical: for both interpretations, Winckelmann's *History of the Art of Antiquity* is not only a historical work, but also – to a significant degree – a political one, from which decisive conclusions can be drawn for contemporary questions of art policy.

The reception at the same time in the German-speaking world was very different. German readers in the late eighteenth and early nineteenth centuries understood Winckelmann's works more as a doctrine of beauty embedded in a historical description. They showed remarkable tenacity in rejecting any political interpretations whatsoever. Precisely at a time when, in France, Winckelmann's name was increasingly associated with the concept of freedom, in Germany it was largely linked with the category of "noble simplicity and sedate grandeur", which – according to the famous formula of *Reflections on the Painting and Sculpture of the Greeks* – was characteristic of the Greek

artworks.[21] In the light of the European discourse on Winckelmann outlined above, however, it is questionable whether the concepts of nobility, sedateness and grandeur – to which Winckelmann's texts are repeatedly traced back in the German-speaking world – possess a purely artistic, aesthetic meaning. Against the background of the revolutionary unrest in neighbouring France, the emphasis on tranquillity as a basic aesthetic quality of ancient artworks takes on a de facto political dimension.

There is, however, an exception to this apparently predominantly apolitical reception in Germany. Christian Gottlob Heyne, professor of rhetoric in Göttingen, was noted early on for his rather critical distance to the author of *History of the Art of Antiquity*. Although Heyne was willing to acknowledge Winckelmann's pioneering role in establishing the study of antiquity as a scholarly discipline, he repeatedly emphasized Winckelmann's numerous errors in interpretation and dating.[22]

It is no coincidence that one of the main points of contention between Heyne and Winckelmann is the interpretation of the concept of freedom. Heyne acknowledged that freedom can "be accompanied by conditions" that can "stimulate artists, excite their genius", such as the "desire for glory". However, freedom is more often a threat, even an obstacle to artistic production: "In and of itself" freedom may be "an inactive, dull, stupid state," that may also "be afflicted with such great unrest and physical, moral, and political pressure that art and science have little potential."[23] To these anthropological reservations regarding the advantages of freedom for the arts, Heyne added historical objections to Winckelmann's interpretation, saying that freedom was by no means an attribute solely of the cultural heyday of the Greek *polis,* but also of its decline. Heyne felt there were so many necessary additions or restrictions to Winckelmann's principle, which "derives the perfection of Greek art from freedom," that little remains. It is not freedom that explains the flourishing of Greek art, but "prosperity and magnificence", which may grow "in conditions of political freedom and under those of political slavery".[24]

Winckelmann was the first to offer a complete overview of the development of art in antiquity, in particular in Greece, thereby connecting two important areas of the historiography of the age of Enlightenment: the long-established field of ancient history, and the new "art history", for which he intended his *History of the Art of Antiquity* to serve as a matrix model. He thereby also made a significant contribution to the central discourse of the Enlightenment on the relationships between art and politics, human nature and freedom.

1. See Winckelmann 2006, 187.
2. Ibid., 71.
3. Diderot 1995, 157. For the French original see Diderot 1960, 207.
4. See exhib. cat. Munich 2017, 194–95, 296–304.
5. See Décultot 2000, 175–189, etc.; Décultot 2004, 106–112, etc.; Décultot 2020.
6. See Winckelmann 1765b.
7. Winckelmann 2006, 187.
8. Ibid., 188.
9. Ibid., 150.
10. Ibid., 317.
11. Ibid., 340.
12. See Loraux/Vidal-Naquet 1979; Grell 1995, vol. 1, 449–513.
13. Winckelmann 2006, 188.
14. Ibid., 187. See also Décultot 2000, 151–159, 175–189; Décultot 2004, 95–99, 106–112.
15. Winckelmann 1755/56; Winckelmann 1756; Winckelmann 1765a; Winckelmann 1786.
16. Winckelmann 1766; Winckelmann 1781; Winckelmann 1794.
17. See Pommier 1989; Pommier 1991.
18. See Kersaint 1792. In general, see also Chartier 1991.
19. See Chaussard 1798. See also Pommier 1991, 448.
20. See Quatremère de Quincy 1796, 24–25; and Quatremère de Quincy 2012.
21. Winckelmann 1765b, 30.
22. See Heyne 1963, inter alia 24–25.
23. Heyne 1778/79, 171–72; transl. in Harloe 2013, 183.
24. Heyne, ibid.; Harloe 2013, 184.

Longcase clock in the form of an obelisk, Workshop David Roentgen, Neuwied, ca. 1790 / Deutsches Historisches Museum, Berlin

At the end of the 18th century, the workshop of Abraham and David Roentgen in Neuwied was among the leading European furniture manufacturers. Operating under the self-assured appellation *méchaniste-ébéniste*, Roentgen created luxury furniture with a precision, understated elegance and functional form, combined with new kinds of veneer and varnish techniques, that made their products valued not only by courtly clients, but also by members of the newly emerging bourgeoisie. The recourse to classical forms – in the documented case of twelve different variations of the obelisk-like longcase clock – drew on the libertarian ideals of the Enlightenment. Even the dial designed by the clockmaker Reichel in the Kinzing workshop in Neuwied (a longtime partner of the Roentgen enterprise) seems to be introducing a new, post-revolutionary way of keeping time. It has only one large hand that shows both hours and minutes and makes a full circle every four hours; the division of the dial into four sections follows this logic. WOLFGANG CORTJAENS

Joseph Wright of Derby, *Three Persons viewing the Gladiator by Candle-Light,* 1765 / Private collection

As an object of historical interest and artistic exploration, Wright's first publicly displayed work drew attention to antiquity in the form of an "enlightened group portrait": three men, among them the artist himself, are gathered by candlelight around a downsized replica of the *Borghese Gladiator* (90 BC, Paris, Musée du Louvre). In the 18th century, the original of the statue, which was still in Rome, was among the most admired classical sculptures; casts and smaller reproductions in plaster or marble were highly sought-after collector's items. Wright's nocturnal scene accentuates the anatomy and quickened muscle play of the small statue through the use of chiaroscuro and the device of a hidden light source borrowed from Caravaggio. Three years later Wright was again to use this old-masterly lighting technique in the experimental scene found in his probably most famous painting *An Experiment on a Bird in the Air Pump* (1768).

WOLFGANG CORTJAENS

Carl Kuntz, *The Stone of Wörlitz,* Dessau-Rosslau, ca. 1800 / Deutsches Historisches Museum, Berlin

The staged eruption of an artificial volcano was supposed to recall Vesuvius. However, this "volcano" was situated in the Wörlitz Garden Realm, a park in the principality of Anhalt-Dessau. Its construction was commissioned by the enlightened Prince Franz, who had climbed Vesuvius in 1766 during an educational tour through Europe. The journey through Italy had a strong influence on the prince and his principality. Under the tutelage of the historian and archaeologist Johann Joachim Winckelmann and the British ambassador and volcanologist William Hamilton, Franz learned about the art of antiquity and classicist architecture as well as about current findings in the fields of volcanology and archaeology. Franz brought these teachings to Dessau, with projects such as publicly accessible classicist buildings, the artificial volcano, and the collection of ancient art in the newly built Villa Hamilton, all intended to facilitate the enlightenment of the general population. CRAWFORD MATTHEWS

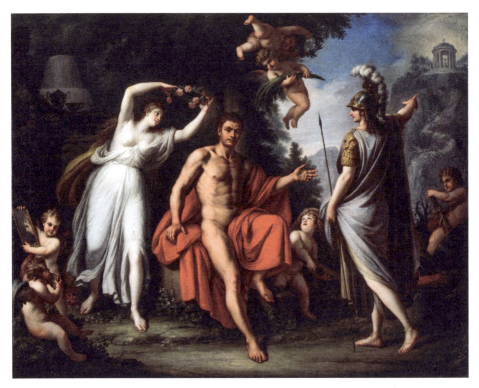

Johann Heinrich Wilhelm Tischbein, *The Choice of Hercules*, Rome, 1779/80 / Deutsches Historisches Museum, Berlin

The demigod Hercules has to decide between a life of idleness and pleasure and a path of virtue full of deprivation. From back left comes the personification of lust, while Minerva, goddess of strategic warfare, patroness of the arts and sciences, and personification of virtue, stands to the right. She points to the temple of fame, which can only be reached with great effort. Hercules seems to be torn between the alternatives. But his bearing shows him drawn to Minerva. For Landgrave Friedrich II von Hessen-Kassel, Hercules was a symbol of statesmanship, strength and intelligence. Tischbein, who was sent to Rome by Friedrich with a stipend in 1779, paid tribute to his patron with this painting: Hercules symbolises the Landgrave, who saw himself as a prince of Enlightenment, guided by reason.

SABINE BENEKE

STATESMANSHIP AND POLITICAL LIBERTY

Martin Mulsow

Illuminatism, Kantianism and Early Constitutionalism

In the words of Friedrich Schlegel's celebrated dictum from *Athenaeum Fragments* (1798): "The French Revolution, Fichte's *Wissenschaftslehre* and Goethe's *Meister* are the greatest tendencies of the age."[1] We can easily modify the focus of this statement, firstly by replacing the French Revolution with constitutionalism. This movement aimed to endow states with a constitution as the supreme instance of law, by which everyone, including the ruler, must abide. Secondly, instead of Fichte's *Foundations of the Science of Knowledge*, we could mention Kantianism, from which Fichte's philosophy arose. And Goethe's *Wilhelm Meister's Apprenticeship* could make way for the secret society that appears in the novel under the name of the Tower Society: the Order of Illuminati. Now we have a description of the intellectual trends that characterized the last decade of the eighteenth century.

In the German debate about constitutional reform, especially after the French Revolution, early constitutionalists drew up multiple scenarios of what a German constitutional state might look like.[2] Although nothing of the like was implemented until the nineteenth century, some of these drafts prefigured the plans of the 1848 revolution – or rather, they were initial attempts at thinking such ideas through. Secondly, Kant's philosophy centred on the autonomy of the individual, whose practical reason is the measure of his appropriation of the world. Thirdly, the Order of Illuminati was, in a certain sense, an early precursor of the progressive political parties that aimed to change society gradually. Of course, in the territories of Germany under absolutist rule, parties as vehicles of political convictions and political participation were not yet permitted, but within the secret societies there emerged something like a social "indoor space"[3], a sphere in which politicization could take place, and this ultimately took the form of public political parties during the nineteenth century. Sometimes, all three of these trends of thought appeared together. They are emblematically united in a little-noticed but significant book with the title

Portrait of Schack Hermann Ewald, undated

Kritik der deutschen Reichsverfassung (Critique of the German imperial constitution), which was published in three volumes between 1796 and 1798 without any mention of the author.[4]

Its forerunner was a book published in Göttingen in 1794, also anonymously, by the same author: *Von dem Staate und den wesentlichen Rechten*

der höchsten Gewalt (On the state and the essential rights of the supreme power), in which the principles of Kantian philosophy were consistently applied to political theory for the first time. In *Kritik der deutschen Reichsverfassung*, it was the general form of government, the military constitution and the national economy of the empire that were scrutinized according to Kantian criteria, but following the economic liberal ideas of Adam Smith. These three volumes are the most important texts among the often covert debates that preceded the dissolution of the Holy Roman Empire in 1806. They progressively develop a republican concept of the state in line with the early constitutionalism that was emerging at the time.

The writer of all three books was Schack Hermann Ewald – Freemason, member of the Illuminati (until it was banned), editor of the bi-weekly *Gothaische gelehrte Zeitungen*, poet, translator, and secretary of the Hofmarschall's office at the ducal court in Gotha.[5] Ewald made sure that his name never appeared in connection with such projects. The reviews that he wrote in the *Gothaische gelehrte Zeitungen* made him the most important early promoter of Kantian philosophy in Germany, alongside Christian Gottfried Schütz of the *Allgemeine Literatur-Zeitung* newspaper in Jena. Furthermore, he was the first to translate Spinoza's *Tractatus theologico-politicus* into German (at the height of the controversy over pantheism) and he edited the first two parts of Spinoza's *Ethica* in German translation with Kantian footnotes. It was all highly political and all done anonymously. Ewald also remained invisible in his considerable endeavours as a Freemason and Illuminatus. He regularly reviewed new publications in the Freemasonry section of the *Allgemeine Literatur-Zeitung* – as usual, anonymously. His success at concealing his identity meant that his significance and intellectual stature were completely overlooked for a long time.[6] His claim to greater recognition is made even stronger by his constitutionalist works of the 1790s.

Critique of the German Imperial Constitution

Ewald begins *Kritik der deutschen Reichsverfassung* with the following comment: "The observations contained in the following pages are the fruit of reflective reasoning, wedded to pure and unfeigned love of the fatherland." (I, V)[7] The reasoning is Kantian; the fatherland is Germany and not just Gotha – which was not self-evident at the time. Patriotic feeling for a united German empire had been expressed in Gotha since at least 1785, when the less powerful rulers formally discussed – but ultimately failed to establish – an alliance to resist Prussian and Austrian dominance. "German blood still flows in my veins," wrote Duke Ernst II of Gotha angrily at the time, "and I will gladly

shed it for the fatherland; I would also rather seek and find my grave under the ruins of the imperial constitution than nestle idly and meekly under a shameful yoke."[8] With the outbreak of the French Revolution in 1789 – a development that was welcomed by many in Gotha, first and foremost by the Duke's brother, Prince August – the discussions about the imperial constitution and the unity of the German nation took on even greater urgency. In general, there was no desire for a violent upheaval in Germany – indeed, Germany was to be protected from such turmoil precisely by means of reform, but the composite structure and complementary statehood of the Holy Roman Empire stood in the way of any such transformation.[9]

The first word in the title *Kritik der deutschen Reichsverfassung* should certainly be understood as a reference to Kant's *Critique of Pure Reason*. In fact, with these three volumes, Ewald wrote three critiques that Kant did not write: a critique of the constitution, a critique of peace and a critique of the economy. In the first volume, to which Ewald gave the title *Kritik der Regierungsform des deutschen Reichs* (Critique of the form of government of the German Empire), he drew on the principles of human rights, democracy, the separation of powers, and representation. The basis of executive power is a modified categorical imperative: "The rights of the supreme power must be administered by those who hold them, or to whom the state has delegated them, in the name of the state; that is, in other words, in such a way as all the members of the state could morally wish it to be administered." (I, 251) Ewald's fellow Illuminatus Gottlieb Hufeland had already taken the categorical imperative and made it the basis of natural law in 1785.[10] Ewald applied it to the exercise of the general will, as understood by Rousseau. The purpose of the state is the "defence and promotion" of human rights. These he differentiates according to the categories of substantiality (freedom of conscience and thought, including freedom of the press, and the right to use one's own powers), freedom (ownership of one's own body, and the right "to demand from others a conduct towards oneself from which it is clear that they recognize one ... as a free human being, as a person") and equality (equal opportunity to acquire rights, free use of one's rights, and entitlement "to the enjoyment of life and the use of one's property"). (I, 6–9) Ewald calls the ideal form of government "pantocracy" and understands it as one "where everyone takes part in legislation or, in the event that not all are in agreement, the majority preference of the votes of all of those in the civic association passes laws." (I, 61) His vision of the German Empire is one of cooperation between the Emperor and the Imperial Estates as a whole, whereby the Imperial Estates would have to be reformed so that they comprise every social class: "a pantocracy of the

Charles-Louis de Secondat, Baron de La Brède et de Montesquieu, *The Spirit of Laws*, Amsterdam, 1749

representatives of the individual, united German states under the lawful authority of the veto of a single person elected from among their midst". (I, 57)

Although the second volume is titled *Kritik der Kriegsverfassung des deutschen Reichs* (Critique of the military constitution of the German empire), it is primarily a treatise on the capacity for peace in the sense of Kant's writings *Perpetual Peace* (1795) and *Doctrine of Right* (1797), combined with thoughts from Montesquieu, Johann Jakob Moser and Johannes von Müller. Germany has to become part of a comprehensive "state of nations" (II, 149), meaning a peaceful alliance of independent republics. According to Ewald, if nations are independent, have legal equality among themselves, can act independently, are free from feudal oppression, exist within fixed borders and are mutually committed to resolving conflicts through arbitration, then lasting peace is possible. (II, 105–107) More than a hundred years before the founding of the League of Nations in 1920 and decades before Carl von Clausewitz's work *On War* (1832), this text formulates a political view of war and peace, which proceeds from the assumptions that only a legislature representing the citizenry may decide to go to war, but that nations with a republican constitution are fundamentally peaceable and that the command of the army must be exercised by the monarch of the republic himself (or a general appointed by him, whom he can, however, dismiss).

Ewald called his third volume *Kritik der staatswirthschaftlichen Verfassung* (Critique of the state economic constitution). Following Adam Smith, he examines the Holy Roman Empire from the perspective of the history of civilization as a modern mercantile state, to which liberal market principles should apply on the basis of external peace. Such a state "becomes, on the part of its inhabitants, unfit to be a warlike state inasmuch as the pursuit of gain through trade and commerce, in which everyone, down to the lowest day labourer, is engaged, does not allow them even to entertain the thought of war with their neighbours." (III, 16) On the contrary, in the interests of European policy, state intervention and restrictions on exports or imports should be avoided because such restrictions are "un-cosmopolitan". (III, 232) Ewald's work demonstrates the great hopes that the early constitutionalists placed in the peace-building power of civic participation and economic development. This may seem somewhat naïve today, but since historical experience was still lacking, it must have seemed reasonable to derive this consequence from the principles that had been laid down. Overall, the third volume is a bit more radical than the others. Ewald completely abandons the administrative structure of imperial districts (*Reichskreise*), to which he had still attached importance in 1796. The national assembly is now referred to by the former Illuminatus as

the "Areopagus" (III, 73) – the name that the Illuminati had once given to their ruling council.

Patriotism and Enlightenment
As far as we know, Kant never reacted to his thinking being taken in the direction of a political reform of Germany. Ewald's volumes appeared without the name of an author or a printer; only "Germania" and the year of publication were stated. So what did the cryptic mention of „Germania" signify? It was used in 1797 for the *Neueste Staats-Anzeigen, gesammelt und herausgegeben von Freunden der Publizität und der Staatskunde*, published anonymously by Theophil Friedrich Ehrmann, and earlier, in 1790, for the *Novellen aus dem Archiv der Wahrheit und Aufklärung, für Menschen in allen Ständen und Verhältnißen*, written by Julius Friedrich Knüppeln, a radical figure of the Prussian Enlightenment. "Germania" was also used by other early constitutionalists and was clearly a code word for the combination of patriotism with enlightenment.

This kind of patriotism may well also be attributed to Rudolf Zacharias Becker, a friend of Ewald's. Becker expressed a generally positive view of the events unfolding in France and the Declaration of the Rights of Man and of the Citizen, but these were highly controversial topics and his *Vorlesungen über die Pflichten und Rechte des Menschen* (Lectures on the duties and rights of man) could not be published until 1791. Becker, too, was thinking in terms of nationwide, imperial patriotism with his weekly *Deutsche Zeitung für die Jugend und ihre Freunde* (German newspaper for young people and their friends), which in 1796 changed its name to *National-Zeitung der Deutschen* (National newspaper of the Germans).

Ewald apparently sent his books to several friends and acquaintances who were experts on constitutional politics. August Ludwig Schlözer – whom Ewald knew from his student days in Göttingen, and whom he had also dealt with in his capacity as editor of the *Gothaische gelehrte Zeitungen* – received two books through the publisher Dieterich in the autumn of 1796. These were the newly published first volume of the *Kritik der deutschen Reichsverfassung* and *Von dem Staate*, published two yearly previously in 1794. Schlözer responded cautiously. He wanted to see, he wrote to Ewald, whether the new book could "cure" him of his reservations "that 1. the German form of government (constitution) is the most unsuitable of all since Nimrod's time, and 2. the Peace of Westphalia is even more atrocious than the partition of Poland of 1772–1795". He then added: "But this difference in our political opinions does not affect our friendship!"[11] Schlözer believed that constitutional reform was fundamentally pointless, given all the contradictions inherent in the political system that had existed since 1648.

Ewald apparently also sent a copy of *Kritik der deutschen Reichsverfassung* to Friedrich Immanuel Niethammer, who edited the *Philosophisches Journal* in Jena together with Johann Gottlieb Fichte. Niethammer had previously worked with Ewald on the *Gothaische gelehrte Zeitungen* during his stay in Gotha from May to December 1791, which is how they had come to know and esteem each other. Niethammer thanked him for the "gift" and complied with Ewald's request to review the book insofar as he "handed it over to a reviewer specializing in natural law".[12] Unfortunately, the review never appeared.

Ewald corresponded with another, no less prominent professor, August Friedrich Wilhelm Crome in Giessen.[13] He sent Ewald book announcements to be printed in the *Gothaische gelehrte Zeitungen*, for example of his work *Die Staatsverwaltung von Toskana*. This deals with the state administration of Tuscany as reformed by Archduke Peter Leopold, later Leopold II, Emperor of the Holy Roman Empire, and regards it as a kind of model constitution for the Enlightenment. Crome was a reform mercantilist and Francophile who belonged to potentially radical enlightenment circles in central Hesse.

Last but not least, Ewald's friend and fellow Kantian, Ludwig Heinrich von Jakob, who was professor of philosophy in Halle, also turned his attention to constitutional issues and national economics in the 1790s. In 1794, he anonymously published a treatise "against Machiavelli, or on the limits of civil obedience" with a dedication to Schlözer. He asked Ewald to review it and discussed it with him, as he did with his book on the duties of man, which appeared a little later.[14] His *Antimachiavel* defends the right of resistance to the state and demands what might be called early constitutional jurisdiction; it is therefore regarded as an example of early liberal journalism.

Schack Hermann Ewald was no Jacobin. Contrary to prejudices about the Illuminati and their revolutionary convictions, he did not push for the forcible implementation of his reform proposals. He paid attention to the events and ideas of the French Revolution, but remained mindful of the constitutional traditions of the Holy Roman Empire in the German states, which he wanted to improve in respect of the consistent application of the principles of the rule of law. Admittedly, he does not shrink from action in his proposals regarding the regional princes in particular, whose power and privileges he wanted to see almost completely curtailed, including the expropriation of their lands for distribution among the rural population. (III, 184–210) It is possible to identify a certain continuity from early democratic liberalism in the manner of Jakob and Ewald to the so-called Gotha Post-Parliament of 1849 (in which certain factions of the Frankfurt National Assembly of 1848 united) and more gen-

erally to the constitutional debates of fully-fledged liberalism.[15] In much the same way as the politicizing tendencies of the secret societies of the 1780s extend into the political professoriate and the early democratic societies of the 1810s,[16] a politicizing phenomenon is also visible in the shift of attention towards economics among a number of professors, some of whom were still partly organized in secret societies. Among them were Crome, Gottlieb Welcker and the Follen brothers in Giessen, and Schlözer in Göttingen. After 1800, national consciousness, popular enlightenment and constitutional thinking, from Rudolf Zacharias Becker to Friedrich Ludwig Jahn, became intertwined in various ways, and this complicated the situation. The later secret societies of the 1830s and 1840s that worked towards a democratic Europe, such as Junges Deutschland and its inspiration, Giuseppe Mazzini's *Giovine Italia*, also introduced new aspects. The afterglow of the late Enlightenment was thus reflected, albeit in fragments, long into the nineteenth century. But without the combination of Kantianism, constitutionalism and the Illuminati, it would not have brought forth the visions, still valid today, that found their brilliant culmination in *Kritik der deutschen Reichsverfassung*.

1. Athenaeum 1798.
2. See Gagliardo 1980, 175–182; Burgdorf 1998, 475–501; Dippel 1991. For scenarios up to 1848, see Schulze 2002.
3. Koselleck 1988.
4. "Germanien" 1796 (vol. 1) and 1798 (vols. 2 and 3). There is even a reprint of the book by Wolfgang Burgdorf (Hildesheim 2009), but unfortunately the wrong author is named, as Burgdorf erroneously attributed the work to Johann Nikolaus Becker.
5. The attribution to Ewald is substantiated by the testimony of Ewald's friend Josias Friedrich Christian Löffler, in Löffler 1812, 79, and by Ewald's correspondence with colleagues, cited below.
6. This only changed when a biography of Ewald was published, Schröpfer 2014. See also Mulsow 2015.
7. Here and in the following, citations refer to the volume and page number in the original work.
8. Quoted from Schmidt 2009, 221.
9. Ibid., 233–235.
10. See Hufeland 1785.
11. Schlözer to Ewald, 17 October 1796, Forschungsbibliothek Gotha, Ch. B. 1918 II, Schlözer.
12. Niethammer to Ewald, 1796, Forschungsbibliothek Gotha, Ch. B. 1918 II, Niethammer.
13. Crome to Ewald, 11 February 1797, Forschungsbibliothek Gotha, Ch. B. 1918 II, Crome.
14. See Jakob's letters to Ewald between 1794 and 1796, Forschungsbibliothek Gotha Ch. B 1918 II, Jacob, fol. 3–17.
15. On the revolution of 1848, see Clark 2023.
16. See Ries 2007. On the continuities in membership of secret societies into the 1790s, see Mulsow/Naschert 2022.

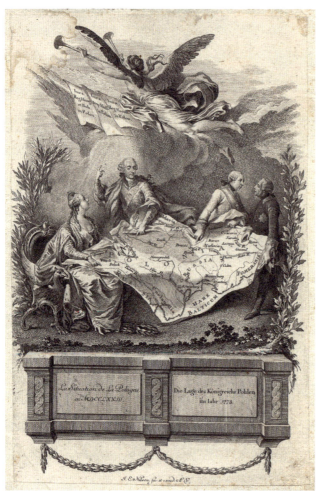

Johannes Esaias Nilson, *The Situation of Poland in the Year 1773*, Augsburg, 1773 / Deutsches Historisches Museum, Berlin

The Polish territories annexed by Russia, Austria and Prussia are marked on the map. Catherine II, the Russian minister Panin, Joseph II, and Frederick II point to further provinces. The intellectual justification for the partition of Poland came from theories that postulated a hierarchical categorisation of nations according to their degree of "civilisation". *Philosophes* like Voltaire and the Encyclopaedists propagated the image of a "barbarian" or "backward" Poland. This rhetoric was taken up by supposedly enlightened rulers in order to portray their annexations as civilising missions. However, it was their interventions in Polish politics that prevented important reforms and contributed to the region's instability.
CRAWFORD MATTHEWS

Toussaint Louverture, Leader of the Black Insurgents in Saint-Domingue, Paris, 1796–1799 / Bibliothèque nationale de France, Paris

The Haitian Revolution (1791–1804) is considered the only successful uprising of slaves in history. Its course became the touchstone of the enlightened ideas of freedom, equality and the struggle against tyranny. Officially a French colony since 1697, Haiti – formerly Saint-Domingue – with its remorseless plantation and slave economy was among the most important and embattled sugar suppliers of Europe. In 1794 Toussaint Louverture, here depicted heroically on horseback, led the uprising of the enslaved West African population of the Caribbean island against the system of oppression. In 1801 he decreed a constitution that combined political equality with "race" for the first time. As an authoritarian leader he also reorganised the plantation economy in order to maintain the economic viability of the island. Toussaint Louverture no longer experienced the culmination of the revolution, the founding of the independent Republic of Haiti. He died in a French prison in 1803. NINA MARKERT

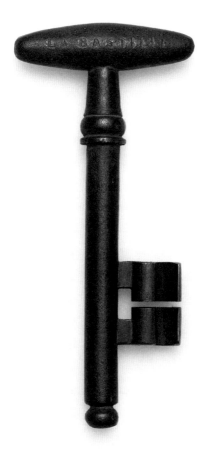

Key to the Bastille (reproduction), France, before 1789 (original) / Deutsches Historisches Museum, Berlin

Since the early 17th century, the Bastille, part of the medieval fortifications of the city of Paris, had acted as the state prison for prominent prisoners who had been incarcerated under various conditions, but always without trial, sentence, or duration of the arrest. Arbitrariness was central to the horror of the fortress. In 1789, however, there were hardly any inmates left. During the popular uprising in Paris on 14 July 1789, it was the symbolic importance of the storming of the Bastille that counted. Seven prisoners were freed, the prison governor and officers hanged. As commander of the National Guard, Marie-Joseph Motier Marquis de La Fayette was given a key to the fortress, which he passed on to George Washington, under whose command he had fought in the American Revolutionary War. The original is now located at Mount Vernon. Another key came to the Musée Carnavalet, a copy of which the Museum für Deutsche Geschichte in (East) Berlin purchased in 1988 as a potential showpiece. When the museum was dissolved, the key came to the DHM.
SVEN LÜKEN

MERCANTILISM AND COSMOPOLITANISM

Urvashi Chakravarty

What is the Racial Enlightenment?

Let us revise the famous question, "What is Enlightenment?" by seeking to amend it, to ask instead: what is the *racial* Enlightenment? And how does the Enlightenment pertain to the economy in chattel slavery in the eighteenth century? In thinking through these questions, we need to attend to the meanings of race in the Enlightenment, to the reciprocal growth in the trade in enslaved peoples and consumer goods, and to the relationship between race and slavery. Finally, let us touch on the question of how these (re)configurations of race and slavery were transmitted and transmuted both through the propagation of the popular literature of the eighteenth and nineteenth centuries, and via the medium of classical translation.

To talk about the Enlightenment has famously been a longstanding source of potential tension: on the one hand, the Enlightenment's purported commitment to freedom and autonomy has been a benchmark in the history of intellectual thought; on the other hand, the period of the Enlightenment witnessed a significant growth in the economy of chattel slavery, the consolidation of racial hierarchies, and the rise of racial capitalism as a system that continues to operate into the present day. Indeed, if we consider the period of the Enlightenment itself, broadly speaking – from the late seventeenth century to the early nineteenth century – it maps uncomfortably onto the history of British slavery, from the consolidation of enslavement as a legal, heritable condition to its British abolition.[1]

The Slave Trade and the Abolitionist Cause

This is not to say that slavery began with the age of Enlightenment or during it; rather, enslaving practices as a whole had been in place as long as anyone could remember – the reception of classical antiquity, I argue, was a touchpoint for the reception of eighteenth-century slavery – and even in the British context, slaving voyages had been underway from the sixteenth century onwards,

with the African expeditions of John Hawkins and others.[2] But the systemization of slavery as a heritable condition characterized the late seventeenth and eighteenth centuries, as did notable legal cases that sought to resolve the meanings of slavery, and which asked: Are enslaved people property? How is unfreedom affected by national or geographical location?

The 1677 case of *Butts v Penny*, for instance, found that enslaved people comprised chattels for whom compensation could be claimed in the case of loss. Yet in the subsequent decades, Lord Chief Justice John Holt held that slavery was not permitted in England. Despite an enduring lack of legal clarity around the status of slavery, the famous 1772 case of *Somerset v Stewart* seemed to confirm Holt's ruling, in a legal precedent widely if erroneously interpreted to suggest that enslaved people in England were free.[3] This did not stop the traders responsible for the vicious *Zong* massacre of 1781 – wherein more than 130 enslaved Africans were deliberately murdered by being thrown overboard from the ship owing to low supplies of drinking water – from seeking compensation from their insurers for the economic 'loss' of these victims. This request ultimately failed, but it was not until 1833 that slavery was finally abolished in Britain. France, meanwhile, which similarly maintained the non-existence of slavery on the mainland, established the Code Noir in 1685 to manage the treatment of enslaved people in overseas colonies, and in 1716 passed an edict which instituted a process for bringing enslaved people to France. Although this technically consisted in a process of registration, it effectively provided a pathway for slavery to continue on French soil.[4]

The question of whether or not slavery was legal, permissible in English or European contexts, or revocable depending on geography may have been vexed. But the trade in enslaved people nonetheless had a profound impact on the consumption of goods and, more broadly, on the Enlightenment's claim to cosmopolitanism. It was in the eighteenth century that cities of industry and trade flourished; in Britain, the period of the Enlightenment saw London, Liverpool, and Bristol expand rapidly as port cities, with Liverpool in particular becoming the 'slaving capital' of Britain. Indeed, Liverpool's role in the enslaving economy was so significant that by the end of the eighteenth century, it accounted for nearly half of the entire European trade in slavery.[5] An image published in 1788 by the Plymouth chapter of the Society for Effecting the Abolition of the Slave Trade (and widely reprinted and disseminated thereafter) depicted a ship packed with enslaved African people, an illustration based on an actual ship, the *Brookes*, which first set sail from Liverpool in 1781.[6] The visceral shock at the arrangement of human 'cargo' is only increased by the dispassionate, quotidian nature of its presentation.

The Liverpool slave trade was deeply bound up with the consumption and dissemination of numerous foodstuffs and novel commodities in Britain and Europe. Liverpool traders carried textiles and pottery, for instance, from England to trade for enslaved people in West Africa; on the return voyage, traders would carry sugar, cotton, and coffee.[7] It was not just that ships trafficked in persons as chattel as well as luxury commodities; rather, the slave trade itself was economically underwritten by a diverse trading portfolio which secured against the financial risks of chattel slavery.[8]

Anti-Slavery Sentiment in Popular Literature

Some of these foodstuffs were of course framed as explicitly and often horrifically implicated in the slave trade. The consumption of sugar was directly represented as a form of cannibalism by contemporary abolitionist commentators. William Fox's famous and widely disseminated anti-slavery treatise *An Address to the People of Great Britain, on the Utility of Refraining from the Use of West India Sugar and Rum* (1791), for instance, explicitly excoriates the hypocrisy of the current 'enlightened age' for its complicity in the fact that

Nicolas De Fer, *Map of the island of Saint-Dominque, discovered by the Spanish in 1492*, Paris, 1723

What is the Racial Enlightenment? 243

"we ... have greatly surpassed, in brutality and injustice, the most ignorant and barbarous ages".[9] Fox goes on to remark: "so necessarily connected is our consumption of the commodity, and the misery resulting from it, that in every pound of sugar used, we may be considered as consuming two ounces of human flesh."[10]

Meanwhile, in the children's story *Cuffy the Negro's Doggrel Description of the Progress of Sugar* (1823), one of a series of illustrated 'progress narratives' for children tracing the conveyance of goods from slave plantations in the Caribbean to English consumers, the narrator not only observes that "blood" is part of what comprises white sugar, he tacitly racialises the progress of sugar in making this observation: "To make sugar white (sure he be a ninny!) / Blood, and nasty someting, baker now put in-ee."[11] The narrator has already revealed the role of sugar in quotidian English life as well as its national traditions, not only emphasising the everyday "tea and cakee" it allows, but also pointing out how quotidian English life and celebrated customs are reliant on the trade in foodstuffs.[12] But in depicting blood as the material that "make[s] sugar white", the narrator indexes the shift in the colour of sugar – from brown to white – to its movement between its Black producers and its white consumers in England.

This shift in colour, though only tacitly registered, also speaks to the contours of racial thinking in the Enlightenment. The eighteenth century is often read as marking the development of racial science and its forms of racial classification perhaps most infamously evident in the taxonomies of Carl Linnaeus. The natural history that Linnaeus delineates with *Systema Naturae* (1735) in turn casts a long shadow in the form of scientific racism today, but it has also led to a longstanding investment in a so-called 'biological' basis for classifying human beings.[13] This understanding of racial history – which locates the Enlightenment as the source of race thinking – has also found its way into popular discourse, with recent cultural criticism underscoring the fundamental "paradox between Enlightenment liberalism and racial domination" and tracing the significance of the "racial taxonomy" that arose during the Enlightenment.[14]

These conversations about the origins of racial formation are long overdue. Yet there is also a danger of reifying the Enlightenment as *the* repository of race thinking, and of calcifying race as an after-effect of slavery. By locating the Enlightenment as the turning point of racial thought, we perhaps risk consolidating race as something 'real', even as being located in the body, rather than as an apparatus of power. Meanwhile, the very name of the Enlightenment speaks to the movement from dark to light; this rhetoric leans on

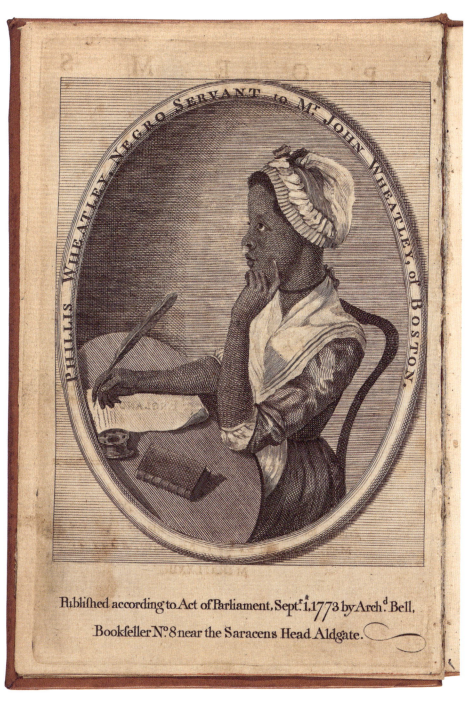

Scipio Moorhead, Frontispiece from: *Poems on Various Subjects: Religious and Moral* by Phillis Wheatley, London, 1773

a binary of white and black that constitutes a fundamental move of race thinking. As Kim F. Hall has noted, the language of light and dark is the originary language of racial formation around which the axes of power take shape.[15] This binary of light and dark and its mutual relationship to the contingencies of phenotype and somatic difference comprise part of the "strategic essentialisms" to which Geraldine Heng refers when she argues that "race is a structural relationship for the articulation and management of human differences, rather than a substantive content".[16]

The process of 'whitening' a newly ubiquitous and seemingly indispensable commodity deeply bound up with the trade in enslaved peoples did not only apply to sugar. As another production narrative in the Cuffy series makes clear, cotton, too, must be bleached "Until it gets so white, / Your eyes it dazzles truly".[17] *The Progress of Cotton* also asserts that the production of cotton provides opportunities for labour in Britain ("And much work it makes / In this happy land-o!") at the same time as it suggestively analogises that work to the labour involved in cotton picking and packing on the other side of the Atlantic: "Hard the work, 'tis true; / What of that? we're willing; / Idleness makes sick, / Working is not killing."[18] The illustrations in the third production narrative in the Cuffy series, *The Progress of Coffee*, also, however, demonstrate the reliance on Black labour even once these newly processed and "lightened" goods find their way to white consumers in Britain: a liveried Black servant prepares the coffee, then stands to attention as it is consumed by its white customers.[19]

The production narratives in the Cuffy series are, of course, targeted towards children, and as such they serve a didactic function.[20] Let us end, then, by turning briefly to an eighteenth-century translation of plays by the classical dramatist Terence, which was "adapted to the Capacities of Youth at School".[21] In his prefatory treatise on the life of Terence – a Roman playwright and freedman from North Africa who lived in the second century BC – the author and translator, Thomas Cooke, both leans on the exceptional nature of Terence's genius and asserts that Terence's slavery was due to being a "Captive of War".[22] It was "because of his extraordinary Genius and Beauty," Cooke insists, that "he not only receiv'd a Liberal education, but his Freedom, and that early: which Advantages he improved."[23] It is this sense of Terence's exceptional status that the enslaved poet Phillis Wheatley also invokes – but with dismay – in her poem 'To Maecenas', when she asks the Muses "why this partial grace / To one *alone* of Afric's sable race"?[24] Wheatley's question, I think, also looks ahead to an abolitionist propensity to "prioritize the figure of Black genius" in a structure that works, as Surya Parekh has recently argued, to

"accommodate exceptional Black thinkers and a certain notion of humanism while still endorsing large-scale exclusion".[25] This, ultimately, is the challenge that Wheatley – and Parekh – leave us with: that of acknowledging and unfolding the larger racial structures of the Enlightenment, above and beyond its exceptional individual thinkers.

1. See Roberts 2013; Curran 2011; and Sala-Molins 2006.
2. See Chakravarty 2022.
3. See, amongst others, Cleve 2006, 601–45; and Kaufmann 2008, 200–203.
4. See, for instance, Peabody 1996 and Dubois 2006, 1–14.
5. See National Museums Liverpool, "Liverpool and the transatlantic slave trade".
6. See Library of Congress, "Stowage of the British slave ship *Brookes* under the Regulated Slave Trade Act of 1788". See Rediker 2007.
7. See Richardson et al. 2007.
8. See Haggerty 2008, 17–34. See also Zuroski 2013 and Gikandi 2011 on slavery and the cultivation of taste in the age of Enlightenment.
9. Fox 1791a, 7.
10. Ibid., 9. On sugar consumption and abolitionism, see, amongst others, Matthew (forthcoming); and Van Dyk 2021, 51–68.
11. Cuffy Sugar 1823, 15. See also Chakravarty 2022. Despite the narrator's observation, this is not altogether an anti-slavery text; this is also the case in the other production narratives in the series.
12. Ibid., 14.
13. For a discussion of the meanings of race in the eighteenth century, see, amongst others, Wheeler 2000. For a recent treatment, see Hudson 2021.
14. See Bouie 2018.
15. See Hall 1995.
16. See Heng 2018, 3.
17. Cuffy Cotton 1833, 13.
18. Ibid., 10, 7.
19. Cuffy Coffee 1820, 14–15.
20. See Chakravarty 2022.
21. Cooke 1755, title page.
22. Ibid., 17.
23. Ibid., 18.
24. Wheatley 1773, 11 [author's emphasis]. See also Chakravarty 2022, 203.
25. Parekh 2023, 8.

Michael F. Suarez, S. J.

Slavery, Sugar, and the Abolitionist Movement

In April 1791, William Wilberforce, the leading abolitionist voice in the British parliament at the time, spoke forcefully before the House of Commons, urging his colleagues to abolish the slave trade. When his motion failed miserably, by a vote of 163 to 88, many ordinary people were outraged. After years of educating both the parliament and the public about the horrors of the slave trade, the abolitionists had harboured great expectations of success, but now their cause had suffered a major defeat. Yet approximately one year later, some 300,000 people in Great Britain were boycotting sugar and rum in protest against Britain's continued participation in the West Indian slave trade.[1]

How did the first major consumer boycott in British history come about? One particularly important rallying cry was William Fox's *Address to the People of Great Britain, on the Propriety of Abstaining from the Use of West India Sugar and Rum* (1791), which called for a boycott in highly graphic terms. Because Parliament had refused to abolish the slave trade, Fox called upon his readers to abstain from sugar and rum until they were able to procure them "unconnected with slavery, and unpolluted with blood".[2] Accordingly, he presented consumers with a stark moral decision: "if we purchase the commodity we participate in the crime".[3]

In just two years, 26 London 'editions' of the *Address* (some merely re-issues of sheets printed earlier and sold with altered title pages) were published. Martha Gurney, who was both printer and publisher of nearly all the London editions, claimed that 50,000 copies were "printed in about 4 months".[4] Although Gurney's claim is demonstrably exaggerated, Fox's *Address* should nonetheless be counted among the most widely disseminated political pamphlets of the eighteenth century.[5] The *Address* was a small pamphlet that was easy and cost-effective to reproduce; British provincial editions were published in Sheffield, Manchester, Sunderland, Birmingham, Hull, Sevenoaks, Glasgow, Dundee, and Edinburgh. There were Irish editions printed in Belfast

Martin Friedrich Müller, Lockable silver sugar box, Berlin, 1776/77

and Limerick, Dublin, as well as U.S. printings in Lancaster [Pennsylvania], Boston, Philadelphia, and New York. Some twenty other pamphlets variously supporting or attacking the "antisaccharites" followed the initial publication of William Fox's best-selling tract.

The boycott also garnered attention because it was represented in contemporary political cartoons by popular artists. James Gillray's satirical print *Anti-Saccharrites, or John Bull* [that is, King George III] *and his Family leaving off the use of Sugar* (March 1792) enjoyed wide circulation. Isaac Cruikshank's *The Gradual Abolition off* [sic] *the Slave Trade. or leaving of Sugar by Degrees* (April 1792) also pokes fun at the royal family's reputed participation in the boycott – and may have helped to normalize a groundbreaking consumer activism with potentially radical consequences. Far more impactful than these jocular satires, however, was an earlier James Gillray print, *Barbarities in the West Indies* (April 1791), vividly depicting an incident that Wilberforce had described in his abolitionist speech before the Commons: a cruel overseer, discovering that a captive African was unable to work because of illness, brutally punished the young man by submerging him in a vat of boiling cane juice and not letting him escape until he suffered grievous burns.[6] For many ordinary Britons who could not vote, boycotting sugar and rum was

both the exercise of a kind of consumer-based franchise and an attempt at repairing an egregious moral wrong.

Many newspapers also took up the cause. One particularly savvy strategy to promote the antisaccharite campaign entailed a printed circular, *A Subject for Conversation and Reflection at the Tea-Table*, featuring William Cowper's popular poem "The Negro's Complaint" (1788) which considers slavery from the perspective of an African captive, emphasizing a common humanity ("Skins may differ, but affection / Dwells in white and black the same") and asking the reader to "Think how many backs have smarted / For the sweets your cane affords" (lines 15–16, 23–24). An unnamed commentator first asks: "what benevolent mind would not willingly sacrifice many gratifications, for the extermination of so accursed a traffic?" and exhorts: "Slavery depends on the consumption of the produce of its labour for support. Refuse this produce, and slavery *must* cease."[7]

Printed on a single sheet of high-quality wove paper so that it could easily be folded into a little 'letter' to be sent through the post, these provocative conversation starters were directed to women throughout the country so as to prick their consciences at the very site of domestic sugar consumption.[8] Using the sociability of the tea-table, "A Subject for Conversation and Reflection" sought to garner support for the sugar boycott, not by isolating righteous individuals, but by normalizing abstinence among local groups of women who might collectively decide to join a burgeoning humanitarian movement.

Many women poets also added their verses to the cause of abolition. For example, Ann Yearsley, a dairywoman, challenged her readers, "Must our wants / Find their supply in murder?"[9]

The success of the tea boycott in the American colonies some twenty years earlier encouraged the sugar boycotters in Britain.[10] Particularly memorable was the Boston Tea Party (1773) when The Sons of Liberty, some of them 'disguised' as indigenous Americans, threw an entire shipment of East India Company tea into Boston Harbor in protest against import duties imposed by Great Britain.

In the United States, Benjamin Rush, a Philadelphia physician and signatory of the Declaration of Independence, promoted both the British consumer boycott and an American alternative to the sugar cane grown, harvested, and processed by slaves. In his *Account of the Sugar Maple-Tree of the United States* (1792), he intriguingly observes: "Mr. Jefferson uses no other sugar in his family, than that which is obtained from the sugar maple tree."[11] Rush's pamphlet was quickly reprinted in London by the Quaker abolitionist printer James Phillips, but his proposal never enjoyed popular appeal. A more

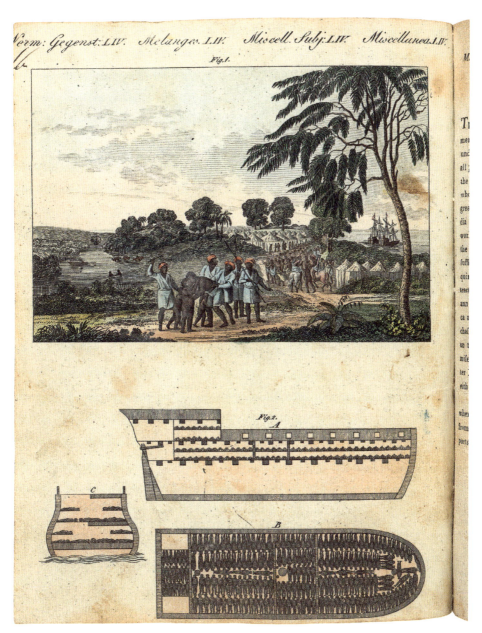

Friedrich Justin Bertuch, *The Slave Trade*, in: *Picture Book for Children*, Vol. 4/5, Weimar, 1802–1805

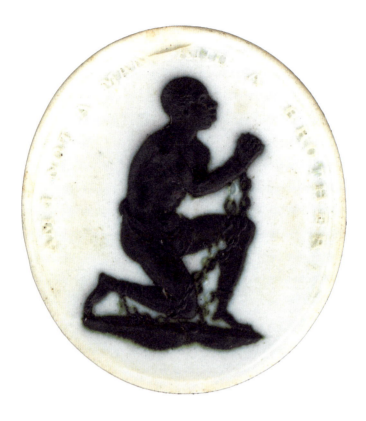

William Hackwood, Wedgwood medallion of the abolitionist movement with a kneeling slave and the inscription, "Am I Not A Man And A Brother?", ca. 1787/1790

prominent and persistent alternative was so-called East India sugar, touted as the produce of free labour, although many workers in colonial British India were themselves toiling under highly exploitative conditions.[12]

In keeping with its policy of not wishing to alienate members of Parliament, the London Committee for Effecting the Abolition of the Slave Trade never officially endorsed the sugar boycott; instead, the Committee's Chairman Granville Sharp weakly affirmed in a circular letter of 26 April, 1791, "We cannot persuade ourselves that the prosperity of the West-India Islands depends on the misery of Africa; or that the luxuries of Rum and Sugar can be attained only by tearing asunder those ties of affection which unite our species." Sharp implies the Committee's tacit endorsement of the boycott when he refers to "the period of Abolition, a period which we call on every

man . . . to assist in hastening", but that is as close as the most powerful and visible abolitionist group in Britain came to a public affirmation of the boycotters' activities.[13]

Would the boycott have been successful if it had received an unqualified endorsement from the London Committee? We can never know, but it is revealing that more than four years later the poet Samuel Taylor Coleridge had not relented: "If only one tenth part among you who profess yourselves Christians; if one half only of the Petitioners [for abolition of the slave trade]; instead of bustling about with ostentatious sensibility, were to leave off – not all the West-India commodities – but only Sugar and Rum, the one useless and the other pernicious – all this misery might be stopped."[14] Britain outlawed the slave trade in 1807, but did not abolish slavery as such until 1833; before that would happen, there would be more boycotts to come.[15]

1 See Clarkson 1808, Vol. 2, 350. Another contemporary witness estimated the number at 400,000; see Bradburn 1792, 13.
2 Fox 2011, 7.
3 Ibid., 3.
4 Fox 1791b, 13th edition, title page. On Martha Gurney, see Whelan 2011, 44–65.
5 For a discussion of false editions of this pamphlet, see Suarez 2021.
6 On these three prints, see Stephens/George 1870–1954, Vol. 6: nos. 8074, 8081, and 7848.
7 Cowper 1791, 3–4.
8 See Clarkson 1808, Vol 2, 190.
9 Ann Yearsley, *A Poem on the Inhumanity of the Slave-Trade* (1788) and Mary Birkett, *A Poem on the African Slave Trade. Addressed to Her Own Sex* (1792), quoted in Basker 2002, 376, 444.
10 See Sussman 1994, 48–69.
11 Rush 1792, 14.
12 See Major 2012, 293–315.
13 Granville Sharp, Chairman, Society Instituted for Effecting the Abolition of the Slave Trade, Circular letter, 26 April 1791.
14 Coleridge 1970, 138.
15 See Midgley 1992, 1–119.

Tobacco tin with Wedgwood motif and the inscription "Humanity", England, ca. 1800 / National Maritime Museum, Greenwich, London

The tobacco tin bears the motif of a kneeling enslaved person, which was introduced as the symbol of the Society for Effecting the Abolition of the Slave Trade in 1787. After the abolitionist and ceramics manufacturer Josiah Wedgwood had medallions made with this political emblem, it evolved into the identity mark of a whole movement and inspired the decoration of a variety of every-day objects. The tobacco tin stands out in the veritable flood of items, and for a scurrilous reason: it served to store a product the high European demand of which spurred on the exploitation of the colonised territories and the institution of slavery. The paradox between the function of the tin and its appeal for "Humanity" mirrors the conflicts both between social engagement and economic interests and between morality and the conduct of the product's consumers.

NINA MARKERT

Account book of the slave ship *Molly,* England, 1759 / National Maritime Museum, Greenwich, London

The entries in the account book of the ship *Molly* from 8 February 1759 on (the now Nigerian) Bonny Island shed light on the inhuman slave trade. Alongside columns for rifles and muskets, oranges, brandy, and the West Indian textile "Nickanees" there are entries for "men", "women", "boys" and "girls". Since the Early Modern Age and on into the 19th century, European countries like Great Britain, the Netherlands, Portugal and Prussia carried on the so-called "triangular trade". The sale of enslaved people, for the most part West Africans who had been abducted and deprived of their rights, was of central importance to this form of trade. Many Europeans who understood themselves as cosmopolitans ("citizens of the world") and as such endorsed the Enlightenment and its ideal of liberty profited from the slave trade. HARRIET MERROW

Convertible table (Architect's table) with mahogany veneer, England or Northern Ireland, ca. 1760/1770 / Deutsches Historisches Museum, Berlin

Starting around 1720, the colonial power England laid the cornerstone in Jamaica for a lucrative trade with mahogany wood. After a scarcity of imports due to the Seven Years' War (1756–1763), the British acquired new sources by driving the French out of their West Indian colonies Martinique and Guadeloupe, while the demand for luxury furniture with mahogany veneer simultaneously flourished in Europe. As a quasi-national working material, the tropical wood became the distinguishing feature of English manufactories. Their speciality was "intelligent" furniture that could change its form according to need. A prime example of the tectonic construction of such a convertible piece of furniture is this extendable table in the elegant, block-like, George III style with a hinged tabletop, lockable at different levels. The lower extendable half of the table has a leather-covered worktop and two sideways swing-out drawers. WOLFGANG CORTJAENS

PUBLICATION MEDIA AND PUBLIC SPHERES

12

Roger Chartier

The Influence of Publication Media

In Enlightenment Germany, terms such as *Lesesucht* (reading mania), *Lesefieber* (reading fever) and *Lesewut* (reading craze) were used to describe the perceived new reality of ubiquitous reading.[1] Throughout Europe, travelogues and genre paintings pointed to reading as a universal phenomenon of the age. The practice of reading texts of all kinds could be observed everywhere, in all walks of life and in every social milieu. Depictions of readers – in paintings or engravings, on earthenware and porcelain crockery, on personal objects or in the form of silhouettes and figurines – reinforced this impression. This genre rendered visible new groups of readers – women, children, craftsmen, farmers – as well as new habits: reading outdoors, in the garden or in nature, on a walk; in bed as foreplay or as a substitute for erotic encounters; and with others in literary salons or at home with the family. All of these representations indicate that reading practices had changed and that a growing number of readers were demanding ever more texts.

In the medical field, this observation culminated in diagnoses by physicians concerned about the destructive effects of excessive reading, which was perceived either as an individual disorder or as a collective epidemic.[2] The notion that reading combined the inertia of the body with the arousal of the imagination led to the conclusion that reading would lead to physical exhaustion or to the loss of a sense of reality. As a result, reading came to be associated with other solitary practices, particularly sexual ones, and both medical treatises and erotic novels drew analogies between reading and masturbation. Both activities were characterized as causing the same symptoms: pallor, restlessness, apathy, enfeeblement. The greatest danger was considered to be posed by lascivious or erotic novels, especially if read by a solitary woman. Excessive reading was generally regarded as dangerous, as the ailments it caused, such as indigestion, constipation or nervous disorders, were the same as those caused by hypochondria – the disease par excellence of the insatiably

reading scholar.[3] In philosophical discussions as well, reading was judged negatively if it was pursued solely as a pastime. The essential role that reading could have on the progress of Enlightenment, it was argued, would be undermined if readers indulged in unproductive reading material. If, on the other hand, reading was applied to the use of reason, it was seen as an essential aid to rational judgement and the critical examination of ideas, beliefs and institutions.

Do these contemporary perceptions allow us to conclude that an actual "reading revolution" took place in the eighteenth century? There is no consensus on this question among historians. While Robert Darnton remains sceptical ("the 'reading revolution' might be safely ignored"),[4] Reinhard Wittmann is more convinced: "Was there a reading revolution at the end of the eighteenth century? In this rough outline I have attempted to show that, in spite of all limitations, the answer to this question is yes."[5] The profound changes that the culture of the printed word underwent in the eighteenth century do seem to confirm the existence of such a revolution.

The Transformation of Print Production

First, there was the tremendous increase and diversification of print production, with the range of available books growing exponentially.[6] Based on the numbers of surviving editions, 65,000 titles were published in England in the 1790s compared with 21,000 in the 1710s. In Germany, the catalogues of books offered for sale at the Frankfurt Book Fair list 1,384 titles for the year 1765, 1,892 for the year 1775, 2,713 for the year 1785, 3,257 for the year 1795 and 3,906 for the year 1800. The genres of books being published also changed significantly. Religious works, which still made up the largest share of published works in the seventeenth and early eighteenth centuries, declined in favour of science and art as well as literature (whose share at the Frankfurt Book Fair went from 6 percent in 1740 to 21.5 percent in 1800). Based on the number of printing licences applied for, the increase in scientific books in France was proportional to the decline in religious titles. The latter still accounted for a third of the total number of books published in the 1720s, only a quarter in the 1750s and only a tenth in the 1780s.[7]

Aside from authorized publications, there was the massive dissemination of those titles the book trade labelled "philosophical". These included illegally distributed works of erotic, canonical and modern literature; radical Enlightenment writings; as well as diatribes and chronicles of scandals denouncing monarchical despotism and the corruption of those in power.[8] The political use of pornographic satire indicates that the boundaries between the

List of censored works from the archive of the Bastille, Paris, 1745–1790

genres were blurred.⁹ "Philosophical books" were a dangerous but highly sought-after commodity. They were published in Switzerland, the Netherlands and the German principalities and, despite being banned, were smuggled into France in large numbers – only for some of them to be confiscated at the gates of Paris or in bookshops. According to Darnton, their mass distribution after 1770 played an important role in the desacralization of absolutism and in criticism of the authorities generally.¹⁰ In July 1789, there were only seven prisoners in the Bastille, but 564 books were 'incarcerated' there, a representative cross-section of the books then banned: in addition to works by Voltaire, Rousseau, Diderot, Helvétius and Raynal, pornographic texts and political diatribes were also awaiting execution.¹¹

The most spectacular upheavals in print were undoubtedly in the newspaper sector. There was an impressive number of new periodicals (some long-lived, others short-lived).¹² In Germany there were 64 new titles in the 1700s, 133 in the 1720s, 260 in the 1740s, 410 in the 1760s, 718 in the 1770s and 1,225 in the last decade of the century. The growing number of titles was due to the emergence of a new type of periodical that was fundamentally different from the gazettes and scholarly journals of the seventeenth century: in England it was exemplified by *The Tatler* (1709–1711) and *The Spectator* (1711–1712), in Germany by the moral weeklies devoted to social issues. Newspapers and magazines were essential, not only for communicating aesthetic judgement and spreading controversy, but also for discussing matters of state, criticizing institutions and debating reforms.

Books, meanwhile, were becoming more accessible and, due to smaller formats (12° or duodecimo, 16° or sextodecimo and 18° or octodecimo), they became the constant companions of a large number of readers. As Louis-Sébastien Mercier writes in his *Tableau de Paris* (1782): "The mania for small formats followed that for huge white borders . . . The advantage of these books is that you can stick them in your pocket so that they can help you relax while taking a stroll or relieve boredom when travelling."¹³ These small formats made reading more free: the book no longer had to lie on a table to be read; the reader no longer had to be seated to read. This allowed a new, more immediate relationship to the written word. Books were now also easier to buy. The negative effects of increasing prices – in Germany, the price of novels in the original edition rose eight- or ninefold in the last third of the eighteenth century – were tempered by two phenomena. One was large-scale pirating: the publication of works bypassing the publisher who owned them or held the copyright.¹⁴ Pirated editions lowered the sale prices as these printers saved on manuscript licensing costs and printing patent fees. In France, it

Pornographic scene from: *Thérèse philosophe (Thérèse the Philosopher)* by Jean-Baptiste de Boyer, Marquis d'Argens, London, 1783

was provincial booksellers or foreign printing houses that pirated at the expense of Parisian publishers who owned the royal printing patents. Scottish and Irish booksellers pirated at the expense of the Stationers' Company booksellers' guild members in London, whose exclusive right to print had been revoked by the Statute of Anne in 1710.[15] The condemnation of illegal reprinting by both Fichte and Kant indicates how widespread this practice was in the Holy Roman Empire.[16] Given the different laws in the various German-speaking territories, it was hardly possible to insist in one country on a privilege granted by the authorities of another. These commercial disputes were to the benefit of readers.

Reading without Buying
The second phenomenon was the increasing number of institutions springing up all over Europe that made it possible to read a book without purchasing it. They created a far wider access to books than the princely or ecclesiastical libraries, which were only open to a small, select circle of people.[17] Booksellers now began to establish lending facilities under various names (circulating library, rental library, lending library, *cabinet littéraire*, etc.), where, for an annual or monthly subscription fee, any of the books in the library catalogue could be read on site or taken home. This offer proved very popular in England, where it first appeared in the early eighteenth century and flourished from 1740 onwards, possibly inspired by the common practice of coffee houses providing their customers with newspapers and polemic pamphlets. An (incomplete) list shows 380 such circulating libraries that maintained operations more or less consistently in the eighteenth century: 112 in London and 268 in the rest of the country, spread out over 119 locations. The phenomenon was not limited to the major cities: the first French *cabinet littéraire* was opened in Lyon in 1759, and until 1789, according to a very incomplete survey, there were 13 *cabinets* in Paris and 36 in the provinces.[18]

Book clubs presented another new way of borrowing books. For an annual fee, members could borrow the publications they had purchased collectively, which were then auctioned off at the end of the year or kept in the club's own subscription library. In England, book clubs began to proliferate from the 1720s and the first subscription library was founded in Liverpool in 1758. In Germany, the number of reading societies increased significantly and continually from 1770: while only 17 societies existed before then, between 1770 and 1779 there were 50, 170 in the following decade and 200 between 1790 and 1800. They spread from the Reformed, enlightened areas on the Rhine and in northern Germany to the neighbouring Protestant countries and from 1780

also to the Catholic regions of southern Germany. And throughout the country, they spread from the urban centres to the small towns.[19]

Reading societies played a profound role in the three key developments of the Enlightenment: they promoted democratic processes, as decisions were made by majority vote without regard to social status; they contributed to the civilizing process, as their statutes sanctioned uncivilized behaviour; and, along with literary societies and Masonic lodges, they helped create a new public space in which private citizens could discuss matters of state without interference by the authorities. Because they made it possible for a wider readership to read more books and provided a large market for periodicals and costly series (dictionaries, encyclopaedias, and multi-volume anthologies often called "libraries"), reading societies fundamentally changed reading practices and contributed to the emergence of a new type of reader.

All of this created the foundation for a greater presence of the printed word, for the spread of new literary genres and new publishing products, and for new ways of reading. The latter is implicit in a motif that was very popular in literature and painting in the late eighteenth century: the rustic and patriarchal trope of the evening reading hour, when the head of the family reads aloud to the assembled household. This idealized representation expressed a longing for a lost mode of reading, a regret over the disappearance of a world in which books were revered and authority respected. This mythical image of communal reading unmistakably addressed – and stigmatized – the banal gesture of the urban, casual and careless approach to reading that stood in contrast to it.

A Reading Revolution?

Are there then two types of reading – traditional, "intensive" reading on the one hand and modern, "extensive" reading on the other, with the latter drawing the attention of contemporary observers (who often condemned it)? According to Rolf Engelsing, the intensive type of reader engages with a limited, closed body of texts that are read again and again, memorized, recited, listened to, known inside out and passed on from generation to generation.[20] There is something sacral about this old way of reading, which subjects the reader to the authority of the text. The modern extensive type of reader, takes a quite different approach, consuming many new, short-lived print products, reads quickly and avidly and approaches texts with a distanced, sceptical eye. Engelsing maintains that the traditional relationship with the written word, characterized by communality and respect, was replaced by a freer, less forced, more critical way of reading.

Susanna Duncombe, *Group portrait with Samuel Richardson*, 1801–1815

Numerous objections have been raised to this characterization and its division of reading into a before and after with a bona fide "reading revolution" in between. For one, because some people – the humanist scholars of the Renaissance, for instance – were already reading extensively in the "intensive" phase. Conversely, it was precisely during the extensive "reading revolution" that the most intensive of all reading styles developed. This was the era of Richardson, Rousseau, Bernardin de Saint-Pierre and Goethe, whose novels captured their readers, shackled them to the word and dictated their thinking and behaviour.[21] Epistolary novels such as Samuel Richardson's *Pamela* (1740) or *Clarissa* (1748), and Jean-Jacques Rousseau's *Julie or The New Heloise* (1761), as well as novels such as Bernardin de Saint-Pierre's *Paul and Virginia* (1788) and Goethe's *The Sorrows of Young Werther* (1774) were read, memorized, quoted and recited over and over again. The reader identified with the main character of the story and interpreted their own life based on the fictional events of the plot. This new kind of intensive reading appealed to sensibility as such. The reader, who was most often female, was unable to hold back her emotions or her tears. Shaken, readers sometimes took up the pen themselves or entered into correspondence with the author, who had become nothing less than a guiding star of conscience and existence.[22]

Furthermore, novel lovers were not the only "intensive" readers at the time of the "reading revolution". The reading behaviour of the majority of the population and of ordinary people, whose reading material was provided by the peddlers of cheap books, still largely kept to the old habits. Reading English chapbooks or the *Bibliothèque bleue* volumes in France retained the traits of a rare and difficult practice that required memorization. Thus the texts in these anthologies were less about discovering new things than about recognizing genres, themes and motifs, and as such they differed from the expectations and behaviour of avid, critical readers.[23]

Paradoxically, the changes in printing and reading practices were accompanied by a twofold continuity. First, there was administrative continuity: everywhere in eighteenth-century Europe, printed matter was subject to both pre-censorship (license to print) and post-censorship (monitoring of printed products). The former fell under the jurisdiction of the state, which issued licences and printing permits; these often went hand in hand with the granting of a privilege. In the latter case, the books were placed on the Index of the Catholic Church or on lists maintained by the state. The police confiscated banned works from bookshops or private libraries and destroyed them.

Second, there was technical continuity: as the plates of the *Encyclopédie* (vol. 6, 1769) show, book production in the eighteenth century was still very much like that of the fifteenth century; there had been no significant changes, neither in the organization of the workshops nor in the production process. The print run was usually between 1,250 and 1,750 copies, changes could be made during the printing process, and proofreaders and typesetters played important roles. In this sense, the eighteenth century was closer to the incunabula period than to the era of the double revolution in printing and typesetting, which fundamentally changed workshops and editions in the nineteenth century.

The persistence of letterpress printing should not obscure the importance of rolling press printing, which led to a great increase in the production and circulation of images. Images were the main drivers of the "first media revolution", as Antoine Lilti puts it.[24] Printed pictures – which were sold by itinerant peddlers, were displayed on walls and could also be understood by illiterate people – fulfilled several purposes. For one, they portrayed heroes and episodes from novels for those who only had access to extracts from these works or were unable to read them at all. Thus scenes from *Pamela* were depicted in paintings and engravings, with wax figures and on fans. Alongside lockets, miniatures and statuettes, prints were a key ingredient of celebrity culture, used to lend visibility to the heroes of the era – such as Benjamin

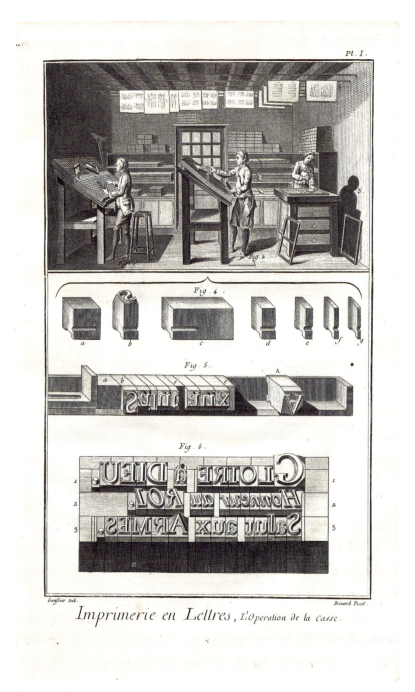

Goussier after Bernard, Illustration on the art of printing, from: Illustrated volume 7 of the *Encyclopédie* by Denis Diderot and Jean le Rond d'Alembert, Paris, 1769

Franklin, of whom likenesses could be found all over Paris. Printed images were ultimately able to generate stronger emotions than the printed word, as demonstrated by the response to depictions of the sad fate of Jean Calas, who fell victim to an intolerant and unjust justice system.

Women were taken up into the community of readers in the eighteenth century, and they were often depicted reading or with a well-stocked library in the background. For them, as for male readers, the spectrum of reading possibilities expanded to include duty as well as entertainment, immersion as well as spontaneity. The variety of reading practices available to the individual reader does not allow for too distinct a comparison between the different modes. In general, depending on the situation or their needs, readers could either read intensively or extensively, alone or with others, for study or for pleasure. As Lord Chesterfield put it in a letter in 1757: "Solid *folios* are the people of business, with whom I converse in the morning. *Quartos* are the easier mixed company with whom I sit after dinner; and I pass my evenings in the light, and often frivolous *chit-chat* of small *octavos* und *duodecimos*. This, on the whole, hinders me from wishing for death, while other considerations hinder me from fearing it."[25]

Is it conceivable that the Enlightenment "reading revolution" consisted precisely in the plurality of ways of reading? This would also explain its limitations, given that far from everyone had the means to explore these different modes – they were reserved for the most knowledgeable and wealthy, not for the common readers, despite advances in literacy, and even less so for the illiterate who had to rely on the oral transmission of texts. It is to this that we can attribute the complexity of this revolution, which is not to be seen in the hegemonic imposition of a new reading style, but in the diversity of reading practices made possible by changes in the culture of the printed word.

1. See Goetsch 1994.
2. See Wenger 2007.
3. See Tissot 2001.
4. Darnton 1995b, 219.
5. Wittmann 1999, 311.
6. See Barber/Fabian 1981.
7. See Furet 1965.
8. See Darnton 1995a.
9. See Goulemot 1993.
10. See Darnton 1991, 214 f.
11. See Chartier 1991.
12. See Bödeker 1996.
13. Mercier 2012, 99.
14. See Darnton 2021.
15. See Rose 1993.
16. See Fichte 1793 and Kant 1907 (AA 6), 289–291; see also Woodmansee 1994.
17. See Dann 1981.
18. See Genequand 1995.
19. See Prüsener 1972.
20. See Engelsing 1969 and 1974.
21. See Chartier 2005.
22. See Labrosse 1985; Darnton 1984.
23. See Chartier/Lüsebrink 1996.
24. See Lilti 2017, chapter 3.
25. "Letters to Dr. Richard Chenevix, Lord Bishop of Waterford", Letter XXXI, Bath, Nov. 22, 1757, in Stanhope 1777, 348–350.

Robert Darnton

Kant, Piracy, and Enlightenment

Half a year after answering the famous question, "What is enlightenment?" in the *Berlinische Monatsschrift* of December 1784, Immanuel Kant posed a follow-up question in the same periodical: "What is a Book?" His answer was: "the instrument for delivering the author's speech to the public." (In the original German: "Ein Buch ist das Werkzeug der Überbringung einer Rede ans Publikum."[1]) As reformulated in *Metaphysics of Morals* (1797), the answer was virtually the same: "A book is a writing which contains a discourse addressed by someone to the public through visible signs of speech."[2]

The definition differs markedly from Denis Diderot's celebration of the book as the product of an author's creativity: "a work of his spirit, the unique fruit of his education, of his studies, his vigils, his time, his research, his observations... the sentiments of his heart, the most precious portion of his self, that which does not perish, that which immortalizes him."[3] The two ways of describing a book's essence pointed in opposite directions. Paradoxically, however, Diderot's poetic language belonged to an economic argument (books were property), and Kant's prosaic definition supported an elevated notion of communication (books spread enlightenment).

Although Diderot certainly meant what he said, his remarks were intended to support the lobbying of his publisher, André-François Le Breton, who wanted to protect the interests of the Parisian booksellers' guild at a time when the state was planning to reform the book trade.[4] The Parisian publishers claimed that they possessed limitless rights to the books they produced, because they had purchased the texts from the authors and the authors had owned them in the same way as a farmer owned land. The argument was based on a Lockean view of property as a natural right, and it had appeared in polemics that went back to the book-trade code issued by the Crown in 1723. The code did not define the nature of literary property. It merely regulated procedures for obtaining a privilege – that is, the exclusive right to sell a

book granted by the Crown to a member of the booksellers' guild for a certain time. That time period, according to the guild members, was unlimited, because a privilege expressed an implicit, absolute right to property. When the state finally addressed this issue, in a new code issued on August 30, 1777, it rejected the guild's view. It defined a book privilege as "a grace founded in justice". Authors and their heirs could hold privileges perpetually, the Crown ruled, but when they sold a privilege to a bookseller, it would be valid only for a limited time. To extend privileges indefinitely "would be to convert the enjoyment of a grace into a property by right".[5] The code even authorized the sale of pirated books for a limited period, provided that they were inspected and stamped by royal officials. By this time at least half the works on the French book market were pirated, and piracy had become the most important issue in the struggles to dominate the book trade.[6] France did not acquire a copyright law until 1793.

Copyright existed in Britain since the "Statute of Anne" of 1710, which limited the right to sell a book to fourteen years, renewable once.[7] However, the London Stationers' Company contested this limit in a series of court cases by arguing that the statutory law should be subject to the right of property, which made copyright permanent in accordance with a natural law principle implicit in common law. The issue was decided in the famous case of Donaldson v. Becket of 1774, which made statutory law supreme, thereby limiting copyright to a maximum of 28 years. Debate in the House of Lords, where the case was resolved, expressed the view that publishing should serve the public welfare by promoting the circulation of knowledge.

In German-speaking parts of Europe, rulers granted privileges for books within their territories, but there were so many territories that no legislation, not even privileges issued in the name of the Holy Roman Emperor, established common rules about literary property.[8] Instead of favouring a Lockean concept of property, theoretical discourse combined elements of natural law and Roman law in language that was shifting from an archaic notion of literary property (*geistiges Eigentum*) toward a concept of copyright (*Urheberrecht*) that would prevail in the nineteenth century. While publishing expanded, the legal book trade was badly damaged by pirating, especially from protected enclaves like Vienna. Indeed, pirating flourished throughout Europe, even in England, where the monopoly of the Stationers' Company was undercut by raids from publishers in Ireland and Scotland. Publishers and booksellers were well aware of the debates over piracy and literary property everywhere in Europe. When the publishers in Lyon received word of Donaldson v. Becket, they wrote triumphantly to allies in the provinces that they should make use

of the British precedent in lobbying against the Parisian guild's monopoly of privileges in France.[9]

Kant issued his "What is a Book?" in full awareness of this international context. The importance of pirate publishing in his argument stood out in the original title of the essay: "On the injustice of unauthorized publication of books" ("Von der Unrechtmässigkeit des Büchernachdrucks"). The injustice did not consist in the violation of a property right transferred from the author to the publisher, Kant maintained, because the book was an instrument of speech addressed by the author to the public. The author gave the publisher an exclusive mandate to speak in his name, and the wrong committed by the pirate was an infringement of that mandate. In the *Metaphysics of Morals*, Kant writes: "Now the unauthorized printer and publisher speaks by an assumed authority in his publication in the name indeed of the author, but without a mandate to that effect... Consequently such an unauthorized publication is a wrong committed upon the authorized and only lawful publisher, as it amounts to a pilfering of the profits to which the latter was entitled..."[10] That was Kant's only reference to money. What concerned him was the author's agency in the transmission of his ideas.

Conspicuously absent from this argument was the Lockean concept of property. Kant understood publishing as an act of communication. His essay on the book therefore complemented his essay on the Enlightenment, which he defined as "man's emergence from his self-incurred immaturity... *Sapere aude* [dare to know]!"[11] Most people lacked the daring as well as the maturity to think for themselves, Kant wrote. But within the public, a few independent thinkers "... will spread about them the spirit of a reasonable appreciation of man's value and of his duty to think for himself". How did this spreading take place? By "the public use of one's reason" – that is, by communication through the printed word. It was not until 1794 that a copyright was finally adopted in Prussia that created a particular publication right (*Verlagsrecht*) that belonged to the author for life.

Ironically, however, some eighteenth-century pirates justified their activity in a way that was compatible with Kant's emphasis on communication. They claimed that they contributed to the Enlightenment, because they spread ideas by selling books – more and cheaper books than those offered by publishers with the privileges to them. Moreover, they did not break the law – at least not French law, if they reproduced books outside France's borders. As no international copyright existed, pirates in the Netherlands and Switzerland acted as respectable businessmen in reprinting books that had appeared with a privilege in France.

Fortuné Barthélemy de Félice, a prolific pirate publisher in Yverdon, Switzerland, sounded downright Kantian in describing his business. He did not consider the works he produced as mere articles of commerce, and he wrote: "Any bookseller or printer who by means of unauthorized reprints [*contrefaçons*] spreads good books more abundantly and rapidly, deserves well of humanity."[12] Nicolas-Guillaume Quandet de Lachenal, an underground dealer who acted as the Parisian agent of another Swiss pirate, claimed to work for the same cause: "I do not enlighten myself; I am content to carry the torch."[13] His employer, the Société typographique de Neuchâtel, wrote to one of its clients, "If Enlightenment [*lumières philosophiques*] is lacking in this best of all possible worlds, it certainly won't be our fault".[14] The same justification applied to pirate publishers in German-speaking parts of Europe.[15]

I doubt that the pirates read Kant's essays, and I do not want to minimize the economic motives behind their businesses. But I believe the Enlightenment was essentially a struggle to spread light. Pirate publishers played a crucial role in this process, and so did booksellers, peddlers, smugglers, and even wagon drivers. The cultural middlemen deserve a place, along with Kant and other philosophers, in the history of the Enlightenment.

Kant's place warrants consideration in today's debates about the communication industries. Copyright law has turned into an enclosure movement, which excludes from the public domain almost every book that was published within the last hundred years. Monopolistic practices have prevented readers from having access to vast numbers of scholarly articles. Although Kant's ideas had little effect on copyright in his time, they are directly relevant to the current movement for open access to knowledge on the Internet. If Kant were alive today, he probably would subscribe to the Budapest Open Access Initiative of 2002: "The literature that should be freely accessible online is that which scholars give to the world without expectation of payment... The only role for copyright in this domain should be to give authors control over the integrity of their work and the right to be properly acknowledged and cited."[16] He might go further. As he rejected a Lockean view of property in books, he might advocate that all knowledge should be freely available, like clean air and water, to everyone everywhere.

Library and bookshop, from: *Bildergalerie weltlicher Misbräuche [...] (Picture Gallery of Worldly Abuses . . .)* by Joseph Richter (pseudonym Pater Hilarion), Leipzig/Frankfurt a. M., 1785

1. Kant 1785, 407.
2. Reproduced in Kawohl 2008. The following discussion draws on Kawohl's excellent commentary and on Laursen 2012. For slightly different translations, see Gregor 1996.
3. Diderot [1763] ed. Bon/Mailler 1984, 57.
4. See Darnton 2021, 14–15. Cf. Birn 1971, IV, 131–68.
5. The reformed code was issued in six edicts of 30 August 1777, see Darnton 2021, 34–37. The quotations refer to the original manuscript in the Bibliothèque nationale de France, Fonds Français, 22180, nr. 80.
6. See Darnton 2021, chapter 1.
7. On the debates over copyright in England, see Rose 1993. On publishing and the book trade, see Raven 2007; and Suarez/Turner 2009.
8. See Wittmann 1991.
9. See Darnton 2021, 32.
10. "What is a Book?" (the text consists of only three paragraphs), in Kawohl 2008, which also contains the original German text.
11. Here and in the following quoted from Kant, "Answering the Question: What is Enlightenment?", translation in Gregor 1996, 11–12.
12. Quoted in Perret 1945, 205.
13. Quandet de Lachenal to the Société typographique de Neuchâtel, 4 Dec. 1780 in Bibliothèque publique et universitaire de Neuchâtel, papers of the Société typographique de Neuchâtel, Quandet dossier.
14. Société typographique de Neuchâtel to J. G. Bruere of Hamburg, 19 August 1779, papers of the Société typographique de Neuchâtel.
15. See Wittmann 1981, 292–320.
16. See https://www.budapestopenaccessinitiative.org.

Volker Gerhardt

Enlightenment, the Public Sphere, and Morality

In trying to describe what cognition and knowledge are about, we soon find ourselves using terms and metaphors related to seeing and light. "View", "vision", "elucidation" and "insight", for example, are indispensable when we want to recognize and understand something. However, the test of whether we have truly understood something is being able to communicate it – ideally in such a way that it can be understood by others. And for this, we must rely on the accomplishments that make comprehension possible in the light of a common understanding. Cognition, knowledge and understanding therefore involve a realm of communication in which it can become clear, to a large number of people, what cognition and knowledge are about. And if this realm of mutual insight also allows action on their part, we speak of the public sphere. Only there is it possible for the enlightenment associated with acts of cognition to become a social reality.

It is by no means the case that public realms were first created through modern communication technologies, as some people believe. Rather, it is the large areas of comprehensive sovereignty asserted by earlier states that gave rise to public realms in the Middle East and along the major rivers of China, India and North Africa. These enabled the spread of writing, crafts and law, as well as the concomitant achievements of an administration spanning multiple generations. They also facilitated the circulation of mythical narratives and expansive religious doctrines, all the while encouraging wide-ranging trade that was capable of transcending cultural boundaries. It was in these circumstances, in the last few millennia before the Common Era, that the first methodically guided scientific endeavours took place in fields that would later be known as astronomy, medicine and mathematics. The highly developed cultural technologies that were employed along the Euphrates and the Nile bear witness to the fact that there were already numerous skilled workers there with the knowledge required to master the diverse and sometimes highly

specialized tasks involved in the construction of stately palaces, temples, fortifications, or pyramids, as well as in irrigation, material refinement and the mummification of humans and animals. Records show that even in these early years there were priests and scribes responsible for preserving historical knowledge and tradition. They too served to promote understanding across the generations. It may be taken for granted that all of this required knowledge of what had succeeded elsewhere. To be sure, there were many different forms of social segregation, especially among priests, doctors, architects, astronomers and, indeed, among literate people in general. However, the achievements of cognition, discovery and manufacturing in vast and diverse realms demonstrate the success of communication and cooperation despite enormous social, religious and political differences.

Pre-Socratic Enlightenment

As we approach the last millennium before the Common Era, we find more and more traces of sages, prophets and poets – those whose statements attracted so much attention that their utterances have been preserved in transcripts. Some of them are still known by name today, such as the Biblical prophets, the poet (or "singer") Homer, and the cultural critic Hesiod. A few hundred years later come the songs of Sappho and Pindar. Their contemporaries now included people such as Thales and Pythagoras, who were not only renowned as mathematicians and engineers, but also acclaimed for their reflections on the laws of nature, the course of the stars and the place of mankind. They are "wise men" (*sophoi*) who make fundamental statements about the relationship of men to gods, determine the differences between peoples and try to analyse the difference between men and animals or the nature of war and peace.

Anyone who distinguished themselves with such pronouncements in the Greek cultural sphere was retrospectively called a "philosopher" (*philosophos*); and those who attracted particular attention were later regarded as "pre-Socratics". They are the first who may justifiably be termed "enlighteners", as they were generally also concerned with communicating their discoveries and insights. This is reflected in the fact that they acted as advisors to rulers, as teachers or, like Solon, as politicians themselves. They endeavoured to address all areas of human knowledge, but also to make people aware of its inherent limitations. It is of particular importance to the understanding of "enlightenment" that these sages were concerned with insights for which they vouched personally.

Emanuel Bardou, *Immanuel Kant*, 1798 (original), copy, Berlin, 1994

Socratic Enlightenment

Anyone who is unsure whether the proverbial wisdom of the pre-Socratics actually constitutes enlightenment can turn directly to the person to whom the pre-Socratics owe their name: namely Socrates. He was put on trial in 399 BC, sentenced to death, and subsequently executed on account of views that he had expressed in public and then defended in court – views that allegedly corrupted the youth and defamed the gods, and thus were considered dangerous to society. It was with Socrates, if not earlier, that the Greek enlightenment began. It was he who gave precedence to cognition and knowledge – and with them to reflection and individual insight as well as the exchange of opinions and their justification on grounds that are valid for all people. Socrates spoke in public and expounded upon his ideas in numerous discussions in the public spaces of Athens. We know this mainly from the sophisticated dialogues of his

pupil Plato, whose works have preserved a vivid portrait of the thinker for posterity.

It is also to Plato that we owe the continuation and exemplary elaboration of the Socratic enlightenment. Deeply impressed by his teacher's life and death, he abandoned his plans for a career as a writer of tragedies and instead became a philosopher, an enlightener par excellence. As a thinker, Plato succeeded in combining the notional universality of knowledge with the perception of the sensory diversity of existence; as an artist, which he fully remained even as a philosopher, he demonstrated the ability to illustrate the uniqueness of the human experience of life in important literary works of art.

More than two thousand years later, Friedrich Nietzsche judged that Socrates had managed to save humanity from "collective suicide" in desperate situations solely through the example of rational confidence provided by his life and death.[1] Nietzsche also expresses the greatest admiration for Plato's aesthetic creativity and speaks of him as a "divine"[2] human being who, in the *Dialogues*, has created the "prototype of the novel".[3] In this astute admiration for his two philosophical antipodes, of whom he usually has nothing good to say, Nietzsche hints that he is nonetheless an enlightener himself – a suspicion reinforced by a sentence that can be found among his notes for the unfinished book *We Philologists*: "*Socrates*, just to confess it, is so close to me that I am almost always fighting a battle with him."[4] It may be considered a general characteristic of enlighteners that they, as individuals, seek knowledge that is honed through contradiction with their peers, and which in this very way serves the interests of all. Incidentally, looking at Nietzsche makes it clear that an artist, too, can be regarded as a bringer of enlightenment.

Leaving the Darkness of the Cave

In a myth that is one of the great artistic treasures of the Occident, Plato unfolds a panorama of how the human origin of culture might have come about. The myth tells of the beginning of enlightenment and of the opportunities that it opens up for humanity, in full awareness of the dangers that it can never fully overcome.

I am referring to a parable that we know today as the "Allegory of the Cave". Even today, its detractors regard it as a paradigm of the promise of an afterlife with a far-fetched "doctrine of ideas" that supposedly places humans in proximity to the gods. However, Plato's allegory of the cave has not the slightest thing to do with this. It is rather the case that Plato seeks to prepare people for a life led under the condition of objective knowledge. The aim is to enable each individual to recognize common problems through a truthful ap-

proach to the world and its physical objects, to deal with them cooperatively and thus ultimately to enable all people to establish a well-grounded political community.

The myth has been erroneously burdened with a meaning primarily related to the hereafter, although Plato is obviously concerned with the solution of contemporary social and political problems. This misconception originates in the misleading translation of the Greek word ιδέα as "idea" although the word now used in English is "form", usually capitalized. If ιδέα is taken to mean only a means of access to something otherworldly, then ultimately the allegory of the cave merely offers a view of a supernatural future. In fact, however, the ιδέα is nothing other than the notion that allows people to recognize and use a substance as a specific thing. And thus ιδέα – that is, the unchangeable, absolute essence of a thing – also helps to draw clear distinctions between the object and the substance.

Once we correctly understand the meaning of ιδέα, we can recognise Plato's allegory of the cave as the key narrative of an enlightenment of mankind in general. It begins with people who cannot yet move freely, who do not speak to anyone and who can only perceive the shadows of random objects cast by firelight. The chained and imprisoned cave-dwellers live in a *pre-enlightenment state*. The chance of anything at all changing for them lies solely in the fact that they can leave the cave so that the brilliant rays of the sun can – literally – enlighten them. Only the sun radiates a brightness that encompasses everyone equally and recurs periodically, a light in which people can move of their own accord, perceive one another and think for themselves.

Here, the radiance of the sun is the source of all earthly light, in which people are bathed day after day and to which they, as living creatures, even owe the ability to see. In the light of the sun, individuals who have escaped from the cave can perceive everything that their eyes are capable of seeing. And under the conditions of general visibility, people can communicate with their peers about the objects that they see – without having to touch, dismantle or destroy them in doing so.

This myth can be read, as Plato envisaged, as a parable, taken to the extreme, about the origin of cognition and the formation of knowledge. He thus illustrates not only the origin of the conscious division of labour, but also the initial conditions of consensually accepted politics.

Counter-Enlightenment from the Beginning

It is not unimportant that Plato's origin myth also takes the opponents of enlightenment into account. In the allegory of the cave, there are anonymous

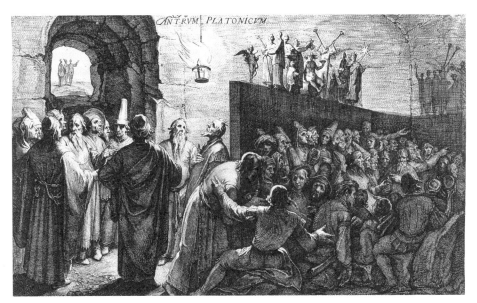

Jan Pietersz Saenredam, after Cornelis Cornelisz van Haarlem, *Antrum Platonicum (The Cave of Plato)*, 1604

prison warders who have locked people up in the darkness of the cave, shackled them and forced them to gaze only at the cave wall on which shadows are cast. They can be described as torturers who not only prevent the prisoners from moving around, but also make it impossible for them to have contact with each other. They prevent enlightenment – which enables clear vision, free movement and unambiguous mutual understanding – from coming about at all.

After the captives have managed to leave the cave, some of their former tormentors apparently follow them. Because from then on, there are also people who exploit cognition to achieve its opposite. They use their knowledge not to open a gateway to a world in which they may live in harmony with others, but rather to mislead them and lure them to their ruin. They deny the truth and merely feign the appearance of searching for it seriously, making false claims and false promises in order to distract gullible people from proper insights and to stir up suspicion against those who think differently. They misuse, in full awareness, the achievements that are due to enlightenment and exploit them to mislead others. This in itself could be described as the "dialectic" of enlightenment, because here the achievements of cognition are used to undermine well-founded insights and the agreements based upon them.

This practice may seem like a logic inherent to the Enlightenment, especially as every insight deserves to be subjected to scrutiny. In this case, however, it is wilful inversion, driven by particular vested interests and malicious intent. The ostensible "dialectic" is the result of abuse that occurs when cognition is not combined with the openness and sincerity that every human being should feel ethically obliged to demonstrate. It is no coincidence that Plato deals with the principles of ethics and law before he presents the allegory of the cave. In these dialogues it is made clear that ethics and law oblige individuals to be truthful with themselves and just in their dealings with their peers.[5]

Plato presents the enemies of enlightenment as "sophists". Their literary representative is a certain Thrasymachus, for whom notions serve only to invert their meaning. Thus, more than two thousand years before the appearance of the phrase "dialectic of enlightenment",[6] Plato provides an example of a way in which enlightenment can turn into its opposite. Yet this is far from being a predetermined logic of history. It is nothing more than the abuse of insight and knowledge by people who expect to gain a personal or political advantage from doing so. This is why Plato sees the sophists as the attendant enemies of the evolution, attained through insight and understanding, of a humane way of life.[7]

In fact, the sophists specialize in using notions and seemingly logical discourse to pursue the exact opposite of enlightenment. Their method involves distorting the facts and flatly denying the truth. Against this background, the history of the ancient enlightenment may be understood as the endeavour to find a way out of a maze of deception, dissimulation and gross fabrication in order to enable consensual action among people through verifiable knowledge, universal reasoning and mutual understanding. For Plato, it is not until we have stepped out into the earthly world illuminated by sunlight that we can deliberate laws, found states committed to justice, take ethics seriously and create art. Once we accept this premise, we can appreciate how comprehensive the paradigmatic significance of the allegory of the cave is.

Enlightenment and Humanity

The basic idea of enlightenment remains alive in the subsequent philosophy of antiquity. This applies in particular to Cicero, who saw himself as a Platonist and who remains influential to this day. In the centuries following Cicero's death in 43 BC, Plato faded into the background, and for a long time attention centred above all on his pupil Aristotle, who focused on – and became eminent for – dispassionate objectivity.

Plato's work was rediscovered after Ottoman forces conquered Athens in 1456 and part of the library there was brought to Florence. His work was then translated into Latin. The historical impact was enormous, as Plato became a source of inspiration for the Renaissance and a spokesman for modern humanism. Ultimately, Socrates and Plato also proceeded to become the definitive enlighteners of modern-era thought. How this came about can be shown by looking, for example, at the republicanism of Erasmus of Rotterdam, the progress made by Las Casas in pioneering human rights, Montaigne's era-defining essays, and the work of John Milton. Milton harnessed the notion of the ancient public sphere in his criticism of censorship and his defence of English parliamentarianism. In the 1644 polemic *Areopagitica* (the title is derived from the site of tribunals in ancient Athens), he draws on examples ranging from antiquity to his own day in an attempt to secure the achievements and the future of enlightened progress in the public sphere, law, the institution of Parliament, the sciences and, not least, printing and publishing. He was followed by John Locke, Voltaire, Montesquieu, d'Alembert, David Hume, Rousseau and many other important thinkers of the European Enlightenment.[8]

Within their ranks, Immanuel Kant, whom I regard as the modern counterpart of Plato, can be understood as a modern enlightener par excellence. To him we owe not only the most succinct programme of the rational Enlightenment, but also the repeated acknowledgement of the ancient origins of his critical philosophy. In defining enlightenment as "man's emergence from his self-incurred immaturity"[9] and generalizing it as indispensable to the evolution of a peaceful, global order that encompasses everyone, Kant implicitly declares the Enlightenment to be an era that humankind must sustain if it wants to have a future at all. In Kant's fear that humankind will deprive itself of its future if it does not succeed in keeping peace throughout the world, the drama of Plato's allegory of the cave resurfaces. And when he reminds his listeners and readers of the origins of his conviction that people should think for themselves, he repeatedly – and primarily – turns to the thinker who convinced him to follow the path of individual sincerity and independence. This is none other than Socrates, to whom even his predecessors owe their collective designation, and who set Plato on the path of philosophy.

In a lecture announcement from 1765, Kant, who was then still a young university lecturer, seeks to explain to his students what it means to be a philosopher. At this point, he limits himself to the brief explanation that philosophizing means learning to "think for oneself".[10] Later, in his lectures on pedagogy, he repeatedly explains that one must proceed "socratically" in culti-

vating reason, adding: " Socrates, namely, who called himself the midwife of his listeners' knowledge, gives in his dialogues, which Plato has preserved for us to a certain extent, examples of how, even in the case of old people, one can bring forth quite a lot from their own reason."[11] In fact, we are all "old people"! We can realize at any time that the origin of enlightenment lies within ourselves. All we have to do is use our own sense of reason – and at once we are contributing to enlightenment.

1 Nietzsche 1994.
2 Ibid.
3 Ibid.
4 Nietzsche 1980, 97 (emphasis in German original).
5 See Plato 1971, 555–573.
6 Horkheimer/Adorno 2002.
7 See Plato 1971, 623–673.
8 See Gerhardt 2023.
9 Kant 1970, 54.
10 Kant 1905 (AA 2), 306.
11 Kant 1923 (AA 9), 477.

Peep-box, ca. 1750 / Deutsches Historisches Museum, Berlin

Peep-boxes, or raree-boxes as they were sometimes called, served to present images and create optical illusions. Coloured copperplate engravings could be viewed in them through a magnifying lens. The motifs were printed in strong perspective and were inverted. The boxes were made primarily in Paris, London, Bassano, Berlin and Augsburg. The illusion and the three-dimensional effect were enhanced by placing parts of the motifs behind parchment paper or metal foil and by using effective lighting with candles as well as placing mirrors inside the box. The scenes on the peep-box prints were primarily views of European cities, real or made-up scenarios and places of interest. Projectionists travelled from town to town with these "curiosity" boxes, thus offering not only entertainment, but a wondrous view of the wide world. SABINE WITT

Autograph album of Ernst Friedrich Ludwig Hoyoll, Breslau et al., 1781–1790 / Deutsches Historisches Museum, Berlin

The use of autograph albums, also known as *alba amicorum* (friendship books), became established in student academic circles at the time of the Reformation. Their owners collected comments and dedications from teachers, friends, acquaintances and benefactors. In the 18th century, the function of these handy albums changed. They were now increasingly used by the bourgeoisie, above all in German-speaking regions, to cultivate friendship cults and were artistically designed. Alongside sentimental pictures such as archaic altars, temples, memorial stones and urns that symbolised lasting friendship beyond the grave, they now contained more enlightened allegorical figures and signs such as Minerva, the goddess of wisdom, or the beehive, which came to be used as the symbol of many charitable organisations. SARO GORGIS

287

Léonard Defrance de Liège, *À l'Égide de Minerve,* Liège, 1781 / Musée des Beaux-Arts, Dijon

This street scene in front of a bookshop is an allegory on the 1782 Edict of Tolerance issued by Emperor Joseph II. The picture also addresses the importance of print media for the spread of the ideas of the Enlightenment. The sign above the entrance to a bookshop bears the name of Minerva, the goddess of wisdom, science and art. The shop's walls are plastered with advertisements for the philosophical works of Enlightenment authors critical of state and church (d'Alembert, Rousseau, Montesquieu), which hide the notices for religious treatises. Piles of packages ready to be sent to such destinations as Portugal, Spain, Rome (RO) and Naples (...PLES) refer to the role played by Liège as the hub of printing and of the Europe-wide dissemination of prohibited works. The anticlerical, pro-revolutionary stance of the artist culminated in his active participation in the razing of the medieval Cathedral of Saint Lambertus in 1793. WOLFGANG CORTJAENS

WHAT REMAINS?

Peter E. Gordon

The Enlightenment and Its Legacy

"If we are asked: do we now live in an *enlightened* age? so is our answer: No, but we indeed live in an *Age of Enlightenment*."[1] The above remark is quoted from the well-known essay by the philosopher Immanuel Kant, "Answer to the Question: What is Enlightenment?", which was first published in the December 1784 issue of the *Berlinische Monatsschrift*. If we wish to grasp the essential lesson of this memorable essay, we must first of all understand the urgency of Kant's distinction between an "enlightened age" and an "Age of Enlightenment" – not least because it is this distinction that permits us, even today, to recognize our own faces in this eighteenth-century mirror.

The philosopher distinguishes between fulfilment and process, between a completed event and an ongoing collective effort. The notion that one already inhabits a fully *enlightened age* implies a certain arrogance, the self-satisfied mood of an epoch that could claim for itself the accomplishment of its own highest ideals. Kant endorses only the far more modest notion that his own time is one that is directed *toward* the still-unrealized *ideal* of enlightenment; it is an ideal that remains *counterfactual* but (to use Kant's own philosophical language) *regulative*. It provides him with a certain *orientation,* but does not furnish him with any *guarantee* that will ever arrive at the historical and intellectual plateau that Hegel would later call "absolute knowing [*das absolute Wissen*]".[2]

When we revisit Kant's essay today, readers may find it hard to suppress a wry smile of doubt. The hopeful spirit of the eighteenth century radiates from the essay with an optimism that long ago lost its credibility, and after nearly two and a half centuries of imperialism, genocide, and global war, we may feel tempted to see its *Denkstil* as obsolete. Our own era provides us with little guarantee that the Enlightenment's trust in tolerance and progress still warrants our assent, nor are we inclined to embrace the Kantian vision of a public sphere in which participants argue with one another on the basis of

Berlinische Monatsschrift.

1784.

Zwölftes Stük. December.

I.

Beantwortung der Frage: Was ist Aufklärung?

(S. Decemb. 1783. S. 516.)

Aufklärung ist der Ausgang des Menschen aus seiner selbst verschuldeten Unmündigkeit. Unmündigkeit ist das Unvermögen, sich seines Verstandes ohne Leitung eines anderen zu bedienen. Selbstverschuldet ist diese Unmündigkeit, wenn die Ursache derselben nicht am Mangel des Verstandes, sondern der Entschließung und des Muthes liegt, sich seiner ohne Leitung eines andern zu bedienen. Sapere aude! Habe Muth dich deines eigenen Verstandes zu bedienen! ist also der Wahlspruch der Aufklärung.

Faulheit und Feigheit sind die Ursachen, warum ein so großer Theil der Menschen, nachdem sie die Natur längst von fremder Leitung frei gesprochen

Title page of Immanuel Kant's essay „Answer to the Question: What is Enlightenment?", in: *Berlinische Monatsschrift*, Berlin, 1784

their shared rationality. Many intellectuals have adopted a more cynical view that equates reason only with power, and the eighteenth-century conception of a shared history moving toward enhanced freedom and inclusion now confronts the harsh reality that humanity is not a unified collective: it remains fractured into competing ethno-national groups that look upon one another not as partners in enlightenment, but as enemies whose divergent values seem to warrant only a dark future characterized by a 'clash of civilizations'. In this new era of pessimism, we must ask what remains of the Enlightenment, and of Kant's claim that we live in an age that is oriented toward its ideals.

It should be obvious that the *Aufklärung* does not present us with ideas that can be endorsed today without modification. This is especially the case when we examine the ideal of a *public use of reason*. In his 1784 essay, Kant still endorses a bifurcated understanding of society where the public use of reason is not equated with political sovereignty. He praises Frederick II of Prussia as an enlightened *ruler* who insists on obedience and only allows for argumentation within the framework of a highly hierarchical state. In such a monarchy the sovereign can declare: "argue, as much as you want and about whatever you want, only obey!"[3] Writing in fear of the Prussian censors and at a time when the overt declaration of republican sympathies could prove dangerous, Kant nonetheless insinuates that when an enlightened monarch allows the intellectual class the freedom for argumentation, the result is "paradoxical". A state that imposes strong limits on civil freedom nonetheless creates a space in which intellectual freedom can develop to the fullest extent possible. "When nature has, under this hard shell, developed the seed for which she cares most tenderly – namely, the inclination and the vocation for *free thinking* – this works back upon the character of the people (who thereby become more and more capable of *acting freely*) and finally even on the principles of government, which finds it to its advantage to treat man . . . in accord with his dignity."[4]

What Kant describes as a paradox is more accurately understood as a dialectic: an enlightened monarch may oppose the republican form of self-government, but if he permits the practice of public deliberation he ultimately prepares the way for the dissolution of monarchy itself. This model of dialectical history would later emerge as an important justification for the public use of reason. In 1793 the young philosopher J. G. Fichte (who had drawn much of his initial inspiration from Kant) published an essay anonymously with the title, "Reclamation of the Freedom of Thought from the Princes of Europe, Who Have Oppressed It Until Now". Much like his predecessor, Fichte argues that the path toward political freedom should take a path

that is more dialectical than linear. Rather than endorsing democratic revolution, he warns that "powerful revolutions" always bring a risk of failure and increased misery. It follows that "Gradual steps forward are a more certain path to greater enlightenment".[5] It may be that the gradual movement toward political freedom does not yield immediate satisfaction, but the results ultimately provide us with a stronger assurance of historical growth: "The progress they make is less noticeable when it occurs, but when you look back, you see a path on which a large distance has been traversed."[6] Like Kant, Fichte believes that this progress requires *freedom of thought*. He urges monarchs in Germany that "Only those around you who advise you to advance enlightenment have true confidence in you and true respect for you".[7] However Fichte, like Kant, also sees a historical dialectic in which freedom of thought will result in a potentially dramatic revision of political arrangements. To the monarchs he writes: "Direct the investigations of the inquiring spirit into the most current, most pressing needs of mankind, but do so with a light, wise hand, *never as a ruler, but as a free co-worker*."[8] Implicit in this essay is the conviction that the Enlightenment's ideal of public reason may eventually result in political equality.

Adorno and the Enlightenment

When we turn from the philosophical texts of the eighteenth-century *Aufklärung* to the intellectual arguments of our own time, we confront a sensibility that is far less confident in the necessary link between freedom of thought and freedom in politics. In their co-authored *Dialectic of Enlightenment*, written in 1944 but officially published in 1947, Theodor W. Adorno and Max Horkheimer write in the shadow of catastrophe and express only the faintest hope that reason still retains its emancipatory purpose.[9] Reason, they argue, first emerged as a faculty that served humanity in its bid for an enhanced power of self-determination over the overwhelming threat of nature. Enlightenment in this sense is an ongoing historical and cognitive process that continues across the millennia. But it is their claim that this process has a strong (though not quite inevitable) tendency to betray its own purposes: the task of self-liberation through reason tends to become merely an instrument for achieving *any ends whatsoever*. When reason becomes untethered from the norm of human freedom, it hardens into a compulsive and unreflective exercise that takes on the opacity of myth: reason becomes irrational. Adorno and Horkheimer pursue this argument with such vigour that many have suspected that they trap themselves in a *huis clos* of total pessimism: what, after all, would be the rational validity of their own argument once they have declared that rationality is simply an instrument of domination?

To this question, we should respond that it is based on a false premise. Despite their pessimism, Adorno and Horkheimer never surrender their belief that reason has an intrinsic bond with emancipation. Many readers have often misunderstood them on this point. Rather than announcing that the Enlightenment has betrayed itself entirely, they insist that humanity can only gain its true freedom if it remains faithful to the Enlightenment's highest ideals. In his summer 1958 lectures on dialectics, Adorno admits that we must acknowledge "all the sacrifice and injustice which the Enlightenment has brought in its course". But he takes care to explain that we must acknowledge precisely these historical misdeeds as occasions when the Enlightenment has forgotten its very own promise and has revealed "that it is still partial, as actually not yet enlightened enough [*als eine noch partielle, also nicht aufgefklärt genug*]".[10] Rather than issuing a totalizing and negative verdict on the Enlightenment, Adorno insists that "it is only by pursuing *the enlightenment's own principle* through *to its end* that these wounds may perhaps be healed".[11] With this affirmation of the Enlightenment's "own principle" it should not surprise us that Adorno also took care to endorse the ideal of "maturity" (*Mündigkeit*) that Kant, in his 1784 essay, had defined as ranking among the key ideals of an age of enlightenment.[12] In the radio lecture "Education after Auschwitz" (April 1966), Adorno also intimated that against the long-term patterns of authoritarianism and submission that first made Nazism possible, "education and enlightenment [*Erziehung und Aufklärung*] can still manage a little something".[13]

As Adorno's rather modest affirmation indicates, it is undeniable that we seldom express ourselves with the confidence in the Enlightenment that is evident in the writings of the eighteenth century. One explanation for the change is that we have come to recognize the sociological conditions that confined the Enlightenment to a remarkably narrow stratum of the educated bourgeoisie. Intellectual freedom in argumentation was possible only for those who possessed the rhetorical talent (or even the basic skill in literacy) to join universities and salons, or to publish in the journals that were the locus of philosophical and political debate. The Enlightenment's ideal of rational argumentation, which may have been open *in principle* to all citizens irrespective of class (not to mention gender, racial, or ethno-religious difference) remained only an ideal; it stood in contradiction to socio-economic reality. It is for this reason that in his 1962 habilitation thesis, *Strukturwandel der Öffentlichkeit,* Jürgen Habermas characterized the Enlightenment's ideal of a universally inclusive public sphere of rational deliberation as *both an ideal and an ideology.*[14]

The Enlightenment Between Ideal and Ideology: Marx, Habermas, Foucault

With this dialectical argument, Habermas inherited what was the most nuanced feature in the Marxist critique of bourgeois ideology. Marx, after all, had never meant to impugn bourgeois ideals as *wholly* false, because he understood the dialectical lesson that our philosophical values can be simultaneously *false and true*, when they express principles that contradict the present social structure but also point toward the undermining of that structure. This dialectical insight was already implicit when Kant and Fichte suggested that the public use of reason, even under conditions of political authoritarianism, could nourish the development of insights that might eventually overturn that political form. In his essay on the "Jewish Question" (1843), Marx further develops this dialectical insight and suggests that the principle of *formal* (legal and political) freedom may be a necessary precondition for the emergence of bourgeois society, though it *also* contains a universalist demand that bourgeois society cannot satisfy. This dialectical insight, however, does not lead him to reject bourgeois ideals as *merely* ideological.[15] In *The Holy Family* (co-written with Engels in 1845) Marx goes so far as to suggest that "states which cannot yet *politically* emancipate the Jews must be rated by comparison with accomplished states and must be considered as underdeveloped".[16] Such statements confirm that even Marx, despite his strong critique of bourgeois ideology, felt it was necessary as a matter of dialectical principle to see in bourgeois society the latent, if still-unrealized, ideal of freedom that pointed *forward* to a higher condition of freedom: by invoking a standard of *development*, Marxism retained an essential commitment to an Enlightenment-derived concept of *progress*.[17] In this respect it is not implausible to consider Marx as a social theorist whose thinking still reflected the Enlightenment (though this hardly means that his works have meanings that are confined only to that time).[18]

Like Marx, Habermas remains faithful to this dialectical affirmation of Enlightenment universalism even when bourgeois social structures do not realize the original promise of universal inclusion. Unlike his eighteenth-century antecedents, however, Habermas naturally recognizes that the social division between those who argue and those who rule is no longer tenable. Kant still believed that the practice of rational argumentation could be confined to a politically powerless stratum of philosophers. Under conditions of modern democracy, this social division is hardly defensible. As Habermas has noted, *"in a process of enlightenment there can only be participants"*.[19]

Unlike Habermas, however, the stark contradiction between ideal and reality has moved many other social theorists to conclude that the principles of the Enlightenment were never *more* than ideology. It is tempting to say that

the ideal of the public use of reason cannot claim for itself any credible promise of universalism if, in actual practice, it has applied only to exclusive or particular groups. This conclusion has found its foremost exponent in Michel Foucault, whose genealogical method (drawing inspiration from Nietzsche rather than Marx) excelled at a strategy of undialectical *unmasking*. For Foucault, the ideal of the public use of reason cannot claim any principled validity beyond the historical record of its complicity with power: to demonstrate that reason and power are historically intertwined is to demonstrate that public reason simply *is* merely social power in a different guise. The difficulty with this argument is that once Foucault has achieved this unmasking of reason's complicity with power, he can no longer explain why any one form of power is preferable to another. If he is to make an *argument* for unrealized modes of freedom he must appeal (even if only implicitly) to standards of public reason that are not merely equivalent to coercion. But the levelling effect of a generalized tactic of genealogy levels the distinction between freedom and unfreedom – a distinction that could only have meaning if it appealed to the rational capacities that belong to all of us as members of society. Without this trust in our rational capacities, Foucault robs himself of the ideal that Habermas calls "the unforced force of the better argument".[20]

At the end of his life, however, Foucault embraced the legacy of the Enlightenment, even if he did not express himself with the confidence in emancipatory reason that animated the writers of the eighteenth century. Precisely two centuries after Kant, in the 1984 lecture "What is Enlightenment?" Foucault recalled the German philosopher's definition: "Enlightenment is mankind's exit from its own self-incurred immaturity." To embark on the path of Enlightenment is to gain greater maturity [*Mündigkeit*].[21] Foucault responds to this definition with doubt: "I do not know whether we will ever reach mature adulthood. Many things in our experience convince us that the historical event of the Enlightenment did not make us mature adults, and we have not reached that stage yet."[22] This rejoinder may strike us as somewhat perplexing, since Kant himself never actually *affirms* that the condition of enlightenment has already been *achieved*: he claims that we live in an *age of enlightenment* and not an *enlightened age*. In other words, the ideal retains its validity only as an orientation in thought. But we can nonetheless appreciate why Foucault may have felt that it was necessary to make explicit the *historical distance* that we have travelled since the eighteenth century. His anodyne reference to "many things in our experience" seems deliberately oblique: implicit in this phrase is the accumulated evidence of two centuries of catastrophe during which any philosophical confidence in an arc of history has been shattered. He no longer

accepts Kant's belief in public *reason* as the foundation for collective freedom. But even if he has lost this confidence in *reason,* he still embraces the general "attitude" of the Enlightenment, which he defines as an ethos of *critique*:

> . . . it seems to me that a meaning can be attributed to that critical interrogation on the present and on ourselves which Kant formulated by reflecting on the Enlightenment. It seems to me that Kant's reflection is even a way of philosophizing that has not been without its importance or effectiveness during the last two centuries. The critical ontology of ourselves has to be considered not, certainly, as a theory, a doctrine, nor even as a permanent body of knowledge that is accumulating; it has to be conceived as an attitude, an ethos, a philosophical life in which the critique of what we are is at one and the same time the historical analysis of the limits that are imposed on us and an experiment with the possibility of going beyond them.[23]

For Foucault, what remains from the Enlightenment is not a "doctrine" but a distinctive ethos of *ongoing experimentation.* "Critique" no longer signifies (as it did for Kant) reason's interrogation of its own limits for the sake of establishing the conditions of knowledge. Critique now signifies the *testing* of *any* limits, alongside an attitude of historical scepticism that refuses to see *any* body of knowledge or any moral code as eternally valid. What he calls "a philosophical life" remains faithful to Kant's original idea that "enlightenment" is not a final condition but an ongoing *practice.* To be sure, Foucault wishes to evade the question of whether he is *for* or *against* the Enlightenment – for a theorist of transgression such a question must strike him as intolerably moralistic. But it seems clear that he wants to retain at least the essential spirit of the Enlightenment insofar as it still orients us toward freedom: "I do not know whether it must be said today that the critical task still entails faith in Enlightenment; I continue to think that this task requires work on our limits, that is, a patient labour giving form to our impatience for liberty."[24]

If we ask whether any inherited values of the Enlightenment still retain their validity today, we find ourselves in a curious position. Many critics of the Enlightenment often find fault with its precepts (such as the commitment to progress or public reason) because they feel that those precepts have too often been used to justify global inequality or domination. But when we object to inequality or domination, we can do so only by invoking standards of equality and freedom that derive from the Enlightenment itself. It turns out that even the Enlightenment's critics remain faithful to its precepts, and, most of all, to

its spirit of *critique*. We remain not merely the legatees of the Enlightenment as an historical inheritance but *participants* in a process of enlightenment that remains unfinished.[25]

1. Kant [1784], trans. in Schmidt 1996, 58–64.
2. See Hegel 2018, 454–467.
3. Kant [1784], in Schmidt, 63.
4. Ibid. [author's emphasis].
5. Fichte [1793], in Schmidt, 121.
6. Ibid.
7. Ibid, 139.
8. Ibid. [author's emphasis].
9. See Horkheimer/ Adorno 2002.
10. Adorno 2017a, 188.
11. Ibid. [author's emphasis].
12. See Adorno 2017b, 133–147.
13. Adorno 1998, 204.
14. See Habermas 1989, 88.
15. For an important comment on this dialectical insight, see Avineri 1964, 445–450.
16. Marx/Engels 1975, 110.
17. For a critique of the idea of progress in post-Marxist critical theory (especially as exemplified in the theories of Habermas, Axel Honneth, and Rainer Forst) see Allen 2016.
18. On Marx as a thinker of the Enlightenment, see Sperber 2014. Although it is true that key themes in Marx were first developed in the era of the eighteenth century, Sperber falsely infers from the fact of historical origin that these themes are no longer valid today. But this mistakes genesis with validity. For a criticism, see Gordon 2013.
19. Habermas 1974, 40 [author's emphasis].
20. See Habermas 1972, 161. Also see Habermas 1998, 306.
21. Kant [1784], in Schmidt, 58.
22. Foucault 1997, 318–319.
23. Ibid, 319.
24. Ibid.
25. See Honneth et al. 1992.

Jürgen Habermas

What Does Enlightenment Mean?

Even today, there is still no better answer to the question, "What is enlightenment?" than the one given by Kant almost two and a half centuries ago: enlightenment requires nothing more than the freedom to make public use of one's reason in all matters. This may sound like the now-routine appeal to the rational exercise of democratic rights – rather than the conceptual definition of an epoch at the self-conscious center of which Kant lived in 1783. But the philosophical generality of the appeal makes us aware of the curious fact that, by the name "Enlightenment," we mean an epoch whose message extends far beyond the boundaries of a particular historical era to the present day.

This is already shown by the attempt to restrict enlightenment to a clearly defined historical period. The classical restriction of the Age of Enlightenment to the decades between 1750 and 1800 focus attention on the American and French constitutional revolutions and the literature and philosophy of the great French encyclopedists. However, there are also good reasons for a more liberal definition of this period, covering the years from 1660 to 1830, which includes the beginnings in Great Britain of the political and scientific developments at the heart of the "Enlightenment." By this reckoning, however, the Enlightenment overlaps with the Baroque period that preceded it and the Biedermeier period that followed it. Such difficulties of demarcation reveal that the Enlightenment does not merely refer to one of those modern epochs between which we discriminate primarily in terms of styles of artistic development.

That spirit of early modernity is already "enlightened" which found expression in the dynamism of commercial capitalism and publishing and subsequently took shape in the advances of the mathematical empirical sciences. Two consequences are important for enlightenment in this *more general* sense: on the one hand, the capitalist form of economic activity leads to an exponential *acceleration* of social change, as we are currently witnessing once again;

on the other hand, scientific progress also initially leads to the spread of the political self-confidence that it is possible to *steer* a mobilized society *according to ideas of its own*. These two tendencies were then distilled into philosophical conceptions of history and promoted the political forces that led to the bourgeois constitutional revolutions in the United States and France towards the end of the eighteenth century. The Enlightenment finds expression in an entirely new historical consciousness that sees itself as the heir to a cultural and social heritage that democratically acting nations can deliberately develop – and that they should consciously *shape*.

At the time of the classical Enlightenment, the notion of taking control of accelerating social change gave rise to the idea of an increasingly malleable history. But the profound ambivalence of this self-confidence, inspired by the expectation of progress, becomes clear when we look at the political mobilization of the following nineteenth century, which was marked by nationalism and imperialism. Nor was the spirit of the Enlightenment able to prevent the two world wars of the twentieth century. On the contrary, the Holocaust provided a deeper view than ever into the abyss of utterly unthinkable crimes against humanity that were nevertheless *committed* and supported by a civilized nation. But perhaps the awareness that such a regression was possible – and therefore could happen again – has created a threshold. Thanks to the role of the United States, which emerged as a superpower in the last century, the rule of law and democracy have finally spread to some privileged regions of the world. *Today, these legally institutionalized freedoms still form the fragile rational core of the spirit of the Enlightenment*. And this spirit teaches us how to make the right use of these freedoms.

The luster of the Enlightenment's optimistic belief in progress has long since been tarnished by an awareness of its profound dialectical setbacks. The remnants of the hybrid idea that the course of history could be politically steered, or even technologically steered by the means of Silicon Valley, rightly seem bizarre to us today. But the postcolonial critique is still a matter of the Enlightenment subjecting itself to its own critical standards. And the rational core of the Enlightenment tradition is emerging all the more clearly today.

In the classical Age of Enlightenment, the accelerated rate at which traditional lifeworlds were overthrown was intuitively felt as a *tailwind* and was interpreted as an *empowerment* of one's own agency. Later, the disturbing significance of the exponential acceleration of economic, social and technological change was widely publicized, probably for the first time at the great world exhibitions of the nineteenth century. And today, the growth of social complexity no longer intrudes on us merely in the guise of expanded opportunities

for us to exploit. By now, the risks associated with the exponential acceleration of social change have long been seen as a *challenge* to be *met* politically, that is, deliberately and consciously. The climate crisis has raised public awareness that we have crossed the threshold into the Anthropocene and must confront the risks of the long recognized, but hitherto unchecked global side effects of systemically generated growth. And the risks of recent developments in areas such as genetic engineering and artificial intelligence remind us that we cannot leave scientific and technological progress to the nature-like dynamics of private sector economic calculations.

This may sound like skepticism concerning enlightenment. But the point of my reflections is, on the contrary, to reaffirm the insight of the classical Enlightenment, which has become *reflexive*: its rational core still consists in the appeal to the freedom of citizens *to make public use of their reason* in order to exert political influence over how the foundations of their social existence are shaped. Such *rational* political will formation is, of course, only possible within the institutions of an *intact* democratic constitutional state and on the basis of a society that is at least reasonably *just*.

APPENDIX

Bibliography

Adorno 1974
Theodor W. Adorno, *Minima Moralia: Reflections From Damaged Life*, trans. by Edmund F. N. Jephcott, London 1974.

Adorno 1998
Theodor W. Adorno, 'Education after Auschwitz,' in: *Critical Models: Interventions and Catchwords*, trans. by Henry Pickford, New York 1998: 191–204.

Adorno 2017a
Theodor W. Adorno, *An Introduction to Dialectics*, trans. by Nicholas Walker, Cambridge 2017.

Adorno 2017b
Theodor W. Adorno, *Erziehung zur Mündigkeit. Vorträge und Gespräche mit Hellmut Becker 1959–1969*, Frankfurt a. M. 2017.

Allen 2016
Amy Allen, *The End of Progress: Decolonizing the Normative Foundations of Critical Theory*, New York 2016.

Altmann 1973
Alexander Altmann, *Moses Mendelssohn. A Biographical Study*, Tuscaloosa 1973.

Aristotle 1935
Aristotle, *de Anima (On the Soul)*, trans. by W. S. Hett, Loeb Classical Library 288, Cambridge, MA 1935.

Aristotle 1996
Aristotle, *Physics*, 2 vols., trans. by P. H. Wicksteed and F.M. Cornford, Loeb Classical Library 228/255, Cambridge, MA 1996.

Arkush 1994
Allan Arkush, *Moses Mendelssohn and the Enlightenment,* Albany 1994.

Athenaeum 1798
Athenaeum. A literary magazine est. by August Wilhelm Schlegel und Friedrich Schlegel, vol. 1, part 2, Berlin 1798.

Avineri 1964
Shlomo Avineri, 'Marx and Jewish Emancipation', in: *Journal of the History of Ideas*, vol. 25, no. 3 (1964): 445–450.

Bacon 2008
Francis Bacon, *The Advancement of Learning*, in: Brian Vickers (ed.), *The Major Works*, Oxford 2008.

Bailyn 1960
Bernard Bailyn, *Education in the Forming of American Society*, New York 1960.

Baker 2007
Philip Baker (ed.), *The Putney Debates*, New York 2007.

Barber/Fabian 1981
Giles Barber and Bernhard Fabian (eds.), *Buch und Buchhandel in Europa im achtzehnten Jahrhundert*, Hamburg 1981.

Barruel 1803
Augustin Barruel, *Mémoires pour servir à l'histoire du jacobinisme*, Hamburg 1803.

Bartlett 2022
Roger Bartlett, *The Bentham Brothers and Russia. The Imperial Russian Constitution and the St. Petersburg Panopticon*, London 2022.

Basker 2002
James Basker (ed.), *Amazing Grace. An Anthology of Poems About Slavery 1660–1810*, New Haven 2002.

Beaumont 1768
Jeanne-Marie Leprince de Beaumont, *Magazin des enfants, ou Dialogues entre une sage gouvernante et plusieurs de ses eleves de la premiere distinction*, La Haye 1768.

Birn 1971
Raymond Birn, 'The Profits of Ideas: *Privilèges en librairie* in Eighteenth-Century France,' in: *Eighteenth-Century Studies* (1971), IV.

Blumenbach 1790
Johann Friedrich Blumenbach, 'Ueber die Negern insbesondere', in: Blumenbach, *Beyträge zur Naturgeschichte. Erster Theil*, Göttingen 1790: 84–118.

Blumenberg 1993
Hans Blumenberg, 'Light as a Metaphor for Truth: At the Preliminary Stage of Philosophical Concept Formation', in: David Michael Levin (ed.), *Modernity and the Hegemony of Vision*, trans. by Joel Anderson, Berkeley 1993: 30–62.

Bödeker 1990
Hans Erich Bödeker, 'Journals and Public Opinion: The Politicization of the German Enlightenment in the Second Half of the Eighteenth Century', in: Eckhart Hellmuth (ed.), *The Transformation of Political Culture: England and Germany in the Late Eighteenth Century*, Oxford 1990: 423–445.

Bonald 1838
Louis de Bonald, *Recherches philosophiques*, Paris 1838.

Bouie 2018
Jamelle Bouie, 'The Enlightenment's Dark Side', in: *Slate*, 5 June 2018, https://slate.com/news-and-politics/2018/06/taking-the-enlightenment-seriously-requires-talking-about-race.html (visited 12 April 2024).

Bradburn 1792
Samuel Bradburn, *An Address to the People Called Methodists Concerning the Evil of Encouraging the Slave Trade*, Manchester 1792.

Bredekamp 2016
Horst Bredekamp, 'Galilei's Spiral Scribbles, Campanella and Fludd', in: Wendy Doniger, Peter Galison, and Susan Neiman (eds.), *What Reason Promises. Essays on Reason, Nature, and History*, Berlin/Boston 2016.

Burgdorf 1998
Wolfgang Burgdorf, *Reichskonstitution und Nation. Verfassungsreformprojekte für das Heilige Römische Reich Deutscher Nation im politischen Schrifttum von 1648 bis 1806*, Mainz 1998.

Butler/Tomsinov 2010
William Butler and Vladimir Tomsinov (eds.), *The Nakaz of Catherine the Great: Collected Texts*, Clark 2010.

Carey/Festa 2009
Daniel Carey and Lynn Festa (eds.), *The Postcolonial Enlightenment. Eighteenth-Century Colonialism and Postcolonial Theory*, Oxford 2009.

Chakravarty 2022
Urvashi Chakravarty, *Fictions of Consent: Slavery, Servitude, and Free Service in Early Modern England*, Philadelphia 2022.

Chartier 1991
Roger Chartier, *The Cultural Origins of the French Revolution*, trans. by Lydia G. Cochrane, Durham 1991.

Chartier 2007
Roger Chartier, 'Commerce in the novel: Damilaville's tears and the impatient reader" in: *Inscription and Erasure: Literature and Written Culture from the Eleventh to the Eighteenth Century*, trans. by Arthur Goldhammer. Philadelphia 2007.

Chartier/Lüsebrink 1996
Roger Chartier and Hans-Jürgen Lüsebrink (eds.), *Colportage et lecture populaire. Imprimés de large circulation en Europe XVIe–XIXe siècles*, Paris 1996.

Chaussard 1798
Pierre Chaussard, *Fête des arts. Projet relatif à la translation des objets d'art conquis en* Italie, adressé au ministère de l'Intérieur, Paris 15 floréal an VI [4 May 1798].

Cheek 2019
Pamela Cheek, *Heroines and local girls: The transnational emergence of women's writing in the Long Eighteenth Century*, Philadelphia 2019.

Clark 2023
Christopher Clark, *Frühling der Revolution. Europa 1848/49 und der Kampf für eine neue Welt*, Munich 2023.

Clarkson 1808
Thomas Clarkson, *The History of the Rise, Progress, and Accomplishment of the Abolition of the African Slave-Trade by the British Parliament*, vol. 2, London 1808.

Cleve 2006
George van Cleve, 'Somerset's Case and its Antecedents in Imperial Perspective', in: *Law and History Review* 24, no. 3 (2006): 601–45.

Coleridge 1970
Samuel Taylor Coleridge, 'Lecture on the Slave Trade, Bristol, 16 June 1795', in: *The Collected Works of Samuel Taylor Coleridge: The Watchman*, edited by Lewis Patton, Princeton 1970.

Comay 2011
Rebecca Comay, *Mourning Sickness. Hegel and the French Revolution*, Stanford 2011.

Condorcet 1847–1849
M.R.A.J. Condorcet, *Oeuvres de Condorcet*, Paris 1847–1849.

Condorcet 2004
Jean-Antoine-Nicolas de Caritat de Condorcet, *Tableau historique des progrès de l'esprit humain. Projets, esquisse, fragments et notes, 1772–1794*, Paris 2004.

Conrad 2012
Sebastian Conrad, 'Enlightenment in Global History. A Historiographical Critique', in: *American Historical Review*, vol. 117, no. 4 (2012): 999–1027.

Consett 1962
Thomas Consett, *The Present State and Regulations of the Church of Russia* [1729], in: James Cracraft (ed.), *For God and Peter the Great: The Works of Thomas Consett, 1723–1729*, Boulder 1962.

Cooke 1755
Thomas Cooke, *Terence's Comedies, Translated into English, Together with the Original Latin*, Second Edition, vol. 1, London 1755.

Courtney/Mander 2015
Cecil Courtney and Jenny Mander (eds.), *Raynal's 'Histoire des deux Indes'. Colonialism, Networks and Global Exchange*, Oxford 2015.

Cowper 1791
William Cowper, *A Subject for Conversation and Reflection at the Tea-Table*, London 1791.

Craciun 2005
Adriana Craciun, *British women writers and the French Revolution: Citizens of the world*, New York 2005.

Cracraft 1971
James Cracraft, *The Church Reform of Peter the Great*, London 1971.

Cranz 1782
August Friedrich Cranz, *Das Forschen nach Licht und Recht, in einem Schreiben an Herrn Moses Mendelssohn auf Veranlassung seiner merkwürdigen Vorrede zu Menasse Ben Israel*, Berlin 1782.

Cronk/Décultot 2023
Nicholas Cronk und Elisabeth Décultot (eds.), *Inventions of Enlightenment since 1800. Concepts of Lumières, Enlightenment and Aufklärung*, Oxford 2023.

Crouter/Klassen 2004
Richard Crouter and Julie A. Klassen (eds.), *A Debate on Jewish Emancipation and Christian Theology in Old Berlin*, Indianapolis 2004.

Cuffy Coffee 1820
Cuffy's Description of the Progress of Coffee, London 1820.

Cuffy Cotton 1833
Cuffy's Description of the Progress of Cotton, London 1833.

Cuffy Sugar 1823
Cuffy the Negro's Doggrel Description of the Progress of Sugar, London 1823.

Curran 2011
Andrew S. Curran, *The Anatomy of Blackness: Science and Slavery in an Age of Enlightenment*, Baltimore 2011.

Dann 1981
Otto Dann (ed.), *Lesegesellschaften und bürgerliche Emanzipation. Ein europäischer Vergleich*, Munich 1981.

Darnton 1984
Robert Darnton, 'Readers Respond to Rousseau: The Fabrication of Romantic Sensitivity', in: Robert Darnton, *The Great Cat Massacre and Other Episodes in French Cultural History*, New York 1984: 215–256.

Darnton 1987
Robert Darnton, *The Business of Enlightenment: A publishing history of the Encyclopédie*, Cambridge 1987.

Darnton 1991
Robert Darnton, *Édition et sédition. L'univers de la littérature clandestine au XVIIIe siècle*, Paris 1991.

Darnton 1995a
Robert Darnton, *The Corpus of Clandestine Literature in France 1769–1789*, New York 1995.

Darnton 1995b
Robert Darnton, *The Forbidden Best-Sellers of Pre-Revolutionary France*, New York 1995.

Darnton 2021
Robert Darnton, *Pirating and Publishing. The Book Trade in the Age of Enlightenment*, New York 2021.

Daut 2017
Marlene L. Daut, *Baron de Vastey and the Origins of Black Atlantic Humanism*, New York 2017.

Dawson 2002
Ruth P. Dawson, *The Contested quill: Literature by women in Germany, 1770-1800*, Newark 2002.

De Maistre 1861
Joseph de Maistre, *Lettres et opuscules inédits*, Paris 1861.

De Staël 1800
Germaine de Staël, *De la littérature considérée dans ses rapports avec les institutions sociales*, Paris 1800.

Décultot 2000
Elisabeth Décultot, *Johann Joachim Winckelmann. Enquête sur la genèse de l'histoire de l'art*, Paris 2000.

Décultot 2004
Elisabeth Décultot, *Untersuchungen zu Winckelmanns Exzerptheften. Ein Beitrag zur Genealogie der Kunstgeschichte im 18. Jahrhundert*, Ruhpolding 2004.

Décultot 2020
Elisabeth Décultot, 'Metamorphosen der Freiheit. Zur Genealogie und Rezeption einer Schlüsselkategorie Winckelmanns', in: Adolf Heinrich Borbein and Ernst Osterkamp (eds.), *Kunst und Freiheit. Eine Leitthese Winckelmanns und ihre Folgen*, Stuttgart 2020: 1–25.

Delon 2001
Michel Delon, 'Enlightenment (Representations of)', in: Delon (ed.), *Encyclopedia of the Enlightenment*, London 2001: 457–462.

Descartes 2006
René Descrates, *A Discourse on the Method,* trans. by Ian Maclean, Oxford 2006.

Diderot 1960
Denis Diderot, 'Salon de 1765', in: Diderot (ed.), *Salons*, vol. 2, Oxford 1960.

Diderot 1979
Denis Diderot, *Nachtrag zu Bougainvilles Reise oder Dialog zwischen A und B über die Mißlichkeit, gewisse körperliche Vorgänge mit moralischen Ideen zu belasten, die sie nicht tragen*, in: Diderot, *Das erzählerische Werk*, vol. 4, Berlin 1979: 209–258.

Diderot 1984
Denis Diderot, *Lettre sur le commerce de la librairie*, Charles Bon and J. C. Mailler (eds.) Paris 1984.

Diderot 1995
Denis Diderot, *Diderot on Art – 1: The Salon of 1765 and Notes on Painting*, trans. by J. Goodman, New Haven/London 1995.

Dippel 1991
Horst Dippel (ed.), *Die Anfänge des Konstitutionalismus in Deutschland. Texte deutscher Verfassungsentwürfe am Ende des 18. Jahrhunderts*, Frankfurt a. M. 1991.

Dohm 1781
Christian Wilhelm Dohm, Über die bürgerliche Verbesserung der Juden, vol. 1, Berlin/Stettin 1781.

Dubois 2006
Laurent Dubois, 'An Enslaved Enlightenment: Rethinking the Intellectual History of the French Atlantic', in: *Social History* 31, no. 1 (2006): 1–14.

E. v. R. 1783
E. v. R., 'Vorschlag, die Geistlichen nicht mehr bei Vollziehung der Ehen zu bemühen', in: *Berlinische Monatsschrift,* no. 9 (1783): 265–276.

Eibeschütz 2016
R. Jonathan Eibeschütz, *And I Came this Day unto the Fountain* [*Va-Avo ha-Yom el ha-Ayyin*]. Critically edited and introduced by Paweł Maciejko, revised 2nd edition, Los Angeles 2016.

Engelsing 1969
Rolf Engelsing, 'Die Perioden der Lesergeschichte in der Neuzeit. Das statistische Ausmaß und die soziokulturelle Bedeutung der Lektüre', in: *Archiv für Geschichte des Buchwesens*, 10 (1969): col. 945–1002.

Engelsing 1974
Rolf Engelsing, *Der Bürger als Leser. Lesergeschichte in Deutschland 1500–1800*, Stuttgart 1974.

Exhib. Cat. Gotha 1997
Die Große Nordische Expedition. Georg Wilhelm Steller (1709–1746). Ein Lutheraner erforscht Sibirien und Alaska, Wieland Hintzsche and Thomas Nickol (eds.), Francke Foundations Halle, Gotha 1997.

Exhib. cat. Munich 2017
Winckelmann. Moderne Antike, Elisabeth Décultot et al. (eds.), Neues Museum Weimar, Munich 2017.

Exhib. cat. Potsdam 2023
Sonne. Die Quelle des Lichts in der Kunst, edited by Ortrud Westheider et al., Museum Barberini Potsdam, Munich et al. 2023.

Fediukin/Lavrinovich 2015
I. I. Fediukin and M. B. Lavrinovich (eds.), *"Reguliarnaia akademiia uchrezhdena budet ...": Obrazovatel'nye proekty v Rossii v pervoi polovine XVIII veka*, Moscow 2015.

Fedyukin 2018
Igor Fedyukin, 'Shaping Up the Stubborn: School Building and 'Discipline' in Early Modern Russia', in: *The Russian Review* 77: 200–218.

Fénelon 2009
François de Fénelon, *Les aventures de Télémaque*, Paris 2009.

Ferguson 1792
Adam Ferguson, *Principles of Moral and Political Science*, Edinburgh 1792.

Fichte 1793
Johann Gottlieb Fichte, 'Beweis der Unrechtmäßigkeit des Büchernachdrucks. Ein Räsonnement und eine Parabel', in: *Berlinische Monatsschrift*, vol. 21 (1793): 443–483.

Fludd 2018
Robert Fludd, *Utriusque Cosmi Historia. Faksimile-Edition der Ausgabe Oppenheim - Frankfurt/M.*, Johann Theodor de Bruy, 1617-1624. Wilhelm Schmidt-Biggemann (ed.), 5 vols., Stuttgart-Bad Cannstatt 2018.

Foucault 1984
Michel Foucault, 'What is Enlightenment?', in: Paul Rabinow (ed.), *The Foucault Reader*, New York 1984, 32–50.

Foucault 1995
Michel Foucault, *Discipline and Punish: The Birth of the Prison,* trans. by Alan Sheridan, New York 1995.

Foucault 1997
Michel Foucault, 'What is Enlightenment?' trans. by Catherine Porter (with amendments), in: Paul Rabinow (ed.), *Ethics: Subjectivity and Truth. Essential Works of Foucault, 1954-1984*. vol. 1, New York 1997: 303–319.

Fox 1791a
William Fox, *A Short Account of the African Slave Trade, and an Address to the People of Great Britain, on the Propriety of Abstaining from West India Sugar and Rum*, 1791.

Fox 1791b
William Fox, *An Address to the People of Great Britain, on the Propriety of Abstaining from West India Sugar and Rum,* 13th edition, 1791.

Fox 2011
William Fox, *The Political Writings of William Fox*, Nottingham 2011.

Freud 1932–1936
Sigmund Freud, *New Introductory Lectures On Psycho-Analysis* [1933], in: *The Standard Edition of the Complete Psychological Works of Sigmund Freud,* edited and trans. by James Strachey et al., vol. xxii, London 1932–36.

Freud 1940
Sigmund Freud, *Totem und Tabu. Einige Übereinstimmungen im Seelenleben der Wilden und der Neurotiker* [1912/13], *Gesammelte Werke*, vol. 9, London 1940.

Freud 1957
Sigmund Freud, Mourning and Melancholia [1915], in: *The Standard Edition of the Complete Psychological Works of Sigmund Freud,* edited and trans. by James Strachey et al., vol. xiv, London 1957.

Freud 1961
Sigmund Freud, *Civilization and its Discontents* [1930], edited and trans. by James Strachey, New York/London 1961.

Freudenthal 2012
Gideon Freudenthal, *No Religion Without Idolatry. Mendelssohn's Jewish Enlightenment*, Notre Dame 2012.

Freund 1912
Ismar Freund, *Die Emanzipation der Juden in Preußen*, vol. 2, Berlin 1912.

Friedländer 1799
David Friedländer, *Sendschreiben an Seine Hochwürden, Herrn Oberconsistorialrath und Probst Teller zu Berlin, von einigen Hausvätern jüdischer Religion*, Berlin 1799.

Fukuzawa 2018
Fukuzawa Yukichi, *L'appel à l'étude*, Paris 2018.

Fulda 2022a
Daniel Fulda, 'Die Erfindung der Aufklärung. Eine Begriffs-, Bild- und Metapherngeschichte aus der "Sattelzeit" um 1700', in: *Archiv für Begriffsgeschichte,* vol. 64, no. 1 (2022): 7–100.

Fulda 2022b
Daniel Fulda, 'Identity in Diversity. Programmatic Pictures of the Enlightenment', in: *Journal for Eighteenth-Century Studies,* vol. 45, no. 1 (2022): 43–62.

Furet 1965
François Furet, 'La "librairie" du royaume de France au XVIIIe siècle', in: Geneviève Bollème and École pratique des Hautes Études (eds.), *Livre et société dans la France du XVIIIe siècle*, vol. 1, Paris/La Haye 1965: 3–32.

Gagliardo 1980
John G. Gagliardo, *Reich and Nation. Holy Roman Empire as Idea and Reality, 1763–1806,* Bloomington 1980.

Gelbart 2021
Nina Ratner Gelbart, *Minerva's French sisters: women of science in Enlightenment France*, New Haven 2021.

Gembicki 1996
Dieter Gembicki, 'Siècle', in: Rolf Reichardt et al. (eds.), *Handbuch politisch-sozialer Grundbegriffe in Frankreich 1680–1820*, Munich 1996: 235–272.

Genequand 1995
Christiane Genequand (ed.), *Sociétés et cabinets de lecture entre lumières et romantisme*, colloquium of the *Société de lecture*, Geneva 1995.

Gerhardt 2023
Volker Gerhardt, *Individuum und Menschheit. Eine Philosophie der Demokratie,* Munich 2023.

Geulen 2007
Christian Geulen, *Geschichte des Rassismus*, Munich 2007.

Gikandi 2011
Simon Gikandi, *Slavery and the Culture of Taste*, Princeton 2011.

Godwin 1979
 Joscelyn Godwin, *Robert Fludd. Hermetic Philosophy and Surveyor of Two Worlds*, London 1979.
Goetsch 1994
 Paul Goetsch (ed.), *Lesen und Schreiben im 17. und 18. Jahrhundert. Studien zu ihrer Bewertung in Deutschland, England, Frankreich*, Tübingen 1994.
Goodman 2009
 Dena Goodman, *Becoming a woman in the Age of Letters*, Ithaca 2009.
Gordon 2013
 Peter E. Gordon, 'Marx after Marxism,' in: *The New Republic* (2 May, 2013).
Goulemot 1994
 Jean Marie Goulemot, *Forbidden Texts: Erotic Literature and its Readers in Eighteenth-Century France*, trans. by James Simpson. Cambridge/Malden 1994.
Graetz 1882
 Heinrich Graetz, *Geschichte der Juden von den ältesten Zeiten bis auf die Gegenwart*, vol. 10, Leipzig 1882.
Gregor 1996
 Mary J. Gregor (ed.), Immanuel Kant, *Practical Philosophy*, Cambridge 1996.
Grell 1995
 Chantal Grell, *Le dix-huitième siècle et l'Antiquité en France, 1680–1789*, 2 vols., Oxford 1995.
Grimm 2002
 Jacob and Wilhelm Grimm, *Deutsches Wörterbuch,* reworking, vol. 3, Stuttgart 2002.
Guerrier 1873
 W. Guerrier, *Leibniz in seinen Beziehungen zu Russland und Peter dem Grossen*, St. Petersburg/Leipzig 1873.
Guyer/Wood 1998.
 Paul Guyer and Allen W. Wood (eds.), Immanuel Kant, *Critique of Pure Reason*. Cambridge 1998.
Habermas 1972
 Jürgen Habermas, 'Wahrheitstheorien', in: *Vorstudien und Ergänzungen zur Theorie des kommunikativen Handelns*, Frankfurt a. M. 1972.

Habermas 1974
 Jürgen Habermas, 'Some Difficulties in the Attempt to Link Theory and Praxis', in: *Theory and Practice*, London 1974 1–40.
Habermas 1989
 Jürgen Habermas, *The Structural Transformation of the Public Sphere: an Inquiry into a Category of Bourgeois Society*. trans. by Thomas Burger and Frederick Lawrence, Cambridge, MA 1989.
Habermas 1998
 Jürgen Habermas, *Between Facts and Norms: Contributions to a Discourse Theory of Law and Democracy*. trans. by William Rehg, Cambridge, MA 1998.
Haggerty 2008
 Sheryllynne Haggerty, 'Liverpool, the slave trade, and the British-Atlantic Empire, c. 1750–75', in: Sheryllynne Haggerty, Anthony Webster, and Nicholas J. White (eds.), *The Empire in One City? Liverpool's Inconvenient Imperial Past*, Manchester 2008: 17–34.
Hagner 2004
 Michael Hagner, *Geniale Gehirne. Zur Geschichte der Elitegehirnforschung*, Göttingen 2004.
Hall 1995
 Kim F. Hall, *Things of Darkness: Economies of Race and Gender in Early Modern England*, Ithaca 1995.
Harloe 2013
 Katherine Harloe, *Winckelmann and the Invention of Antiquity: History and Aesthetics in the Age of* Alterthumswissenschaft, Oxford 2013.
Heath/Schneewind 1997
 Peter Heath and J. B. Schneewind (eds.), Immanuel Kant, *Lectures on Ethics*, Cambridge 1997.
Hegel 1977
 G. W. F. Hegel, *Phänomenologie des Geistes* [1807], trans. by A. V. Miller as *Phenomenology of Spirit*, Oxford 1977.
Hegel 2018
 G.W.F. Hegel, *The Phenomenology of Spirit*, trans. by Terry Pinkard, Cambridge 2018: 454–467.

Heng 2018
Geraldine Heng, *The Invention of Race in the European Middle Ages*, Cambridge 2018.

Herder 1889–1894
Johann Gottfried Herder, *Herders sämmtliche Werke*. Stuttgart 1889–1894.

Hesse 2003
Carla Hesse, *The Other Enlightenment: How French women became modern*, Princeton 2003.

Heyne 1778/79
Christian Gottlob Heyne, 'Über die Künstlerepochen beym Plinius', in: Heyne, *Sammlung antiquarischer Aufsätze*, Leipzig 1778/79, vol. 1: 165–235.

Heyne 1963
Christian Gottlob Heyne, 'Lobschrift auf Winckelmann' [1778], in: Arthur Schulz (ed.), *Die Kasseler Lobschriften auf Winckelmann*, Berlin 1963: 17–27.

Honneth et al. 1992
Axel Honneth, Thomas McCarthy, Claus Offe and Albrecht Wellmer (eds.), *Philosophical Interventions in the Unfinished Project of Enlightenment*, Cambridge, MA 1992.

Horkheimer/Adorno 2002
Max Horkheimer and Theodor W. Adorno, *Dialectic of Enlightenment: Philosophical Fragments*, trans. by Edmund Jephcott, Stanford 2007.

Hudson 2021
Nicholas Hudson (ed.), *A Cultural History of Race in the Reformation and Enlightenment*, London 2021.

Hufeland 1785
Gottlieb Hufeland, *Versuch über den Grundsatz des Naturrechts*, Leipzig 1785.

Israel 2023
Jonathan Israel, *Spinoza, Life and Legacy*, Oxford 2023.

Jacob 1990
Margaret C. Jacob, *The Newtonians and the English Revolution 1689–1720*, New York 1990.

Jacob 1991
Margaret C. Jacob, *Living the Enlightenment. Freemasonry and Politics in Eighteenth-Century Europe*, New York 1991.

Jacob/Sturkenboom 2003
Margaret C. Jacob and Dorothée Sturkenboom, 'A Women's Scientific Society in the West: The Late Eighteenth-Century Assimilation of Science', in: *Isis* 94, no. 2 (2003): 217–52.

Jersch-Wenzel 1997
Stefi Jersch-Wenzel, 'Legal Status and Emancipation', in: Michael A. Meyer (ed.), *German-Jewish History in Modern Times*, vol. 2, New York 1997: 7–49.

Johns 2014
Alessa Johns, *Bluestocking feminism and British-German cultural transfer*, Ann Arbor 2014.

Jones 1985
Gareth Jones, *Nikolay Novikov, Enlightener of Russia*, Cambridge 1985.

Kant 1785
Immanuel Kant, 'Von der Unrechtmäßigkeit des Büchernachdrucks', in: *Berlinische Monatsschrift*, vol. 3, no. 5 (1785): 403–417.

Kant 1905 (AA 2)
Immanuel Kant, *Kants gesammelte Schriften*. Edited by the Königlich-Preussische Akademie der Wissenschaften (later Berlin-Brandenburgische Akademie), vol. 2, Berlin 1905.

Kant 1907 (AA 6)
Immanuel Kant, *Metaphysics of Morals, Doctrine of Virtue* [1797], *Kants gesammelte Schriften*. Edited by the Königlich-Preussische Akademie der Wissenschaften (later Berlin-Brandenburgische Akademie), vol. 6, Berlin 1907.

Kant 1911 (AA 4)
Immanuel Kant, *Groundwork for the Metaphysics of Morals* [1785], *Kants gesammelte Schriften*. Edited by the Königlich-Preussische Akademie der Wissenschaften (later Berlin-Brandenburgische Akademie), vol. 4, Berlin 1911.

Kant 1912 (AA 8)
Immanuel Kant, *Bestimmung des Begriffs einer Menschenrace* [1785], *Kants gesammelte Schriften,* Edited by the Königlich-Preussische Akademie der Wissenschaften (later Berlin-Brandenburgische Akademie), vol. 8, Berlin 1912.

Kant 1917 (AA 7)
Immanuel Kant, *Der Streit der Facultäten* [1798], *Kants gesammelte Schriften,* Edited by the Königlich-Preussische Akademie der Wissenschaften (later Berlin-Brandenburgische Akademie), vol. 7, Berlin 1917.

Kant 1923 (AA 9)
Immanuel Kant, *Pädagogik* [1803], *Kants gesammelte Schriften,* Edited by the Königlich-Preussische Akademie der Wissenschaften (later Berlin-Brandenburgische Akademie), vol. 9, Berlin 1923.

Kant 1970
Immanuel Kant, 'What is Enlightenment?', in: H. S. Reiss (ed.) *Kant's Political Writings*, trans. by H. B. Nisbet, Cambridge 1970.

Kant 1974 (AA 27.1)
Immanuel Kant, *Moral Philosophy*, *Kants gesammelte Schriften*. Edited by the Königlich-Preussische Akademie der Wissenschaften (later Berlin-Brandenburgische Akademie), vol. 27.1, Berlin 1974.

Kant 2003
Immanuel Kant, *Critique of Pure Reason*, trans. by Norman Kemp Smith, revised 2nd edition, New York 2003.

Kant 2006
Immanuel Kant, *Anthropology from a Pragmatic Point of View* [1798], edited and translated by Robert B. Louden, Cambridge 2006.

Kaufmann 2008
Miranda Kaufmann, 'English Common Law, Slavery, and', in: Eric Martone (ed.), *Encyclopedia of Blacks in European History and Culture*, vol. 1, Westport 2008: 200–203.

Kawohl 2008
Friedemann Kawohl, 'Commentary on Kant's Essay *On the Injustice of Reprinting Books* (1785)' in: Lionel Bently et al. (eds.) *Primary Sources on Copyright (1450-1900)*, 2008, www.copyrighthistory.org (visited 18 January 2024).

Keenan 2013
Paul Keenan, *St. Petersburg and the Russian Court, 1703–1761*, London 2013.

Kersaint 1792
Armand-Guy Kersaint, *Discours sur les monuments publics, prononcé au Conseil du département de Paris, le 15 décembre 1791*, Paris 1792.

Koselleck 1988
Reinhart Koselleck, *Critique and Crisis. Enlightenment and the Pathogenesis of Modern Society*, series editor Thomas McCarthy, Cambridge, MA 1988.

Koselleck 2001
Reinhart Koselleck, 'Begriffliche Innovationen der Aufklärungssprache', in: Ulrich Kronauer et al. (eds.), *Recht und Sprache in der deutschen Aufklärung*, Tübingen 2001: 4–26.

La Boétie 2019
Étienne de La Boétie, *Abhandlung über die freiwillige Knechtschaft* [1575], Innsbruck 2019.

La Mettrie 1990
Julien Offray de La Mettrie, *L'homme machine/Die Maschine Mensch*, Hamburg 1990.

Labrosse 1985
Claude Labrosse, *Lire au XVIIIe siècle. La Nouvelle Héloïse et ses lecteurs*, Lyon 1985.

Lahontan 2023
Lahontan, *Dialogues de M. le baron de Lahontan et d'un sauvage dans l'Amérique*, Paris 2023.

Lamennais 1819
Félicité de Lamennais, *Réflexions sur l'état de l'église en France*, Paris 1819.

Laursen 2012
John Christian Laursen, 'Kant, Freedom of the Press, and Book Piracy,' in: Elisabeth Ellis (ed.), *Kant's Political Theory: Interpretations and Applications*, Philadelphia 2012.

Lavater 1775
Johann Caspar Lavater, *Physiognomische Fragmente, zur Beförderung der Menschenkenntniß und Menschenliebe*, vol. 1, Leipzig 1775.

Leckey 2011
Colum Leckey, *Patrons of Enlightenment: The Free Economic Society in Eighteenth-Century Russia*, Newark 2011.

Levy/Applewhite/Johnson 1979
Darlene Gay Levy, Harriet Branson Applewhite and Mary Durham Johnson (eds.), *Women in Revolutionary Paris, 1789–1795*, Champaign 1979.

Lichtenberg 1972
Georg Christoph Lichtenberg, *Über Physiognomik* [1778], *Schriften und Briefe*, vol. 3, Munich 1972.

Library of Congress
Library of Congress, 'Stowage of the British slave ship *Brookes* under the Regulated Slave Trade Act of 1788', https://www.loc.gov/pictures/item/98504459/ (visited 12 April 2024).

Lilti 2017
Antoine Lilti, *The Invention of Celebrity (1750–1850)*, trans. by Lynn Jeffress, Cambridge/Malden 2017.

Lilti 2019
Antoine Lilti, *L'Héritage des Lumières. Ambivalences de la modernité*, Paris 2019.

Linke 2022
Alexander Linke, *Tiepolos Moderne. Aufklärung und ästhetische Reform*, Berlin 2022.

Linnaeus 1758
Carl Linnaeus, *Systema naturae*, 10th edition, Stockholm 1758.

Linnean Society of London
Linnean Society of London, 'Linnaeus and Race', https://www.linnean.org/learning/who-was-linnaeus/linnaeus-and-race (visited 28 December 2023).

Löffler 1812
Josias Friedrich Christian Löffler, *Bonifacius, oder Feyer des Andenkens an die erste christliche Kirche in Thüringen, bey Altenberga im Herzogthum Gotha*, Gotha 1812.

Loraux/Vidal-Naquet 1979
Nicole Loraux and Pierre Vidal-Naquet, 'La formation de l'Athènes bourgeoise: essai d'historiographie, 1750–1850', in: Robert Ralph Bolgar (ed.), *Classical Influences on Western Thought A. D. 1650–1870*, Cambridge et al. 1979: 169–222.

Loudon 1992
Irvine Loudon, 'The Eighteenth Century and the Origins of Man-Midwifery', *Death in Childbirth: An International Study of Maternal Care and Maternal Mortality 1800-1950*, Oxford 1992.

Lübbe 1980
Hermann Lübbe, *Philosophie nach der Aufklärung. Von der Notwendigkeit pragmatischer Vernunft*, Düsseldorf 1980.

Lübbe 1986
Hermann Lübbe, *Religion nach der Aufklärung*, Graz 1986.

Lübbe 2001
Hermann Lübbe, *Politik nach der Aufklärung. Philosophische Aufsätze*, Munich 2001.

Maciejko 2014
Paweł Maciejko, 'The Rabbi and the Jesuit. On Rabbi Jonathan Eibeschütz and Father Franciscus Haselbauer Editing the Talmud', in: *Jewish Social Studies. History, Culture, Society,* vol. 20, no. 2 (2014): 147–183.

Major 2012
Andrea Major, '"The Produce of the East by Free Men". Indian Sugar and Indian Slavery in British Abolitionist Debates, 1793–1833', in: Major, *Slavery, Abolitionism and Empire in India, 1772–1843*, Liverpool 2012: 293–315.

Marx/Engels 1975
Karl Marx and Frederick Engels, 'The Holy Family, or, *Critique of Critical Criticism. Against Bruno Bauer and Company*,' Moscow 1975: 3–211.

Matthew (forthcoming)
Patricia Matthew, 'And freedom to the slave': Sugar and the Afterlives of Abolition, forthcoming.

McDowell 1998
 Paula McDowell, *The Women of Grub Street: press, politics, and gender in the London literary marketplace, 1678–1730*, Oxford 1998.

Melton 2001
 James van Horn Melton, *The Rise of the public in Enlightenment Europe*, Cambridge 2001.

Mendelssohn 1784
 Moses Mendelssohn, 'Ueber die Frage: was heißt aufklären?', in: *Berlinische Monatsschrift,* vol. 2, no. 9 (1784): 193–200.

Mendelssohn 1983
 Moses Mendelssohn, *Jerusalem oder über religiöse Macht und Judenthum* [1783], in: *Gesammelte Schriften. Jubiläumsausgabe*, vol. 8, Stuttgart 1983.

Mendelssohn 2014
 Moses Mendelssohn, *On Enlightening the Mind*, posted on 18 March 2014 by James Schmidt https://persistentenlightenment.com/2014/03/18/moses-mendelssohn-on-enlightening-the-mind/ (visited 28 July 2024).

Mendes-Flohr/Reinharz 1995
 Paul Mendes.Flohr and Jehuda Reinharz, *The Jew in the Modern World: A Documentary History*, 2nd edition, Oxford 1995.

Mercier 2012
 Louis-Sébastien Mercier, *Bücher, Literaten und Leser am Vorabend der Revolution. Auszüge aus dem 'Tableau de Paris',* Göttingen 2012.

Michaelis 1783
 Johann David Michaelis, 'Herr Ritter Michaelis Beurtheilung' [1782], in: Christian Wilhelm Dohm, *Über die bürgerliche Verbesserung der Juden*, vol. 2, Berlin/Stettin 1783: 31–71.

Mignolo 2011
 Walter Mignolo, *The Darker Side of European Modernity. Global Futures, Decolonial Options*, Durham 2011.

Midgley 1992
 Clare Midgley, *Women Against Slavery. The British Campaigns, 1780–1870*, London 1992.

Mill 1981
 John Stuart Mill, *Collected Works*, Toronto/London 1981.

Mill 2001
 John Stuart Mill, *On Liberty*, Ontario 2001.

Mortier 1969
 Roland Mortier, '*Lumière* et *Lumières*, histoire d'une image et d'une idée', in: Mortier, *Clartés et ombres du siècle des Lumières. Etudes sur le XVIIIe siècle littéraire*, Geneva 1969: 13–59.

Mulsow 2015
 Martin Mulsow, 'Diskussionskultur im Illuminatenorden. Schack Hermann Ewald und die Gothaer Minervalkirche', in: *Aufklärung*, vol. 26, Hamburg 2015: 153–203.

Mulsow/Naschert 2022
 Martin Mulsow and Guido Naschert, 'Geheimbünde und radikaler Kantianismus. Unberücksichtigte Diskussionszusammenhänge und Konstellationen im Umkreis der klassischen deutschen Philosophie', in: Manfred Frank and Jan Kuneš (eds.), *Selbstbewusstsein. Dieter Henrich und die Heidelberger Schule*, Stuttgart 2022: 443–468.

National Museums Liverpool
 National Museums Liverpool, 'Liverpool and the transatlantic slave trade', https://www.liverpoolmuseums.org.uk/archive sheet3 (visited 12 April 2024).

Nietzsche 1980
 Friedrich Nietzsche, *Nachgelassene Fragmente* [1875], *Sämtliche Werke*, vol. 8, Munich 1980.

Nietzsche 1994
 Friedrich Nietzsche, *The Birth of Tragedy: Out of the Spirit of Music*, edited by Michael Tanner, trans. by Shaun Whiteside, London 1993.

Ospovat 2022
 Kirill Ospovat, 'Sovereignty and the Politics of Knowledge. Royal Society, Leibniz, Wolff, and Peter the Great's Academy of Sciences', in: Thomas Biskup et al. (eds.), *Enlightenment at Court*, Liverpool 2022: 259–280.

Pagden 1982
Anthony Pagden, *The Fall of Natural Man. The American Indian and the Origins of Comparative Ethnology*, Cambridge et al. 1982.

Panofsky 2006
Erwin Panofsky, *Korrespondenz 1950 bis 1956,* Dieter Wuttke (ed.), vol. III, Wiesbaden 2006: 273–278.

Parekh 2023
Surya Parekh, *Black Enlightenment*, Durham 2023.

Pauli 1996
Wolfgang Pauli, *Wissenschaftlicher Briefwechsel mit Bohr, Einstein, Heisenberg u. a. (Scientific Correspondence with Bohr, Einstein, Heisenberg, a. o.),* vol. 4, part 1, 1950–52, Berlin/Heidelberg 1996.

Peabody 1996
Sue Peabody, *'There Are No Slaves in France': The Political Culture of Race and Slavery in the* Ancien Régime, Oxford 1996.

Perlmuter 1947
Moshe Aryeh Perlmuter, *Rabbi Yehonatan Aybeshits ve-yahaso el ha-Shabbeta'ut*, Jerusalem 1947.

Perret 1945
Jean-Pierre Perret, *Les Imprimeries d'Yverdon au XVIIe et au XVIIIe siècle*, Lausanne 1945.

Piper 2006
Andrew Piper, "The Making of Transnational Textual Communities: German women translators, 1800-1850", in: *Women in German Yearbook*, vol. 22 (2006): 119–144.

Plato 1971
Plato, *Politeia/Der Staat*, trans. by Friedrich Schleiermacher, reworked in Dietrich Kurz, *Werke*, vol. 4, Darmstadt 1971.

Plato 2013
Plato, *Republic,* vol. 2, books 6–10, edited and trans. by Chris Emlyn-Jones and William Preddy, Loeb Classical Library 276, Cambridge, MA 2013.

Playfair 1805
William Playfair, 'Supplementary chapter,' in: *The Wealth of Nations*, London 1805.

Pommier 1989
Edouard Pommier, 'Winckelmann et la vision de l'Antiquité classique dans la France des Lumières et de la Révolution', in: *Revue de l'art*, vol. 83 (1989): 9–20.

Pommier 1991
Edouard Pommier, *L'art de la liberté. Doctrines et débats de la Révolution française*, Paris 1991.

Posselt 1990
Doris Posselt (ed.), *Die Große Nordische Expedition von 1733 bis 1743. Aus Berichten der Forschungsreisenden Johann Georg Gmelin und Georg Wilhelm Steller*, Leipzig/Weimar 1990.

Pribram 1918
Alfred Pribram, *Urkunden und Akten zur Geschichte der Juden in Wien*, vol. 2, Wien 1918.

Prokopovych 2010
Feofan Prokopovych, *Izbrannye Trudy*, Moscow 2010.

Prüsener 1972
Marlies Prüsener, 'Lesegesellschaften im achtzehnten Jahrhundert. Ein Beitrag zur Lesergeschichte', in: *Archiv für Geschichte des Buchwesens,* vol. 13, no. 1–2 (1972): col. 369–594.

Quatremère de Quincy 2012
Antoine Quatremère de Quincy, *Letters to Miranda and Canova on the Abduction of Antiquities from Rome and Athens* (introduction), trans. by Dominique Poulot, Chris Miller and David Gilks, Los Angeles, 2012.

Radishchev 2020
Alexander Radishchev, *Journey from St. Petersburg to Moscow,* trans. by Andrew Kahn and Irina Reyfman, New York 2020.

Raeff 1991
Marc Raeff, 'Transfiguration and Modernization. The Paradoxes of Social Disciplining, Paedagogical Leadership, and the Enlightenment in 18th Century Russia', in: Hans-Erich Bödeker and Ernst Hinrichs (eds.), *Alteuropa, Ancien Régime, frühe Neuzeit. Probleme und Methoden der Forschung*, Stuttgart 1991: 99–115.

Raven 2007
James Raven, *The Business of Books: Booksellers and the English Book Trade 1450-1850*, New Haven 2007.

Raynal 1780
Guillaume-Thomas Raynal, *Histoire philosophique et politique des établissements et du commerce des Européens dans les deux Indes*, 5 vols., Geneva 1780.

Reddaway 1931
W. F. Reddaway (ed.), *Documents of Catherine the Great*, Cambridge 1931.

Rediker 2007
Marcus Rediker, *The Slave Ship: A Human History*, New York 2007.

Reimmann 1708–1713
Jacob Friedrich Reimmann, *Versuch einer Einleitung In die Historiam Literariam Insgemein und derer Teutschen insonderheit*, vol. 1–3 (in 6), Halle 1708–1713.

Richardson et al. 2007
David Richardson et al. (eds.), *Liverpool and Transatlantic Slavery*, Liverpool 2007.

Ries 2007
Klaus Ries, *Wort und Tat. Das politische Professorentum der Universität Jena im frühen 19. Jahrhundert,* Stuttgart 2007.

Roberts 2013
Justin Roberts, *Slavery and the Enlightenment in the British Atlantic, 1750–1807*, Cambridge 2013.

Rose 1993
Mark Rose, *Authors and Owners. The Invention of Copyright*, Cambridge, MA et al. 1993.

Rosenthal 2006
Laura J. Rosenthal, *Infamous Commerce: Prostitution in 18th-Century British culture*, Ithaca 2006.

Rossignol/Roy 2023
Marie-Jeanne Rossignol and Michaël Roy (eds.), *Anthologie de la pensée noire. Etats-Unis et Haïti (XVIIIe–XIXe siècles)*, Marseille 2023.

Rürup 1986
Reinhard Rürup, 'The Tortuous and Thorny Path to Legal Equality. 'Jew Laws' and Emancipatory Legislation in Germany from the Late Eighteenth Century', in: *Leo Baeck Institute Year Book*, 31, no. 1 (1986): 3–33.

Rush 1792
Benjamin Rush, *An Account of the Sugar Maple-Tree of the United States, and the Methods of Obtaining Sugar from It... In a Letter to Thomas Jefferson*, Philadelphia 1792.

Sala-Molins 2006
Louis Sala-Molins, *Dark Side of the Light: Slavery and the French Enlightenment*, trans. John Conteh-Morgan, Minneapolis 2006.

Schacter 1988
Jacob J. Schacter, *Rabbi Jacob Emden. Life and Major Works*, Diss. Harvard University 1988.

Schiebinger 2004
Londa Schiebinger, *Nature's body: Gender in the making of modern science*, New Jersey 2004.

Schmidt 1996
James Schmidt (ed.), *What is Enlightenment? Eighteenth-Century Answers and Twentieth-Century Questions*, Berkeley 1996.

Schmidt 2009
Georg Schmidt, *Wandel durch Vernunft. Deutsche Geschichte im 18. Jahrhundert,* Munich 2009.

Schneiders 1975
Werner Schneiders, 'Sozietätspläne und Sozialutopie bei Leibniz', in: *Studia Leibnitiana,* 7 (1975): 58–80.

Schneiders 1990
Werner Schneiders, *Hoffnung auf Vernunft. Aufklärungsphilosophie in Deutschland*, Hamburg 1990.

Schöne 1954
Wolfgang Schöne, Über das Licht in der Malerei, Berlin 1954.

Schröpfer 2014
Horst Schröpfer, *Schack Hermann Ewald (1745–1822). Ein Kantianer in der thüringischen Residenzstadt Gotha*, Cologne/Weimar 2014.

Schulze 2002
Carola Schulze, *Frühkonstitutionalismus in Deutschland*, Baden-Baden 2002.

Shapin/Schaffer 2011
Steven Shapin and Simon Schaffer, *Leviathan and the Air-Pump: Hobbes, Boyle, and the Experimental Life*, Princeton 2011.

Shmuely 1940
Efraim Shmuely, 'Review of Mortimer Cohen's *Jacob Emden. A Man of Controversy*', in: *Moznaim*, no. 1/2 (1940): 144.

Simon 1960
Brian Simon, *Studies in the History of Education: 1780–1870*, London 1960.

Smirnov 1979
Nikolai Smirnov (Daurets Nakhomon), 'Zara', in: P. A. Orlov (ed.), *Russkaia sentimental'naia povest'*, Moscow 1979.

Smirnov 2009
Nikolai Smirnov, 'Autobiography' [1785], in *Four Russian Serf Narratives*, edited and trans. by John MacKay, Madison 2009.

Smith 1976a
Adam Smith, *The Theory of Moral Sentiments*, Oxford 1976.

Smith 1976b
Adam Smith, *An Inquiry into the Nature and Causes of the Wealth of Nations*, Oxford 1976.

Smith 1791
Adam Smith, *Theorie der sittlichen Gefühle*, trans. by Kosegarten, Leipzig 1791.

Smith 1978
Adam Smith, *Lectures on Jurisprudence*, Oxford 1978.

Soemmerring 1785
Samuel Thomas Soemmerring, *Ueber die körperliche Verschiedenheit des Negers vom Europäer*, Frankfurt 1785.

Sorkin 1996
David Sorkin, *Moses Mendelssohn and the Religious Enlightenment*, Berkeley 1996.

Sperber 2014
Jonathan Sperber, *Karl Marx: A Nineteenth-Century Life*, New York 2014).

Spinoza 2022
Baruch Spinoza, *Œuvres completes*, Bernard Pautrat et al. (eds.), Paris 2022.

Spruit/Totaro 2011
Leen Spruit and Pina Totaro (eds.), *The Vatican Manuscript of Spinoza's Ethica*, Leiden/Boston 2011.

Stanhope 1777
Philip Dormer Stanhope of Chesterfield, *Miscellaneous Works*, vol. III, Dublin 1777.

Steidele 2022
Angela Steidele, *Aufklärung. Ein Roman*, Berlin 2022.

Stephens/George 1870–1954
Frederic George Stephens and Mary Dorothy George (eds.), *Catalogue of prints and drawings in the British Museum. Division I, Political and Personal Satires*, 11 vols., London 1870–1954.

Steuart 1966
Sir James Steuart, *An Inquiry Into the Principles of Political Economy*, Chicago 1966.

Stieler 1673
Kaspar von Stieler, *Teutsche Sekretariat-Kunst*, vol. 2, Nuremberg 1673.

Suarez 2021
Michael F. Suarez, S. J., 'Commodity Culture and the Political Economies of Print', The 2021 A. S. W. Rosenbach Lectures in Bibliography, University of Pennsylvania, https://www.youtube.com/watch?v=WHKbrVVDbEs (visited 29 July 2024).

Suarez/Turner 2009
Michael F. Suarez and Michael L. Turner (eds.), *The Cambridge History of the Book in Britain*, vol. 5, 2009.

Sussman 1994
Charlotte Sussman, 'Women and the Politics of Sugar, 1792', in: *Representations*, no. 48 (1994): 48–69.

Sutcliffe 2003
Adam Sutcliffe, *Judaism and Enlightenment,* Cambridge 2003.

Tissot 2001
Samuel Tissot, *De la Santé des gens de lettres.* Geneva 2001.

Tricoire 2023
Damien Tricoire, *Die Aufklärung*, Stuttgart 2023.

Van Damme 2023
Stéphane Van Damme, *Les voyageurs du doute. L'invention d'un altermondialisme libertin, 1620–1820,* Paris 2023.

Van Dyk 2021
Garritt Van Dyk, 'A Tale of Two Boycotts: Riot, Reform, and Sugar Consumption in Late Eighteenth-Century Britain and France', in: *Eighteenth-Century Life* 45, no. 3 (2021): 51–68.

Voltaire 1878
Voltaire, *Essai sur les mœurs* [1756], in: *Œuvres complètes de Voltaire*, Louis Moland (ed.), vol. XI, Paris 1878.

Voltaire 1999
Voltaire, *Histoire de l'empire de Russie sous Pierre le Grand* [1775], *Œuvres complètes de Voltaire,* vols. 46–47, Oxford 1999.

Vulpius 2017
Ricarda Vulpius, 'Civilizing Strategies and the Beginning of Colonial Policy in the Eighteenth-Century Russian Empire', in: Damien Tricoire (ed.), *Enlightened Colonialism. Civilization Narratives and Imperial Politics in the Age of Reason*, London 2017: 113–132.

Warner 1998
William Beatty Warner, *Licensing Entertainment: The Elevation of Novel Reading in Britain, 1684-1750*, Berkeley 1998.

Weber 2002
Max Weber, *The Protestant Ethic and the "Spirit" of Capitalism and Other Writings*, Peter R. Baehr and Gordon C. Wells (eds.), London 2002.

Wenger 2007
Alexandre Wenger, *La fibre littéraire. Le discours médical sur la lecture au XVIIIe siècle*, Geneva 2007.

Wheatley 1773
Phillis Wheatley, *Poems on Various Subjects, Religious and Moral*, London 1773.

Wheatley 1988
Phillis Wheatley, *The Collected Works of Phillis Wheatley*, Oxford 1988.

Wheeler 2000
Roxann Wheeler, *The Complexion of Race: Categories of Difference in Eighteenth-Century British Culture*, Philadelphia 2000.

Whelan 2011
Timothy Whelan, 'Martha Gurney and the Anti-Slave Trade Movement, 1788–94', in: Elizabeth J. Clapp and Julie Roy Jeffrey (eds.), *Women, Dissent, and Anti-Slavery in Britain and America, 1790–1865*, Oxford 2011: 44–65.

Wieland 1789
Christoph Martin Wieland, 'A couple of gold nuggets, from the … wastepaper, or six answers to six questions' (1789), in: James Schmidt, *What is Enlightenment? Eighteenth-Century Answers and Twentieth-Century Questions*, Berkeley 1996.

Willaschek 2023
Marcus Willaschek, *Kant. Die Revolution des Denkens,* Munich 2023.

Winckelmann 1755/56
Johann Joachim Winckelmann, 'Pensées sur l'imitation des Grecs dans les ouvrages de Peinture et de Sculpture', in: *Nouvelle Bibliothèque Germanique*, vol. 17 (1755): 302–329; vol. 18 (1756): 72–100.

Winckelmann 1756
Johann Joachim Winckelmann, 'Réflexions sur l'imitation des ouvrages des Grecs', in: *Journal étranger* (January 1756): 104–163 and 'Méthode suivie par Michel-Ange, pour transporter dans un bloc et pour y exprimer toutes les parties et toutes les beautés sensibles d'un modèle', in: *Journal étranger* (May 1756): 176–196.

Winckelmann 1765a
Johann Joachim Winckelmann, 'Réflexions sur l'imitation des Artistes Grecs dans la Peinture & la Sculpture par M. l'Abbé Winckelmann', in: *Gazette littéraire de l'Europe*, vol. 4 (1765): 114–121, 209–221, 365–379 and vol. 5 (1765): 105–121.

Winckelmann 1765b
Johann Joachim Winckelmann, *Reflections on the imitation of Greek works in painting and sculpture*, trans. by Henry Fusseli, London 1765.

Winckelmann 1766
Johann Joachim Winckelmann, *Histoire de l'art de l'Antiquité*, 2 vols., Paris 1766.

Winckelmann 1781
Johann Joachim Winckelmann, *Histoire de l'art de l'Antiquité*, 3 vols., Leipzig 1781 (2nd edition: 3 vols., Paris 1789).

Winckelmann 1786
Johann Joachim Winckelmann, 'Réflexions sur l'imitation des artistes grecs dans la peinture et la sculpture', in: Winckelmann, *Recueil de différentes pièces sur les arts*, Paris 1786: 1–62.

Winckelmann 1794
Johann Joachim Winckelmann, *Histoire de l'art chez les Anciens*, 2 vols., Paris an II [1794].

Winckelmann 2006
Johann Joachim Winckelmann, *History of the Art of Antiquity*, trans. By Harry Francis Mallgrave, Los Angeles 2006.

Wittmann 1981
Reinhard Wittmann, '"Der gerechtfertigte Nachdrucker". Nachdruck und literarisches Leben im 18. Jahrhundert' in: Giles Barber and Bernhard Fabian (eds.), *Buch und Buchhandel in Europa im 18. Jahrhundert*, Hamburg 1981: 292–320.

Wittmann 1991
Reinhard Wittmann, *Geschichte des deutschen Buchhandels*, Munich 1991.

Wittmann 1999
Reinhard Wittmann, 'Was there a Reading Revolution at the End of the Eighteenth Century?', in: Guglielmo Cavallo and Roger Chartier (eds.), *A History of Reading in the West*, Amherst 1999: 284–312.

Woodmansee 1994
Martha Woodmansee, *The Author, Art, and the Market. Rereading the History of Aesthetics*, New York 1994.

Wollstonecraft 2010
Mary Wollstonecraft, *A Vindication of the rights of woman: With strictures on political and moral subjects*, Auckland 2010.

Wüthrich 2007
Lucas Heinrich Wüthrich, *Matthaeus Merian d. Ä. Eine Biographie*, Hamburg 2007.

Zakonodatel'nye akty Petra I 1945
Zakonodatel'nye akty Petra I, vol. 1., Moscow/Leningrad 1945.

Zelle 1999
Carsten Zelle, 'Was ist und was war Aufklärung?', in: Herbert Beck et al. (eds.), *Mehr Licht. Europa um 1770. Die bildende Kunst der Aufklärung*, Munich 1999: 449–459.

Zöllner 1783
Johann Friedrich Zöllner, 'Ist es rathsam, das Ehebündniß nicht ferner durch die Religion zu sanciren?', in: *Berlinische Monatsschrift,* vol. 1, no. 12 (1783): 508–517.

[Zöllner] 1784
[Johann Friedrich Zöllner], 'Der Affe / Ein Fabelchen', in: *Berlinische Monatsschrift,* vol. 2, no. 11 (1784): 480.

Zuroski 2013
Eugenia Zuroski, *A Taste for China: English Subjectivity and the Prehistory of Orientalism*, Oxford 2013.

Notes on the Authors

Dr Sabine Beneke, Head of Arts Collection, Deutsches Historisches Museum, Berlin

Dorlis Blume M. A., Head of Special Exhibitions and Projects, Deutsches Historisches Museum, Berlin; Head of Project *What is Enlightenment? Questions for the Eighteenth Century*

Prof em. Dr Hartmut Böhme, Professor Emeritus of Cultural Studies, Humboldt-Universität zu Berlin

Prof em. Dr Horst Bredekamp, Professor Emeritus of Art & Visual History, Humboldt-Universität zu Berlin; Senior Co-Director of the Cluster of Excellence »Matters of Activity«

Dr Urvashi Chakravarty, Associate Professor of English, University of Toronto, Canada

Prof em. Dr Roger Chartier, Professeur em., Écrit et cultures dans l'Europe moderne, Collège de France, Paris; Annenberg Visiting Professor of History, University of Pennsylvania, Philadelphia, USA

Prof Dr Pamela Cheek, Professor of French and Comparative Literature, University of New Mexico, Albuquerque, USA

Dr Wolfgang Cortjaens, Head of Applied Arts and Graphics Collection, Deutsches Historisches Museum, Berlin; Research Associate *What is Enlightenment? Questions for the Eighteenth Century*

Dipl.-Phil. Ursula Cosmann, former Head of Graphics Collections, Stiftung Stadtmuseum Berlin

Prof em. Dr Robert Darnton, Carl H. Pforzheimer University Professor Emeritus of History and University Librarian Emeritus, Harvard University, Cambridge, USA

Prof Dr Elisabeth Décultot, Professor of Modern German Literature and Director of the Interdisciplinary Centre for European Enlightenment Studies, Martin-Luther-Universität Halle-Wittenberg

Julia Franke M. A., Head of Everyday Culture Collection, Deutsches Historisches Museum, Berlin

Prof Dr Paul Franks, Robert F. and Patricia Ross Weis Professor of Philosophy and Jewish Studies, Yale University, New Haven, USA

Prof Dr Daniel Fulda, Professor of Modern Literature, Martin-Luther-Universität Halle-Wittenberg; President of the International Society for Eighteenth-Century Studies/Société internationale d'étude du dix-huitième siècle

Prof Dr Volker Gerhardt, Senior Professor, Institute of Philosophy, Humboldt-Universität zu Berlin

Prof Dr Peter E. Gordon, Amabel B. James Professor of History and Professor of Philosophy, Harvard University, Cambridge, USA

Saro Gorgis M. A., Research Associate *What is Enlightenment? Questions for the Eighteenth Century*

Prof Dr Raphael Gross, President of the Stiftung Deutsches Historisches Museum, Berlin

Prof em. Dr Paul Guyer, Jonathan Nelson Professor Emeritus of Humanities and Philosophy, Brown University, Providence, USA

Prof em. Dr Jürgen Habermas, Professor emeritus, Institute of Philosophy, Goethe-Universität Frankfurt a. M.

Prof Dr Michael Hagner, Department of Humanities, Social and Political Sciences, ETH Zürich

Prof Dr Gunnar Hindrichs, Institute of Philosophy, Universität Basel

Prof em. Dr Jonathan Israel, School for Historical Studies, Institute for Advanced Study, Princeton, USA

Prof Dr Margaret Jacob, Distinguished Research Professor of History, University of California, Los Angeles, USA

Thomas Jander M. A., Head of Documents Collection, Deutsches Historisches Museum, Berlin

Prof Dr Antoine Lilti, Directeur des études, Ecole des hautes études en sciences sociales (EHESS); Professeur, Histoire des Lumières, XVIIIe–XXIe siècle, Collège de France, Paris

Dr Sven Lüken, Head of Militaria Collection, Deutsches Historisches Museum, Berlin

Dr Paweł Maciejko, Associate Professor of History and Leonhard and Helen R. Stulman Chair in Classical Jewish Religion, Thought and Culture, Johns Hopkins University, Baltimore, USA

Nina Markert B. A., Student Assistant *What is Enlightenment? Questions for the Eighteenth Century*

Dr Crawford Matthews, Research Associate for Outreach *What is Enlightenment? Questions for the Eighteenth Century*

Harriet Merrow M. A., Project Assistant *What is Enlightenment? Questions for the Eighteenth Century*

Dr Matthias Miller, Head of the Library and of manuscripts collection of old and rare books, Deutsches Historisches Museum, Berlin

Prof Dr Martin Mulsow, Professorship Wissenskulturen der Europäischen Neuzeit, Faculty of Philosophy, Universität Erfurt; Director of the Gotha Research Centre

Julia Nagel M. A., Museologist for the Graphic Arts and Painting Collections, Stiftung Stadtmuseum Berlin

Prof Dr Anne Norton, Stacey and Henry Jackson President's Distinguished Professor of Political Science, University of Pennsylvania, Philadelphia, USA

Dr Kirill Ospovat, Associate Professor of Slavic Languages and Literature, University of Wisconsin-Madison, USA

Dr Lili Reyels, Head of Financial and Economic History Collection, Deutsches Historisches Museum, Berlin

Prof Dr Emma Rothschild, Jeremy and James Knowles Professor of History and Director of the Center for History and Economics, Harvard University, Cambridge, USA

Prof Dr Ulrich Johannes Schneider, University Librarian Emeritus and Adjunct Professor of Philosophy, Institute for Cultural Studies, Universität Leipzig

Prof Dr Michael Suarez, S. J., University Professor, Professor of English and Director of Rare Book School, University of Virginia, Charlottesville, USA

Prof Dr Adam Sutcliffe, Professor of European History and Co-Director of the Centre for Enlightenment Studies, King's College London

Brigitte Vogel-Janotta M. A., Head of Education and Communication, Deutsches Historisches Museum, Berlin; Head of Project: Inclusion and Outreach *What is Enlightenment? Questions for the Eighteenth Century*

Lilja-Ruben Vowe M. A., Research Associate, Education and Communication Deutsches Historisches Museum, Berlin; Inclusion *What is Enlightenment? Questions for the Eighteenth Century*

Prof Dr Liliane Weissberg, Christopher H. Browne Distinguished Professor in Arts and Science, University of Pennsylvania, USA; Curator *What is Enlightenment? Questions for the Eighteenth Century*

Dr Sabine Witt, Head of Everyday Culture Collection, Deutsches Historisches Museum, Berlin

Index of Persons

A

Adorno, Gretel 26
Adorno, Theodor Wiesengrund 7–8, 26, 39, 42, 65–66, 73, 294–295
Agamemnon 215
Alembert, Jean le Rond d' 18, 36–37, 68, 104, 268, 284, 288
Alexander, Cecil Frances 194
al-Fārābī, Abū Nasr Muhammad 50
Amo, Anton Wilhelm 25
Arendt, Hannah 8, 26
Argens, Jean-Baptiste de Boyer, Marquis d' 125, 263
Aristotle 40, 50, 283
August, Prince of Saxe-Coburg and Gotha 230
Averroës (also known as Abū I-Walīd Muhammad ibn Ahmad Ibn Ruschd) 50
Avicenna 50

B

Bach, Johann Sebastian 37
Bacon, Francis 113
Bailyn, Bernard 164
Barbapiccola, Giuseppa Eleonora 148
Baret, Jeanne 152
Barruel, Augustin 163
Basedow, Johann Bernhard 167
Bassi, Laura 152
Bayle, Pierre 88
Beaumont, Jeanne-Marie Leprince de 147
Becker, Rudolf Zacharias 233, 235
Beer, Johann Friedrich 142
Bentham, Jeremy 110–111
Bering, Vitus 100–101
Berlin, Isaiah 26
Bernard, Jean Frédéric 196
Bernini, Giovanni Lorenzo 37
Bertuch, Friedrich Justin 251
Biester, Johann Erich 13
Bihéron, Marie-Marguerite 152
Birck, F. 180

Bloch, Marcus Elieser 22
Blumenbach, Johann Friedrich 83, 85
Blumenberg, Hans 39–40
Boccaccio, Giovanni 19
Bonald, Louis-Gabriel-Ambroise de 163
Bonaparte, Napoleon 18, 203–205
Botero, Giovanni 113
Bougainville, Louis-Antoine de 47, 49
Bscherer, Daniel 93
Buffon, Georges-Louis Leclerc de 68
Burke, Edmund 128

C

Calas, Jean 269
Calmet, Augustin 105
Capitaine, Louis 197
Caravaggio, Michelangelo Merisi da 222
Cassirer, Ernst 8, 26
Catherine II of Russia (also known as Catherin the Great) 114–117, 162, 236
Chambers, Ephraim 99
Charles II of England 127
Châtelet, Gabrielle Émilie Le Tonnelier de Breteuil, Marquise du 148
Chaussard, Pierre 217
Chénier, André 217
Chodowiecki, Daniel Nikolaus 14–15
Cicero 35, 283
Cist, Charles 193
Clarke, Samuel 128
Clausewitz, Carl von 232
Cochin le jeune, Charles-Nicolas 36
Coleridge, Samuel Taylor 253
Comay, Rebecca 65
Comenius, Johann Amos 166
Condorcet, Marie Jean Antoine Nicolas Caritat, Marquis de 49, 92, 168, 170
Cook, James 47, 121
Cooke, Thomas 246
Cordovero, Moses 135
Cowper, William 250
Cranz, August 202

324 Appendix

Crome, August Friedrich Wilhelm 234–235
Croutelle, Louis 21
Cruikshank, Isaac 249

D
Dacier, Anne Le Fèvre 148
Danton, Georges 24
Darbes, Friedrich August (also known as d'Arbes) 207
Darwin, Charles 128
David, Jacques-Louis 217
Defrance, Léonard (also known as Defrance de Liège) 288
Descartes, René 78, 83, 113, 126, 148
Deseine, Louis-Pierre 217
Diderot, Denis 16, 18, 36–37, 49, 51, 68, 89, 92, 104, 114, 130, 211, 218, 262, 268, 271
Dohm, Christian Wilhelm 22, 201
Döll, Friedrich Wilhelm Eugen 216
Duplessi-Bertaux, Jean 50

E
Égalité, Philippe (also known as Louis Philippe II Joseph, Duke of Orléans) 187
Ehrmann, Theophil Friedrich 233
Eibeschütz, Jonathan 138–141
Einem, Charlotte von 147
Elizabeth I of Russia 110
Emden, Ya'acov 139–140
Engelbrecht, Martin 143
Engels, Friedrich 296
Ephraim, Veitel 208
Ernst II, Duke of Saxe-Coburg and Gotha 229
Erxleben, Dorothea Christiane 152
Euchel, Isaac 135
Ewald, Schack Hermann 228–230, 232–234

F
Félice, Fortuné Barthélemy de 274
Fénelon, François de Salignac de La Mothe 161, 214
Fer, Nicolas de 243
Ferguson, Adam 161
Fichte, Johann Gottlieb 227, 234, 264, 293–294, 296
Fielding, Sarah 147
Flaubert, Gustave 18
Fleury, André-Hercule de (Catholic cardinal) 130
Fludd, Robert 39–42

Fontenelle, Bernard le Bovier de 68
Fonvizin, Denis 114, 116
Forster, Georg 121
Foucault, Michel 26, 296–298
Fox, William 243–244, 248–249
Frank, Johann Peter 70
Fränkel, David 133
Franklin, Benjamin 18, 269
Frederick II of Prussia (also known as Frederick the Great) 14, 23–24, 200, 207–208, 236, 293
Freud, Sigmund 16, 65–66, 73, 77, 81
Friedländer, David 203, 205
Friedrich II, Landgrave of Hesse-Kassel 224
Friedrich Wilhelm I of Prussia (also known as Frederick-William I the Soldier King) 120
Fukuzawa Yukichi 51
Füssli, Johann Heinrich (also known as Henry Fuseli) 16, 72

G
Gall, Franz Joseph 80
Gedike, Friedrich 13
Geoffrin, Marie Thérèse Rodet 68
George III of Great Britain 249, 256
Gillray, James 249
Gleim, Johann Wilhelm Ludwig 25
Gmelin, Johann Georg 101–102
Gmelin, Samuel Gottlieb 101
Goethe, Johann Wolfgang von 163, 169, 184, 227, 266
Gottsched, Johann Christoph 37
Gottsched, Luise Adelgunde Victorie 37
Gouges, Olympe de 20, 149, 153
Goya, Francisco de 16, 73–74
Graff, Anton 136
Grégoire, Henri Jean-Baptiste (also known as Abbé Grégoire) 202
Greuze, Jean-Baptiste 156
Grimm, Friedrich Melchior 49
Groschlag zu Dieburg, Friedrich Carl 157
Groschlag zu Dieburg, Sophie Helene (née Countess of Stadion) 157
Gurney, Martha 248

H
Habermas, Jürgen 26, 295–297
Hackwood, William 252
Hadrian (Emperor of Ancient Rome) 213

Haid, Johann Gottfried 195
Haller, Albrecht von 102
Halley, Edmond 100, 152
Hamann, Johann Georg 144
Hamilton, William 223
Hardenberg, Karl August von 205
Harvey, William 106–107
Hawkins, John 242
Haydn, Franz Joseph 195
Hegel, Georg Wilhelm Friedrich 23, 29, 62, 64–65, 291
Heine, Heinrich 69
Hell, François 202
Helvétius, Claude Adrien 68, 262
Herder, Johann Gottfried 22, 131, 144, 161, 164
Herodotus 213
Herrliberger, David 196
Herz, Henriette 25, 204
Hesiod 278
Heyne, Christian Gottlob 219
Holbach, Paul Henri Thiry d' 89, 92, 125
Holt, Lord Chief Justice John 242
Homann, Johann Baptist 112, 120
Homberg, Naftali Herz 137
Homer 215, 278
Horkheimer, Max 7–8, 26, 39, 42, 65–66, 73, 294–295
Houdon, Jean-Antoine 61, 151
Hoyoll, Ernst Friedrich Ludwig 287
Hufeland, Gottlieb 230
Humboldt, Alexander von 8, 191
Hume, David 16, 48, 284
Huygens, Christiaan 93

J

Jahn, Friedrich Ludwig 235
Jakob, Ludwig Heinrich von 234
James II of England 127
Janinet, Jean-François 191
Jansen, Hendrik 217
Jaucourt, Louis de 107, 109
Jefferson, Thomas 22, 48, 250
Joseph II, Holy Roman Emperor 136, 142, 200, 236, 288
Jung, C. G. 39

K

Kalir, Samson 134

Kant, Immanuel 8, 11–14, 16–17, 21, 25, 29, 48, 57–60, 69–70, 78, 82, 85, 105, 110, 114, 116, 161, 163–164, 166–168, 170, 172, 175–182, 227, 229–230, 232–235, 264, 271, 273–274, 279, 284, 291–298, 300
Kauffman, Angelica 150
Kepler, Johannes 39
Kersaint, Armand-Guy 217
Kleiner, Salomon 105
Klemm, Jakob Friedrich 173
Klinger, Johann Georg 47
Knüppeln, Julius Friedrich 233
Koselleck, Reinhart 29
Kraus, Georg Melchior 157
Kuntz, Carl 233

L

La Fayette, Marie-Joseph Motier, Marquis de 23, 238
La Mettrie, Julien Offray de 82–83
La Roche, Sophie von 152
Labille-Guiard, Adélaïde 150
Lahontan, Baron de (also known as Louis-Armand de Lom d'Arce de Lahontan) 51
Lamennais, Félicité de 163
Lange, Joachim 31
Las Casas, Bartolomé de 284
Lavater, Johann Caspar 17, 19, 83–85
Le Breton, André-François 271
Le Paon, Jean-Baptiste 52
Legrand, Augustin 149
Leibniz, Gottfried Wilhelm 110, 112, 136
Lemire, Noël 52
Lemonnier, Anicet Charles Gabriel 68
Lennox, Charlotte 152
Lenoir, Alexandre 217
Leopold II, Holy Roman Emperor 234
Leopold III Friedrich Franz, Prince of Anhalt-Dessau 223
Lepaute, Nicole-Reine 152
Lessing, Gotthold Ephraim 18–19, 69, 131, 200
Levy, Sarah 25
Lichtenberg, Georg Christoph 84, 96, 100
Liechtenstein, Joseph Wenzel von 195
Linck, Heinrich 103
Linck the Elder, Johann Heinrich 103
Linck the Younger, Johann Heinrich 103
Linnaeus, Carl 17, 79, 81–83, 102, 122, 244
Linschoten, Jan van 119

Lisiewski, Georg 158
Locke, John 46, 271–274, 284
Louis, Antoine 107
Louverture, Toussaint 237
Lück, Karl Gottlieb 156
Louis XIV of France (also known as the Sun King) 35
Louis XV of France 68, 125

M
Mably, Gabriel Bonnot de 214
Machiavelli, Niccolò 113
Maimon, Salomon 22
Maimonides 50, 133–134
Maistre, Joseph de 163
Malevich, Kazimir 40
Mann, Sir Horace 95
Maria Theresa of Austria 200
Marivaux, Pierre Carlet de 168
Maron, Anton von 212
Martin, François 79
Marx, Karl 8, 69, 117, 296–297
Maximilian III Joseph, Elector of Bavaria 198
Mayer, Tobias 100
Mazzini, Giuseppe 235
Melon, Jean-François 214
Mendelssohn, Moses 11, 13, 19, 22, 29, 50, 60, 133–137, 200–202
Mengs, Anton Raphael 218
Mercier, Louis-Sébastien 262
Merian the Elder, Matthäus 40–42
Messerschmidt, Franz Xaver 183
Michaelis, Johann David 101–102, 201
Mill, John Stuart 164
Millar, John 148
Milton, John 284
Moitte, Jean-Guillaume 191
Montaigne, Michel de 51, 284
Montesquieu, Charles-Louis de Secondat, Baron de la Brède et de 68, 114, 148, 231–232, 284, 288
Montfaucon, Bernard de 100
Moorhead, Scipio 245
Moreau le jeune, Jean-Michel 21
Moréri, Louis 106
Morteira, Saul Levi 126
Moser, Johann Jakob 232
Mozart, Wolfgang Amadeus 19, 62, 195
Müller, Johannes von 232

Müller, Martin Friedrich 249
Müntzer, Thomas 187–188

N
Nau, Émile 51
Newton, Isaac 16–17, 46, 83–84, 91, 109, 113, 128, 148
Nicolai, Friedrich 183
Niebuhr, Carsten 102
Niethammer, Friedrich Immanuel 234
Nietzsche, Friedrich 280, 297
Nilson, Johannes Esaias 236
Novikov, Nikolaj Ivanovič 114

P
Paine, Thomas 23, 92
Pallas, Peter Simon 101
Panin, Nikita Ivanovič 236
Panofsky, Erwin 39
Parekh, Surya 246–247
Pauli, Wolfgang 39–40, 42
Pesne, Antoine 158
Peter I, also known as Peter the Great, Tsar of Russia 110, 112–114
Pether, William 17
Phillips, James 250
Picart, Bernard 22, 196
Pindar 278
Piranesi, Giovanni Battista 16, 41–42, 44
Plato 40, 280–285
Playfair, William 163
Prévost, Bonaventure-Louis 36
Priestley, Joseph 128
Prokopovych, Feofan 112–113
Pugachev, Yemelyan Ivanovich 117
Pythagoras 278

Q
Quandet de Lachenal, Nicolas-Guillaume 274
Quincy, Antoine Quatremère de 218

R
Radishchev, Aleksandr 116–117
Rainsborough, Thomas 187
Rameau, Jean-Philippe 68
Raynal, Guillaume-Thomas François (also known as Abbé Raynal) 49, 92, 117, 262
Reich, Johann Christian 202
Reimmann, Jacob Friedrich 31–32
Reynolds, Joshua 218
Riccoboni, Marie-Jeanne 168

Index of Persons 327

Richardson, Samuel 168, 266
Roentgen, Abraham 221
Roentgen, David 221
Roth, Chrétien Frédéric Guillaume 108
Rotterdam, Erasmus of 284
Rousseau, Jean-Jacques 20–21, 23, 68, 92, 147, 149, 156, 162, 172, 188, 230, 262, 266, 284, 288
Royen, Adriaan van 102
Rumpf, Georg Eberhard 99–100
Rush, Benjamin 250

S
Saint-Pierre, Bernardin de 266
Sappho 278
Scheuchzer, Johann Jakob 105–106
Schildbach, Carl 122
Schiller, Friedrich 24
Schinkel, Karl Friedrich 23
Schlegel, Friedrich 227
Schlözer, August Ludwig 233–235
Schlözer, Dorothea (also known as von Rodde-Schlözer) 25, 151
Schurman, Anna Maria van 148
Schütz, Christian Gottfried 229
Seutter, Matthäus 129
Shakespeare, William 109
Sharp, Granville 252
Simon, Brian 164
Simon, James 103
Sloane, Hans 18, 103
Smirnov, Nikolaj 116–117
Smith, Adam 16, 163, 166–168, 170, 229, 232
Soemmerring, Samuel Thomas 84–85
Socrates 279–280, 284–285
Solon 278
Spinoza, Baruch de 16–18, 46, 88–90, 92, 126–127, 229
Springer, Friedrich Wilhelm 177
Staël, Germaine de 150
Steidele, Angela 37
Steiner, Johann Nepomuk 195
Steiner, Melchior 193
Steller, Georg Wilhelm 101
Steuart, Sir James 162
Strunz, Franz 183
Swedenborg, Emanuel 17

T
Teller, Wilhelm 203
Terence 246
Thales 278
Therbusch, Anna Dorothea 158
Thrasymachus 283
Tiepolo, Giovanni Battista 41–43
Tischbein, Johann Heinrich Wilhelm 157, 224
Troger, Simon 198
Turgot, Anne Robert Jacques 163, 168
Tsevi, Sabbatai 138–139

V
Vastey, Valentine Pompée 51
Vigée-Lebrun, Élisabeth 150
Vitet, Louis 197
Vivonne, Catherine de, Marquise de Rambouillet 148
Vogel, Christian Leberecht 171
Volckamer the Younger, Johann Georg 93
Voltaire 16, 18, 48, 61, 63–64, 68, 89, 92, 110, 114, 130, 199–200, 214, 236, 262, 284

W
Walpole, Horace 95
Washington, George 23, 52, 238
Watteau, Antoine 158
Weber, Max 66
Wedgwood, Josiah 24, 252, 254
Weisel, Naftali Herz 137
Welcker, Gottlieb 235
Wheatley, Phillis 51, 153, 155, 245–247
White, Charles 87
Wieland, Christoph Martin 30, 69
Wilberforce, William 248–249
Winckelmann, Johann Joachim 23, 211–219, 223
Winkler, Heinrich 107
Wolff, Christian 25, 31, 33–35
Wollstonecraft, Mary 19, 148, 153–154
Wright of Derby, Joseph 17, 222

Y
Yearsley, Ann 250
Young, Edward 135

Z
Zaffonato, Angelo 72
Zamosc, Israel of 134
Zedler, Johann Heinrich 37, 105
Zick, Stephan 93
Zöllner, Johann Friedrich 13–14, 19, 60, 62

Picture credits

Aachen, © Catholic parish of Aachen (formerly St. Peter's Parish Church) / Photo: Anne Gold, Aachen, p. 144

Berlin, © bpk Bildagentur, p. 36

Berlin, © bpk Bildagentur / Kupferstichkabinett, SMB, p. 17 / Photos: Dietmar Katz, p. 72 / Jörg P. Anders, p. 74

Berlin, bpk / © Klassik Stiftung Weimar / Photo: Alexander Burzik, p. 212

Berlin, © bpk / Skulpturensammlung, SMB, Property of the Kaiser Friedrich Museumsverein / Photo: Antje Voigt, p. 151

Berlin, Deutsches Historisches Museum / Photos: Sebastian Ahlers / Indra Desnica / Arne Psille, pp. 15, 47, 50, 52, 58, 61, 79, 93–95, 112, 115, 119–120, 129, 131, 134, 142–143, 149, 154, 156, 162, 167, 177, 184, 191, 193, 196, 198, 202, 208, 214, 216, 221, 223–224, 231, 236, 238, 251, 256, 268, 275, 279, 286–287, 292

Berlin, © Moses Mendelssohn Stiftung Berlin, p. 136

Berlin, © Sammlung Stiftung Stadtmuseum Berlin / Reproductions: Michael Setzpfandt, Berlin, pp. 158, 207 / Oliver Ziebe, Berlin, p. 249

Berlin, © Staatliche Museen zu Berlin, Museum Europäischer Kulturen / Ute Franz-Scarciglia, p. 172

Berlin, © Staatsbibliothek zu Berlin – Preußischer Kulturbesitz, Music Department and Mendelssohn Archive, p. 135

Berlin, © Staatsbibliothek zu Berlin – Preußischer Kulturbesitz, Department of Manuscripts and Early Printed Books, pp. 32, 34, 83, 108

Cambridge (UK), © Cambridge University Library, pp. 91, 128

Coburg, © Kunstsammlung der Veste Coburg / Photo: Lutz Naumann, p. 71

Creative Commons CC BY-SA 4.0 / Photo: Myriam Thyes, p. 43

Dijon, © Musée des Beaux-Arts / François Jay, p. 288

Dresden, © Gemäldegalerie Alte Meister, Staatliche Kunstsammlungen Dresden / Photo: Hans-Peter Klut, p. 171

Göttingen, © Ethnographic Collection, Georg-August-Universität Göttingen (Oz 122) / Photo: Harry Haase, p. 121

Göttingen, © Physikalisches Cabinet, Georg-August-Universität Göttingen / Sauer Marketing, Gerhard und Maren Sauer, p. 96

Gotha, © Landesarchiv Thüringen – Staatsarchiv Gotha CC 15/55, p. 228

Hannover, © Gottfried Wilhelm Leibniz Bibliothek - Niedersächsische Landesbibliothek Hannover, p. 90

Heidelberg, © University Library, Heidelberg University, pp. 41, 87

Heidelberg, © Institute of Anatomy and Cell Biology, Heidelberg University / Photo: Philip Benjamin, p. 80

Karlsruhe, © Pfinzgaumuseum / Photo: Gustai/Pixelgrün, p. 173

Kassel, © Natural History Museum in the Ottoneum / Photo: Peter Mansfeld, p. 122

Leipzig, © Deutsches Buch- und Schriftmuseum der Deutschen Nationalbibliothek in Leipzig, Bö-Bl/P/2074 / Photo: DNB, p. 266

Liverpool, Private collection / © Liverpool National Museums, p. 222

London, © Bentham collection, UCL Library Services, Special Collections, Bentham MS Box 115_43, p. 111

London, © National Maritime Museum, Royal Museums Greenwich, pp. 252, 254–255

London, © The Trustees of the British Museum. All rights reserved, pp. 21, 103, 282

Lyon, © Ville de Lyon (Public Domain 1.0), Archives municipales, Fonds Vitet, 84II/3/1, p. 197

Marbach, G. Leidner Ludwigsburg / Photo: Matthias Michaelis / Deutsches Literaturarchiv Marbach, p. 204

Munich, © Bayerische Staatsbibliothek, p. 263

New York City, © The Miriam and Ira D. Wallach Division of Art, Prints and Photographs: Print Collection, The New York Public Library, p. 180

Nuremberg, © Germanisches Nationalmuseum, Nürnberg, p. 157 / Photo: M. Runge, p. 165 / G. Janßen, p. 174

Paris, © Archives nationales, p. 189

Paris, © BNF – Bibliothèque nationale de France, pp. 63, 237, 261

Paris, © Muséum national d'Histoire naturelle, CA 387 FA, p. 243

Public Domain 1.0, pp. 68, 104

Stuttgart, © Staatsgalerie Stuttgart, p. 44

Vienna, © Belvedere / Photo: Johannes Stoll, p. 183

Vienna, © Wien Museum Inv.-Nr. 215962, CC0 (https://sammlung.wienmuseum.at/objekt/374835/), p. 195

Washington, D.C., Smithsonian Institution, NMAAHC (Public Domain 1.0), p. 245

Weimar, © Klassik Stiftung Weimar, pp. 169, 212

Lenders and Acknowledgements

We would like to express our gratitude to all the museums and private collections which have provided loans for this exhibition

Austria
Baden
Rollettmuseum

Vienna
Belvedere
Josephinum
Jewish Museum
Natural History Museum
Volkskundemuseum
Wien Museum

Belgium
Brussels
Fashion and Lace Museum

France
Dijon
Musée des Beaux-Arts

Lyon
Municipal Archives

Paris
Bibliothèque nationale de France
Musée des Arts et Métiers

Rouen
Musée des Beaux-Arts

Germany
Aachen
Bischöfliches Diözesanarchiv

Augsburg
Maximilianmuseum (Kunstsammlungen und Museen)

Berlin
Akademie der Künste
Berlin-Brandenburg Academy of Sciences and Humanities, Archive
Moses Mendelssohn Stiftung Berlin
Museum für Naturkunde Berlin
Schwules Museum
Secret State Archives Prussian Cultural Heritage Foundation
Staatliche Museen zu Berlin, Alte Nationalgalerie
Staatliche Museen zu Berlin, Ethnologisches Museum
Staatliche Museen zu Berlin, Gipsformerei
Staatliche Museen zu Berlin, Kunstbibliothek
Staatliche Museen zu Berlin, Kunstgewerbemuseum
Staatliche Museen zu Berlin, Kupferstichkabinett
Staatliche Museen zu Berlin, Münzkabinett
Staatliche Museen zu Berlin, Museum Europäischer Kulturen
Staatliche Museen zu Berlin, Skulpturensammlung und Museum für Byzantinische Kunst
Staatsbibliothek zu Berlin – Preußischer Kulturbesitz
Stiftung Stadtmuseum Berlin

Coburg
Kunstsammlungen der Veste Coburg

Dessau-Wörlitz
Kulturstiftung Dessau-Wörlitz

Dresden
Gemäldegalerie Alte Meister, Staatliche Kunstsammlungen Dresden

Freiberg
TU Bergakademie

Göttingen
Archäologisches Institut, Georg-August-Universität
Ethnographic Collection, Georg-August-Universität
Georg-August-Universität Göttingen, Physikalisches Cabinet
Göttingen State and University Library

Halle
City Museum
Francke Foundations
Martin-Luther-Universität Halle-Wittenberg, University and State Library of Saxony-Anhalt

Heidelberg
University Library, Heidelberg University

Karlsruhe
Pfinzgaumuseum

Kassel
Naturaly History Museum in the Ottoneum

Leipzig
Museum of City History

Mannheim
Reiss-Engelhorn-Museen

Marbach
Deutsches Literaturarchiv

Munich
Bayerische Staatsbibliothek
Deutsches Museum of Masterpieces of Science and Technology
Staatliche Graphische Sammlung

Nuremberg
Germanisches Nationalmuseum

Potsdam
Stiftung Preußische Schlösser und Gärten Berlin-Brandenburg

Schwäbisch Hall
Hällisch-Fränkisches Museum

Stuttgart
Württemberg State Museum

Weimar
Klassik Stiftung

Great Britain
Cambridge
University Library, Cambridge University

Liverpool
National Museums Liverpool, Walker Art Gallery

London
National Maritime Museum, Royal Museums Greenwich
Natural History Museum
Wellcome Collection

Oxford
History of Science Museum

and to private lenders who wish to remain anonymous.

We would also like to thank all our colleagues from the Deutsches Historisches Museum, Berlin.

Credits

What is Enlightenment?
Questions for the Eighteenth Century

An exhibition of the Deutsches
Historisches Museum

18 October 2024 – 6 April 2025

Funded by the Federal Government Comissioner for Culture and the Media

 Die Beauftragte der Bundesregierung für Kultur und Medien

The educational programme
is funded by the German Federal Cultural Foundation

Exhibition

President
Raphael Gross

Head of Exhibitions
Ulrike Kretzschmar

Head of Project
Dorlis Blume

Curator
Liliane Weissberg

Research Associates
Wolfgang Cortjaens, Saro Gorgis

Project Assistant
Harriet Merrow

Expert Advisory Board
Elisabeth Décultot, Astrid Deuber-Mankowsky, Moritz Epple, Elísio Macamo, Steffen Martus, Annette Meyer, Damien Tricoire

Video Interviews on Issues of the Age of Enlightenment with:
Asad Q. Ahmed, Peter-André Alt, Kwame Anthony Appiah, Jens Bisky, Daniel Boyarin, Sebastian Conrad, Lorraine Daston, Adrian Daub, Nargess Eskandari-Grünberg, Annette Gordon-Reed, Kurt Grünberg, Jack Halberstam, Jürgen Kaube, Neil MacGregor, Martha C. Nussbaum, Ludger Pesch, Alexander Schwarz, Barbara Stollberg-Rilinger, Andreas Trügler, Drew Weissman, Maryam Zaree

Visual Consultant
Mason Leaver-Yap

Exhibition Design
Hans Hagemeister, Marie-Luise Uhle

Registrar
Nicole Schmidt

Student Assistants
Sina Aghazadehsaeini, Johannes Karger, Nina Markert, Jelle Spieker

Education and Communication
Brigitte Vogel-Janotta (Head of Department), Claudia Braun Carrasco, Miriam Finkeldey, Verena Günther, Attila Magyar, Norman Salusa, Lilja-Ruben Vowe, Max Wandel (Guides), Crawford Matthews (Outreach), Anna-Lena Janako, Andrea Schenk (Booking Service)
Cooperation Partners for Outreach: Bildungszentrum Lohana Berkins, Youth Committee Schattenmuseum and Sideviews e. V., Pestalozzi-Fröbel House, Young Arts Neukölln

Inclusion and Accessibility
Allgemeiner Blinden- und Sehbehindertenverein Berlin gegr. 1874 e. V.
Fabian Müller, Prüfzentrum Leichte Sprache Schwaben, Donauwörth
Deutsche Zentralbücherei für Blinde zu Leipzig (DZB), Leipzig
Sign Support, Berlin
yomma GmbH, Berlin
Cooperation Partners for Inclusion: Zentrum für Kultur und visuelle Kommunikation der Gehörlosen Berlin / Brandenburg e. V. Finkenkrug-Schule, Berlin; Johann-August-Zeune-Schule, Berlin; Wilhelm-von-Türk-Schule, Potsdam

Audio Guide
Nathanael Kuck, Berlin
K13, Kinomischung und Tonstudio, Berlin
soundgarden audioguidance GmbH, Munich

Intern
Julia Sophia Bezold

Media Design and Media Technology
Felice Fornabaio

Media Installation
Eidotech GmbH, Berlin

Film Series
Jörg Frieß, Philipp Stiasny

Editing
Dorit Aurich, Berlin

Translations
Stephen Locke, Berlin; Valentine Meunier, Berlin; Richard Toovey, Berlin

Exhibition Graphics
VISUAL SPACE AGENCY Julia Volkmar with Anja Rausch
STUDIO BENS Jens Ludewig, Benjamin Rheinwald

Photo Service
Anne-Dorte Krause, Claudia Küchler

Photography
Sebastian Ahlers, Indra Desnica

Graphics Production
Digidax, Potsdam

Conservation
Martina Homolka (Head of Department), Michaela Brand, Elke Enzmann, Julia Garve, Juliane Girndt, Barbara Haussmann, Ulrike Hügle, Olaf Ignaszewski, Mathias Lang, Antje Nützmann, Matthes Nützmann, Hannah Pesch, Anne Ristau, Theresa Steinbauer-Schlagheck, Annine Wöllner, Judith Zimmer

Framing
Sabina Fernández-Weiß

Exhibition Construction and Workshops
Lisa Berchtold (Head of Department), Jens Albert, Sven Brosig, Christin Elle, Anette Forkert, Susanne Hennig, Nicholas Kaloplastos, Torsten Ketteniß, Kai-Evert Kriege, Katrin Kunze, Holger Lehmann, Jörg Petzold, Ralf Schulze, Thomas Strehl, Stefan Thimm, Gunnar Wilhelm

Painters
Malermeister Antosch, Berlin

Carpenters
Max Leppinius GmbH Messebauten

Object Installation
Abrell & van den Berg – Ausstellungsservice GbR, Berlin

Collections
Fritz Backhaus (Director of Department), Wolfgang Cortjaens, Julia Franke, Thomas Jander, Sven Lüken, Matthias Miller, Brigitte Reineke, Lili Reyels, Thomas Weißbrich, Sabine Witt

Communications
Stephan Adam, Maria Altnau, Christina Behrendt, Ina Frodermann, Laura Groschopp, Jenny Jakubik, Daniela Lange, Alexandra de Léon, Tabea Lintzmeyer, Ilka Linz, Jana Nawrot, Nicola Schnell, Peter Schützhold, Oliver Schweinoch

Scientific Programme
Stephanie von Steinsdorff, Nike Thurn

IT
Gerhard Schmitt (Head of Department), Sven Bienge, Björn Eichberg, Alexandra Gelemerova, Jan-Dirk Kluge, Uwe Naujack, Magnus Wagner

Controlling
Ines Baginski, Manuela Itzigehl

Communication Campaign
STUDIO BENS Jens Ludewig, Benjamin Rheinwald
VISUAL SPACE AGENCY Julia Volkmar

Catalogue
What is Enlightenment?
Questions for the Eighteenth Century

Published by
Raphael Gross and Liliane Weissberg
for the Deutsches Historisches Museum

Editing
Dorlis Blume, Harriet Merrow,
Liliane Weissberg

Photo Editing
Harriet Merrow

Copy Editors
Dorit Aurich, Berlin; Richard Toovey, Berlin

Translations
Adam Blauhut, Berlin; Ciaran Cronin, Berlin; Caroline Gutberlet, Berlin; Stephen Locke, Berlin; Richard Toovey, Berlin; Robert Zwarg, Leipzig

Photography
Sebastian Ahlers, Indra Desnica

Coordination and Production Management
Ilka Linz

Coordination and Production Management Hirmer
Katja Durchholz

Design
Fotosatz Amann, Memmingen, based on a design by Studio Bens

Reprography
Fotosatz Amann, Memmingen

Printing and Binding
Westermann Druck Zwickau GmbH, Zwickau

Printed in Germany

Bibliographic Information from the Deutsche Nationalbibliothek (German National Library)
The Deutsche Nationalbibliothek has registered this publication in the German National Bibliography; detailed bibliographic data can be accessed online at http://www.dnb.de

© 2024 Stiftung Deutsches Historisches Museum, Berlin and Hirmer Verlag GmbH, Munich and the authors

This work, including all of its parts, is protected by copyright. Any utilisation outside the narrow limits of copyright law without the consent of the publisher is unauthorised and punishable by law: This applies in particular to reproduction, translations, microfilming and the storage and processing in electronic systems.

ISBN 978-3-86102-236-7
(English museum edition)

ISBN 978-3-7774-4414-7
(English trade edition)

www.dhm.de
www.hirmerpublishers.com

Hirmer Publishers
Managing Director: Kerstin Ludolph
Bayerstraße 57–59
80335 Munich
Germany

The Stiftung Deutsches Historisches Museum makes every effort to use gender-appropriate language. Where sources have been cited as quotations, however, the original documents have been reproduced without any changes.